LUXURY FOR CATS

edited and written by Patrice Farameh

teNeues

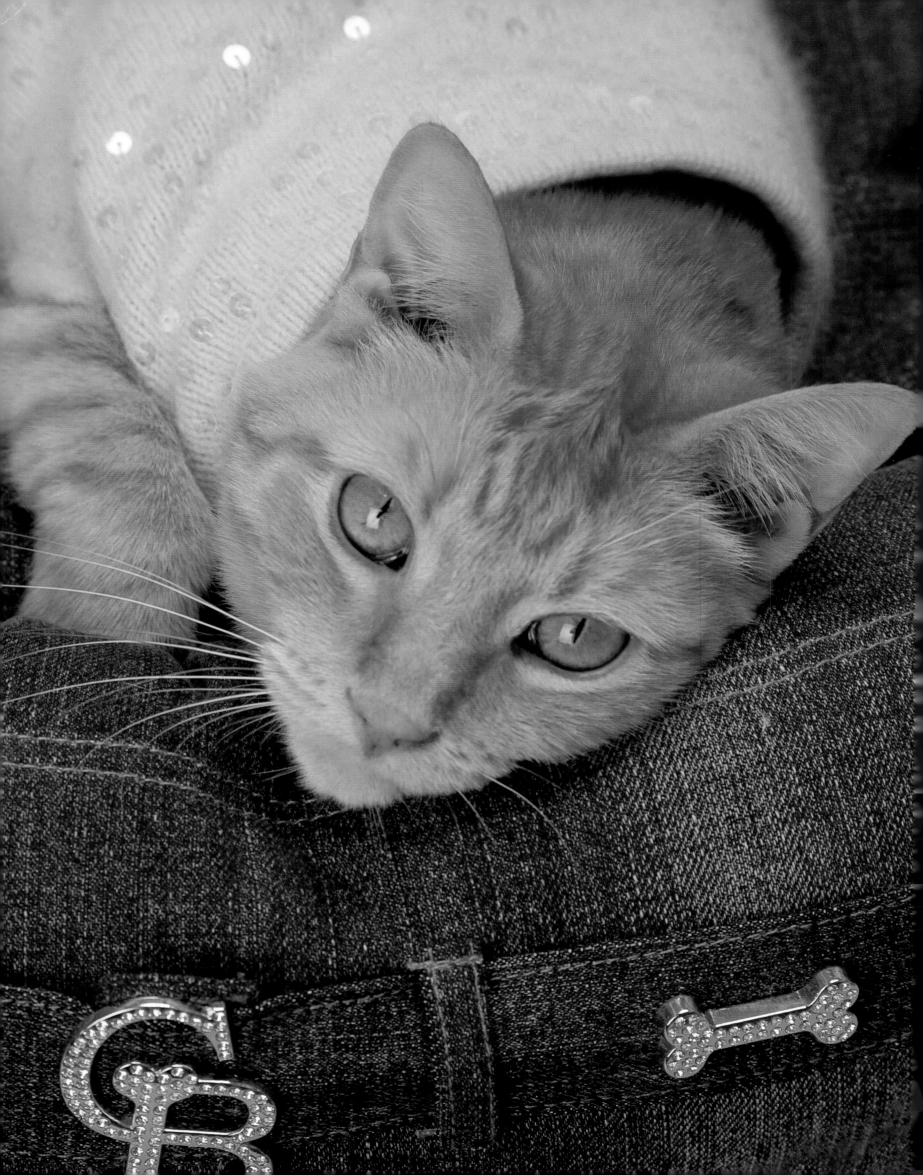

Introduction

"I have studied many philosophers and many cats. The wisdom of cats is infinitely superior" - Hippolyte Taine

I f you are reading this book, I assume either the purring of your feline friend has massaged your heart to the point of uncontrollable ailurophilia, or a cat has at least made a significant impact to your life in some way.

Life with the domesticated cat gives us firsthand knowledge to experience the exotic beauty and (mis-)behavior of their wild and dangerous relatives of jungles and mountains; it is God's way of allowing you to pet a lion on your lap, or as the Japanese say, to possess a "tiger that eats from the hand". Once you own a cat, it is no surprise that this house pet has been prominently featured in history, superstitious folklore, and religion ever since the Egyptians first worshipped this elegant creature as a sacred god. And my own cat has never forgotten this heritage.

I have personally followed the rampant glamorization of cat products for the past decade, but I am not a cat-obsessed lady who excessively pampers her cat. At least not to the extent of passionate breeders and show people who live, breathe, and speak cats. I feel I don't even own a cat. My cat owns me.

Nevertheless, I try to treat my precious feline—named "Sushi"—just like any other cat, but my intense guilt in confining her indoors does provide my four-legged friend many special privileges. Luckily for me, the pet care industry is the second fastest growing category in retail today, exceeding even the candy and toy industries. A current survey estimated that pet lovers now spend more than $40 billion on their furry companions in just one year in the United States alone. The pet marketplace is flooded with savvy entrepreneurs, cutting-edge designers, and feline fanatics who understand the dilemma of owning the 'sophisticated cat', and are creating products that go beyond just the bare essentials. The old days of grocery store pet food and plastic litter trays are long gone. Hello organic chef-prepared meals and hidden litter boxes tucked in lavish armoires. Cat owners today spare no expense when it comes to providing their little family members a more luxurious environment, which has evolved into the newest feline phenomenon: luxury products for cats.

This new wave in the pet care industry has created endless options for the luxury-minded consumer who wants to indulge their fastidious felines. Just a few years ago, a cat lover was forced to succumb to decorating their house with dull, standard, and sometimes embarrassingly ugly cat furnishings. It is a blessing to know that today it is possible to create an inspired, stylish home environment that is in harmony with the cat's needs as well as mine.

Thanks to an outpouring of cat-loving designers in the pet care industry, there is a multitude of distinctive, luxurious products to choose from, such as stylish bed stands, opulent cat cottages, and scratching posts that resemble a piece of sculptural art. For instance, I have designer beds made from the highest quality materials and rich fabrics tucked in corners of each room that complements the décor of my house while providing the ultimate kitty milieu. One bed comes with a heating apparatus, while another cat lounger is an exact miniature replica of a famous designer chair.

The newest trend is the humanization of pet products for those consumers who have made their pet the focal point of their lives. The quality gap between products for humans and cats is diminishing as the pet industry is creating more products and services that closely resemble those sold to humans. This is due to current lifestyle changes in human relationships, partly due to more women in the workforce, more divorces, delays in marriage and children, and the ever increasing rate of young single adults moving into heavily populated cities. The cat is not just an occasional house visitor any longer, but an esteemed family member.

That is why I want Sushi to feel as if I'm the guest and she is the reigning queen of the palace. But there are times that her kitty nature conflicts with my house rules. It is a feline fact of life that all cats have the biological necessity to scratch, and I have all the scratch scars on my hands, walls, mahogany legs of chairs, and my ultra-suede couch to prove it. Thanks to some clever carpenters who embrace innovation and modern design, there are many options for custom-made scratching trees and posts. One is a sleek cat scratching board bolted to the walls that support Sushi as if she was part of some minimalist art installation. Another scratching post is a carpeted structure in the form of a magnificent, multi-colored sculpture of a palm tree. My bedroom is fitted with a beautiful custom-made wooden

lavender-infused hair ointments sold at high-end pet boutiques and cat spas. I leave it up to her own 'paws' to take care of her grooming, unless she is plagued by the matted hair syndrome. This leads to the dreaded visit by the mobile grooming service, their ultra-trendy $100 "lion's cut", and a very angry cat. Assuming that her exotic beauty comes from a royal heritage of lions, it is still incomprehensible to me why she hates to look like one.

After certain traumatic events such getting her teeth cleaned at the kitty dentist or 'surviving' the grooming services, Sushi always has a therapy session with the cat psychologist. Once the veterinarian even prescribed my distressed cat some anxiety-reducing medication after a case of mild depression. Unfortunately, my little foul-faced feline has an addictive personality, and became dependent on these kitty sedatives. I intervened with a local respectable 'cat whisperer' after Sushi started to show some signs of aggression after I stopped giving her the medication. My frantic feline had to spend some time at a local detox cattery where she completed the "12 paw program", which is not unusual since cat therapy here is a rising trend. Now my sober cat visits a new holistic veterinarian who administers strictly homeopathic and herbal remedies, and provides acupuncture and chiropractic sessions as well.

Sushi is also terribly fussy about her cuisine and is impartial to organic cat food with vitamin and mineral supplements prepared with ingredients fit for human consumption. Once when she stayed at a luxury cat boarding hotel—with video catnip on her own personal TV and an aquarium in her private room—they served her the Japanese delicacy sushi. Since then, every time she sees a bento box in my hand, she calls for the 'maguro' (raw tuna sushi) by name—a loud whiney chorus of "meow-guro! meow-guro!". That is why I changed her name from "Miss Princess Sofia of King Bastet the Third" to simply "Sushi".

The luxury element of cat design is not just limited to edible delicacies, designer furnishings, and luxurious beauty treatments, but also fashion and accessories. Sushi owns her own diamond tiara, a pink crystal collar with her name embedded with rhinestones, and has a little drawer full of costumes for special occasions like Halloween. When I take Sushi to the kitty spa every month for her pedicure and monthly massage appointment, I cart her around like royalty in a comfortable cat stroller that folds up and buckles up securely in the car. Once we arrive at our destination, she is placed in a personally monogrammed carrier from an ultra-hip fashion label lined with a mink blanket. Nothing is too outrageous or luxurious for the elegant and regal cat.

There are infinitely more ways to show your love to a cat during all of their nine lives. Today cat lovers have many more choices than ever to improve the quality and lifestyle of the finicky feline. The carefully selected products in these pages capture the alluring mystique of the cat as it becomes one with the owner's life and the home interior. From napping cocoons made from hand-blown glass to beautiful home accessories disguising a cat necessity, these pages introduce you to the most creative products ever made for the sophisticated cat who literally wants to live in the lap of luxury.

In today's modern society, the "cat's life" no longer means enduring the elements and dangers of living outdoors of a congested metropolitan city to avoid a boring lifestyle confined indoors, or dealing with beauty and health problems (even the emotional ones), or eating canned gelatinous, mysterious goop out of old plastic bowls. The cat today has it much better, and these pages show you how good it can actually be.

This beautifully illustrated book is humbly dedicated to all of the sophisticated cats in the world who have given companionship and love in our past lives and present, and those that will undoubtedly improve the quality of our life in the future. As one unknown wise person once said, "every life should have nine cats".

Patrice Farameh
www.luxuryforcats.com

cat condo that spans up to three floors that gives Sushi ample room to entertain herself with the various stuffed toys in the shape of birds and mice dangling from each level.

Some could say that I created my own living environment around an elaborate playground for my darling cat because of the customized "cat-walk" mounted around my living room walls that gives Sushi a plethora of different ledges to lounge and climb. My excuse for such a costly venture: I increased my kitty's playing grounds while using practically no living space of my own. That leads to greater comfort for both cat and keeper, and we all know that comfort is a key ingredient to true luxury.

I have yet to decorate my home with a portrait of my beloved cat commissioned by one of the many oil painters specializing in "feline fine art". I have also never given Sushi a bath with one of those high-end scented organic bath products made exclusively for pets, or smoothed her coat with

Einleitung

"I have studied many philosophers and many cats. The wisdom of cats is infinitely superior" - Hippolyte Taine

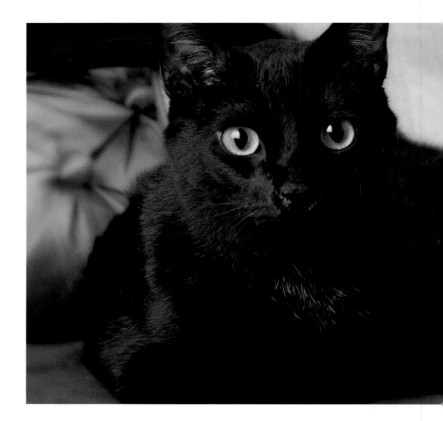

Wenn Sie dieses Buch lesen, nehme ich an, dass Ihr Herz durch das Schnurren Ihres Stubentigers bis zu einem Punkt unkontrollierbarer Katzenliebe bewegt wurde, oder dass mindestens eine Katze Ihr Leben auf irgendeine Art und Weise erheblich beeinflusst hat.

Das Leben mit einer Hauskatze lässt uns aus erster Hand die exotische Schönheit und das (schlechte) Verhalten ihrer wilden und gefährlichen Artverwandten in den Dschungeln und Gebirgen erfahren; Gott erlaubt Ihnen hierdurch auf seine Weise, einen Löwen auf Ihrem Schoß zu streicheln, oder wie die Japaner sagen, einen „Tiger zu besitzen, der einem aus der Hand frisst". Wenn Sie erst einmal eine Katze besitzen, überrascht es Sie nicht, dass dieses Haustier, sowohl im Aberglauben als auch in der Religion, eine herausragende Rolle in der Geschichte spielte, seitdem die Ägypter diese elegante Kreatur einst als ihre Göttin anbeteten. Meine eigene Katze hat dieses Erbe nie vergessen…

Ich selbst habe die stark zunehmende Glorifizierung von Katzenprodukten im letzten Jahrzehnt verfolgt, gehöre allerdings nicht zu den katzenverrückten Damen, die ihren Liebling extrem verwöhnen. Zumindest nicht so wie die leidenschaftlichen Züchter und Wettbewerbsteilnehmer, deren ganzes Denken und Tun um die Katze kreist. Ich habe noch nicht einmal das Gefühl, eine Katze zu besitzen. Meine Katze besitzt mich.

Dennoch versuche ich meine wertvolle Katze – genannt „Sushi" – genau so wie jede andere Katze zu behandeln, allerdings hat meine vierbeinige Freundin viele Sonderprivilegien aufgrund meines schlechten Gewissens, dass ich sie im Haus halte. Ich habe Glück, denn die Haustierproduktindustrie steht heute an zweiter Stelle, was das Einzelhandelswachstum betrifft, und hat sogar die Süßigkeiten- und Spielwarenindustrie überholt. Laut einer aktuellen Studie geben Tierliebhaber allein in den Vereinigten Staaten mittlerweile mehr als 40 Billionen Dollar pro Jahr für ihre pelzigen Lebensgefährten aus. Der Heimtiermarkt wird von cleveren Unternehmern, innovativen Designern und Katzenfanatikern überschwemmt, die etwas von dem Dilemma verstehen, eine „anspruchsvolle" Katze zu besitzen und deshalb Produkte jenseits der lebensnotwendigen Güter kreieren. Die guten alten Zeiten des Supermarktfutters und der Katzentoilette aus Kunststoff sind längst Vergangenheit. Wir leben in einem Zeitalter, in dem Chefköche Katzenmahlzeiten aus Bio-Zutaten zubereiten und Katzentoiletten in aufwändig gestalteten Schränken versteckt werden. Heute sparen Katzenbesitzer an nichts, wenn es darum geht, eine luxuriöse Umgebung für ihre kleinen Familienmitglieder zu schaffen, und genau das führt zum neuesten Katzenphänomen: Luxusprodukte für Katzen.

Diese neue Welle in der Tierproduktindustrie schafft grenzenlose Optionen für die luxusorientierten Verbraucher, die ihre anspruchsvollen Katzen verwöhnen möchten. Noch vor einigen Jahren waren Katzenliebhaber gezwungen, ihr Haus mit wenig spektakulären, standardmäßigen und manchmal sogar hässlichen Einrichtungsgegenständen für Katzen zu dekorieren, die schlichtweg peinlich waren. Also ist es ein Segen zu wissen, dass es heutzutage möglich ist, ein inspiriertes, stylisches Heim zu kreieren, das sowohl meinen Bedürfnissen als auch den Bedürfnissen meiner Katze entspricht.

Dank einer Flut von katzenliebenden Designern stehen nun zahlreiche charakteristische, luxuriöse Produkte zur Auswahl wie stylische Bettge-stelle, opulente Katzenhäuschen und Kratzbäume, die an bildhauerische Kunstwerke erinnern. Ich habe zum Beispiel Designerbetten aus den hochwertigsten Materialien anfertigen lassen und verschwenderisch viel Stoff in den Ecken eines jeden Raumes drapiert, der zur Ausstattung meines Hauses passt, um auf diese Weise das ultimative Milieu für mein Kätzchen zu schaffen. Ein Bett ist beheizbar, während eine andere Relaxzone für meine Katze die exakte Miniaturnachbildung eines berühmten Designerstuhls ist.

Der neueste Trend ist die Vermenschlichung von Tierprodukten für jene Verbraucher, die ihr Tier zu ihrem Lebensmittelpunkt gemacht haben. Es gibt nur noch geringe Qualitätsunterschiede zwischen den Produkten für Menschen und Katzen, da die Heimtierindustrie immer mehr Produkte und Dienstleistungen kreiert, die den für Menschen bestimmten Artikeln zunehmend ähnlicher werden. Ausschlaggebend für diese Entwicklung ist der gegenwärtige Wandel im Lebensstil unserer Gesellschaft; man denke hier an den gestiegenen Anteil der Frauen auf dem Arbeitsmarkt, die zunehmenden Ehescheidungen, die späteren Eheschließungen und Kinderzeugungen sowie die stetig zunehmende Anzahl junger Singles, die in dicht besiedelte Städte ziehen. Die Katze ist nicht mehr nur noch ein gelegentlicher Hausgast, sondern ein geschätztes Familienmitglied.

Deshalb soll Sushi das Gefühl haben, dass ich der Gast bin und sie die regierende Königin des Palastes ist. Allerdings gibt es Momente, in denen ihre Katzeneigenschaften mit meinen Hausregeln kollidieren. Es liegt eben in der Natur der Katze, ein ausgeprägtes Kratzbedürfnis zu verspüren, und deshalb habe ich überall Kratzspuren: an meinen Händen, Wänden, Mahagonistuhlbeinen und meinem wunderschönen Sofa aus Veloursleder – eben der Beweis für dieses Phänomen. Dank einiger cleverer Tischler, die Innovation mit modernem Design verbinden, gibt es eine große Auswahl an maßgefertigten Kratzbäumen und -ständern. Beispielsweise eine glatte Kratzplatte, die an die Wand genagelt wurde und Sushi derart in Szene setzt, als wäre sie Teil einer minimalistischen Kunstausstellung. Ein anderer Kratzbaum ist eine mit Teppich verkleidete Konstruktion in Form einer wunderschönen, bunten Palmenskulptur. Mein Schlafzimmer ziert ein hübsches Katzenheim aus Holz, das sich über drei Etagen erstreckt und Sushi ausreichend Raum zur Zerstreuung bietet dank der zahlreichen Spielsachen aus Plüsch in der Form von Vögeln und Mäusen, die von jeder Ebene herunterbaumeln.

Man könnte sagen, dass ich meinen eigenen Lebensraum rund um einen bis ins kleinste Detail durchdachten Spielplatz für meinen kleinen Liebling geschaffen habe. Nicht zuletzt wegen des maßgefertigten „Catwalk", der an meine Wohnzimmerwände montiert wurde und Sushi eine Unmenge an unterschiedlichen Flächen zum Faulenzen und Klettern bietet. Meine Entschuldigung für diesen teuren Spaß: Ich vergrößerte den Spielraum meines Kätzchens, während ich praktisch keinen Wohnraum mehr für mich alleine habe, was jedoch zu einem gesteigerten Komfort für Katze und Halter führt. Und wir alle wissen doch, dass Komfort der Schlüssel zum wahren Luxus ist.

Ich muss auf jeden Fall noch mein Zuhause mit einem Portrait meiner geliebten Katze schmücken, das ich bei einem der zahlreichen Ölmaler in Auftrag geben werde, die sich auf die „schönen Katzenkünste" spezialisiert haben. Ich habe Sushi auch noch nie ein Bad bereitet mit einem dieser sensationellen, parfümierten, biologischen Badeprodukte, die exklusiv für Tiere kreiert werden, geschweige denn ihr Fell mit speziellen Lavendelsalben gepflegt, die in den High-End-Tierboutiquen und Wellnesszentren für Katzen verkauft werden. Die Fellpflege überlasse ich ihren eigenen Pfötchen, es sei denn, sie wird vom Syndrom des verfilzten Felles geplagt. Das hat dann den gefürchteten Besuch des mobilen Pflegeservices zur Folge, den ultra-trendigen 100-Dollar teuren „Löwenschnitt" und eine außerordentlich verärgerte Katze. Aufgrund der Annahme, dass ihre exotische Schönheit vom wahrhaft königlichen Erbe des Löwen herrührt, ist es mir immer noch unbegreiflich, warum sie es hasst, wie einer auszusehen.

Nach bestimmten traumatisierenden Ereignissen, wie zum Beispiel ihre Zahnreinigung beim Katzenzahnarzt oder das „Überleben" des Pflegeservices, hatte Sushi grundsätzlich eine Therapiesitzung beim Katzenpsychologen. Einmal verschrieb der Veterinär meiner gestressten Katze sogar ein angstreduzierendes Medikament, nachdem eine leichte Depression bei ihr aufgetreten war. Leider hat meine kleine zickige Katze eine zur Abhängigkeit neigende Persönlichkeit, sodass sie von den Kätzchen-Sedativen abhängig wurde. Als Sushi Zeichen einer Aggression entwickelte, nachdem ich aufgehört hatte, ihr die Medikamente zu geben, konnte dies jedoch durch einen ortsansässigen „Katzenflüsterer" behoben werden. Meine wilde Katzendame musste einige Zeit in einer hiesigen Katzenentzugsklinik verbringen, wo sie das „12-Pfoten-Programm" absolvierte, was durchaus

nicht ungewöhnlich ist, seitdem die Katzentherapie ein steigender Trend ist. Jetzt ist meine cleane Katze bei einem neuen, ganzheitlich ausgerichteten Tierarzt in Behandlung, der nicht nur streng homöopathische Arzneien und Kräuter verordnet, sondern auch Akupunktur und Chiropraktik anwendet.

Sushi ist auch schrecklich wählerisch was ihre Ernährung angeht und völlig unvoreingenommen in Bezug auf biologisches Katzenfutter, angereichert mit Vitaminen und Mineralien und zubereitet aus Zutaten, die sich sogar für den menschlichen Konsum eignen. Als sie einmal in einem luxuriösen Katzenhotel mit Vollpension residierte — mit einem Katzenminzevideo auf ihrem persönlichen TV-Gerät und einem Aquarium in ihrem Privatgemach — wurde ihr die japanische Spezialität Sushi serviert. Seitdem verlangt sie nach „Maguro" (rohes Thunfisch-Sushi), sobald sie eine Bento-Box in meinen Händen entdeckt, und nennt es sogar beim Namen, indem sie einen lauten, weinerlichen Refrain anstimmt, der „Meow-guro! Meow-guro!" lautet. Deshalb habe ich sie umgetauft und aus ihrem ursprünglichen Namen „Miss Princess Sofia of King Bastet the Third" einfach „Sushi" gemacht.

Luxuriöses Katzendesign beschränkt sich nicht nur auf essbare Spezialitäten, Designermöbel und luxuriöse Schönheitsbehandlungen, sondern ist auch bei Mode und Accessoires sehr beliebt. Sushi hat ihre eigene Diamantentiara, ein rosafarbenes Kristallhalsband mit ihrem in Strasssteinchen eingefassten Namen und besitzt sogar eine kleine Schublade mit Kostümen für spezielle Anlässe wie zum Beispiel Halloween. Wenn ich Sushi einmal im Monat zum Katzenwellnesscenter bringe, sodass sie ihren monatlichen Termin für ihre Pediküre und Massage wahrnehmen kann, kutschiere ich sie wie eine Hoheit in einem komfortablen Katzenkinderwagen durch die Gegend, der zusammenklappbar ist und sicher im Auto angeschnallt wird. Wenn wir dann an unserem Ziel angekommen sind, wird sie in einer Tragetasche eines ultra-hippen Modelabels mit Monogramm und einer Nerzdecke platziert. Nichts ist eben zu gewagt und luxuriös für die elegante und majestätische Katze.

Es gibt noch unendlich mehr Möglichkeiten, wie Sie Ihre Liebe gegenüber einer Katze während ihrer neun Leben bezeugen können. Heute haben Katzenliebhaber viel mehr Möglichkeiten als je zuvor, um die Lebensqualität und den Lebensstil ihrer wählerischen Samtpfötchen zu verbessern. Die sorgfältig ausgewählten Produkte auf diesen Seiten erfassen den verführerischen, geheimnisvollen Nimbus der Katze, da er eins wird mit dem Leben des Besitzers und dem Interieur seines Heimes. Von Schlummerkokons, gefertigt aus mundgeblasenem Glas, bis hin zu wunderschönen Heimaccessoires, die als Tarnung für ein Katzennecessaire dienen, präsentieren Ihnen diese Seiten die kreativsten Produkte, die jemals für die anspruchsvolle Katze kreiert worden sind, die im wahrsten Sinne des Wortes im Schoße des Luxus leben möchte.

In der modernen Gesellschaft von heute bedeutet ein „Katzenleben" nicht länger, die Naturgewalten und Gefahren eines Lebens draußen in einer verkehrsreichen Großstadt zu überstehen, um einen langweiligen, ans Haus gebundenen Lebensstil zu vermeiden, oder mit Schönheits- und Gesundheitsproblemen zu kämpfen (sogar emotionaler Art), oder gar das Verzehren einer gallertartiger, undefinierbarer Pampe aus alten Plastiknäpfen. Heutzutage hat es die Katze wesentlich besser und diese Seiten zeigen Ihnen, wie gut ein Katzenleben tatsächlich sein kann.

Dieses wunderschön illustrierte Buch wurde in bescheidener Weise all den anspruchsvollen Katzen dieser Welt gewidmet, die uns in unserem früheren und gegenwärtigen Leben mit ihrer Begleitung und Liebe erfreut haben, und denjenigen, die unsere Lebensqualität zukünftig zweifelsohne bereichern werden. Wie eine unbekannte, weise Person einmal sagte: „Jedes Leben sollte neun Katzen haben".

Patrice Farameh
www.luxuryforcats.com

Introduction

"I have studied many philosophers and many cats. The wisdom of cats is infinitely superior" - Hippolyte Taine

Si vous lisez ce livre, je suppose que soit le ronronnement de votre ami félin a touché votre cœur au point de développer chez vous une incontrôlable ailurophilie, soit qu'un chat a compté d'une quelconque manière dans votre vie.

Vivre avec un chat domestique nous permet de connaître de près la beauté exotique et le comportement de ses cousins sauvages et dangereux des jungles et des montagnes : c'est Dieu qui nous autorise à caresser un lion sur nos genoux, ou, comme disent les japonais, c'est posséder « un tigre qui vous mange dans la main ». Une fois qu'on possède un chat, on n'est pas étonné que cet animal domestique ait été hautement distingué à travers l'histoire, les folklores et superstitions et les religions depuis que les Egyptiens ont commencé à vénérer cette créature élégante comme un dieu sacré. Et mon propre chat n'a jamais oublié cet héritage.

J'ai personnellement suivi la « glamourisation » galopante des articles pour chats pendant la dernière décennie, mais je ne suis pas une obsédée des chats qui materne excessivement son animal. Ou tout au moins pas au même niveau que les éleveurs passionnés et les candidats des concours qui vivent, respirent et parlent chat. J'ai l'impression que je ne possède même pas de chat. C'est mon chat me possède.

J'essaie toutefois de traiter mon précieux félin – nommé « Sushi » – tout comme n'importe quel autre chat, mais je me sens si coupable de devoir l'enfermer à la maison que j'octroie à mon amie à quatre pattes de nombreux privilèges spéciaux. Heureusement pour moi, le secteur des animaux domestiques connaît aujourd'hui la deuxième croissance la plus rapide de la vente au détail, dépassant même le secteur des bonbons et des jouets. Une étude actuelle estime que les amis des animaux dépensent plus de 40 milliards de dollars par an pour les seuls Etats-Unis. Le marché des produits pour animaux domestiques est submergé d'entrepreneurs malins, de designers avant-gardistes et de fanatiques des félins qui comprennent le dilemme de posséder un « chat sophistiqué », et créent des produits qui vont bien plus loin que l'essentiel. Le bon vieux temps de la nourriture d'épicerie et des bacs à litière en plastique est dépassé depuis longtemps. Bonjour repas bio préparés par des chefs et litières cachées dans des armoires élégantes. Les propriétaires de chats n'évitent plus aucune dépense quand il s'agit d'offrir à ces petits membres de leur famille un environnement plus luxueux, une évolution qui a mené au nouveau phénomène félin : les produits de luxe pour chats.

Cette nouvelle vague du secteur animalier a ouvert des possibilités illimitées pour le consommateur de luxe désireux de faire plaisir à ses exigeants félins. Il y a seulement quelques années, l'amoureux des chats était obligé de décorer sa maison avec des articles ennuyeux, standardisés et parfois d'une laideur embarrassante. C'est une bénédiction de savoir qu'aujourd'hui il est possible de créer un cadre inspiré et élégant, en harmonie avec les besoins du chat tout comme avec les miens.

Grâce à la multitude de designers amateurs de chats dans le secteur animalier, on dispose d'un immense choix de produits de luxe spécifiques, comme des paniers, d'opulents cottages pour chats et des griffoirs qui ressemblent à des sculptures d'art. Par exemple, j'ai installé des paniers de designer faits des matériaux les plus nobles et de riches tissus dans les coins de chaque pièce, qui complètent le décor de ma maison tout en offrant un univers idéal au matou. Un des paniers est accompagné d'un système de

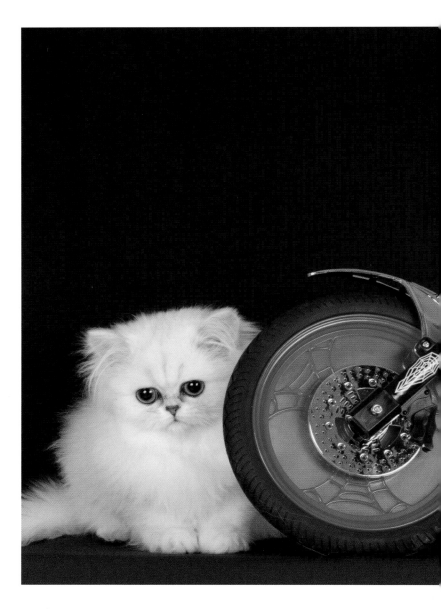

chauffage, tandis qu'un autre coussin est la réplique miniature exacte d'une célèbre chaise de designer.

La tendance la plus récente est l'humanisation des produits pour animaux, pour ces consommateurs qui ont fait de leur animal le point essentiel de leur vie. Le fossé de qualité entre les produits pour humains et produits pour chats diminue au fur et à mesure que le secteur crée de nouveaux produits et services, extrêmement proches de ceux vendus aux humains. Cette tendance est liée aux changements de styles de vie affectant les relations humaines : augmentation du nombre de femmes qui travaillent et des divorces, des mariages et des grossesses tardives, et taux toujours plus élevé de jeunes adultes célibataires s'installant dans des villes densément peuplées. Le chat n'est plus seulement un visiteur occasionnel, mais un membre estimé de la famille.

C'est pourquoi je veux que Sushi ait l'impression que je suis l'invitée et qu'elle règne sur le palais. Mais parfois sa nature de chatte entre en conflit avec les règles de ma maison. C'est un fait avéré que tous les chats ont le besoin biologique de griffer, et toutes les griffures sur mes mains, mes murs, mes pieds de chaise en acajou et mon canapé en daim le prouvent. Des ébénistes malins, combinant innovation et design moderne, proposent de nombreux griffoirs personnalisés. L'un d'entre eux est un panneau pour faire ses griffes, verrouillé au mur, qui soutient Sushi comme si elle faisait partie d'une installation d'art minimaliste. Un autre est une magnifique sculpture multicolore, entièrement tapissée, qui représente un palmier. Ma chambre à coucher comprend une splendide propriété pour chats person-

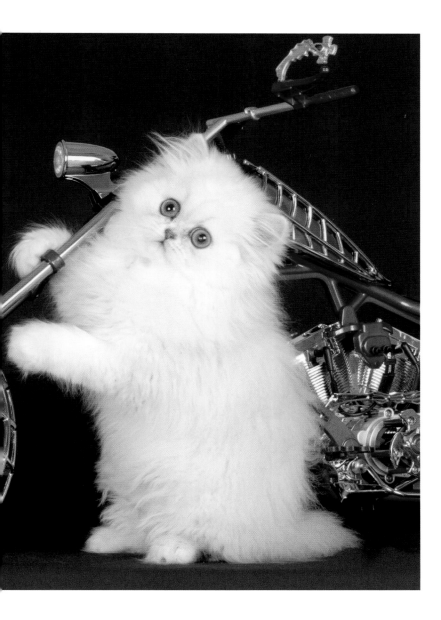

Après quelques événements traumatisants comme un nettoyage des dents chez le dentiste pour chats ou la « survie » à un passage chez le toiletteur, Sushi a toujours droit à une séance de thérapie avec le psychologue félin. Le vétérinaire a même prescrit à mon chat perturbé un traitement anxiolytique après un cas de dépression légère. Malheureusement, mon vilain petit félin a une personnalité dépendante, et est devenu accro à ces sédatifs pour chats. J'ai dû faire intervenir un respectable « homme qui murmure à l'oreille des chats » quand Sushi a commencé à montrer certains signes d'agressivité à l'arrêt du traitement. Mon félin fou a dû passer un certain temps dans une clinique vétérinaire de désintoxication où elle a suivi le « programme en 12 pattes », ce qui n'est pas inhabituel puisque la thérapie pour chat est ici une tendance en hausse. A présent mon chat sevré consulte un nouveau vétérinaire holistique qui prescrit des traitements strictement homéopathiques et phytothérapiques, et propose également des séances d'acupuncture et de chiropractie.

Sushi est également terriblement difficile au niveau culinaire et affiche une préférence nette pour la nourriture pour chats bio, avec suppléments en vitamines et minéraux, préparée avec des ingrédients convenant aux humains. Un jour qu'elle séjournait dans un hôtel de luxe pour chats — avec herbe à chats en vidéo sur sa propre TV et un aquarium dans sa chambre privée — on lui a servi des sushis japonais. Depuis, chaque fois qu'elle voit une boîte à bento dans ma main, elle demande le « maguro » (sushi au thon cru) à haute voix — un grand chœur geignard de « miaou-guro ! miaou-guro ! ». C'est pourquoi, de « Miss Princess Sofia of King Bastet the Third », j'ai changé son nom en « Sushi », tout simplement.

Le luxe félin n'est pas seulement limité aux produits fins, aux meubles de créateurs et aux soins de beauté luxueux, mais s'étend aussi à la mode et aux accessoires. Sushi possède son propre diadème de diamants, un collier en cristal rose avec son nom incrusté en brillants et un petit tiroir rempli de costumes et déguisements pour des occasions spéciales comme Halloween. Quand j'emmène Sushi au spa pour chats tous les mois pour son rendez-vous massage et pédicure, je l'installe royalement dans une poussette pour chat qui se replie et s'attache en toute sécurité dans la voiture. Une fois arrivée à destination, elle est placée dans un chariot revêtu de vison, à ses initiales, d'une marque ultra-tendance. Rien n'est trop outrancier ou luxueux pour le chat noble et élégant.

Il existe infiniment plus de manières de montrer votre amour à un chat pendant chacune de ses neuf vies. Les amateurs de chats d'aujourd'hui ont plus de choix que jamais pour améliorer la qualité de vie des félins difficiles. Les produits présentés dans ces pages, rigoureusement sélectionnés, traduisent la mystique séduisante du chat, qui ne fait plus qu'un avec la vie de son propriétaire et l'intérieur du foyer. Des cocons pour la sieste faits en verre soufflé à la main aux magnifiques accessoires pour la maison recélant un objet de nécessité pour chat, ces pages vous présentent les produits les plus créatifs jamais conçus pour le chat sophistiqué qui veut littéralement vivre sur les genoux du luxe.

Dans la société d'aujourd'hui, une « vie de chat » ne signifie plus avoir à endurer les dangers de la vie à l'extérieur dans une métropole surpeuplée pour éviter une vie ennuyeuse confinée à l'intérieur, ou s'occuper de questions de beauté et de santé (même émotionnelles), ou encore manger une mystérieuse pâté gélatineuse dans un bol en plastique. C'est une vie bien plus belle pour le chat d'aujourd'hui, et ces pages vous montreront jusqu'à quel point.

Ce livre magnifiquement illustré est humblement dédié à tous les chats sophistiqués du monde qui nous offert compagnie et affection dans nos vies passées et présentes, et ceux qui amélioreront sans aucun doute nos vies futures. Comme un sage inconnu l'a dit un jour : « Toutes les vies devraient avoir neuf chats ».

Patrice Farameh

www.luxuryforcats.com

nalisée qui s'étend sur trois niveaux et donne suffisamment d'espace à Sushi pour qu'elle puisse s'amuser avec les divers objets en forme d'oiseaux et de souris pendant de chaque étage.

D'aucuns pourraient dire que j'ai créé mon propre cadre de vie autour d'un terrain de jeu élaboré pour mon minou adoré, à cause des passerelles personnalisées le long des murs de mon salon, qui offrent à Sushi pléthore de corniches pour s'étendre et grimper. Mon excuse pour une entreprise si coûteuse : j'ai étendu le terrain de jeu de mon greffier sans pratiquement utiliser d'espace de vie personnel. Ce qui offre un plus grand confort à la fois au chat et à son maître, et nous savons tous que le confort est un ingrédient clé du véritable luxe.

Il me reste toutefois à décorer ma maison avec un portrait de mon chat adoré commandé à l'un des peintres spécialisés dans la « grande peinture féline » à l'huile. Je n'ai jamais non plus lavé Sushi avec un des ces produits de bain bio parfumés hauts-de-gamme fabriqués exclusivement pour les animaux ; ou adouci sa fourrure avec des huiles senteur lavande vendus en boutique de luxe et dans les spas pour chats. Je lui laisse le soin de mettre la « patte » sur son propre toilettage, à moins qu'elle ne soit harcelée par le syndrome du poil emmêlé. Ce qui conduit alors à la visite redoutée du service de toilettage à domicile, à une « coupe à la lionne » à 100 $ et à un chat très énervé. Etant donné que sa beauté exotique provient d'un héritage royal des lions, je ne parviens toujours pas à comprendre pourquoi elle déteste autant leur ressembler.

Introducción

"I have studied many philosophers and many cats. The wisdom of cats is infinitely superior" - Hippolyte Taine

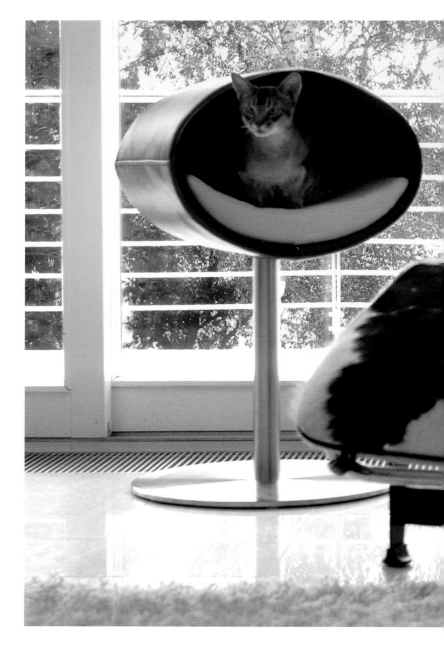

S i está leyendo este libro, imagino que será porque el ronronear de su amigo felino le ha llegado a lo más profundo de su corazón desatando una incontrolable pasión por los gatos, o bien porque un gato en cierto modo haya significado algo muy importante en su vida.

La vida con un gato doméstico nos proporciona un conocimiento directo de la exótica hermosura y los —malos— hábitos de sus parientes salvajes y peligrosos de las junglas y las montañas; es la manera en la que Dios nos permite acariciar a un león en nuestro regazo, o bien, como dicen los japoneses, poseer un "tigre que come de nuestra mano". Una vez que se tiene un gato, no nos sorprende el hecho de que este animal se halle presente de forma significativa en la historia, en la superchería popular y en la religión, desde cuando los egipcios fueron los primeros en adorar a esta elegante criatura como una divinidad sagrada. Y mi propio gato nunca olvida ese legado.

He seguido personalmente la sofisticación rampante de los productos para animales domésticos durante la pasada década, pero no me considero una de esas señoras obsesionadas con lo gatos que los miman en exceso. Por lo menos, no hasta el extremo de vivir para y hablar del gato exclusivamente, como ocurre con algunos participantes en concursos y apasionados criadores. Tengo la sensación de que ni siquiera poseo un gato. Es el gato el que me posee a mí.

De todas formas, intento tratar a mi valiosa felina —cuyo nombre es "Sushi"— como a los demás gatos, pero mi sentimiento de culpa al tener que encerrarla entre cuatro paredes le proporciona a mi pequeña amiga unos cuantos privilegios especiales. Afortunadamente, la industria de artículos para animales es a día de hoy la segunda por tasa de crecimiento en el mercado, superando incluso a las industrias de dulces y juguetes. Una reciente encuesta ha estimado que los amantes de los animales gastan más de 40 billones de dólares cada año tan solo en Estados Unidos. El mercado de los animales domésticos está repleto de expertos empresarios, diseñadores hipermodernos y apasionados de los felinos que son conscientes del dilema que supone poseer un 'gato sofisticado', creando productos que sobrepasan la estricta necesidad. Ya pasaron los días de la comida adquirida tiendas de comestibles y de las bandejas de plástico con arena, cediendo el paso a comidas orgánicas y a pequeños cubos de basura escondidos en lujosos armarios. Los amos de hoy no reparan en gastos a la hora de proporcionar a los pequeños miembros de su familia un entorno más suntuoso. Todo esto ha evolucionado hasta llegar al más reciente fenómeno felino: productos de lujo para gatos.

Estas nuevas tendencias en la industria para animales domésticos han generado infinitas posibilidades para los consumidores que buscan el lujo y que quieran gratificar a sus exigentes felinos. Hasta hace pocos años, el amante de los gatos no tenía otra opción que decorar su casa con sosos artículos gatunos, todos iguales y, a veces, feos límites insospechados. Hoy en día, es una bendición saber que es posible crear un ambiente estimulante y distinguido, en armonía con mis necesidades y las de mi gata.

Gracias a la abundancia de diseñadores amantes de los gatos en la industria de artículos para animales, existe una multitud de objetos de lujo, que van desde lechos con mucho estilo a fastuosas casitas, pasando por rascadores que semejan artísticas esculturas. Por ejemplo, en mi casa hay camitas de diseño construidas con materiales de primera calidad y ricos tejidos dispuestas en un rincón de cada una de las habitaciones, complementando la decoración de mi casa y creando la atmósfera más adecuada para mi ga-

tita. Una de las camas incluye un calefactor, mientras que un canapé es una réplica exacta en miniatura del asiento de un célebre diseñador.

Para todos aquellos consumidores que hayan convertido a sus animales de compañía en el centro de sus vidas, la última tendencia es la humanización de los productos para animales. La diferencia de calidad entre los productos para humanos y para gatos disminuye conforme la industria crea productos y servicios para animales cada vez más parecidos a los que crea para humanos. Esto es debido a los cambios actuales en el estilo de vida y en las relaciones humanas: mayor presencia de las mujeres en el mundo laboral, mayor número de divorcios, postergación del matrimonio y la paternidad, y un número creciente de jóvenes adultos solteros que se mudan a ciudades densamente pobladas. El gato ya no es simplemente un visitante ocasional en la casa, sino un estimado miembro de la familia.

Por todas estas razones quiero que Sushi se sienta como si yo fuera la invitada y ella la reina del palacio. No obstante, hay ocasiones en las que su naturaleza de gata entra en conflicto con las reglas de mi casa. Es indudable que los gatos tienen la necesidad biológica de rascar: los arañazos que tengo en las manos, las paredes, las patas de las sillas de caoba y el sofá de terciopelo son prueba de ello. Gracias a unos habilidosos carpinteros que aúnan innovación y diseño moderno, existen varias opciones para que los mininos puedan rascarse en forma de árboles o postes personalizados. Una opción es un rascador en forma de refinado tablón fijado a la pared que sostiene

supertendencia de 100 dólares y una gata muy enfadada. Suponiendo que su belleza exótica provenga directamente de una estirpe real de leones, sigo sin entender por qué no soporta parecerse a uno de ellos.

Después de unas cuantas experiencias traumáticas, como una limpieza dental o la 'supervivencia' a los servicios de cuidado personal, Sushi siempre disfruta de una sesión de terapia con su psicólogo. Una vez, el veterinario llegó a recetarle unos medicamentos contra la ansiedad a consecuencia de un leve caso de depresión. Desafortunadamente, mi descarada gatita tiene una personalidad adictiva y terminó adquiriendo cierta dependencia a sus sedantes. Tuve que acudir a un respetable 'susurrador de gatos' de la zona después de que Sushi mostrara signos de agresividad tras interrumpir la medicación. Mi frenética amiga tuvo que pasar un tiempo en un centro de desintoxicación, donde completó su "programa de 12 pa(u)tas", algo nada raro en la creciente moda de la terapia para gatos. Mi gata ya está curada y visita un nuevo veterinario holístico que administra remedios estrictamente homeopáticos a base de hierbas e incluye también sesiones de acupuntura y quiropráctica.

Además, Sushi es terriblemente recelosa con lo que come. No tiene prejuicios a la hora de alimentarse con comida orgánica con suplementos vitamínicos y minerales, preparados con ingredientes propios para el consumo humano. Una vez se encontraba en una pensión de lujo para gatos —con sus programas preferidos en la televisión y acuario en su dormitorio privado— donde le sirvieron sushi, la especialidad japonesa. Desde entonces, cada vez que me ve con una caja bento en la mano, llama al 'maguro' (sushi de atún crudo) por su nombre, con un aullido lastimero: "¡Miauguro! ¡Miau-guro!". Esta es la razón por la que le cambié el nombre de "Miss Princess Sofía of King Bastet the Third" por el de un simple "Sushi".

El elemento de lujo en el diseño para gatos no se limita a exquisiteces comestibles, muebles de diseño y fastuosos tratamientos de belleza, sino que incluye también moda y accesorios. Sushi posee su propia tiara de diamantes, un collar de cristal rosado con su nombre engarzado con brillantes y un pequeño cajón lleno de disfraces para ocasiones especiales como Halloween. Cuando llevo Sushi a su spa para la pedicura y el masaje mensual, la transporto como una reina en un cómodo cochecito que se pliega y se fija en el interior del automóvil. Cuando llegamos a nuestro destino, la coloco en un carrito personalizado con su logo de una marca de moda ultramoderna, forrado con una capa de visón. Nada es demasiado escandaloso o lujoso para esta gata de tanta elegancia y alcurnia.

Existen infinitas maneras para demostrar nuestro amor a nuestro gato a lo largo de sus siete vidas. Hoy en día, los amantes de los gatos tienen muchas más posibilidades para mejorar la calidad y el estilo de vida de estos melindrosos felinos. Los productos que figuran en estas páginas, seleccionados con cuidado, capturan la mística fascinación del gato, integrado en la vida de su amo y la decoración de la casa. Desde cápsulas para descansar hechas en cristal soplado artesanalmente hasta preciosos accesorios domésticos para ocultar sus necesidades, en estas páginas se presentan los objetos más creativos jamás concebidos para el gato sofisticado que quiera literalmente acurrucarse en el regazo del lujo.

En la sociedad moderna, una "vida de gatos" ya no significa tener que sufrir a la intemperie y afrontar los peligros de plantea la vida en una congestionada metrópoli para evitar un aburrido encierro, o enfrentarse a problemas de belleza o salud, incluidos los problemas emocionales, o comer potajes gelatinosos sacados de viejos recipientes de plástico. Hoy el gato lo pasa mucho mejor, y estas páginas demuestran hasta dónde es posible llegar.

Este libro maravillosamente ilustrado está dedicado a todos los gatos sofisticados del mundo que nos han obsequiado con su compañía y amor en nuestras vidas pasadas y presentes, y a los que indudablemente mejorarán la calidad de nuestras vidas en el futuro. Como dijo una vez una persona sabia, "every life should have seven cats" (cada vida debería tener siete gatos).

Patrice Farameh
www.luxuryforcats.com

Sushi como si formara parte de una instalación de arte minimalista. Otro rascador es una estructura alfombrada multicolor con la majestuosa forma de una palmera. En mi habitación hay una hermosa finca gatuna de madera en tres niveles, todo a medida. Allí encuentra mi gata espacio en abundancia para entretenerse con los diversos peluches en forma de pájaros y ratones que cuelgan en cada nivel.

Se podría decir que he creado mi propio entorno vital alrededor de un elaborado parque de juegos para mi querida gata por la pasarela a medida montada a lo largo de las paredes de mi sala de estar, en la que Sushi tiene un montón de repisas por las que escalar y descansar. Mi pretexto para un cometido tan caro fue aumentar así la superficie de juego para mi gata, prácticamente sin ocupar mi propio espacio. De esta manera, hay más confort para la gata y también para su ama, y todos sabemos que el confort es un ingrediente fundamental del verdadero lujo.

Todavía no he decorado mi casa con un retrato de mi adorada gata encargado a uno de los pintores especializados en "bellas arte felinas", tampoco he bañado Sushi con uno de esos modernos geles orgánicos aromatizados, creados expresamente para animales, ni le he peinado con los ungüentos perfumados con lavanda que se encuentran en las modernas *boutiques* y centros de salud. Le dejo a sus zarpas la tarea de la limpieza, a menos que se vea afectada por el síndrome del "pelo enmarañado", que conlleva una temida visita al servicio móvil de cuidados personales, un "corte leonino" de

Introduzione

"I have studied many philosophers and many cats. The wisdom of cats is infinitely superior" - Hippolyte Taine

S e state leggendo questo libro, presumo che le fusa del vostro amico felino abbiano massaggiato il vostro cuore fino al punto da portarlo ad un'ailurofilia incontrollabile, o per lo meno significa che un gatto ha avuto impatto significativo nella vostra vita, in un modo o in un altro.

La vita con un gatto domestico ci regala la possibilità di sperimentare direttamente la bellezza esotica ed i comportamenti (più o meno corretti) dei loro parenti selvatici e pericolosi delle giungle e delle montagne; è così che Dio ci concede di tenere un leone sulle ginocchia e accarezzarlo oppure, come dicono i giapponesi, di possedere "una tigre che ti mangia dalla mano". Quando possediamo un gatto, non ci sorprende più che questo animale domestico sia stato rappresentato in modo prominente nella storia, nel folklore superstizioso e nella religione, sin da quando gli egizi per primi adorarono questa elegante creatura come una divinità sacra. E neppure il mio stesso gatto non ha mai dimenticato questa eredità.

Ho seguito personalmente la rampante esaltazione dei prodotti per gatti nell'ultimo decennio, ma non sono una di quelle signore ossessionate dal proprio felino che non fa altro che viziarlo fino agli eccessi. Almeno, non al livello di quegli allevatori appassionati e dei partecipanti alle esposizioni che vivono, parlano e respirano gatti. Non mi sembra neanche di possedere un gatto. E' il mio gatto a possedere me.

Nonostante tutto, cerco di trattare la mia preziosa felina, che risponde al nome di "Sushi", come ogni altro gatto, ma il mio profondo senso di colpa per aver confinato la mia amica a quattro zampe tra le mura domestiche, le concede diversi privilegi speciali. Per mia fortuna, l'industria degli articoli per animali domestici è la seconda categoria commerciale a maggior crescita al giorno d'oggi, che supera persino l'industria dolciaria e quella dei giocattoli. Un recente sondaggio ha confermato che ormai gli amanti degli animali domestici spendono per i loro compagni a quattro zampe dal manto vellutato oltre 40 miliardi di dollari l'anno, solo negli Stati Uniti. Il mercato è inondato da impresari competenti, arditi designer e fanatici felini che comprendono il dilemma di possedere un "gatto sofisticato", creando prodotti che vanno oltre i semplici elementi essenziali. I giorni del cibo per animali comprato in drogheria e delle cassette in plastica sono decisamente tramontati, lasciando spazio a pasti organici firmati da chef veri e propri e lettiere a scomparsa, incorporate in lussuosi mobiletti. Oggi chi possiede un gatto non bada a spese per fornire ai piccoli membri della famiglia un ambiente sontuoso, e tutto ciò si è evoluto nell'ultimo fenomeno felino: i prodotti di lusso per gatti.

Questa nuova ondata nell'industria degli articoli per animali ha generato innumerevoli possibilità per i consumatori orientati al lusso che desiderano accontentare i loro esigenti amici felini. Fino a pochi anni fa, un amante dei gatti doveva rassegnarsi a decorare la propria casa con articoli anonimi, standardizzati e spesso orrendi in modo imbarazzante, a causa del proprio micio. Ringraziando il cielo, oggi so che è possibile creare un ambiente domestico inspirato ed elegante, in armonia sia con le necessità del gatto sia con le mie.

Grazie alla sovrabbondanza di designer amanti dei gatti nell'industria degli articoli per animali, è possibile scegliere tra una moltitudine di prodotti lussuosi e caratteristici, tra cui lettiere in stile, opulente casette, e grattatoi che ricordano opere d'arte scultorea. Ad esempio, a casa mia si trovano letti in stile creati con i materiali della più alta qualità, con ricchi tessuti infilati

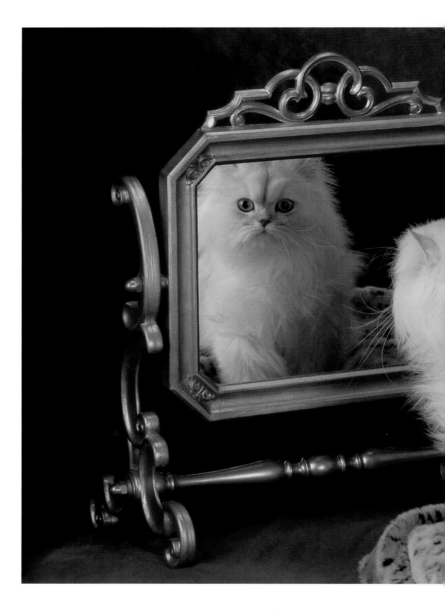

negli angoli di ogni stanza, che completano l'arredamento e al tempo stesso creano un ambiente perfetto per la gattina. Uno dei letti prevede un dispositivo di riscaldamento, mentre un'altra area per bighellonare è un'esatta replica in miniatura della sedia di un famoso designer.

L'ultimo trend è l'umanizzazione dei prodotti per gatti, per i consumatori che hanno fatto del loro animale domestico il punto focale della loro vita. Il divario di qualità tra i prodotti per gli esseri umani e i gatti sta diminuendo, man mano che l'industria degli articoli per animali crea prodotti e servizi che assomigliano nel dettaglio a quelli venduti agli umani. Tutto ciò è dovuto agli attuali cambiamenti nelle relazioni umane, determinati in parte dalla maggiore presenza delle donne nella forza lavoro, dall'aumento dei divorzi, dallo sposarsi tardi e dall'avere figli, e dal numero sempre crescente di giovani adulti single che si trasferiscono in città densamente popolate. Il gatto non è più un semplice visitatore occasionale in casa nostra, ma uno stimato membro della famiglia.

Questa è la ragione per cui desidero che Sushi si senta come se io fossi l'ospite e lei la regina assoluta del reame. A volte però la sua natura felina entra in conflitto con le mie regole domestiche. È una necessità biologica dei gatti, l'avere bisogno di graffiare, come provano i graffi sulle mie mani, sui muri, sulle gambe delle sedie in mogano e sul divano ultra-scamosciato. Grazie ad abili carpentieri che abbracciano l'innovazione e il design moderno, esistono diverse possibilità per alberi e colonnine tiragraffi personalizzati. Una soluzione è una tavola liscia fissata alla parete, che sostiene Sushi come se fosse parte di una qualche installazione di arte minimalista. Un altro

un'eredità reale leonina, per me è tuttora incomprensibile come Sushi non sopporti di assomigliare ad un leone.

Dopo certi eventi traumatici come la pulizia dentale presso un dentista felino o la "sopravvivenza" ai servizi di toilette, Sushi partecipa sempre ad una seduta dallo psicologo felino. Una volta il veterinario ha persino prescritto alla mia gatta stressata una medicina contro l'ansia, dopo un lieve caso di depressione. Sfortunatamente, la mia piccola e capricciosa felina ha una personalità che tende ad assuefarsi ai vizi, ed è diventata dipendente dei suoi sedativi. Dopo che Sushi ha iniziato a mostrare segni di aggressione come conseguenza dell'interruzione delle medicine, sono intervenuta chiamando un rispettabile "uomo che sussurrava ai felini" del posto. La mia inquieta amica ha dovuto passare qualche tempo presso un centro di disintossicazione specializzato, nel quale ha completato il "programma delle 12 zampe", procedura per nulla inusuale visto il trend crescente delle terapie per gatti. Ora che la mia micia è diventata pulita, visita un nuovo veterinario olistico che somministra rimedi rigorosamente omeopatici e a base di erbe, fornendo inoltre sedute di agopuntura e chiroterapia.

Sushi è anche terribilmente schizzinosa riguardo al suo cibo, e non è prevenuta riguardo agli alimenti organici con supplementi di vitamine e minerali, preparati con ingredienti adatti al consumo umano. Una volta, durante un soggiorno presso un albergo di lusso per gatti — con immagini di erba gatta sulla sua TV personale e un acquario nella sua camera privata — le hanno servito la prelibatezza giapponese sushi. Da allora, ogni volta che mi vede con una scatola bento in mano, chiede di avere il "maguro" (sushi di tonno crudo) pronunciandolo per nome — un canto piagnucoloso di "miao-guro! miao-guro!". Questa è la ragione per la quale le ho cambiato il nome da "Princess Sofia of King Bastet the Third" al semplice "Sushi".

L'elemento lussuoso del design felino non si limita a delicatezze commestibili, arredamento di stile e lussuosi trattamenti di bellezza, ma comprende anche moda ed accessori. Sushi possiede un suo diadema di diamanti, un collare di cristallo rosa con il suo nome incassato con brillantini di strass, e ha un cassettino pieno di costumi per occasioni speciali come Halloween. Quando porto Sushi al centro estetico per l'appuntamento mensile con la pedicure e i massaggi, la scarrozzo in giro come una regina in un comodo passeggino che si richiude e si allaccia saldamente all'interno dell'auto. Una volta arrivate alla nostra destinazione, sale su una vettura con monogramma personalizzato prodotto da una casa di moda all'avanguardia, foderata con una coperta di visone. Nulla è troppo esagerato o lussuoso per il gatto elegante e regale.

Esistono infiniti altri modi per dimostrare il vostro amore ad un gatto per tutta la durata delle sue nove vite. Oggi più che mai, gli amanti dei gatti hanno a disposizione varie possibilità per migliorare la qualità e lo stile di vita del capriccioso felino. I prodotti in queste pagine, accuratamente selezionati, catturano l'affascinante misticismo del gatto, mentre diventa un tutt'uno con la vita del suo padrone e con l'arredamento della casa. Dai bozzoli per il pisolino, fatti artigianalmente di vetro soffiato, agli splendidi accessori per la casa che camuffano le necessità dei gatti, queste pagine vi presentano i prodotti più creativi mai creati per il gatto sofisticato, che vuole letteralmente vivere in grembo al lusso.

Nella società moderna di oggi, "vita da gatti" non significa più sopravvivere agli elementi e ai pericoli della vita di strada in una metropoli congestionata, per evitare la noia di una vita rinchiusi in casa, o affrontare problemi estetici e sanitari (compresi i problemi emotivi), oppure cibarsi di misteriose poltiglie gelatinose in vecchie ciotole in plastica. Oggi il gatto se la passa molto meglio, e queste pagine vi mostrano fino a che punto può effettivamente essere meglio.

Questo libro, splendidamente illustrato, è umilmente dedicato a tutti i raffinati gatti del mondo, che hanno regalato compagnia e amore alle nostre vite passate e presenti, e a quelli che senza dubbio miglioreranno la qualità della nostra vita in futuro. Come disse una volta un saggio, "every life should have nine cats" (ogni vita dovrebbe avere nove gatti).

Patrice Farameh
www.luxuryforcats.com

tiragraffi è una struttura tappezzata che forma la magnifica scultura multicolore di una palma. La mia camera da letto accoglie un bellissimo condominio felino in legno, fatto su misura, alto tre piani, che concede a Sushi ampi spazi per divertirsi con i vari giocattoli in pezza a forma di uccellini e topolini che pendono da ciascun livello.

Si potrebbe dire che ho creato il mio ambiente abitativo attorno a un elaborato parco giochi per la mia adorata gattina, a causa della passerella personalizzata, montata attorno alle pareti del mio salotto, che fornisce a Sushi un'abbondanza di sporgenze e scalini su cui salire e oziare. La mia scusa per un'impresa così costosa: ho ampliato le aree giochi della mia micia senza sottrarre praticamente nulla al mio spazio vitale. Ciò porta ad un maggiore comfort sia per il gatto che per il padrone, e sappiamo tutti come il comfort sia un ingrediente chiave per il vero lusso.

Devo ancora decorare casa mia con un ritratto della mia adorata gatta, commissionato ad uno dei molti pittori ad olio specializzati in "belle arti feline". Non ho neanche ancora fatto il bagno a Sushi con uno di quei profumati prodotti organici per il bagno ultramoderni, concepiti esclusivamente per animali domestici, né lisciato il suo pelo con unguento infuso di lavanda, disponibile presso le boutique più innovative per animali domestici e i centri benessere specializzati per gatti. Lascio alle sue "zampe" il compito di prendersi cura della sua pulizia, finché non è affetta dalla sindrome del pelo ingarbugliato. In quel caso ci tocca la temuta visita al servizio di toilette mobile, al loro "taglio leonino" ultra-trendy da 100 dollari, e ad una grave arrabbiatura della gatta. Presumendo che la sua bellezza esotica derivi da

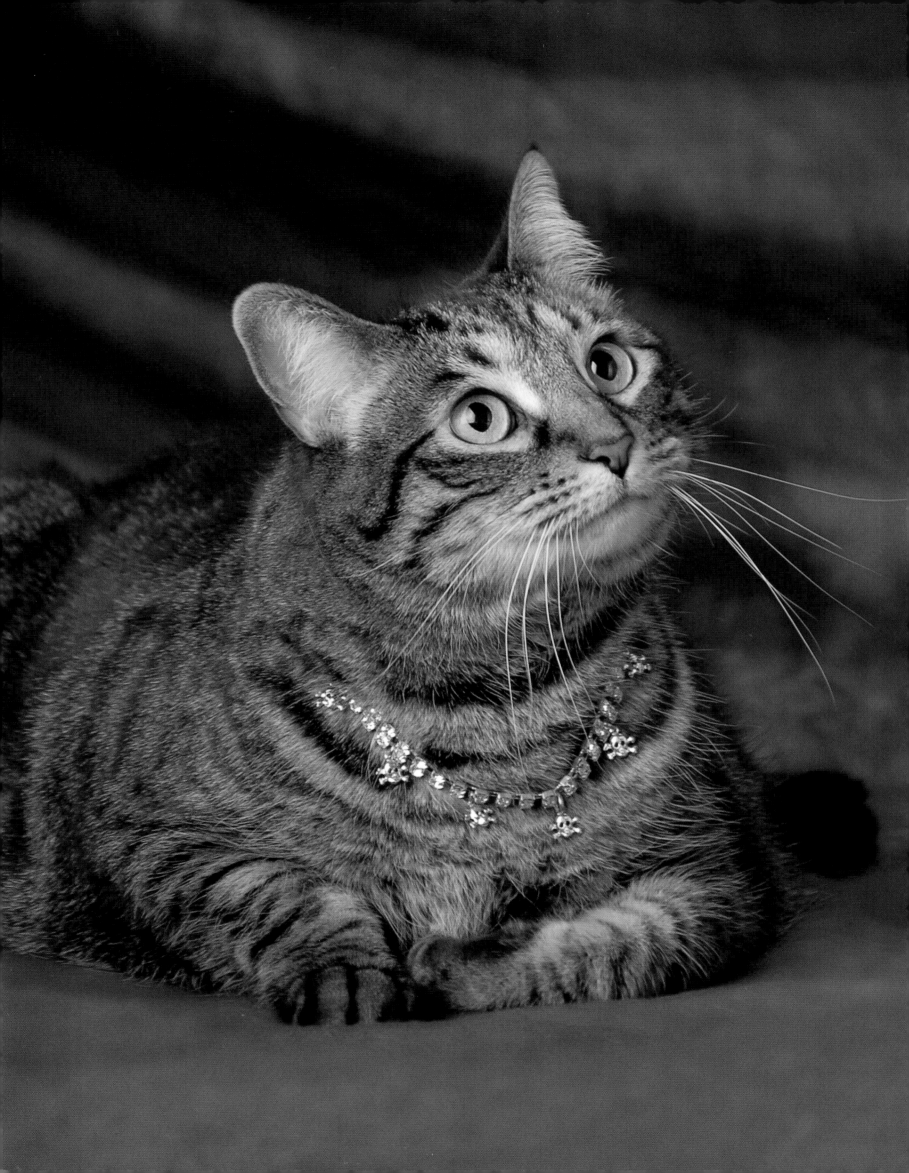

Fashion & Accessories

"A dog will flatter you, but you have to flatter the cat."
George Mikes

The typical cat lover today is able to transform their best friend into their best accessorized companion with the newest products on the kitty market, from crystal-studded collars to couture clothing.

Dank der Neuheiten auf dem Katzenproduktmarkt kann der typische Katzenliebhaber seinen besten Freund zu seinem hübschesten Accessoire machen. Das Angebot ist vielfältig: von kristallbesetzten Halsbändern bis Haute Couture für die Katze.

Aujourd'hui, un passionné des chats peut transformer son meilleur ami en un compagnon superbement accessoirisé grâce aux derniers produits sur le marché, depuis lescolliers incrustés de cristal aux vêtements couture.

Hoy el típico amante de los gatos puede transformar a su mejor amigo en el compañero más galan con los nuevos productos en el mercado felino, desde collares punteados con brillantes hasta ropa de alta costura.

Oggi il tipico amante dei gatti è in grado di trasformare il proprio migliore amico nel compagno più accessoriato, con i più recenti prodotti sul mercato felino, da collari tempestati di cristalli ad abbigliamento d'alta moda.

Fashion & Accessories

The *felis catus* has been enchanting us for thousands of years until today, where in many countries cats are still one of the most popular house pets. But their stubborn independence and fastidious nature is not completely accepted by the entire population, especially those who are more inclined toward man's best friend. But that is not at all of any concern to the cat. The quirky nature and unique solitary splendor of the sophisticated cat can only be appreciated by the cat lover that understands them. People today consider their cats as surrogate children, and their increases in spending to spoil their four-legged family members has spawned a booming industry for more luxurious products that cater to the owner's personal sense of style. The cats share many traits with the high-end luxury consumer: finicky discretion, cool independence, and controlled behavior.

The rising status of the cat as a fashionable home accessory started an unprecedented new niche for more stylish options to entertain the cat as well as the owner. A recent survey of pet owners by the APPMA (American Pet Product Manufacturers Association) confirms for example that American owners are showering their animal companions with much love; 13 percent of cat owners are buying their pets birthday presents, and 37 percent of cat owners are purchasing holiday gifts and accessories for their feline friends.

The old days of jingle bells and feathers tied to sticks as cat entertainment are over. Today the toys are presented in highly creative packages, and many resemble an infant's game with sounds, bold colors, and motorized movements.

The primal urges that drive the fashion world have also penetrated the pet product industry; global luxury brand companies like Louis Vuitton and Goyard to hip fashion labels such as Juicy Couture and Ed Hardy are constantly searching for that next opportunity to attract the luxury cat-loving consumer.

If you think pet fashion simply means a colored collar with a personalized tag, you're already out of fashion. Hip tee shirts for cats with catty sayings, crystal collars with personalized charms, bathrobes for grooming services, kitty costumes for Halloween and Christmas parties, cats taking part in wedding ceremonies wearing bridal gowns, and a Pet Fashion Week that displays the latest designer trends in pet clothing are just a few examples of the kitty couture revolution. The general rule today is: if it is sold to humans, it is also available for your furry friend. Since cats still don't have access to their own kitty credit cards, it's up to the luxury consumer to help them become more fashionable.

Mode &
Accessoires

Seit Tausenden von Jahren erfreut uns die *Felis catus* bis heute, wobei in vielen Ländern Katzen immer noch zu den beliebtesten Haustieren gehören. Aber ihre unbeugsame Unabhängigkeit sowie der anspruchsvolle Charakter werden nicht von allen Menschen akzeptiert, insbesondere nicht von denjenigen, die eher dem „besten Freund" des Menschen zugeneigt sind. Das jedoch stört die Katze überhaupt nicht. Der sehr eigene Charakter und der unvergleichliche, einzelgängerische Ruhm der anspruchsvollen Katze kann nur vom Katzenliebhaber geschätzt werden, der seine Katze versteht. Heute betrachten die Leute ihre Katzen als Kindersatz, und da sie vermehrt Geld für das Verwöhnen ihrer vierbeinigen Familienmitglieder ausgeben, entstand daraus eine boomende Industrie, die immer mehr Luxusgüter auf den Markt bringt, zugeschnitten auf das persönliche Stilempfinden des Besitzers. Katzen teilen viele Wesenszüge mit dem luxusorientierten High-End-Verbraucher: vornehme Zurückhaltung, coole Unabhängigkeit und kontrolliertes Verhalten.

Der aufsteigende Stern der Katze als ein modisches Heimaccessoire avancierte zu einer beispiellosen neuen Nische für immer mehr stylische Optionen, die sowohl der Unterhaltung der Katze als auch der des Besitzers dienen. Eine vor kurzem von der APPMA (American Pet Product Manufacturer Association) erhobene Studie bestätigt zum Beispiel, dass die amerikanischen Tierhalter ihre tierischen Lebensgefährten mit viel Liebe überschütten; 13 Prozent der Katzenbesitzer kaufen ihren Tieren Geburtstagsgeschenke und 37 Prozent der Katzenbesitzer erwerben Festtagspräsente und Accessoires für ihre Stubentiger.

Die Zeit der an Stäben befestigten Glöckchen und Federn, die dem Amüsement der Katze dienten, ist längst vorbei. Heutzutage werden die Spielzeuge in äußerst kreativen Verpackungen präsentiert und viele erinnern mit ihren Geräuschen, knalligen Farben und motorgesteuerten Bewegungen an Kinderspielzeuge.

Jene Urbedürfnisse, welche die Modewelt antreiben, prägen nun auch die Haustierproduktindustrie; weltweit bekannte Luxusmarkenhersteller wie Louis Vuitton und Goyard bis hin zu hippen Modelabels, wie zum Beispiel Juicy Couture und Ed Hardy, sind ständig auf der Suche nach neuen Möglichkeiten, um den luxusorientierten, katzenliebenden Verbraucher als Kunden zu gewinnen.

Wenn Sie denken, Tiermode bedeute einfach nur ein farbiges Halsband mit einem Namensschild, dann sind sie nicht mehr auf dem neuesten Stand. Hippe T-Shirts für Katzen mit katzenspezifischen Redewendungen, Kristallhalsbänder mit personalisierten Anhängern, Bademäntel für den Fellpflegeservice, Katzenkostüme für Halloween und Weihnachtsfeiern, an Heiratszeremonien teilnehmende Katzen in Brautgewändern und sogar eine Fashion Week speziell für Haustiere, während derer die neuesten Designertrends der Tierbekleidung gezeigt werden, sind nur einige Beispiele der Revolution der Katzencouture. Heute gilt allgemein: All das, was für Menschen verkauft wird, ist auch für Ihren pelzigen Freund erhältlich. Da Katzen noch keinen Zugriff auf ihre eigene Katzenkreditkarte haben, liegt es am luxusorientierten Verbraucher, ihnen zu helfen, modischer zu werden.

Mode &
Accessoires

Le *felis catus* nous enchante depuis des millénaires et jusqu'à aujourd'hui, où dans de nombreux pays le chat est toujours l'un des animaux domestiques les plus populaires. Mais leur indépendance têtue et leur nature exigeante n'est pas acceptée par tout le monde, et plus particulièrement de ceux qui sont plus attirés par le meilleur ami de l'homme. Mais tout ceci ne concerne en rien le chat. La nature excentrique et la splendeur solitaire du chat sophistiqué ne peut être apprécié que de l'amoureux des chats qui sait le comprendre. Les gens considèrent aujourd'hui les chats comme leur enfant de substitution, et leurs dépenses croissants pour gâter ces membres à quatre pattes de leur famille ont engendré le boom de produits plus luxueux qui flattent le sens du style de leurs propriétaires. Les chats partagent de nombreux traits avec le consommateur de produits de luxe : discrétion pointilleuse, indépendance blasée, et comportement contrôlé.

L'importance croissante du chat en tant qu'accessoire de maison a ouvert une nouvelle niche sans précédents, offrant plus de possibilités élégantes pour amuser le chat comme son maître. Une étude récente menée auprès des propriétaires de chats par l'APPMA (American Pet Product Manufacturers Association) confirme par exemple que les propriétaires américains inondent leurs compagnons d'amour : 13 % des propriétaires de chats achètent des cadeaux d'anniversaire à leur ami félin, et 37 % lui rapportent cadeaux pour les fêtes et accessoires.

L'époque où les grelots et les plumes collées à un bâton étaient les seuls jeux pour chats est bien révolue. Aujourd'hui les jouets sont présentés dans des emballages extrêmement créatifs, et beaucoup ressemblent à des jouets pour enfants avec bruitages, couleurs vives et mouvements motorisés.

Les envies primitives qui font vivre le monde de la mode ont aussi pénétré le secteur animalier : des marques de luxe à la renommée mondiale comme Louis Vuitton et Goyard aux marques de mode hype comme Juicy Couture et Ed Hardy, toutes recherchent constamment une nouvelle chance d'attirer l'amateur de chats consommateur de luxe.

Si vous pensez que votre chat branché a simplement besoin d'un collier coloré avec message personnalisé, vous êtes déjà dépassé. T-shirts à la mode avec des dictons sur les chats, colliers de cristal avec gri-gri personnalisés, robes de chambre pour toilettage, costumes de chat pour Halloween et Noël, chats participant aux cérémonies de mariage vêtus de robes de mariée, et fashion week pour animaux présentant les dernières tendances des créateurs pour l'habillement animal sont seulement quelques exemples de la révolution couture féline. Aujourd'hui la règle générale est : si c'est vendu aux humains, c'est aussi disponible pour votre ami à fourrure. Comme les chats n'ont pas encore leurs propres cartes de crédit, c'est au consommateur de luxe de les aider à être plus à la mode.

Moda & Accesorios

Moda & Accessori

El *felis catus* nos fascina desde hace millares de años, y en muchos países es uno de los animales domésticos más populares. Sin embargo, su obstinada independencia y su irritante naturaleza no son plenamente aceptadas por toda la población, especialmente por los que más se inclinan hacia el mejor amigo del hombre. Pero todo esto al gato no le afecta en absoluto. La naturaleza extraña y el singular esplendor solitario del sofisticado gato solo pueden ser apreciados por quienes lo amen y lo comprendan. La gente considera hoy en día a sus gatos como hijos adoptivos. Los crecientes gastos para mimar a los miembros cuadrúpedos de la familia han hecho florecer una industria de productos de lujo que sirven al gusto personal del amo. Los gatos tienen mucho en común con los modernos consumidores de lujo: discreción detallista, independencia distante y comportamiento controlado.

El creciente estatus del gato como accesorio de moda para la casa ha generado un nicho inédito de nuevas posibilidades estilísticas para entretener a los gatos y a sus amos. Por ejemplo, una reciente encuesta realizada por la APPMA (American Pet Product Manufacturers Association/Asociación Americana de Productores de Artículos para Animales Domésticos) confirma que en Estados Unidos los propietarios se desviven por sus compañeros del reino animal: el 13 por ciento les ofrece regalos de cumpleaños y el 37 por ciento compra para sus amigos felinos recuerdos y accesorios.

Los días de los cascabeles y de las plumas atadas a un palo para entretener a los gatos han pasado a la historia. En la actualidad, los juguetes se presentan en embalajes de lo más creativos, y muchos recuerdan a los juegos de niños con sonidos, colores vivos y movimientos motorizados.

Las necesidades primarias que empujan el mundo de la moda han penetrado también en el de los animales de compañía. Tanto firmas de lujo mundialmente famosas como Louis Vuitton o Goyard como marcas ultramodernas como Juicy Couture y Ed Hardy están a la continua búsqueda de la próxima oportunidad para atraer a los consumidores de lujo amantes de los gatos.

Quienes crean que la moda para animales significa simplemente un collar de colores con medalla personalizada, se han quedado ya obsoletos. Modernas camisetas con textos serigrafiados relativos al mundo felino, collares de cristal con amuletos personalizados, albornoces para los servicios de atención personal, disfraces para fiestas de Halloween y Navidad, gatos que participan en ceremonias nupciales en traje de novia y una Semana de la Moda para Animales que presenta las últimas tendencias en su ropa constituyen solo unos cuantos ejemplos de la revolución en la alta costura para animales. Hoy en día, la regla general es: si se vende a los humanos, también está disponible para sus amigos de patas. Como los gatos todavía no tienen acceso a sus propias tarjetas de crédito, les toca a los consumidores de artículos de lujo ayudarles a seguir las modas.

Da migliaia di anni il *felis catus* ci ha affascinato, fino ai giorni nostri, nei quali in molte nazioni i gatti sono ancora tra gli animali domestici più comuni. Ma la loro ostinata indipendenza e la loro incontentabile natura non sono completamente accettate da tutta la popolazione, specialmente da coloro che prediligono il migliore amico dell'uomo. Ma il gatto non viene minimamente toccato da tutto ciò. Solo un amante del gatto, che lo comprenda, potrà apprezzare la natura stravagante e l'impareggiabile splendore solitario del sofisticato animale. Oggi la gente considera il loro gatto come un surrogato dei figli, e l'aumento nelle spese destinate a viziare i membri a quattro zampe della famiglia ha originato un boom nell'industria dei prodotti più lussuosi, al servizio del personale gusto stilistico del padrone. I gatti hanno molto in comune con i moderni consumatori del lusso ai massimi livelli: altera discrezione, fredda indipendenza e comportamento controllato.

La posizione in crescita del gatto visto come accessorio domestico di moda ha spianato la via a una nicchia senza precedenti, con nuove possibilità stilistiche per l'intrattenimento di gatti e padroni. Un recente sondaggio tra i proprietari di gatti, realizzata dall' APPMA (American Pet Product Manufacturers Association/Associazione Americana dei Produttori di Articoli per Animali), conferma per esempio, che negli Stati Uniti i proprietari di gatti ricoprono i loro compagni con molto amore; il 13 percento dei proprietari compra ai loro animali domestici dei regali di compleanno e il 37 percento acquista dei souvenir durante i viaggi e degli accessori per i loro amici felini.

I giorni dei campanellini e delle piume attaccate a bastoni, che servivano da intrattenimento per il gatto, sono finiti. Oggi i giocattoli sono presentati in confezioni altamente creative, e molti di essi ricordano giochi da bambini con suoni, colori vivaci e movimenti meccanici.

Le spinte primarie che muovono l'industria della moda hanno penetrato anche quella degli animali domestici; marche di lusso a livello mondiale come Louis Vuitton e Goyard o etichette all'ultimo grido come Ed Hardy e Juicy Couture sono alla ricerca costante di nuove opportunità per attirare il consumatore di lusso amante dei gatti.

Se credete che la moda per gli animali domestici significhi semplicemente un collare colorato con medaglietta personalizzata, siete già fuori moda. Magliette per gatti con frasi da gatto, collari di cristallo con amuleti personalizzati, accappatoi per servizi di toilette, costumi da gattini per Halloween e cenoni di Natale, gatti che partecipano a cerimonie nuziali vestiti in abito da sposa, e una Settimana della Moda dell'Animale Domestico che espone le ultime tendenze dell'abbigliamento per animali sono solo alcuni esempi della rivoluzione dell'alta moda felina. Oggi la regola generale è: se si vende agli umani, è disponibile anche per i vostri amici dal manto vellutato. E poiché i gatti non hanno ancora accesso alle proprie carte di credito, è compito del consumatore di lusso aiutarli a diventare sempre più alla moda.

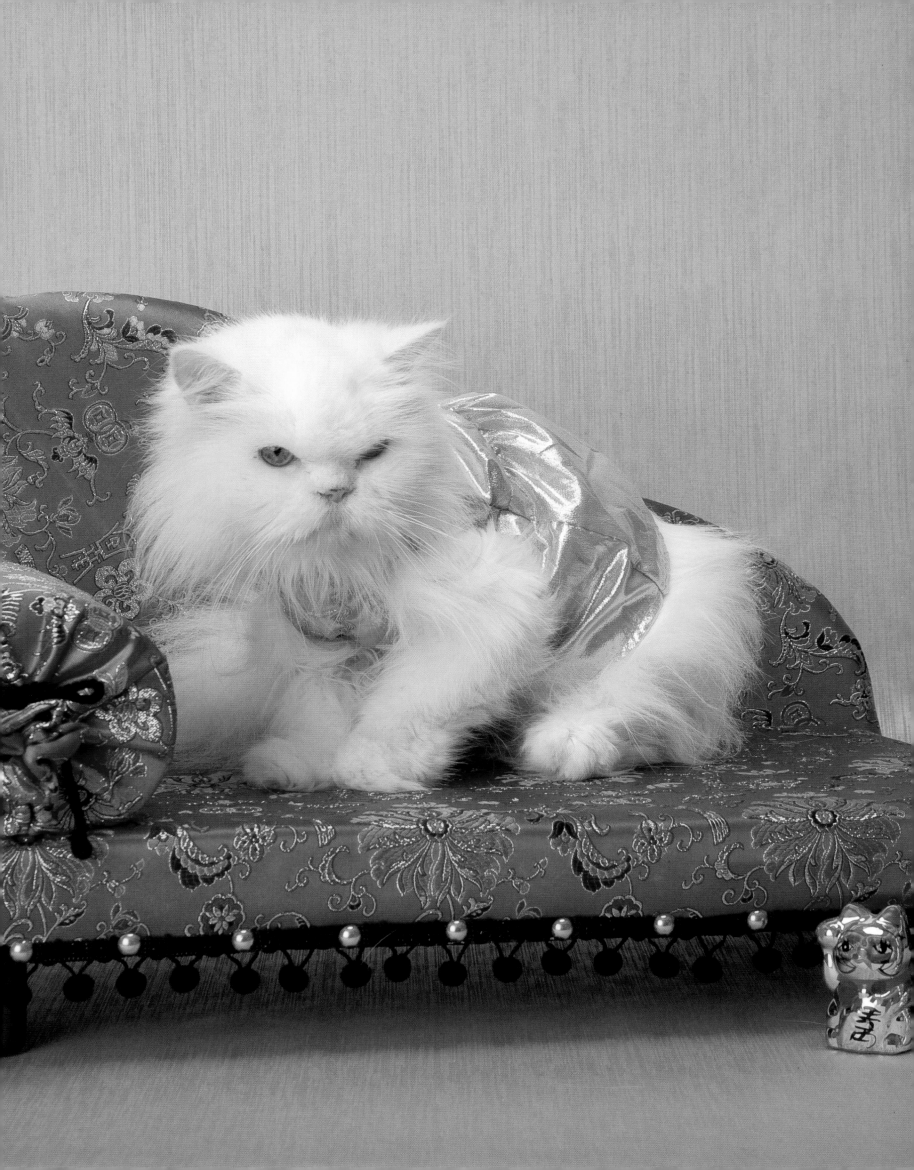

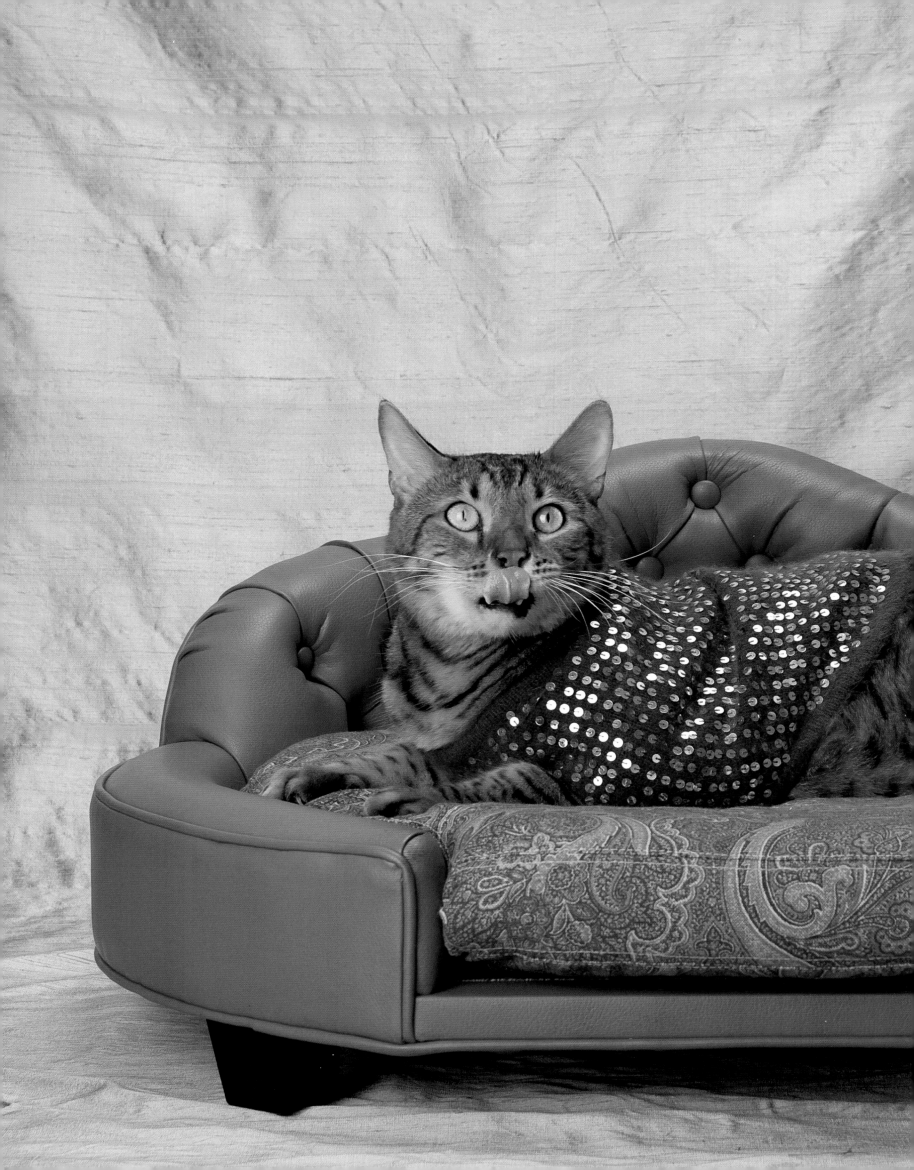

Treat your special friend to the finest in creature comforts with this luxuriously elegant tufted bed designed by Robbie Quinton for So Sadie fine pet furnishings.

Verwöhnen Sie Ihren speziellen Freund mit dem Feinsten vom Feinsten im Bereich des Tierkomforts – diesem luxuriösen, eleganten, kuscheligen Bett, entworfen für So Sadie Fine Pet Furnishings von Robbie Quinton.

Offrez le meilleur du confort animal à votre ami matou avec cet élégant et confortable panier dessiné par Robbie Quinton pour So Sadie Fine Pet Furnishings.

Mime a su amigo especial con lo mejor en el confort animal, como las lujosas y elegantes camitas copetudas diseñadas por Robbie Quinton para So Sadie Fine Pet Furnishings.

Regalate al vostro amico speciale il meglio del comfort animale con il lussuoso ed elegante letto trapuntato, disegnato da Robbie Quinton per So Sadie Fine Pet Furnishings.

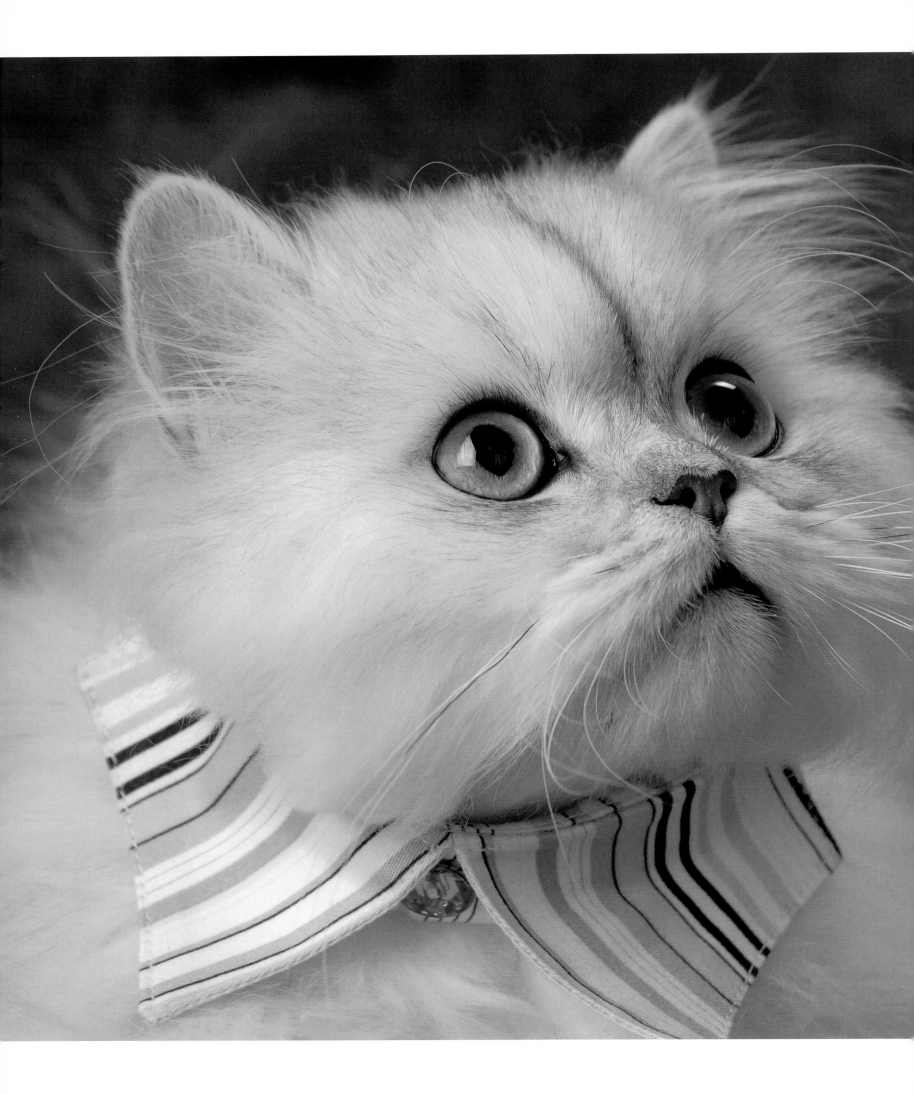

Show your love for sparkling jewels and show off your cat with an unforgettable custom necklace, or a dignified collar that will make your pet look like royalty.

Zeigen Sie ruhig Ihre Vorliebe für funkelnde Juwelen, indem Sie Ihre Katze mit einem unvergleichlichen, maßgeschneiderten Collier oder einem standesgemäßen Halsband in Szene setzen, das Ihr Tier wahrhaft königlich aussehen lässt.

Affichez à la fois votre amour des bijoux étincelants et votre chat paré d'un collier sur mesure inoubliable, ou encore d'un collier majestueux qui donnera une allure royale à votre compagnon.

Demuestre su amor por las hojas relucientes y exhiba a su gato con una inolvidable gargantilla personalizada, o un majestuoso collar que le dará a su mascota un aire monárquico.

Dimostrate il vostro amore per i gioielli luccicanti ed esibite il vostro gatto con un'indimenticabile collana personalizzata, o con un dignitoso collare che darà un aspetto regale al vostro beniamino.

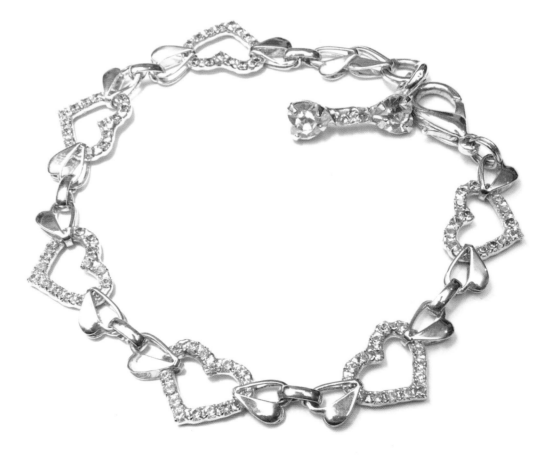

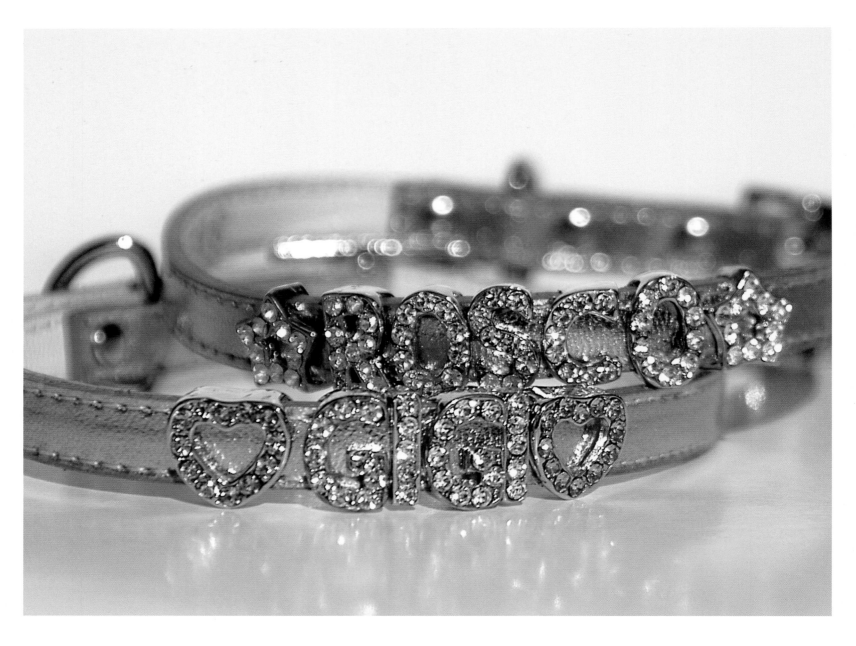

The retail race now is to provide felines with bejeweled collars more closely modeled after the ones sold to their trend-hunting owners.

Mit Juwelen und Edelsteinen besetzte Katzenhalsbänder, nach den Vorbildern der Colliers ihrer trendversessenen Besitzerinnen hergestellt, sind der letzte Schrei im Einzelhandel.

Les boutiques rivalisent à présent pour parer les félins de colliers précieux prenant modèle sur les bijoux vendus aux humains chasseurs de tendances.

Hoy la competición comercial se afana en abastecer a los felinos con collares enjoyados, modelados a semejanza de los de sus amos seguidores de la moda.

L'ultimo grido consiste nell'addobbare i felini con collari ingioiellati modellati a stretta somiglianza di quelli venduti ai loro proprietari modaioli.

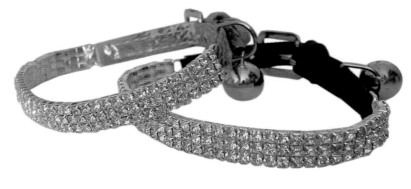

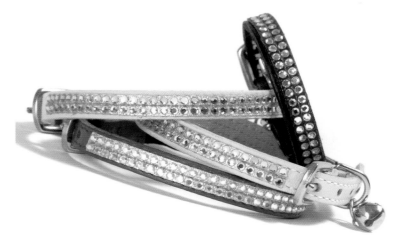

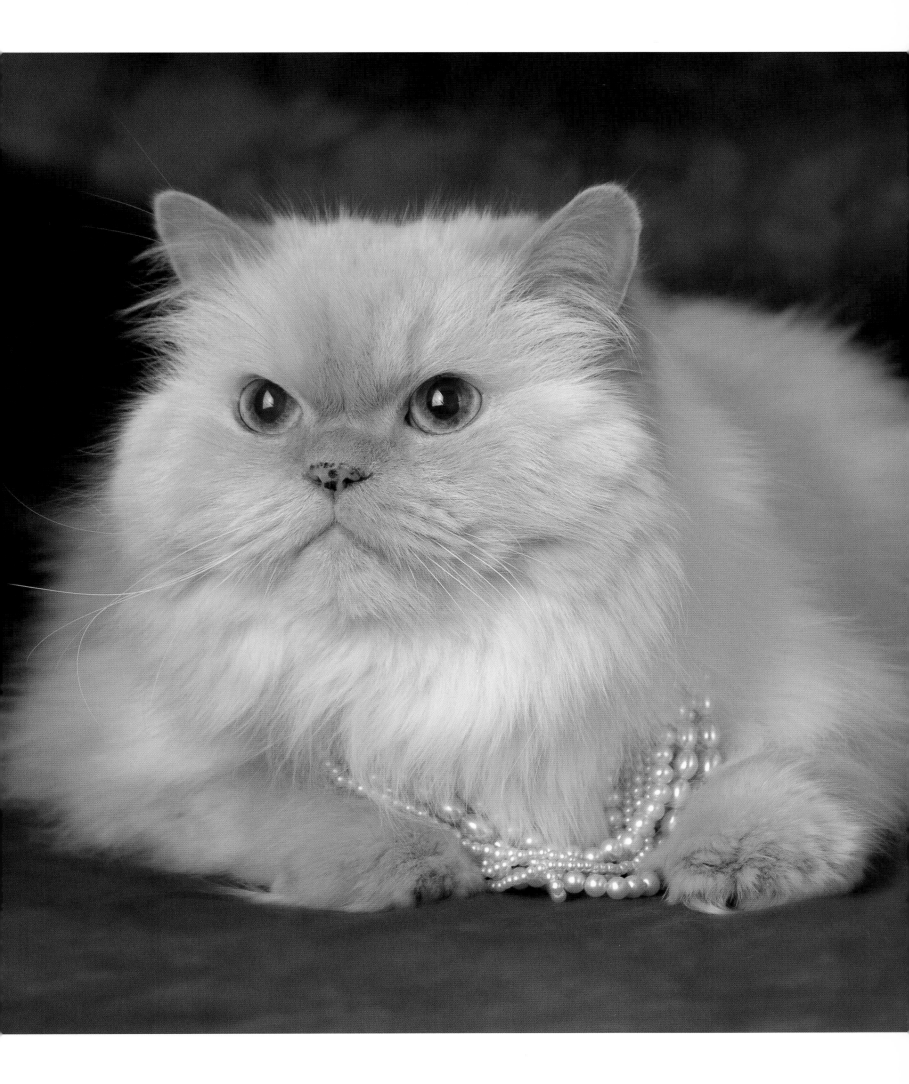

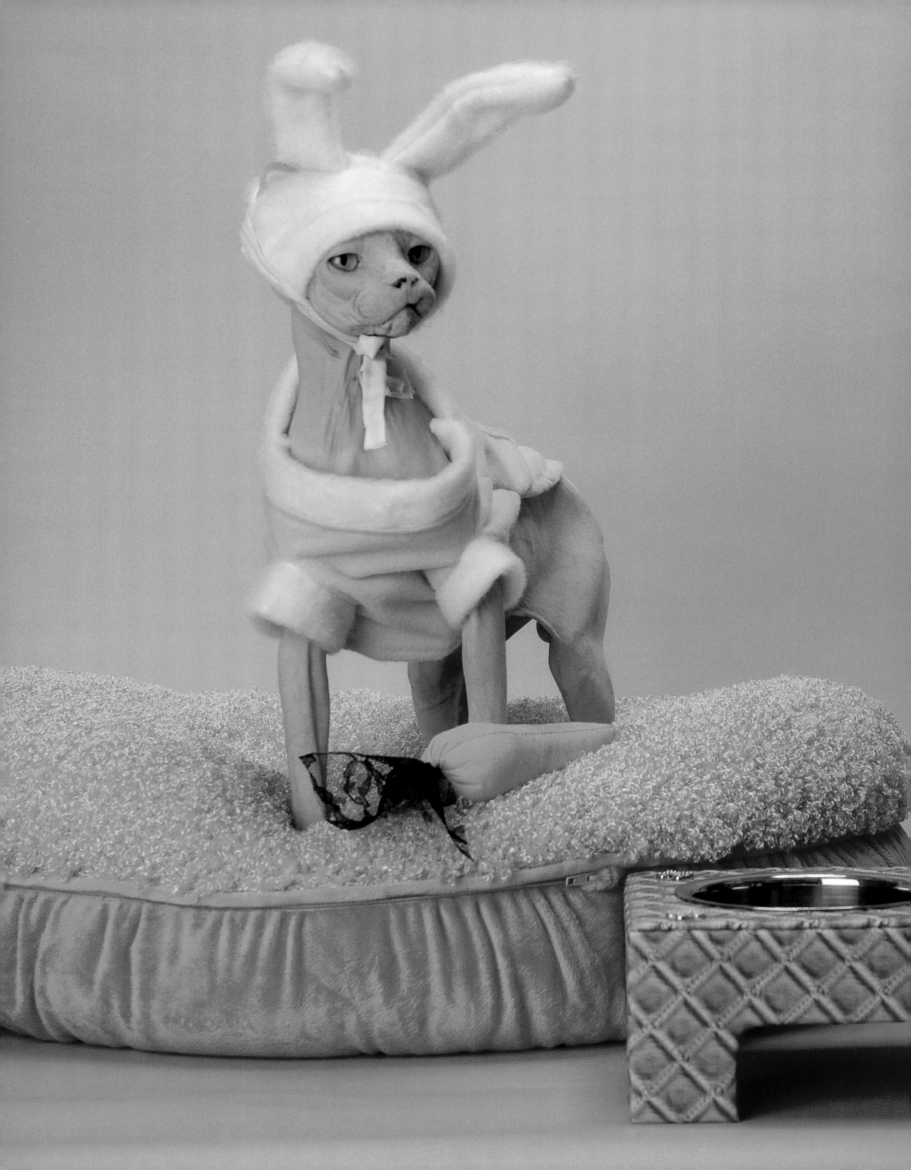

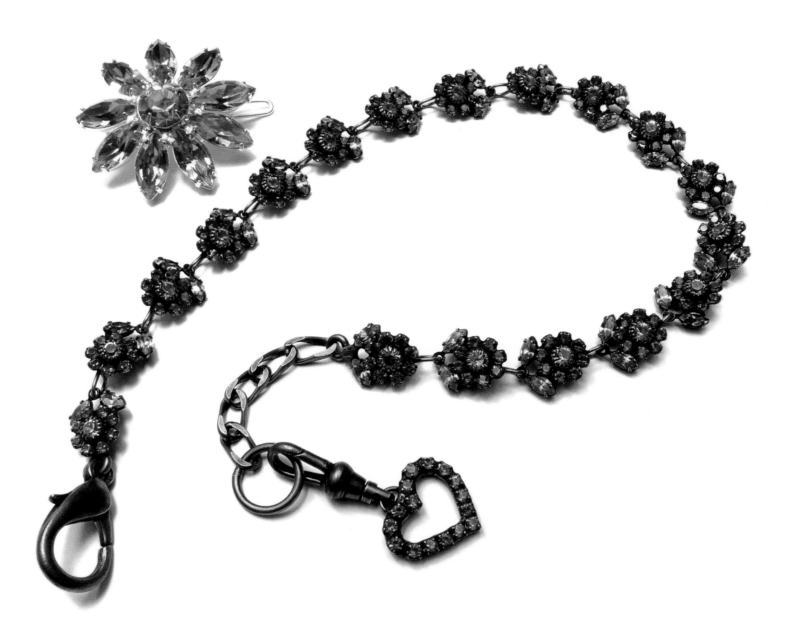

This pretty jewelry set by renowned artisan Dorothy Bauer is constructed and soldered by hand. On the opposite page, this handmade bunny outfit is a great way to integrate your feline into your holiday festivities, complete with hand sewn catnip carrot by Cat Faeries.

Dieses hübsche Schmuckset der berühmten Künstlerin Dorothy Bauer wird in Handarbeit gefertigt und gelötet. Auf der gegenüberliegenden Seite sehen Sie das handgemachte Hasenoutfit, das Ihre Katze hervorragend in Ihre Freizeitaktivitäten integriert. Komplett mit handgenähter, nach Katzenminze duftender Karotte von Cat Faeries.

Cette jolie parure de joaillerie de la renommée Dorothy Bauer est assemblée et soudée à la main. Sur la page opposée, cet ensemble lapin faitmain est une merveilleuse façon d'associer votre félin à vos fêtes ; il est agrémenté d'une carotte d'herbe à chat cousue main de chez Cat Faeries.

Este bonito conjunto, de la conocida artesana Dorothy Bauer, está hecho y soldado a mano. En la página contigua, el atavío de conejito hecho a mano es una buena opción para preparar a su felino para las pascuas, se complementa con hierba de gato y zanahoria cosidas a mano, de Cat Faeries.

Questo grazioso completo di gioielli, opera della nota artigiana Dorothy Bauer, è costruito e saldato a mano. Sulla pagina a fronte, il costume da coniglietto fatto a mano è un'ottima idea per integrare il vostro micio nelle festività, completo di carota piena di erba gatta cucita a mano, di Cat Faeries.

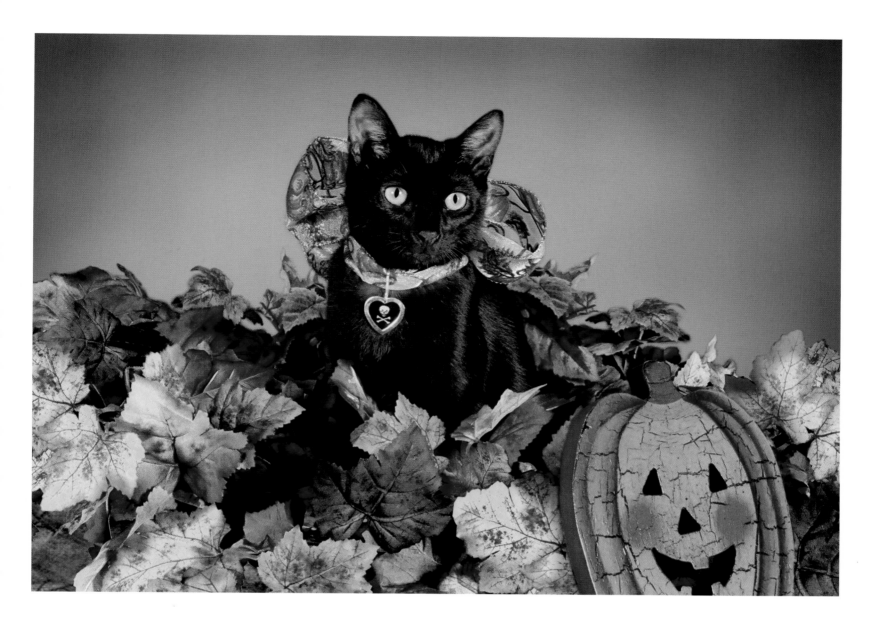

These designer looks by Animal Stars will have heads turning with an expansive selection of pet jewelry that fits any cat-lovers taste and personal style.

Ihre Katze wird viele Blicke auf sich ziehen, wenn sie die von Animal Stars kreierten Designerstücke spazieren führt — es gibt eine große Auswahl an Tierschmuck, passend zum Geschmack und persönlichen Stil eines jeden Katzenliebhabers.

Les créations de designers de chez Animal Stars attirent tous les regards ; le large choix de bijoux pour animaux s'accorde avec tous les goûts et styles des amoureux des chats.

Estas piezas de diseño de Animal Stars atraerán muchas miradas, con su extensa selección de joyería para animales que se adapta al gusto y al estilo personal de todo amante de los gatos.

Questo stile da designer, di Animal Stars, attirerà parecchi sguardi con un'estesa selezione di gioielleria per animali che si adatta ai gusti di ogni amante degli animali e a ogni stile personale.

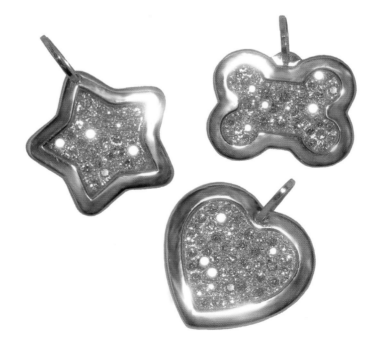

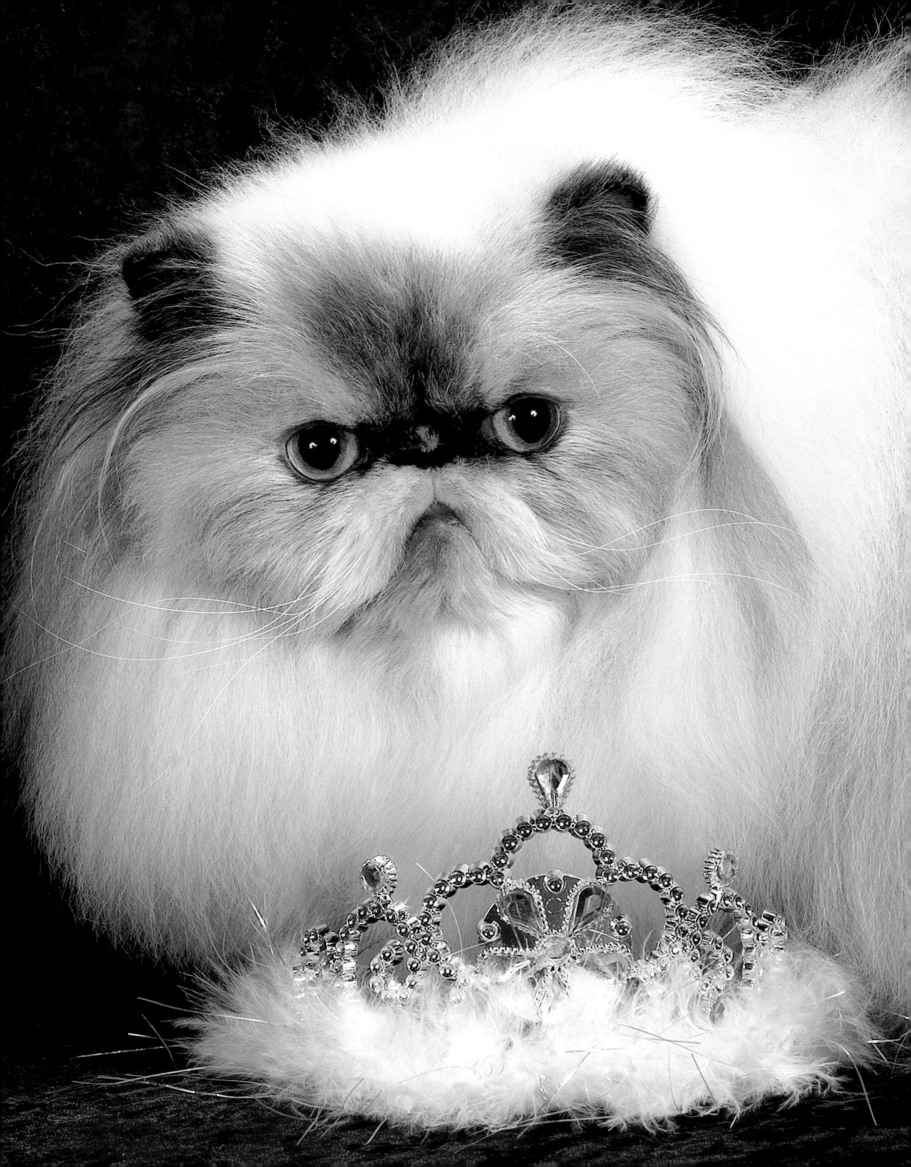

A hand-crafted Austrian Swarovski crystal custom-made tiara, such as the one shown on the right by renowned artisan Dorothy Bauer, is a highly sought-after and collectible piece for any feline princess.

Eine in Handarbeit speziell angefertigte Swarovski-Tiara aus Österreich, wie das auf der rechten Seite abgebildete Stück der bekannten Künstlerin Dorothy Bauer ist ein heißbegehrtes Sammlerstück für jede Katzenprinzessin.

Une tiare sur mesure faitemain en cristal Swarovski autrichien de Dorothy Bauer, artiste réputée, comme celle montrée à droite, est une pièce de collection extrêmement recherchée pour toutes les princesses félines.

Una diadema artesanal de cristal austriaco Swarovski, como la que se ve a la derecha, de la conocida Artesana Dorothy Bauer, constituye una pieza de colección muy deseada por toda princesa felina.

Un diadema personalizzato e lavorato a mano, in cristallo Swarovski austriaco come quello presentato a destra della nota artigiana Dorothy Bauer, costituisce un oggetto da collezione altamente ricercato per ogni principessa felina.

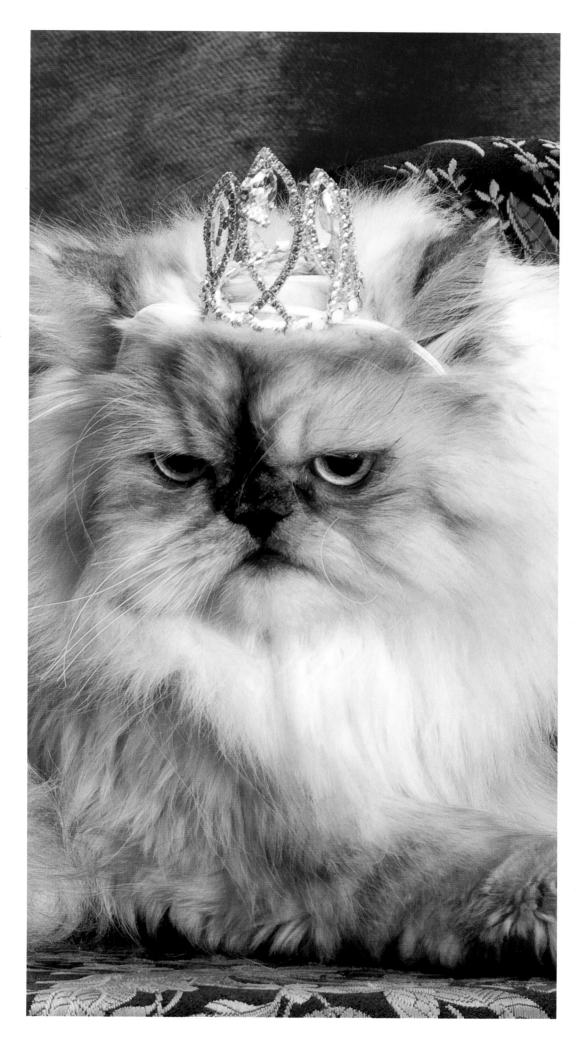

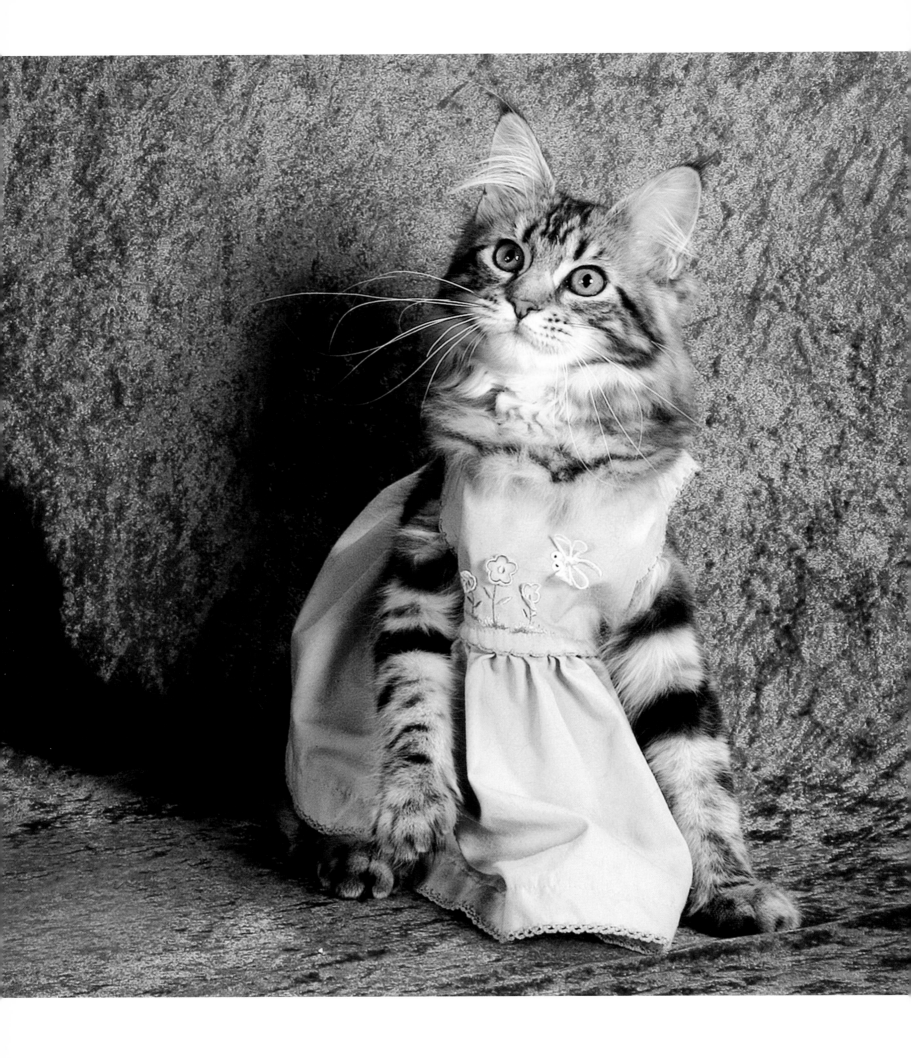

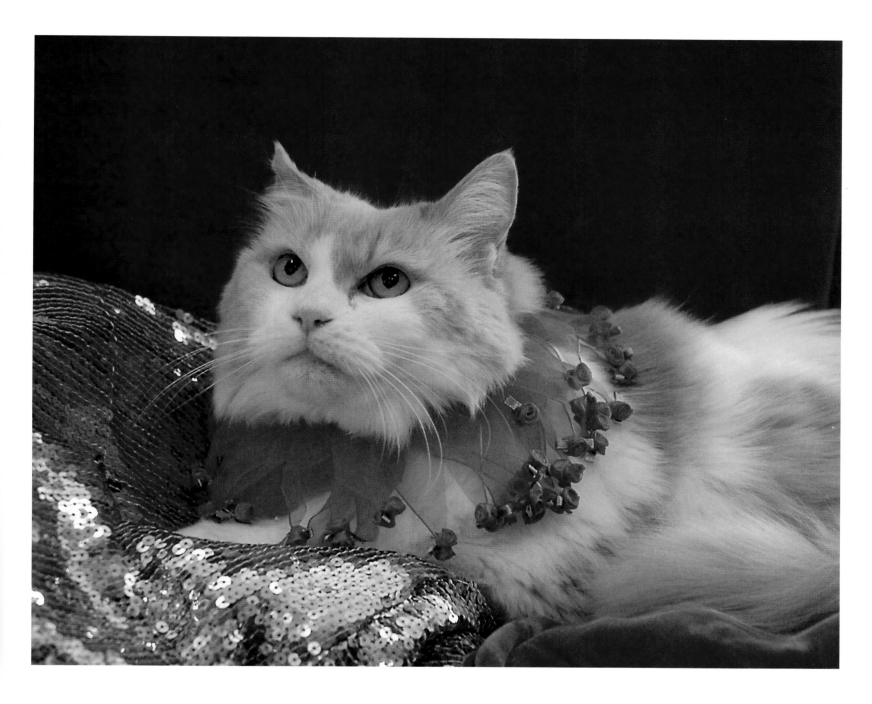

Cat fanciers and their pets will delight in the whimsical array of accessories that are available online from unique gift boutiques such as Kit'n k'poodle.

Katzenliebhaber und ihre Tiere werden entzückt von der neckischen Auswahl an Accessoires sein, die online von einzigartigen Geschenkboutiquen angeboten werden, wie z. B. Kit'n k'poodle.

Les amateurs de chats et leurs animaux se délecteront devant le fabuleux choix d'accessoires proposé par des boutiques de cadeaux en ligne exceptionnelles comme Kit'n k'poodle.

Los amantes de los gatos y sus mascotas se deleitarán con el insólito surtido en accesorios de tiendas tan singulares como Kit'n k'poodle, de venta por Internet.

Gli amanti dei gatti e i loro felini rimarranno incantati di questa serie di stravaganti accessori che sono disponibili online presso alcune boutique regali uniche come Kit'n k'poodle.

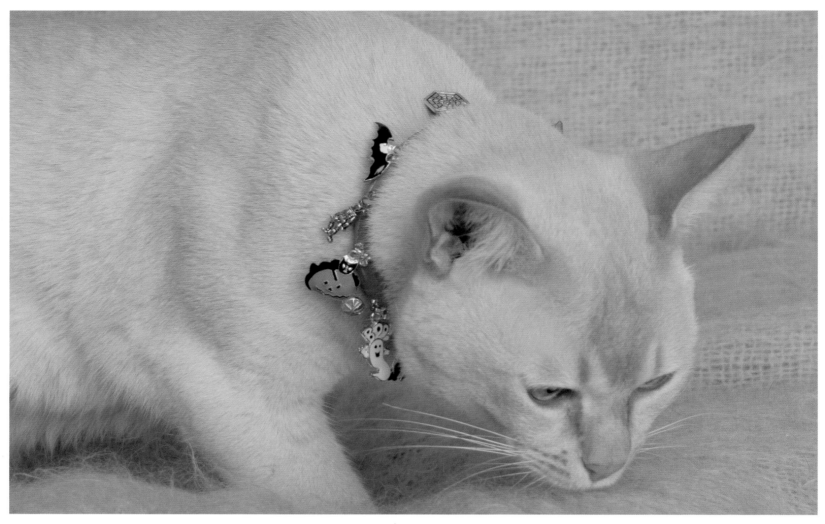

Holly & Lil creates fashionable kitty collars that are handmade with genuine leather and funky designs that meet the needs of any finicky feline.

Holly & Lil kreiert modische Katzenhalsbänder, handgefertigt aus echtem Leder und von unkonventionellem Design, ganz auf die Bedürfnisse wählerischer Katzen abgestimmt.

Holly & Lil crée des colliers à la mode pour chats, faits main en cuir véritable avec un design funky, qui répondent aux besoins de tout chat difficile.

Holly & Lil crea collares de moda para gatos, hechos a mano con cuero auténtico y diseños funky, que satisfacen las demandas de los felinos más detallistas.

Holly & Lil crea collari per mici alla moda, fatti a mano in vero cuoio e con motivi stravaganti, che soddisfano i bisogni del felino più esigente.

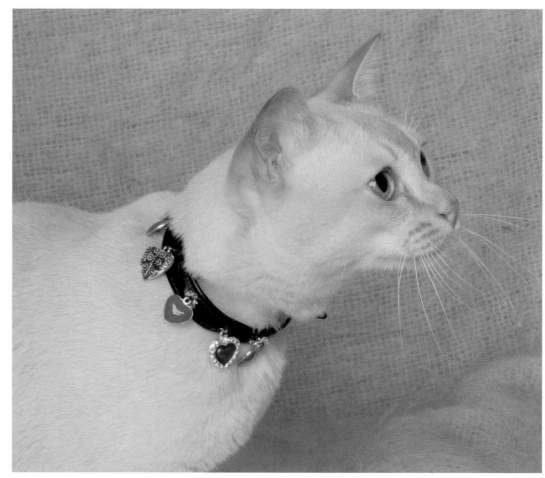

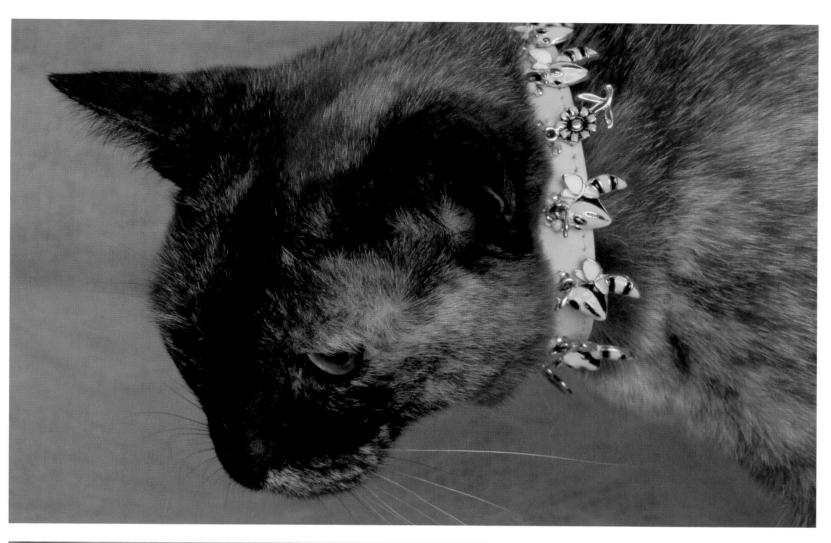

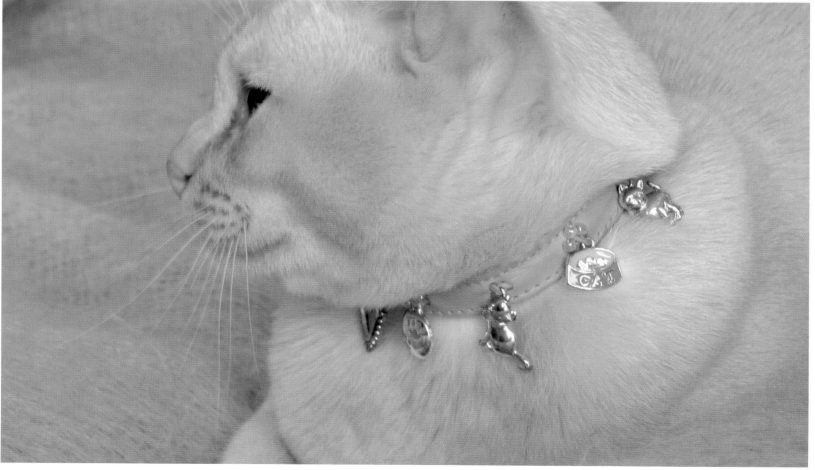

Muttropolis offers intricate cat toys that keep your kitty busy for hours while playing on their natural hunting and stalking instincts, especially if these fun fabric products are enhanced with catnip.

Muttropolis fertigt aufwendige Katzenspielzeuge, die Ihr Kätzchen stundenlang auf Trab halten, ganz auf ihren natürlichen Jagdtrieb und Pirschinstinkt abgestimmt; vor allem wenn diese lustigen Stoffteile verführerisch nach Katzenminze duften.

Muttropolis crée des jouets pour chats complexes qui occupent votre compagnon pendant des heures en faisant appel à son instinct naturel de chasseur et de prédateur, surtout quand ces produits ludiques sont parfumés à l'herbe à chat.

Muttropolis crea intricados juguetes que entretienen a su gato durante horas, usando sus instintos naturales de caza y emboscada, especialmente si estos divertidos productos de tejido están completados por hierba de gatos.

Muttropolis crea intricati giocattoli per animali che impegnano il vostro micio per ore, giocando sui suoi istinti naturali di caccia e agguato, specialmente se questi divertenti prodotti in stoffa sono completati da erba gatta.

A cat can never have too many furry toys to play with. Their interest is not so much on retrieving the toy, but on the simple thrill of the hunt.

Eine Katze kann nie genug Spielsachen haben. Das Interesse der Katze konzentriert sich weniger auf das Wiederfinden ihres Spielzeuges, sondern vielmehr auf den reinen Nervenkitzel der Jagd.

Un chat n'a jamais trop de peluches pour s'amuser. Son intérêt ne repose pas tellement sur l'accès au jouet, mais sur le simple plaisir de pouvoir le chasser.

Un gato nunca tendrá demasiados juguetes peludos para entretenerse. Su interés no se concentra tanto en recuperar el juguete, sino en la simple emoción de la caza.

Un gatto non avrà mai troppi giocattoli pelosi con cui giocare. Suscitano in lui non tanto l'interesse nel recuperarli, quanto la pura eccitazione della caccia.

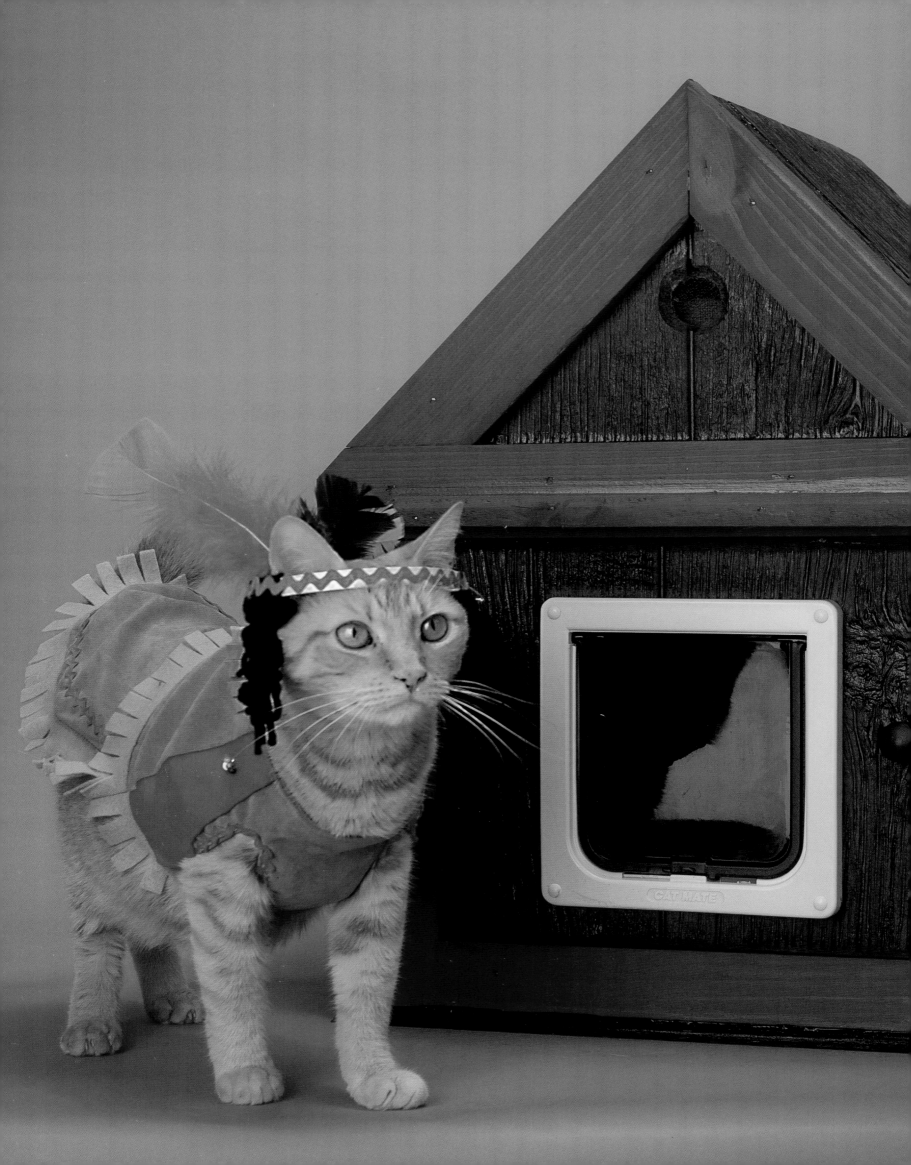

Architecture & Interiors

"The reason cats climb is so that they can look down on almost every other animal…it's also the reason they hate birds."
KC Buffington

Feline companions need their own private spaces to fit a variety of needs, such as napping, lounging, window gazing and playing.

Unsere Katzen benötigen ihre Privatsphäre, wenn es um verschiedenste Bedürfnisse geht, wie zum Beispiel schlummern, faulenzen, aus dem Fenster sehen und spielen.

Nos compagnons félins nécessitent leurs propres espaces privés pour répondre à toute une gamme de besoins : faire la sieste, s'étendre, regarder par la fenêtre et jouer.

Los compañeros felinos necesitan sus propios espacios privados para satisfacer una variedad de necesidades como hacer la siesta, holgazanear, mirar por la ventana y jugar.

I nostri compagni felini hanno bisogno dei loro spazi privati per soddisfare svariate esigenze, come pisolare, oziare, guardare dalla finestra e giocare.

Architecture & Interiors

If your feline friend is an important part of the family, the home should be functional for each family member, even the four-legged ones.

Just a few decades ago, the majority of cats were occasional visitors in the home, but mainly belonged outdoors. But today more and more people are moving to congested metropolitan cities and into smaller spaces. Concerned that there are too many dangers for the sake of their cat's safety, more cat owners than ever are forced to confine their furry felines indoors.

As more people adopt the most favorite domesticated pet each year, the demand for more feline furnishings and products increased as a result. According to a current survey conducted in the United States, the number of pet products introduced into the marketplace each year is now at 15 percent per annum. To satisfy this high demand, there is an overflow of designers and manufacturers that are constantly creating new products to satisfy this growing need.

Not more than a decade ago, there was a very limited number of products that would celebrate the diversity of a cat's life that was integrated within the home environment. But thanks to a multitude of cat-loving creative people designing for our feline friends today, the basic and sometimes tacky cat furnishings have evolved into beautiful products that deserve the label luxury. There is no longer a reason to sacrifice stylish design for perfect functionality. The incredibly lavish pet furnishings not only pamper your pet, but beautify the décor of the owner's home as well.

Some of these furnishings are inspired by the influences of modern designers and current trends in architecture and interior design. These modern pieces with its unique styles offer a complete escape from the ordinary, and some even hide their true purpose at first glance; litter boxes are now hidden behind elegant armoires with stained glass doors or concealed inside tropical plant stands, and cat beds looks like a sculpture of art. The unusual designs of the furniture and structures on the following pages transform even the most mundane pieces into creative showpieces for your home.

A handful of risk-taking designers found ways to create cat furnishings that are truly design objects with the kind of quality and attention to detail usually reserved for the most discerning luxury consumer, while keeping the users—that is, the sophisticated cat—in mind. If you are looking for something unique and highly sophisticated, these pages introduce you to the most avant-garde pieces in today's cat furnishings to create an inspiring living space for both cat and owner.

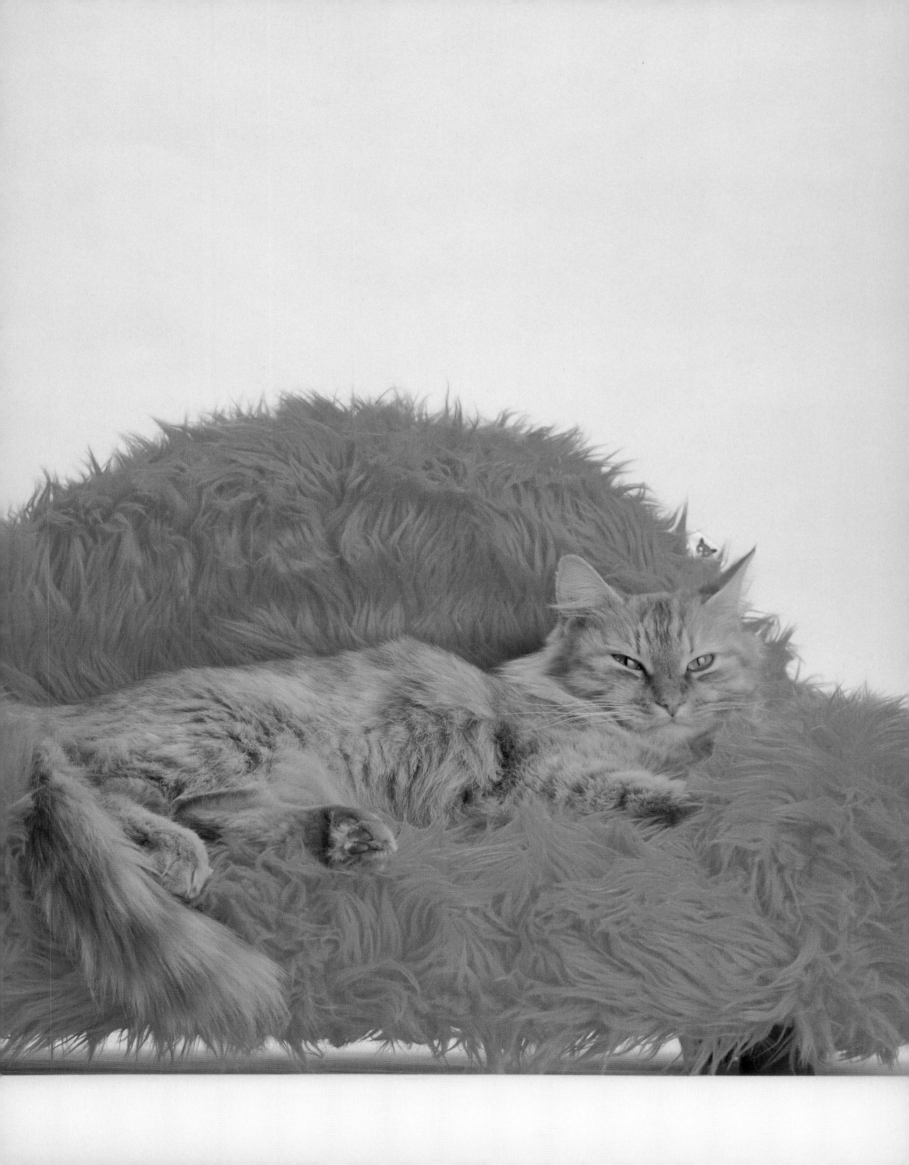

Architektur & Interieur

W enn Ihr pelziger Freund ein wichtiger Teil der Familie ist, sollte das Zuhause für jedes Familienmitglied funktionell sein, d. h. auch für die vierbeinigen Familienmitglieder.

Vor einigen Jahrzehnten waren die meisten Katzen nur gelegentlich zu Gast im Haus, weil sie sich hauptsächlich draußen aufhielten. Heute jedoch ziehen immer mehr Leute in verkehrsreiche Hauptstädte und kleinere Wohnräume. Aus Sorge wegen der zahlreichen, das Wohl ihrer Katze bedrohenden Gefahren, sind mehr Katzenbesitzer als jemals zuvor gezwungen, ihre flauschigen Kätzchen ans Haus zu binden.

Da sich jedes Jahr zunehmend mehr Menschen das beliebteste Haustier anschaffen, ist die Nachfrage nach einer größeren Auswahl an Katzenmobiliar und Produkten gestiegen. Laut einer aktuellen, in den USA erhobenen Studie beträgt die Anzahl der jedes Jahr auf dem Markt lancierten Heimtierprodukte mittlerweile 15 Prozent. Um diese große Nachfrage zu befriedigen, gibt es Designer und Hersteller im Überfluss, die permanent neue Produkte kreieren, um den wachsenden Bedürfnissen gerecht zu werden.

Vor einem Jahrzehnt gab es eine sehr beschränkte Anzahl an Produkten, um die Vielseitigkeit eines in die heimische Umgebung integrierten Katzenlebens zu zelebrieren. Aber dank zahlreicher katzenliebender, kreativer Leute, die heute Produkte für unsere pelzigen Freunde entwerfen, mutierten die simplen, manchmal kitschigen Einrichtungsgegenstände für Katzen zu wunderschönen Dingen, die zu Recht als Luxus bezeichnet werden können. Es gibt nun keinen Grund mehr, stylisches Design für perfekte Funktionalität zu opfern. Das unglaublich aufwändige Tiermobiliar verwöhnt nicht nur Ihr Tier, sondern verschönert auch die Wohnräume des Besitzers.

Einige dieser Einrichtungsgegenstände wurden von den Einflüssen der modernen Designer und aktuellen Trends in der Architektur und Innenausstattung geprägt. Diese modernen Stücke mit ihrem einzigartigen Stil brechen alle Tabus, und manchmal ist ihr eigentlicher Zweck auf den ersten Blick gar nicht sichtbar; Katzentoiletten werden in eleganten Schränken mit Scheiben aus Buntglas verstaut oder in Säulen versteckt, auf denen sich tropische Pflanzen befinden. Sogar Ruheplätze für Katzen muten wie Skulpturen an. Die ungewöhnlichen Designs der Möbel und Konstruktionen auf den folgenden Seiten verwandeln selbst die banalsten Stücke in kreative Dekoobjekte für Ihr Heim.

Eine Handvoll Designer mit Mut zum Risiko haben Wege gefunden, Einrichtungsgegenstände speziell für Katzen zu kreieren, die echte Designerobjekte sind. Hierbei handelt es sich um Qualitätsgegenstände, die mit viel Liebe zum Detail gefertigt werden, wie sie gewöhnlich dem kritischen, luxusorientierten Verbraucher vorbehalten sind. Hier jedoch haben die Designer den Benutzer – nämlich die anspruchsvolle Katze – im Sinn gehabt. Wenn Sie auf der Suche nach etwas Einzigartigem und äußerst Raffiniertem sind, dann finden Sie auf diesen Seiten die avantgardistischsten Stücke der heutigen Einrichtungsgegenstände für Katzen, mit denen ein inspirierender Lebensraum sowohl für die Katze als auch ihren Besitzer geschaffen wird.

Architecture & Intérieurs

S i votre ami félin est un important membre de votre famille, la maison doit être fonctionnelle pour chacun, même pour ceux qui ont quatre pattes.

Il y a seulement quelques décennies, la majorité des chats étaient des visiteurs occasionnels de la maison, ils vivaient majoritairement à l'extérieur. Mais aujourd'hui de plus en plus de personnes partent vivre dans des métropoles surpeuplées, dans des espaces plus petits. Etant donné les dangers pour la sécurité de leur chat, les propriétaires de chat sont plus que jamais obligés de confiner leurs félins à l'intérieur.

De plus en plus de personnes adoptent cet adorable animal domestique chaque année, et la demande en produits et accessoires pour félins augmente en conséquence. Selon une enquête menée actuellement aux Etats-Unis, le nombre de produits pour animaux entrant sur le marché est de 15 pour cent chaque année. Face à cette forte demande, une kyrielle de designers et de fabricants créent constamment de nouveaux produits pour satisfaire ce besoin croissant.

Il n'y a pas plus de dix ans, seul un nombre limité de produits célébrant la diversité d'une vie de chat s'intégrait dans l'environnement de la maison. Mais grâce à une multitude de créatifs fanatiques des chats dessinant aujourd'hui pour nos amis félins, les accessoires basiques et parfois de mauvais goût ont évolué pour devenir des produits magnifiques qui méritent l'étiquette luxe. Il n'y a plus de raison de sacrifier le design à la fonctionnalité. Les meubles incroyablement raffinés pour animaux ne se contentent pas de choyer votre animal, ils embellissent aussi la maison de son maître.

Certains de ces meubles sont inspirés des designers modernes et des dernières tendances en matière d'architecture et d'architecture d'intérieur. Ces meubles modernes au style unique permettent d'échapper totalement à l'ordinaire, et certains cachent même leur utilisation réelle à première vue : les bacs à litière sont maintenant invisibles derrière d'élégantes armoires aux portes en vitrail ou à l'intérieur de structures couvertes de plantes tropicales, et les paniers des chats ressemblent à des œuvres d'art. Les designs originaux des meubles et des structures des pages suivantes transforment même les objets les plus triviaux en œuvres créatives pour votre foyer.

Une poignée de designers audacieux a su créer des meubles pour animaux qui soient de véritables objets designs avec la qualité et l'attention aux détails habituellement réservées au consommateur de luxe le plus avisé, mais en ayant toujours l'utilisateur – c'est-à-dire, le chat raffiné – à l'esprit. Si vous recherchez quelque chose d'unique et d'extrêmement sophistiqué, ces pages vous présentent les meubles les plus avant-gardistes pour le chat d'aujourd'hui, qui permettent de créer un espace de vie transcendant pour lui et pour son maître.

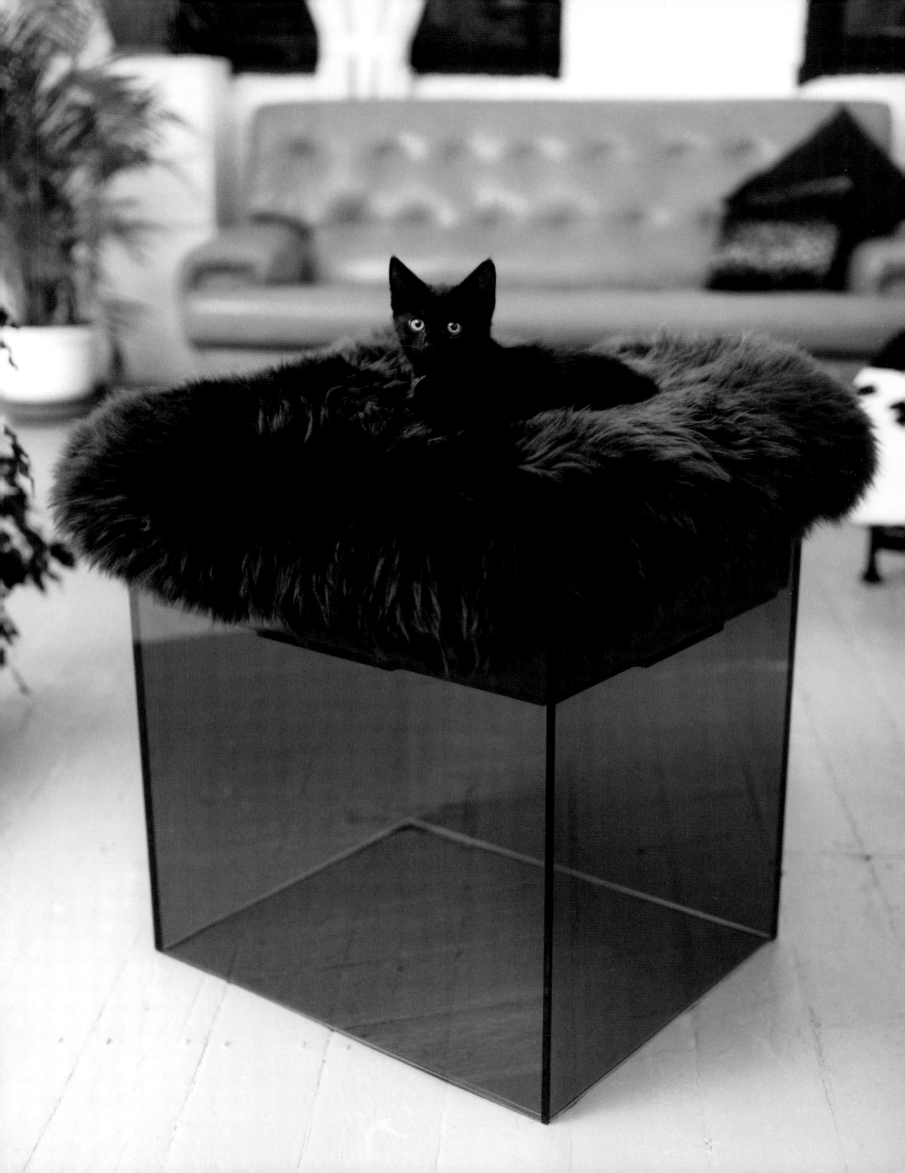

Arquitectura & Interiores

Architettura & Interni

Si nuestro amigo felino es una parte importante de la familia, la casa debería ser funcional para cada miembro de la familia, incluidos los cuadrúpedos.

Hace pocas décadas, la mayoría de los gatos eran meros visitantes ocasionales de la casa, viviendo principalmente en el exterior. Sin embargo, hoy son muchas las personas que se trasladan a espacios reducidos dentro de metrópolis muy congestionadas. Preocupados por los peligros que amenazan la seguridad de sus gatos, muchos amos ya no tienen más remedio que encerrar a los felinos en casa.

Son cada vez más las personas que adoptan animales de compañía cada año: En consecuencia, la demanda de artículos y productos para felinos aumenta. Según una reciente encuesta realizada en los Estados Unidos, cada año se introduce en el mercado un 15 por ciento. Para satisfacer una demanda tal, existe una abundancia de diseñadores y productores creando constantemente nuevos productos.

Hace tan solo una década, existía una cantidad limitada de productos integrados en el ámbito doméstico que hiciera honor a la diversidad de la vida de un gato. Hoy en día, sin embargo, gracias a la multitud de creativos amantes de los gatos que diseñan para ellos, el mobiliario básico —y a veces de mal gusto— ha evolucionado hacia hermosos productos que merecen ser llamados de lujo. Ya no hay razón para sacrificar el diseño y la moda en favor de la perfecta funcionalidad. Los muebles para gatos, increíblemente suntuosos, no solo miman a nuestro amigo, sino que embellecen también la decoración de nuestra casa.

Algunos de estos artículos se inspiran en las influencias de los modernos diseñadores y en las tendencias actuales en arquitectura y diseño interior, suponiendo con sus exclusivos estilos una verdadera huida de las creaciones ordinarias, a veces ocultando su auténtico propósito a primera vista; ahora las cajitas se esconden en juegos de plantas tropicales o en elegantes armarios con puertas de vidrio coloreado, y las camas para gatos parecen esculturas. El diseño inusual de los muebles y las estructuras mostrado en las páginas siguientes transforma hasta los artículos más mundanos en obras de arte expuestas en su propia casa.

Un puñado de atrevidos diseñadores ha encontrado la manera de crear muebles para gatos que constituyan auténticos objetos de diseño, con la calidad y atención al detalle reservada normalmente a los consumidores de artículos de lujo más entendidos, sin olvidar nunca a los usuarios, es decir, de los gatos. Si buscamos algo único y con un alto grado de sofisticación, estas páginas presentan artículos de vanguardia que crean un entorno vital que sirve de inspiración tanto al gato como a su amo.

Se il vostro amico felino è una parte importante della vostra famiglia, la casa dovrebbe essere funzionale per ogni membro della famiglia, compresi quelli a quattro zampe.

Solo pochi decenni fa, la maggioranza dei gatti erano visitatori occasionali in casa, mentre le loro vite si svolgevano principalmente all'aperto. Oggi, però sempre più persone si trasferiscono in congestionate metropoli e in spazi più ristretti. Preoccupati per gli eccessivi pericoli che insidiano la sicurezza dei loro gatti, sempre più proprietari sono costretti a confinare tra le quattro mura di casa i loro felini dal manto vellutato.

Di anno in anno sono sempre più le persone che adottano questo animale domestico preferito, e di conseguenza, aumentano anche le richieste di arredi e altri prodotti a misura di felino. Secondo un recente sondaggio realizzato negli Stati Uniti, la quantità di prodotti per gatti introdotti sul mercato si aggira ormai sul 15 percento l'anno. Per soddisfare una tale richiesta, si è sviluppata una sovrabbondanza di designer e produttori che creano costantemente nuovi prodotti per soddisfare i sempre crescenti bisogni.

Non più di un decennio fa, esisteva un numero molto limitato di prodotti per onorare la diversità della vita dei gatti, integrata nell'ambiente domestico. Ma oggi, grazie alla moltitudine di creativi, amanti dei gatti, che sviluppano un design al servizio dei nostri amici felini, gli arredi basilari e spesso rozzi si sono evoluti in bellissimi prodotti, che meritano l'appellativo di lussuosi. Non c'è più ragione di sacrificare il design di classe in favore di una perfetta funzionalità. Gli arredamenti specializzati, incredibilmente sontuosi, non solo viziano il vostro animale, ma abbelliscono anche l'arredamento della casa del proprietario.

Alcuni di questi arredi sono ispirati dall'influsso di designer moderni e dalle tendenze attuali presenti nell'architettura e nel design d'interni. Questi articoli moderni, con il loro stile unico, offrono una fuga totale dall'ordinario, e alcuni, a prima vista, riescono persino a nascondere la loro vera funzione; ora le lettiere si nascondono in eleganti armadietti con antine in vetro colorato, oppure in contenitori circondati da piante tropicali, e i letti per i gatti sembrano sculture d'arte. Il design insolito dei mobili e delle strutture nelle pagine seguenti trasforma anche gli articoli più mondani in pezzi da esposizione creativi per la vostra casa.

Una manciata di arditi designer ha scoperto dei modi per creare dei mobili per gatti che sono dei veri e propri oggetti di design con la qualità e l'attenzione al dettaglio che di solito riservati ai più competenti consumatori di lusso, tenendo sempre in mente gli utenti, cioè i sofisticati gatti. Se state cercando qualcosa di unico e altamente sofisticato, queste pagine vi presentano gli articoli più all'avanguardia nell'odierno arredamento per gatti, per creare uno spazio vitale d'ispirazione sia per il gatto sia per il padrone.

The Cat Interiors design philosophy is simple: Why must cat beds reveal their purpose at first glance? Those who like to surround themselves with unusual design will find a small yet fine collection of "furniture showpieces" which can be combined perfectly into a modern living environment.

Die Designphilosophie von Cat Interiors ist recht eindeutig: Warum müssen Katzenbetten ihren Zweck auf den ersten Blick offenbaren? Diejenigen, welche sich selbst gerne mit außergewöhnlichem Design umgeben, werden eine kleine, aber feine Kollektion von Möbelexponaten finden, die sich perfekt in einen modernen Lebensraum integrieren lassen.

La philosophie du design de Cat Interiors est simple : pourquoi les paniers pour chats devraient-ils révéler leur fonction au premier coup d'œil ? Ceux qui aiment s'entourer de design original trouveront une petite collection, mais exceptionnelle de « chefs-d'œuvre mobiliers » qui peuvent parfaitement s'harmoniser dans un cadre de vie moderne.

La filosofía de diseño de Cat Interiors es simple: por qué las camitas para gatos tienen que revelar su función al primer vistazo? Los que aman rodearse con diseños insólitos encontrarán una colección, pequeña pero excelente, de "obras maestras de decoración", perfectamente combinables en un moderno espacio vital.

La filosofia nel design di Cat Interiors è semplice: perché i lettini per gatti dovrebbero svelare la propria natura a prima vista? Chi ama circondarsi di oggetti dal design insolito troverà una piccola ma squisita collezione di "pezzi forti d'arredamento" che possono essere combinati perfettamente in un moderno ambiente abitativo.

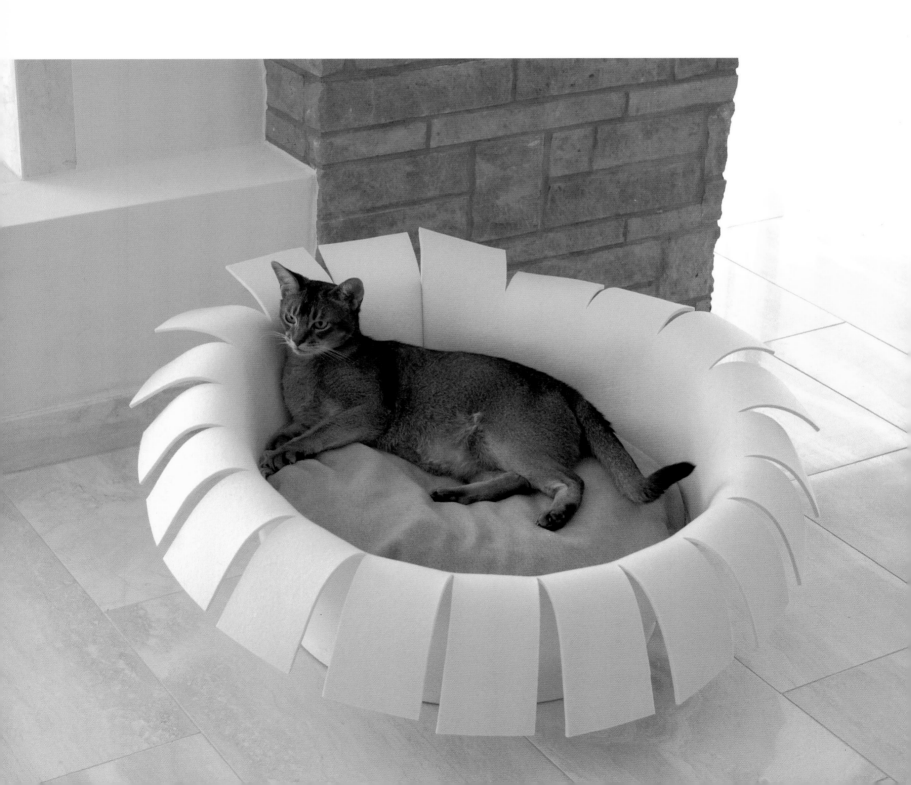

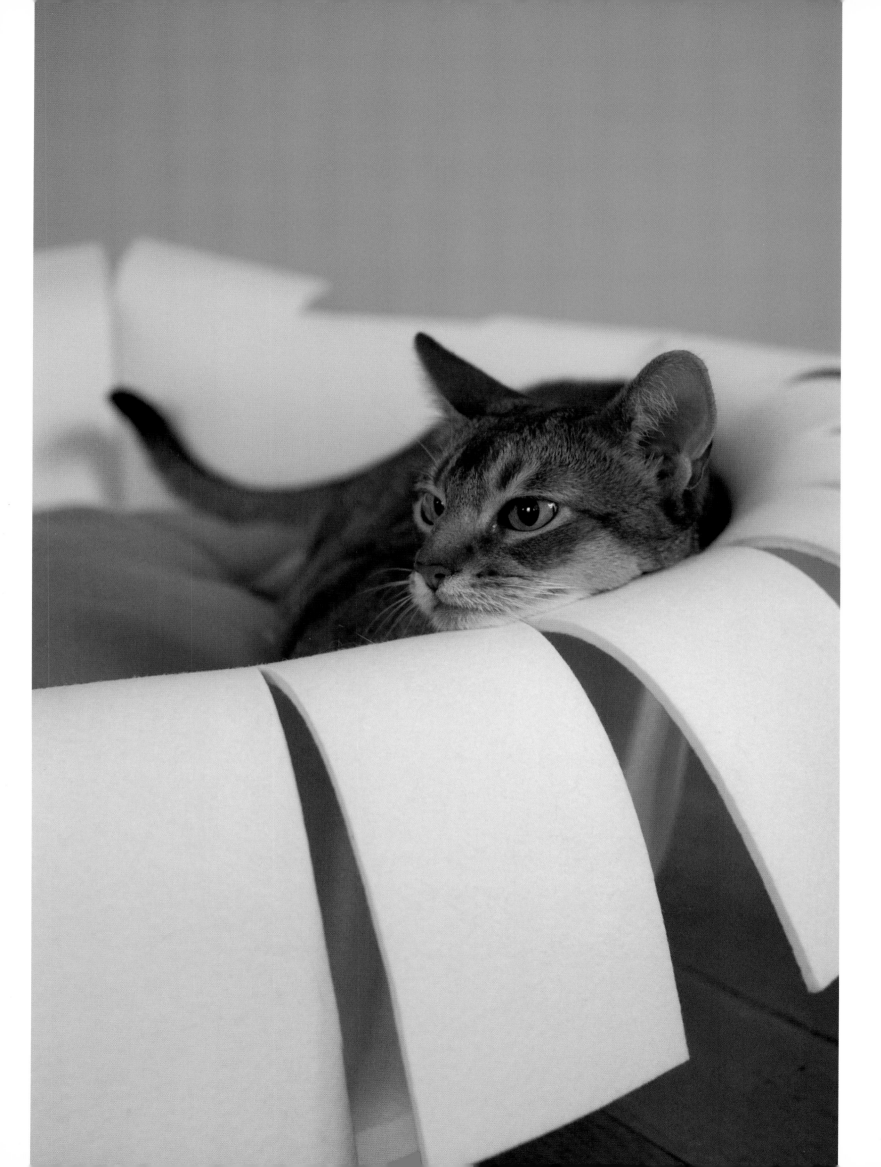

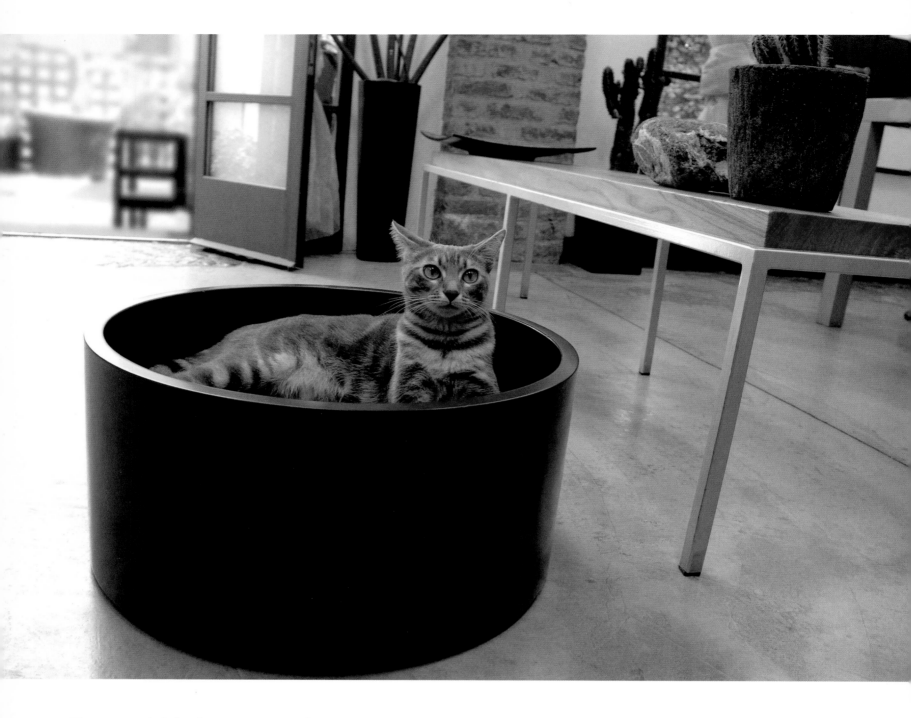

These gorgeous beds from b.pet come in a range of unique styles, lush exotic patterns, and rich fabrics which are well thought out with your feline family member in mind.

Diese wunderschönen Betten von b.pet sind in vielen verschiedenen Ausführungen erhältlich, mit opulenten exotischen Mustern und üppigen Stoffen, die mit Bedacht auf das vierbeinige Familienmitglied ausgewählt wurden.

Ces splendides paniers de chez b.pet existent dans toute une gamme de styles, avec leurs motifs exotiques opulents et leurs tissus riches, ils sont parfaits pour votre félin.

Estas espléndidas camas de b.pet cubren una gama de estilos únicos, lujosos modelos exóticos y ricos tejidos, pensado para el miembro felino de la familia.

Questi splendidi lettini di b.pet variano tra stili unici, rigogliosi motivi esotici e ricche stoffe, pensate con estrema cura per il membro felino della famiglia.

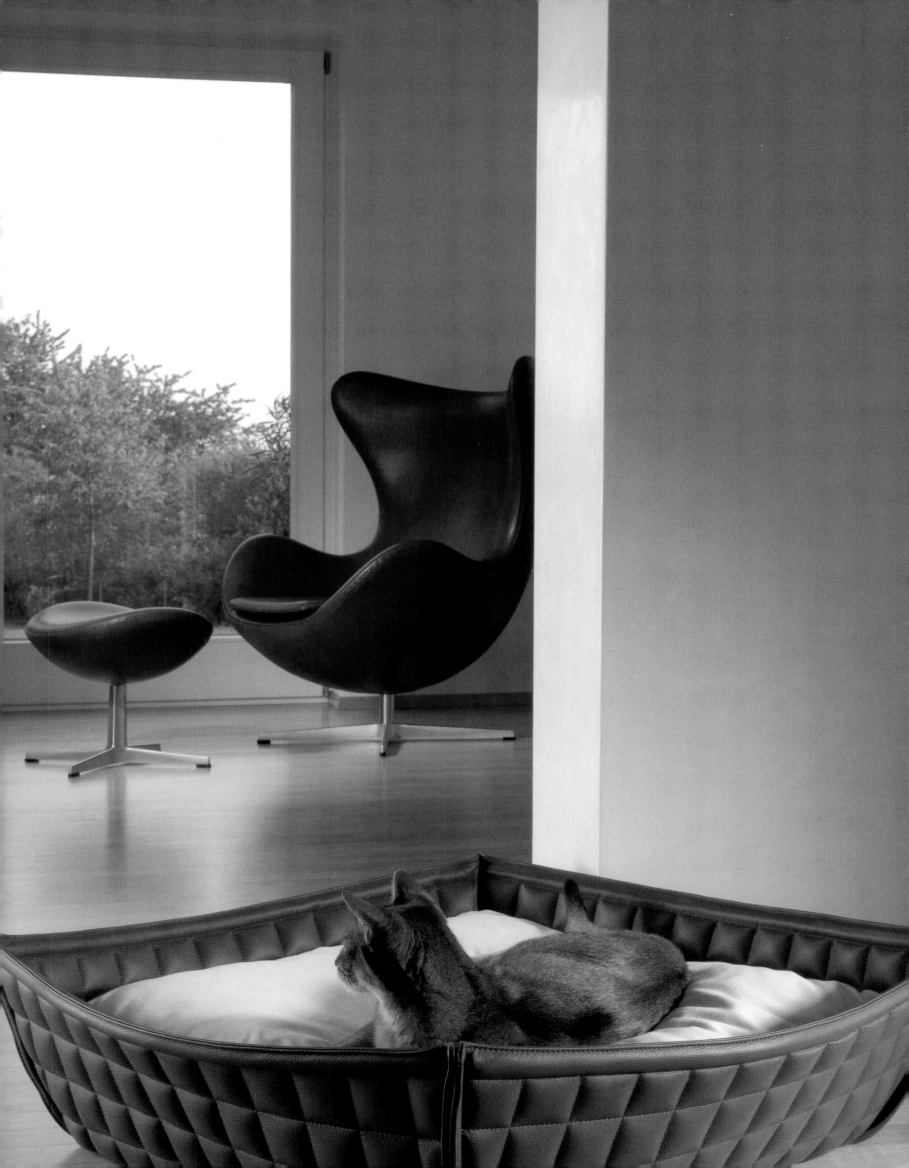

Catnap has designed a whole new generation of pet furniture for those furry friends who spend more time on your sofa than you do. Their comfortable cat beds are designed like a piece of upholstered furniture, but with style written all over them.

Für die pelzigen Freunde, die mehr Zeit auf Ihrem Sofa verbringen als Sie selbst, hat Catnap eine komplett neue Generation von Tiermöbeln entworfen. Die komfortablen Katzenbetten von Catnap wurden wie Polstermöbel gestaltet und tragen die stylische Handschrift des Unternehmens.

Catnap a conçu une toute nouvelle génération de meubles pour ces petits compagnons qui passent plus de temps sur votre canapé que vous. Ses paniers pour chats confortables sont conçus comme des meubles rembourrés à l'élégance évidente.

Catnap ha diseñado una generación completamente nueva de muebles para mascotas, para aquellos compañeros de cuatro patas que pasan más tiempo en el sofá que sus amos. Sus cómodas camas están diseñadas como piezas de decoración tapizadas con toda la elegancia posible.

Catnap ha disegnato un'intera nuova generazione di arredamento per gatti, per tutti i soffici amici che passano più tempo di voi sul divano. I loro comodi lettini sono disegnati come articoli d'arredamento imbottiti dallo stile del tutto particolare.

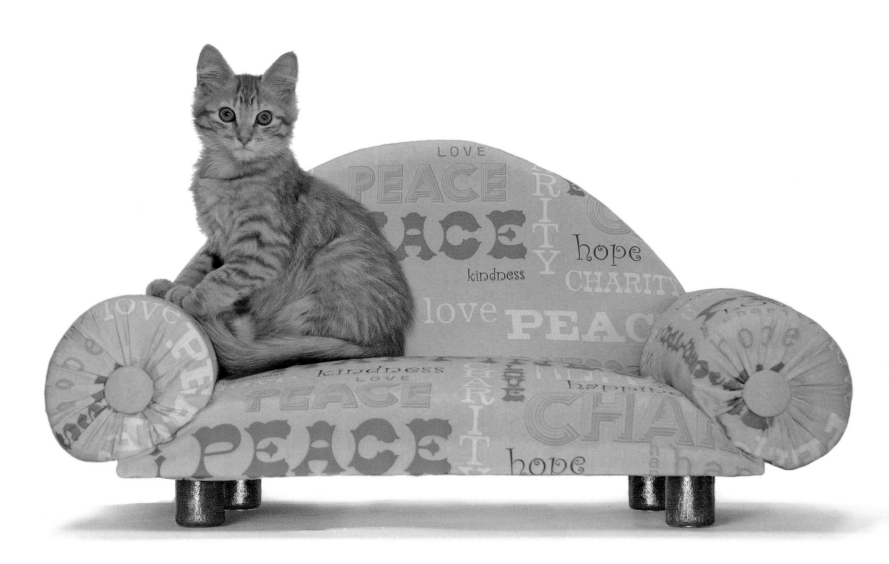

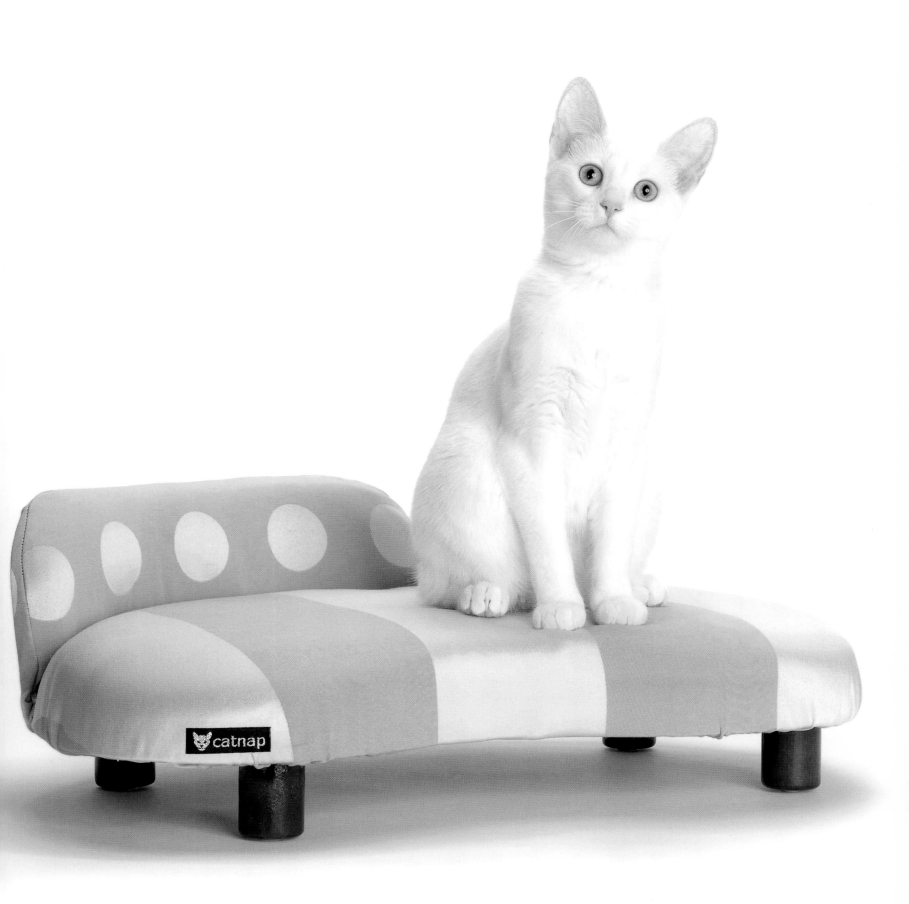

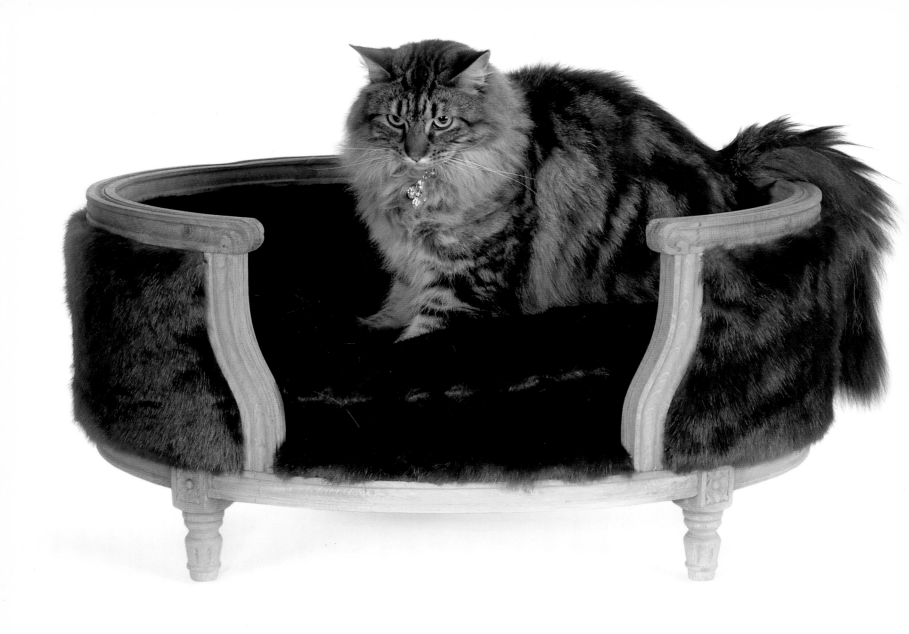

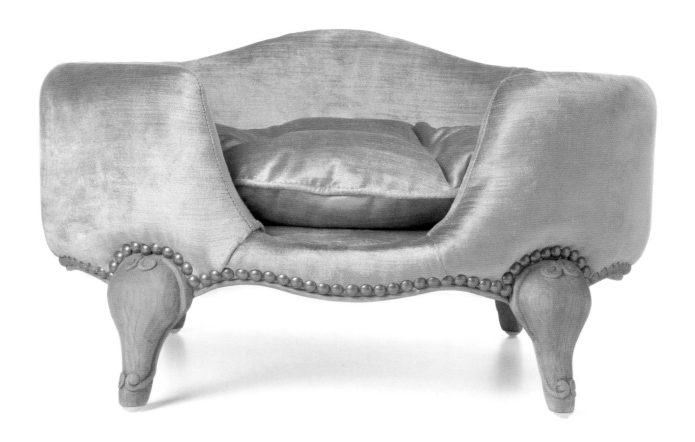

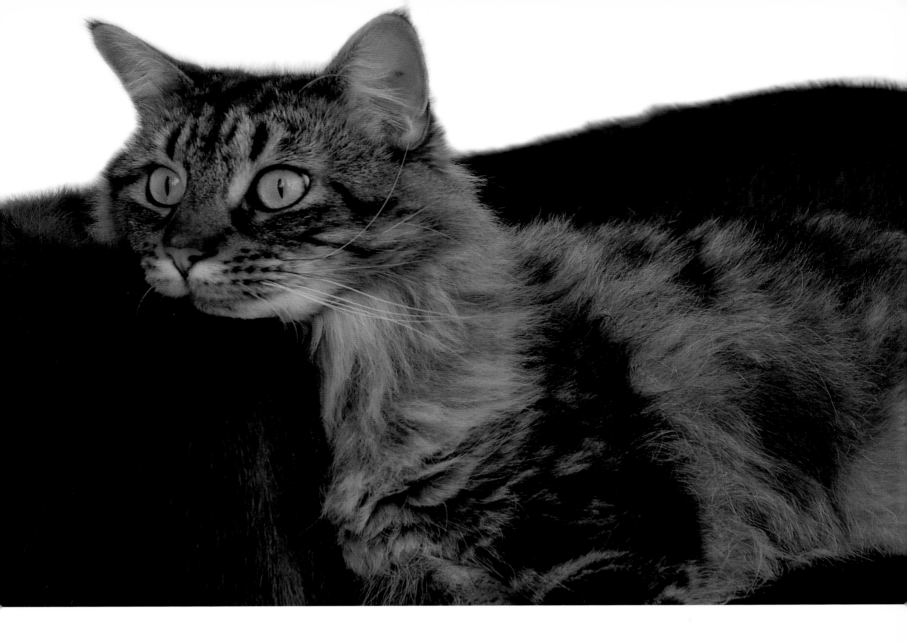

These hand-crafted sofas from Lord Lou differ from the average cat bed in that they are genuine pieces of miniature furniture of the finest quality fabrics and fur.

Diese handgefertigten Sofas von Lord Lou unterscheiden sich von dem durchschnittlichen Katzenbett dadurch, dass sie Original-Miniaturmöbel sind, welche aus edelsten Stoffen und Fell gefertigt werden.

Ces sofas faitsmain de chez Lord Lou se démarquent des paniers pour chats habituels car ce sont de véritables meubles miniatures faits de tissus et de fourrures de la meilleure qualité.

Estos sofás artesanales de Lord Lou difieren de una cama cualquiera ya que constituyen auténticas piezas de decoración en miniatura, con los tejidos y las pieles de calidad más preciada.

Questi sofà lavorati a mano, di Lord Lou, si distinguono dal classico lettino per gatti in quanto rappresentano veri e propri articoli di arredamento in miniatura, con le stoffe e le pelli della migliore qualità.

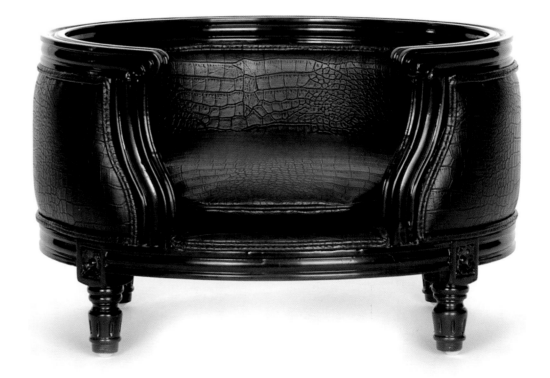

Companies such as Pawsitively Posh and The Royal Dog and Cat are designing creative, award-winning cat beds as limited editions.

Firmen wie Pawsitively Posh und The Royal Dog and Cat entwerfen kreative, prämierte Katzenbetten in limitierter Auflage.

Des compagnies telles que Pawsitively Posh et The Royal Dog and Cat réalisent des paniers créatifs, primés, en édition limitée.

Casas como Pawsitively Posh y The Royal Dog and Cat diseñan, en ediciones limitadas, camitas para gatos creativas y premiadas.

Case come Pawsitively Posh e The Royal Dog and Cat disegnano lettini per gatti creativi e premiati, in edizioni limitate.

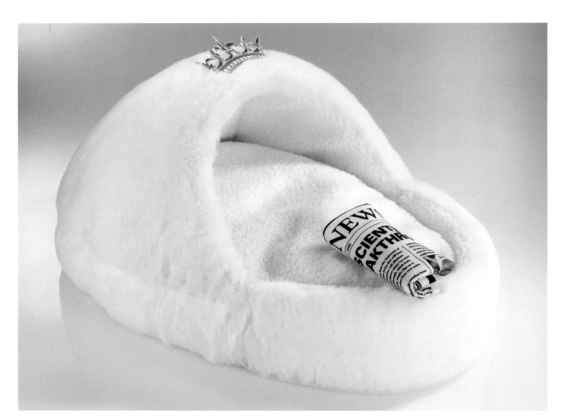

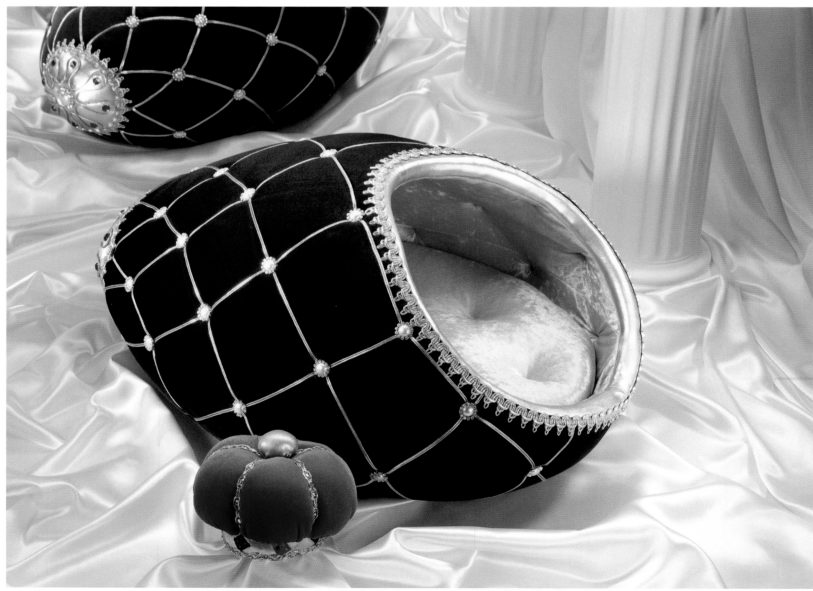

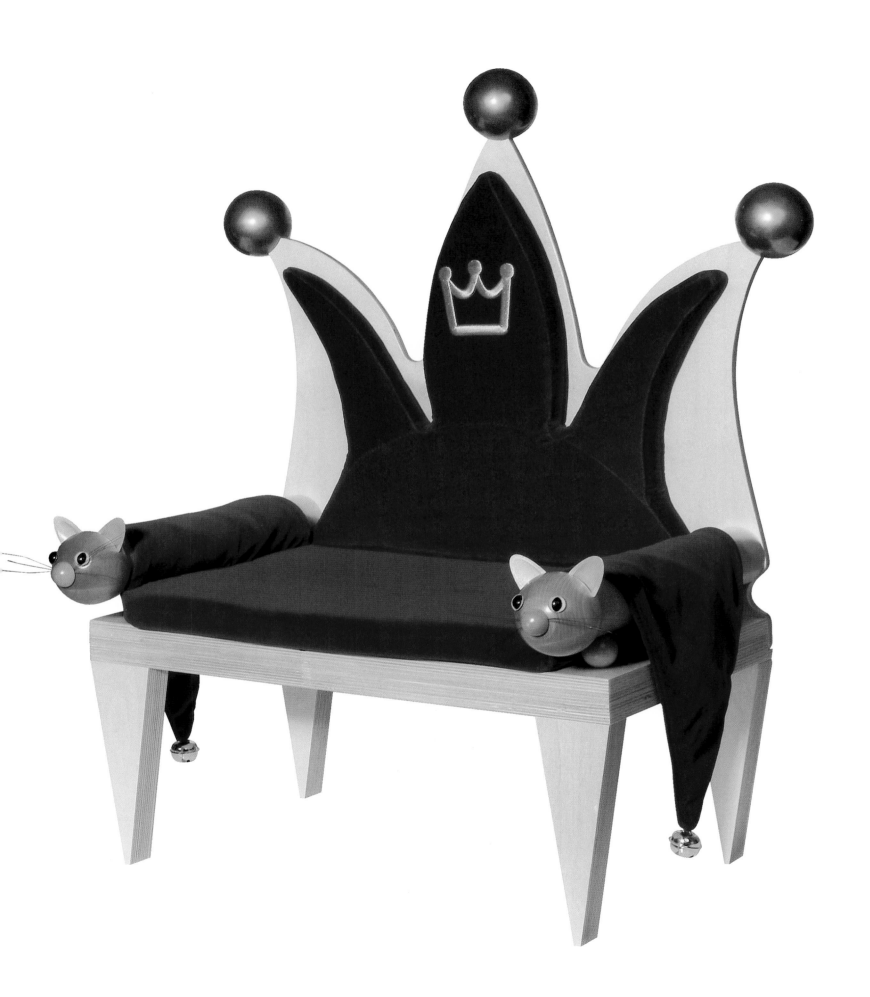

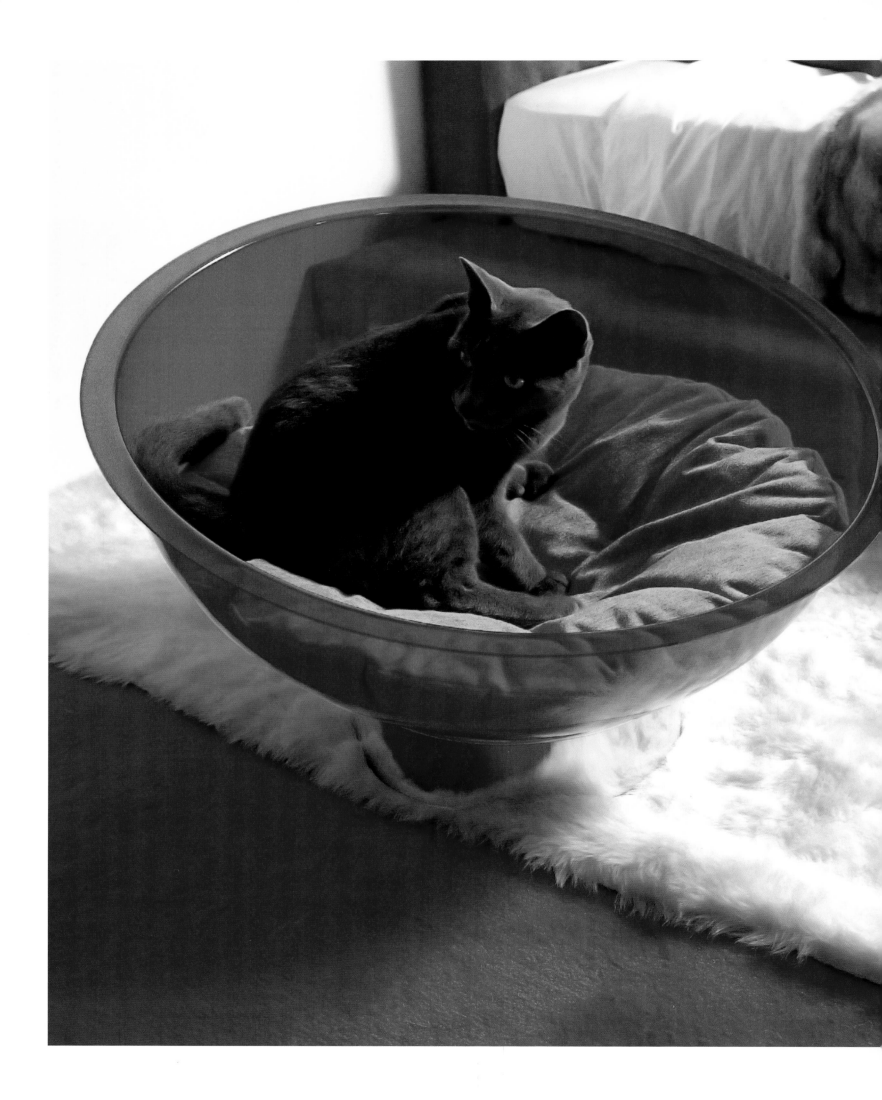

This modern pet collection from b.pet is rooted in Italian design, transforming a normal piece of feline furniture into pieces of sculptural art.

Diese moderne Kollektion für Haustiere von b.pet hat seine Wurzeln im italienischen Design, was aus einem normalen Katzenmöbel ein skulpturales Kunstwerk macht.

Cette collection moderne pour animaux de chez b.pet s'inscrit dans le design italien, et fait d'un banal meuble pour chat une sculpture d'art.

Esta moderna colección para mascotas, de b.pet, tiene sus raíces en el diseño italiano convirtiendo un objeto de decoración felina en una verdadera obra de arte.

Questa moderna collezione per animali domestici, di b.pet, affonda le radici nel design italiano, trasformando un normale articolo di arredamento felino in opere d'arte scultorea.

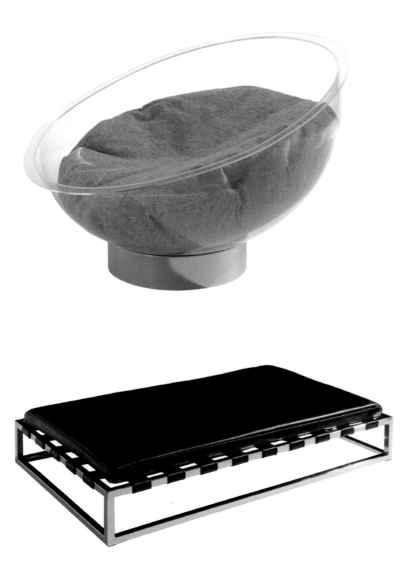

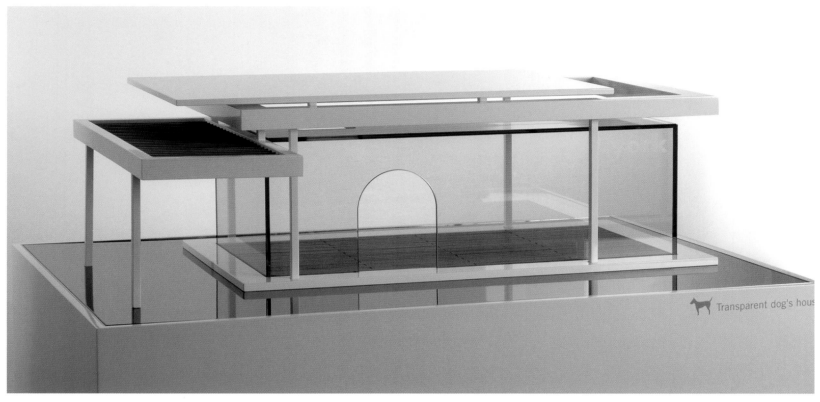

Transparent dog's house

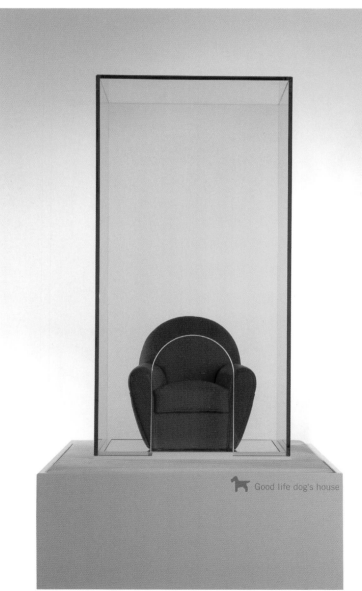

Good life dog's house

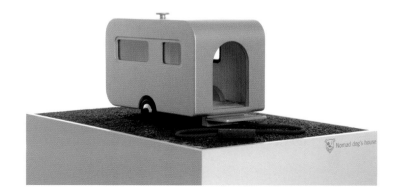

Nomad dog's house

Italian designer Morosini gives more attention to artistic form than actual function with these hand-numbered houses that range up to $7,000.

Dem italienischen Designer Morosini sind künstlerische Formen wichtiger als die eigentliche Funktion dieser handnummerierten Häuser, die bis zu 7.000 $ kosten.

Le designer italien Morosini prête plus d'attention à la forme artistique qu'à l'aspect fonctionnel avec ses maisons numérotées qui coûtent dans les 7000 $.

El diseñador italiano Morosini se concentra más en la forma artística que en la funcionalidad de sus casitas, numeradas a mano, que cuestan desde 7.000 dólares.

Il designer italiano Morosino privilegia la forma artistica più della funzionalità con queste casette numerate a mano che arrivano fino a 7.000 dollari.

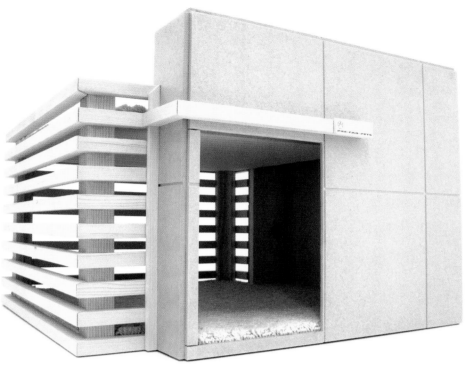

This miniature home created by Pre Fab Pets was inspired by the architecture of Frank Lloyd Wright.

Der Designer dieses von Pre Fab Pets kreierten Miniaturhauses ließ sich von der Architektur Frank Lloyd Wrights inspirieren.

Cette maison miniature créée par Pre Fab Pets s'inspire de l'architecture de Frank Lloyd Wright.

La casa en miniatura creada por Pre Fab Pets fue inspirada en la arquitectura de Frank Lloyd Wright.

Questa casa in miniatura, creata da by Pre Fab Pets, si ispira all'architettura di Frank Lloyd Wright.

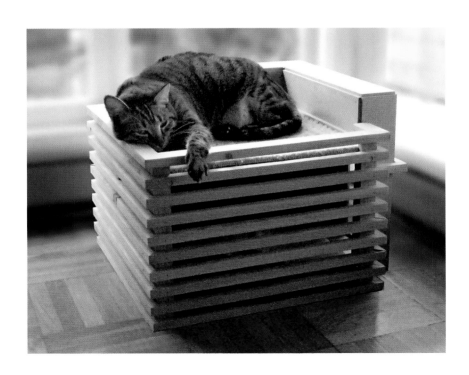

As cat lovers spend more than ever on their furry friends, cat houses evolve into designer artwork and luxurious mini-mansions that are detailed replicas of the cat owners home, such as this cute cottage playhouse by Smart Cat, which satisfies the feline fanatic more than the cat.

Da Katzenliebhaber mehr denn je für ihre pelzigen Freunde ausgeben, mutieren Katzenhäuser zu Designerkunst und luxuriösen Minivillen – exakte Repliken der Häuser der Katzenbesitzer. Ein Beispiel dafür ist dieses niedliche Spiel-Landhaus von Smart Cat, das den Katzenfanatiker in Begeisterungsstürme ausbrechen lässt – mehr als die Katze selbst.

Alors que les amateurs de chats dépensent plus que jamais pour leurs amis à fourrure, les maisons pour chats évoluent pour devenir des œuvres de designer et de luxueuses mini-résidences, répliques détaillées de la maison de leurs maîtres, comme ce mignon cottage de Smart Cat, qui satisfera plus le fanatique des félins que le chat lui-même.

Puesto que los amantes de los gatos pasan más tiempo que nunca con sus pequeños amigos, las casas de los gatos se convierten en trabajos de diseño artístico y lujosas mini-mansiones, replicas en miniatura de las casas de los amos, como este lindo chalet de juegos de Smart Cat, que satisface más al dueño del felino que al gato mismo.

Mentre gli amanti dei gatti passano sempre più tempo con i loro amici a quattro zampe, le casette di questi ultimi si evolvono in opere di design e in lussuosi minipalazzi, copie dettagliate della casa del proprietario, come questo grazioso cottage-casa giochi di Smart Cat, che soddisfa il fanatico dei gatti ancora più dei gatti stessi.

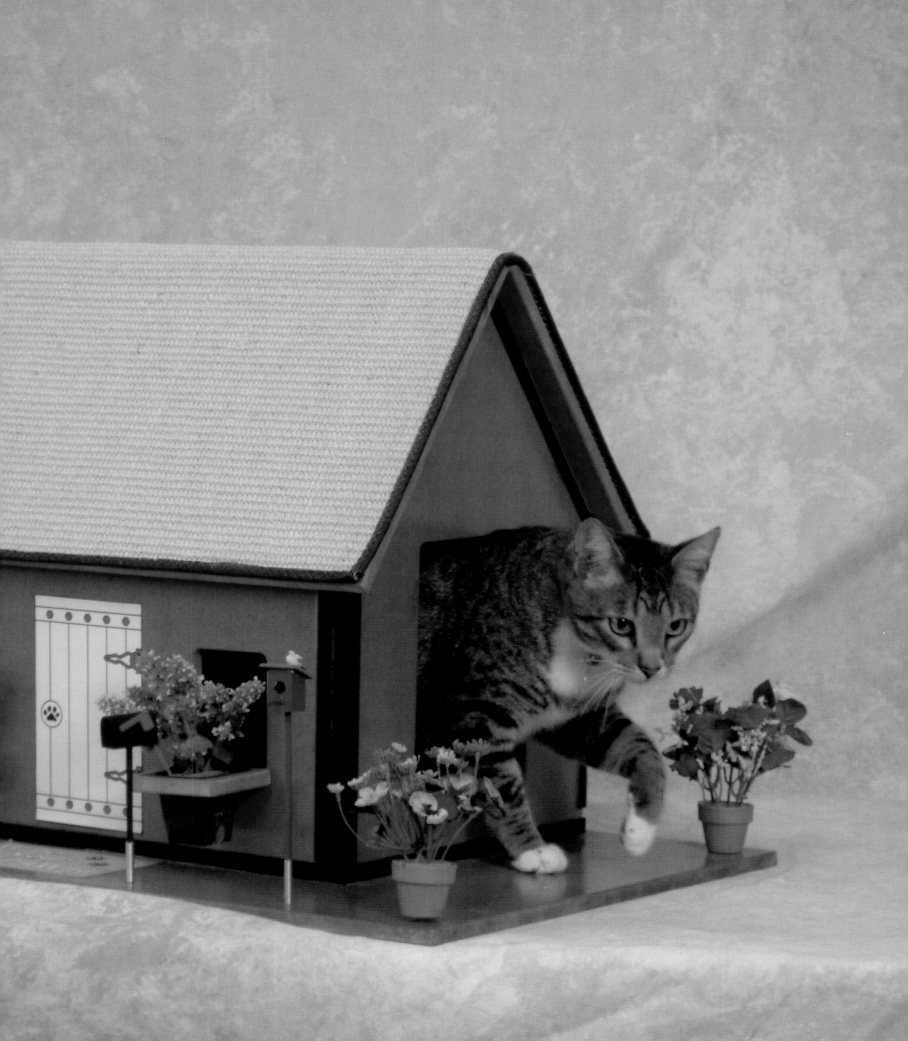

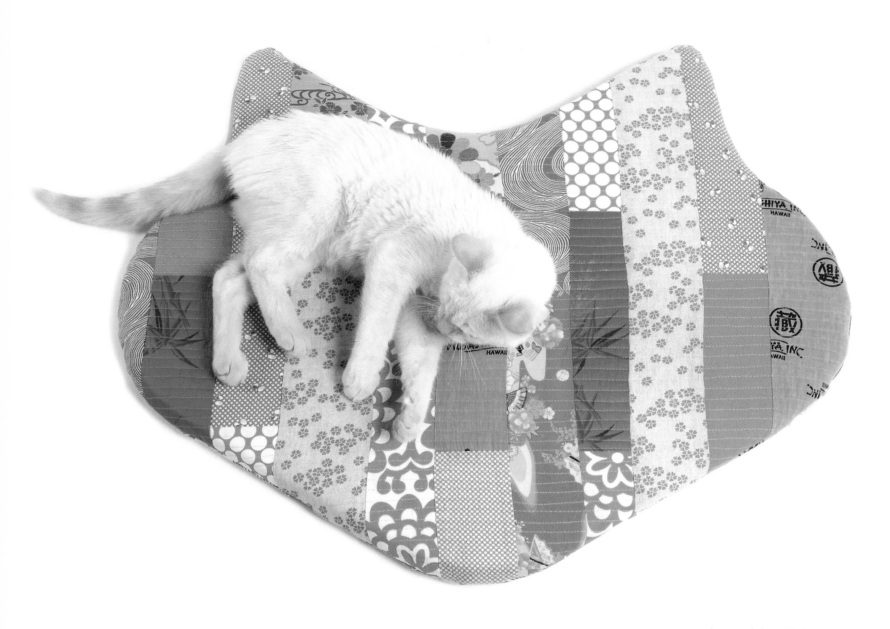

Kittypod creates the most fashionable home products for the most fashion forward feline owner.

Kittypod kreiert die trendigsten Heimprodukte für den äußerst modebewussten Katzenhalter.

Kittypod crée les accessoires les plus branchés pour les propriétaires de chat les plus branchés.

Kittypod crea los productos domésticos más modernos para el amo de gato más adelantado en las tendencias.

Kittypod crea i prodotti domestici di tendenza per il proprietario di felini più modaiolo.

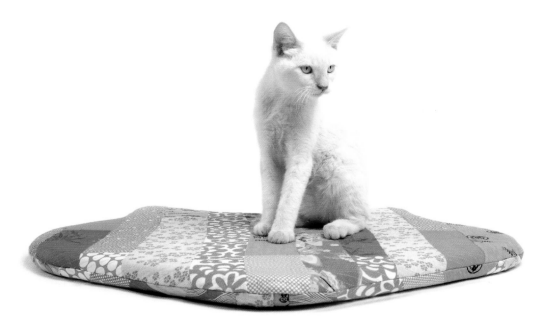

There's nothing more luxurious than a cat bed with color-coordinated cushions and molded exotic wood.

Es gibt nichts Luxuriöseres als ein Katzenbett aus geformtem Tropenholz mit darauf farblich abgestimmten Kissen.

Rien n'est plus luxueux qu'un panier pour chat avec coussins de couleur assortie et bois exotique moulé.

No existe nada más lujoso que una camita para gato con cojines en colores coordinados y madera exótica tallada.

Non esiste nulla di più lussuoso di un letto per gatti con cuscini in colori coordinati e legno esotico modellato.

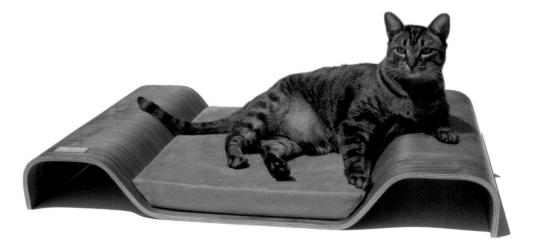

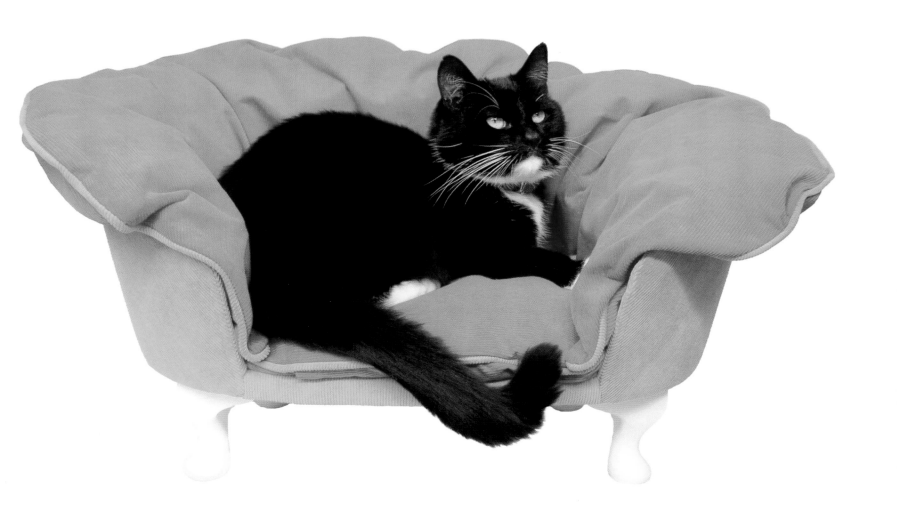

 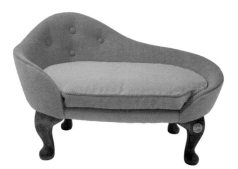

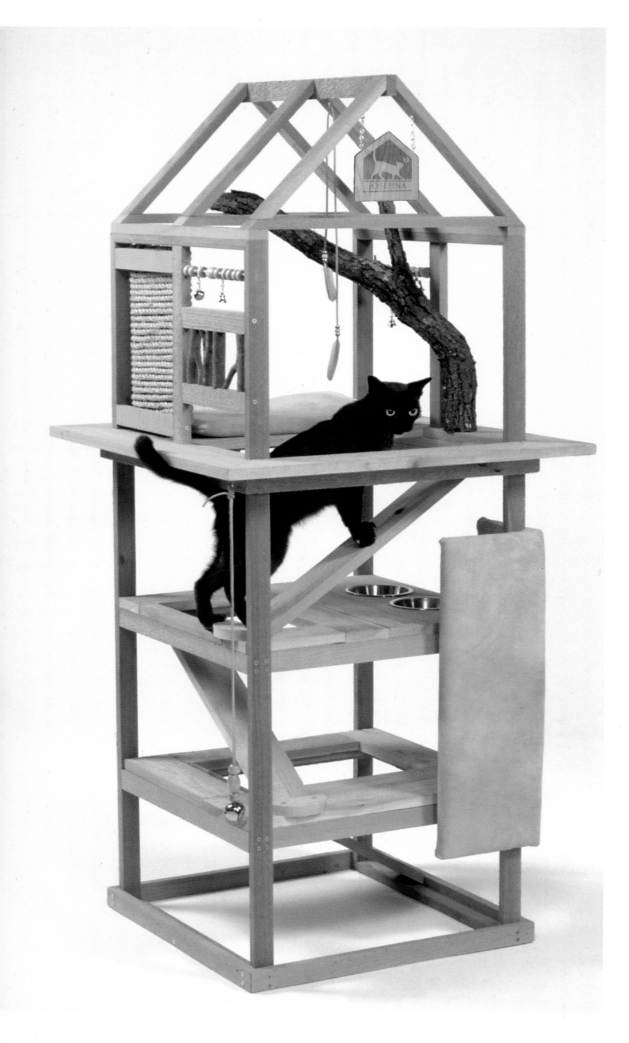

Many designer cat houses and trees today cater to the habits and personality of the owner as well as the cat, while complementing the beauty of the owner's house. Companies such as House of Cats International can custom design elaborate cat structures that are hand-crafted with natural materials to fit even the most complicated requests.

Viele Designerkatzenhäuser und -kratzbäume entsprechen heute den Gewohnheiten und der Persönlichkeit des Besitzers sowie seiner Katze, während sie die Schönheit des Tierhalterheimes unterstreichen. Firmen wie House of Cats International entwerfen maßgefertigte Konstruktionen für Katzen, welche aus natürlichen Materialien von Hand gefertigt werden, damit sie selbst den kompliziertesten Anforderungen entsprechen.

Nombre de maisons et arbres pour chats de designers s'adaptent aujourd'hui autant aux habitudes et à la personnalité du maître qu'à celles du chat, tout en apportant une touche finale à l'esthétique de la maison. Des entreprises comme House of Cats International peuvent concevoir sur mesure des structures complexes, fabriquées à la main avec des matériaux naturels pour répondre même à la plus exigeante des demandes.

Muchas de las casas y árboles de diseño para gatos reflejan tanto las costumbres y la personalidad del amo como la de su mascota, complementando así la belleza de la casa. Compañías como House of Cats International pueden diseñar a medida elaboradas estructuras para gatos, hechas a mano con materiales naturales para satisfacer hasta las demandas más exigentes.

Molte casette e alberi per gatti prodotti dai designer contemporanei si adattano alle abitudini e alla personalità del padrone come a quelle del gatto, completando la bellezza della casa. Aziende come House of Cats International sono in grado di personalizzare elaborate strutture per gatti, lavorate a mano con materiali naturali, per accomodare anche le richieste più complicate.

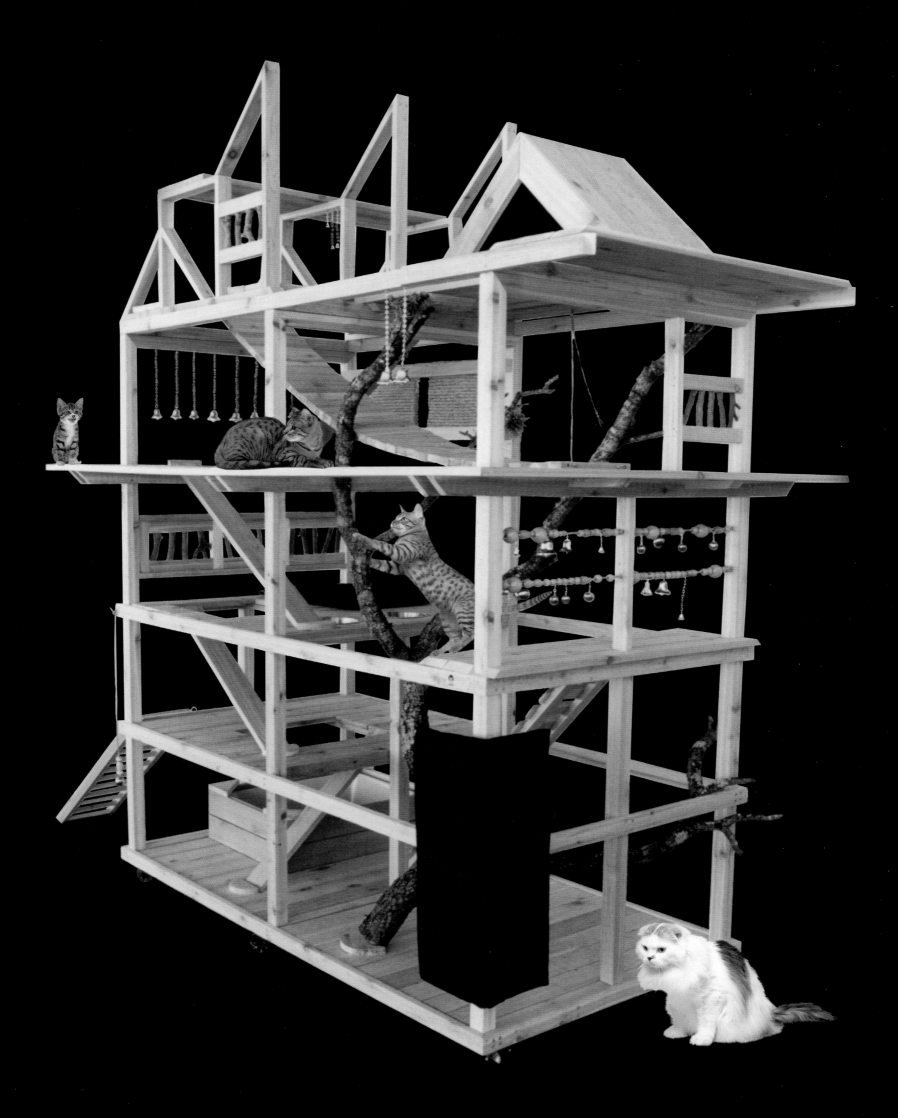

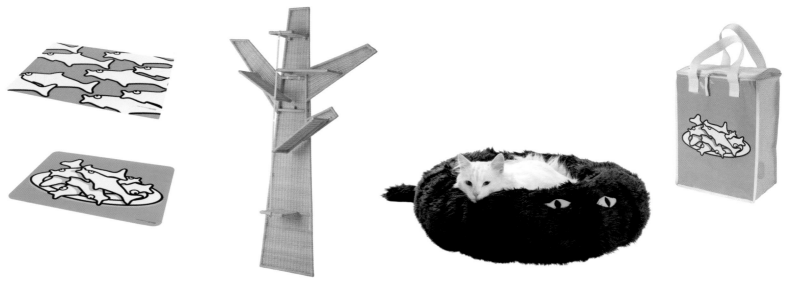

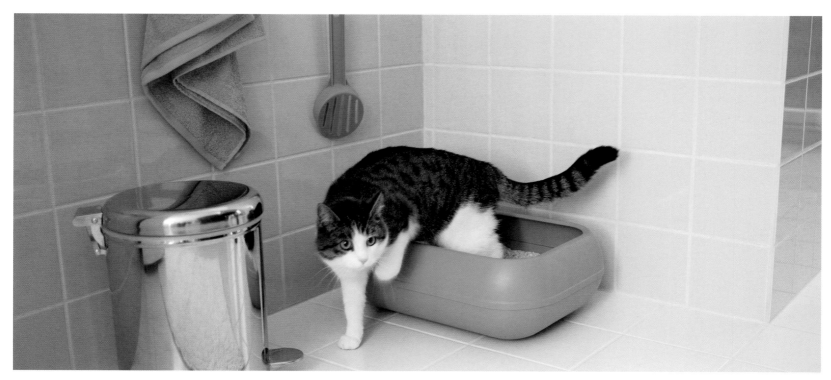

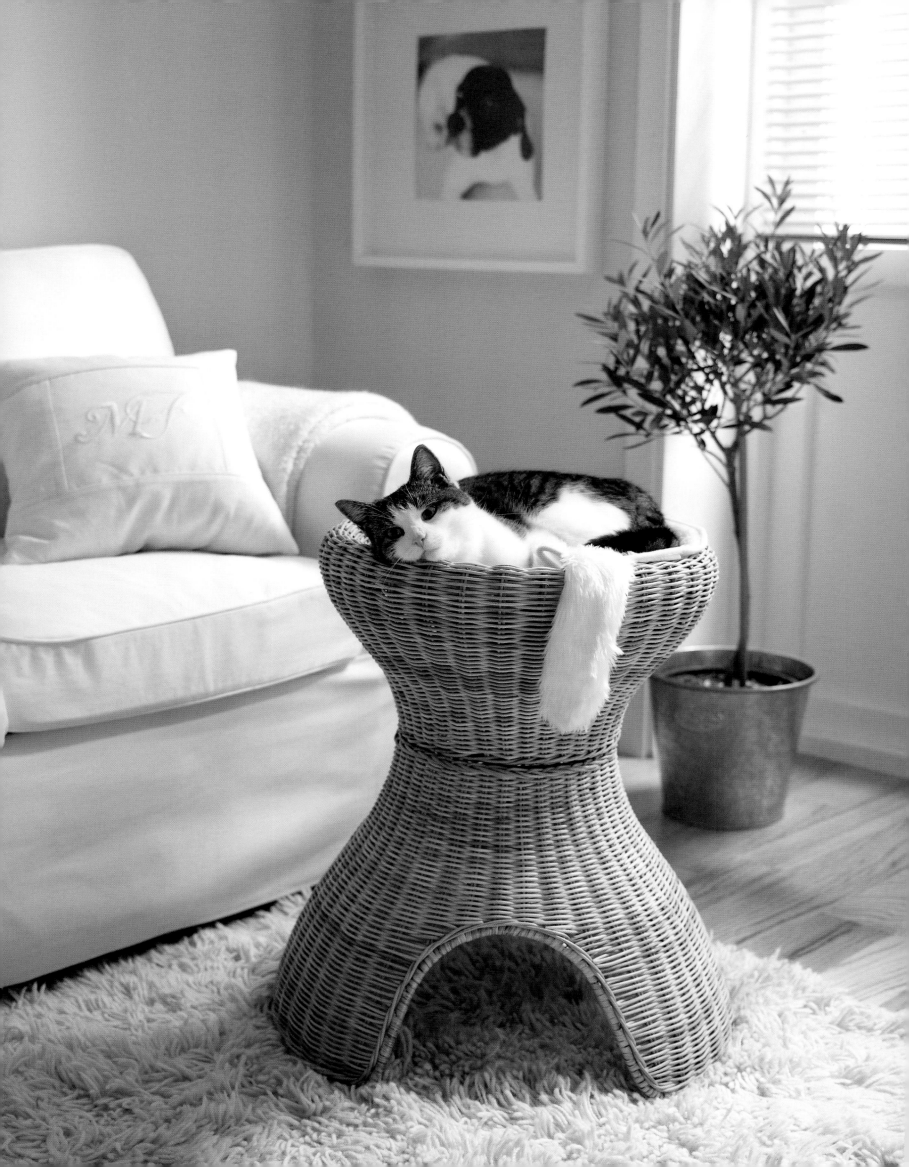

Gone are the days when litter trays were considered an eyesore. Creative companies such as Kattbank offer a contemporary solution to challenging space sharing issues for the felines and their owners, like this beautiful modern bench that serves as a hidden litter box.

Die Tage, als Katzentoiletten der Schandfleck eines Heimes waren, sind zum Glück längst vorbei. Kreative Firmen wie Kattbank bieten eine zeitgemäße Lösung für die Wohngemeinschaft zwischen Mensch und Tier. Ein Beispiel dafür ist diese wunderschöne, moderne Bank, die als Versteck für die Katzentoilette dient.

L'époque où les bacs à litières étaient une horreur est révolue. Des compagnies créatives comme Kattbank proposent des solutions modernes aux problèmes du partage d'espace entre chats et maîtres, comme ce beau banc contemporain qui cache un bac à litière.

Ya quedó atrás la época que las cajitas para las necesidades eran consideradas un estorbo visual. Firmas creativas como Kattbank ofrecen una solución contemporánea a delicadas cuestiones de espacio para compartir entre los felinos y sus amos, como esta linda banqueta moderna, que desempeña la función de cajita oculta.

Sono finiti i tempi delle cassette per gatti considerate come un "pugno in un occhio". Aziende creative come Kattbank offrono una soluzione contemporanea alle impegnative questioni della condivisione dello spazio tra i felini e i loro padroni, come questa splendida panca moderna che funge da cassetta nascosta.

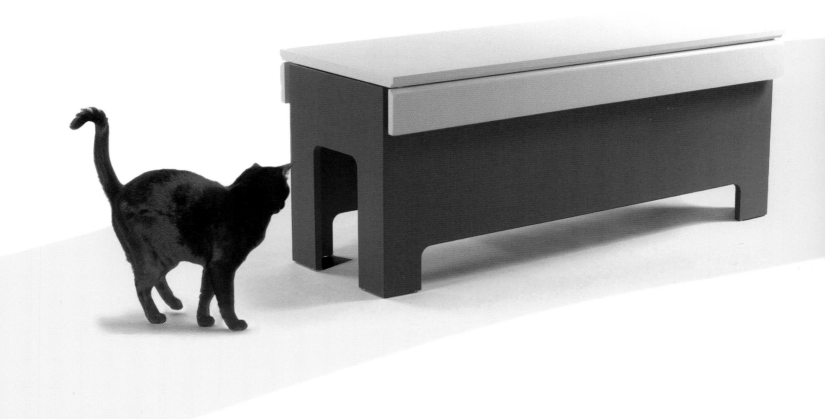

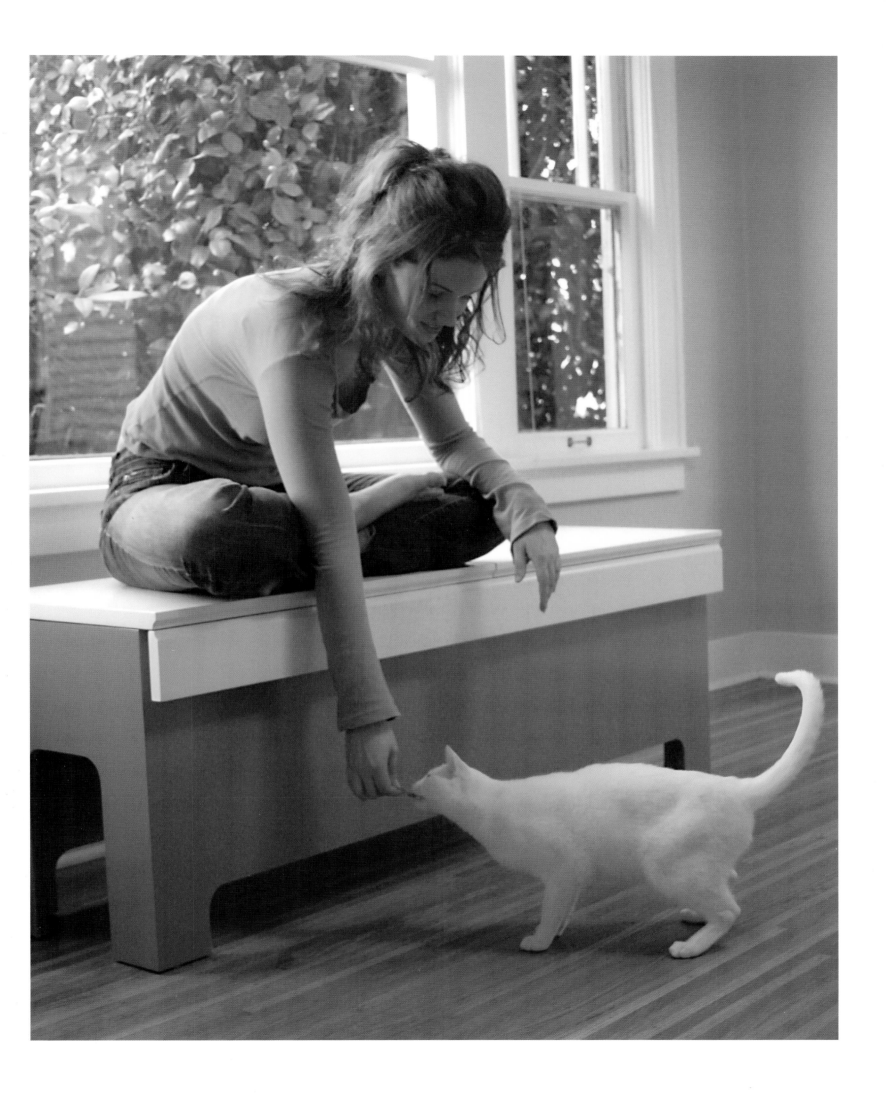

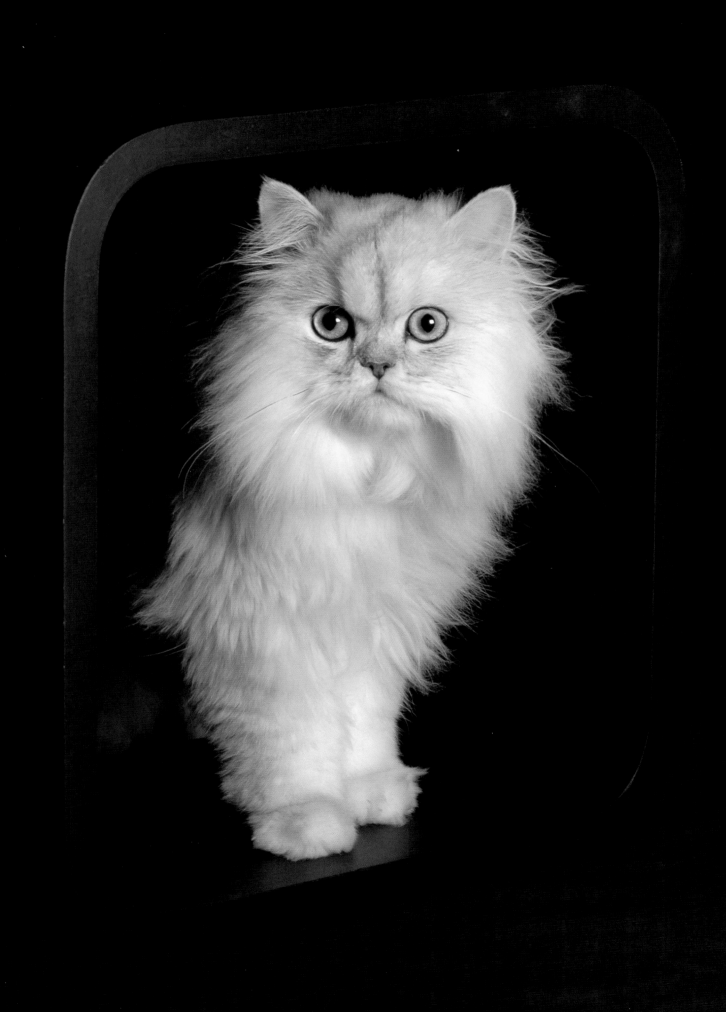

Design

"The phrase 'domestic cat' is an oxymoron."
George Will

The current trend on aesthetic value has prompted many top name designers and style-conscious architects to create ultramodern pet design.

Der aktuelle Trend der ästhetischen Wertigkeit hat viele namhafte Topdesigner und stilbewusste Architekten dazu angeregt, ultramodernes Tierdesign zu kreieren.

La tendance actuelle en matière d'esthétique a conduit de nombreux grands designers et architectes soucieux d'élégance à créer du design ultramoderne pour animaux.

Las tendencias corrientes del valor estético han impulsado a muchos renombrados diseñadores y arquitectos atentos al estilo a crear un diseño ultramoderno para animales.

La tendenza attuale alla valorizzazione estetica ha stimolato molti designer di nome e architetti stilisticamente consapevoli a creare un design ultramoderno per animali domestici.

Design

Once upon a time, there was at least one eyesore in every cat lovers home, but tolerated for sake of the little furry family member. Sometimes the free-standing cat scratching poles and smaller climbing trees could be tucked into closets and backrooms out of sight of discriminating guests. But larger structures, such as wooden cat towers made with bare plywood stapled with left-over carpet, were shoved to the corner of the room when visitors arrived.

As the population ages and more people move into smaller spaces, these larger structures interfered with the limited living space and overpowered the interior design concept of smaller homes and apartments so much that people began to forgot buying them. But city dwellers realized all too quickly there was a biological need for their felines to play, lounge, and sink their claws into something other than your expensive sofa. So a need was born for unique cat furnishings that looked stylish but also could integrate into a home environment without destroying it. Hence, the new niche of designer cat furniture and objects evolved.

Today a group of passionate cat-loving designers have took on the challenging task to create stylish cat products which serve two important needs; one is to create objects of desire that could be proudly displayed in any area of the home, and most importantly, to entertain and divert attention away from your household furniture.

Many architects and interior designers are riding this new wave of putting an animal kingdom spin on luxury items for the human world, such as sleeping cocoons and wall sculptures. The design and style of these special trees, wood houses, and unique structures looks and feels like high quality home furnishings but with special features for your feline friend.

Here we focus on the style-conscious consumer who prefers to invest in haute couture furnishings and see the cat as a beautiful home accessory. This luxury-minded cat lover wants to find ways to incorporate the fashionable cat into the home interior and setting. From luxurious slumber nooks to spacious multi-leveled cat trees and kitty condos to cuddly-soft beds for a precious sanctuary, some of the following furnishings and objects can even be described as conversation pieces.

Let's face it: cats are the most sophisticated and elegant of all domesticated animals. Because of their natural affinity for refined living, cats have been labeled as the ultimate connoisseurs of comfort. As comfort is the main key ingredient for ultimate luxury, one could deduce that the cat is the quintessential luxury enthusiast. This next chapter concentrates on the future of design for the most demanding cat and owner: objects of art that are both comfortable and entirely luxurious.

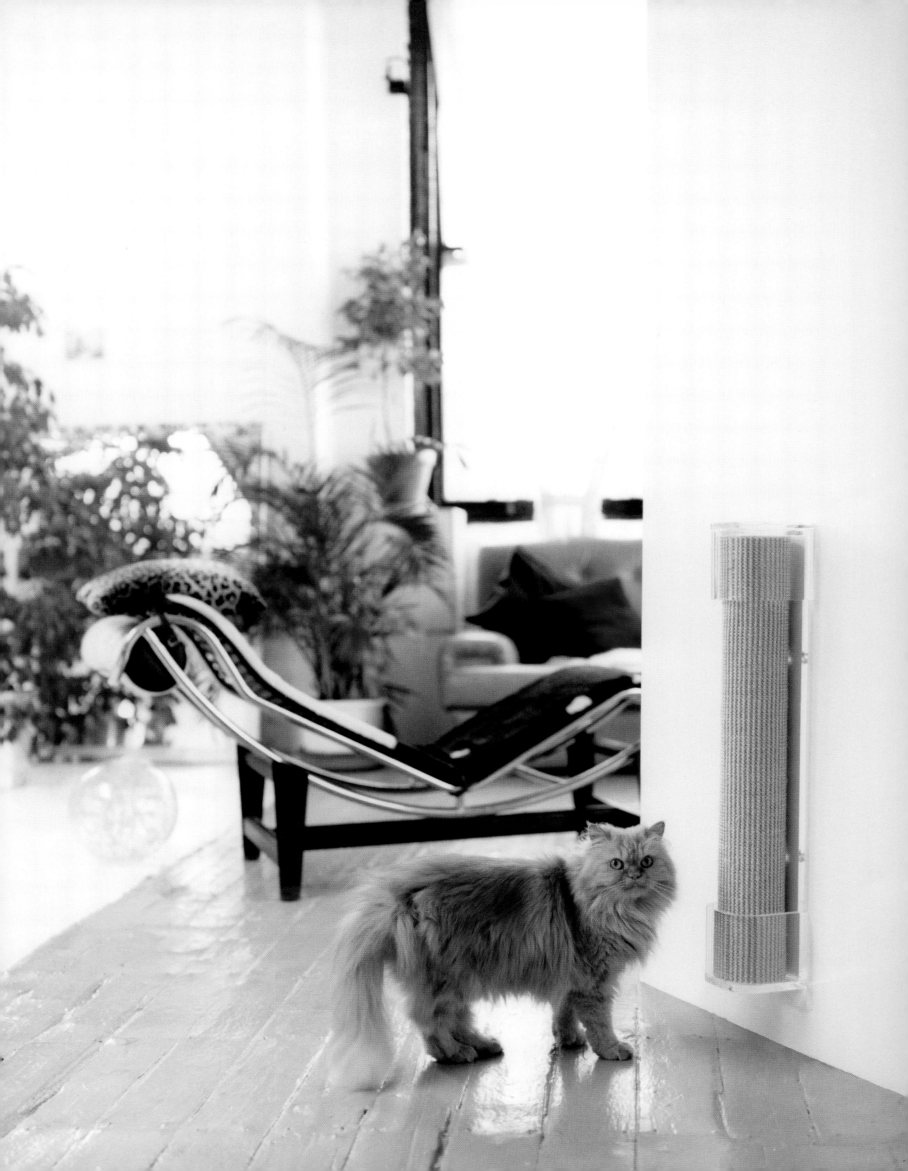

Design

Früher gab es mindestens einen Schandfleck im Heim eines jeden Katzenliebhabers, der jedoch zum Wohle des kleinen pelzigen Familienmitgliedes gerne toleriert wurde. Manchmal konnten die freistehenden Kratzbäume und kleineren Kletterbäume in Schränken und Abstellräumen außerhalb der Sichtweite des kritischen Blickes der Gäste verstaut werden. Größere Konstruktionen, wie zum Beispiel aus einfachem Sperrholz gefertigte und mit Teppichresten verkleidete Kratztürme, mussten derweil in eine Ecke des Raumes geschoben werden, wenn Besuch kam.

Da die Bevölkerung immer älter wird und immer mehr Menschen in kleinere Wohnräume ziehen, beeinträchtigten solche größeren Objekte die ohnehin eingeschränkten Lebensräume und überfrachteten das Innenausstattungskonzept kleinerer Häuser und Wohnungen derart, dass die Menschen sie schließlich nicht mehr kaufen wollten. Die Stadtbewohner bemerkten allerdings sehr schnell, dass ihre Katzen das biologische Bedürfnis haben zu spielen, zu faulenzen und ihre Krallen in etwas anderes als das teure Sofa zu schlagen. So wurde der Bedarf an einzigartigen Einrichtungsgegenständen für Katzen geweckt, die stylisch aussehen und in die heimische Umgebung integriert werden können, ohne störend zu wirken. Somit entstand eine neue Marktnische für Designermöbel und -objekte für Katzen.

Heute hat eine Gruppe passionierter katzenliebender Designer die Herausforderung angenommen, stylische Katzenprodukte zu kreieren, die zwei wichtige Bedürfnisse berücksichtigen: Zum einen Objekte der Begierde zu kreieren, die stolz in jedem Bereich des Heimes präsentiert werden können und, was noch wichtiger ist, die zum anderen zur Unterhaltung dienen und die Aufmerksamkeit des Vierbeiners vom übrigen Mobiliar des Haushaltes ablenken.

Viele Architekten und Innenarchitekten reiten auf dieser neuen Welle, indem sie ein tierisches Königreich mit Luxusartikeln aus der menschlichen Welt ausstatten, wie zum Beispiel Schlafkokons und Wandskulpturen. Das Design und die Ausführung dieser speziellen Kratzbäume, Holzhäuser und einzigartigen Konstruktionen gleichen Einrichtungsstücken von Topqualität, jedoch sind sie zusätzlich mit speziellen Eigenschaften für Ihren pelzigen Freund ausgestattet.

Hier fokussieren wir den stilbewussten Verbraucher, der gerne in Haut-Couture-Möbel investiert und die Katze als hübsches Heimaccessoire betrachtet. Dieser luxusorientierte Katzenliebhaber möchte Wege finden, um die modische Katze in sein Interieur zu integrieren. Von luxuriösen Schlummerecken über geräumige Kratzbäume mit mehreren Ebenen und Wohnanlagen für Stubentiger, bis hin zu kuschelig weichen Betten für einen heißgeliebten Zufluchtsort. Einige der folgenden Einrichtungsgegenstände und Objekte könnte man sogar als würdige Konversationsthemen bezeichnen.

Lassen Sie es uns auf den Punkt bringen: Katzen sind die anspruchsvollsten und elegantesten Geschöpfe unter den Haustieren. Aufgrund ihrer natürlichen Affinität zum Leben im Luxus werden Katzen zum ultimativen Komfortconnaisseur abgestempelt. Da Komfort der Hauptschlüssel für den ultimativen Luxus ist, könnte man daraus folgern, dass die Katze der absolute Luxusfreak ist. Das nächste Kapitel fokussiert das Design der Zukunft für die anspruchsvollsten Katzen und ihre Besitzer: Kunstobjekte, die sowohl komfortabel als auch durch und durch luxuriös sind.

Design

Jadis, il y avait au moins une horreur dans chaque foyer d'amoureux des chats, mais qui était tolérée pour le bien de ce petit membre de la famille. Parfois les griffoirs indépendants et les plus petits arbres de grimpe pouvaient être cachés dans les placards et les arrière-salles, hors de vue des invités au goût délicat. Mais les plus grandes structures, comme les tours pour chats en contreplaqué tapissées de restes de moquettes, étaient simplement poussées dans un coin de la pièce à l'arrivée des visiteurs.

Alors que la population vieillit et que plus de gens vivent dans des espaces plus petits, ces grandes structures interfèrent avec l'espace de vie et prennent tellement de place dans maisons et appartements de petite taille que les gens ont commencé à renoncer à les acheter. Mais les citadins se sont rapidement rendu compte que leurs félins avaient un besoin biologique de jouer, de s'allonger et de faire leurs griffes sur autre chose que leur canapé cuir. De là est né le besoin de meubles uniques pour chats à la fois élégants et pouvant s'intégrer dans un cadre sans le détruire. Et cette nouvelle niche des objets et meubles de designer pour chats a ainsi évolué.

Aujourd'hui un groupe de designers passionnés et amoureux des chats a relevé le défi de créer des produits pour chats élégants qui répondent à deux besoins importants : premièrement, de créer de beaux objets pouvant être fièrement exposés dans n'importe quelle pièce, et deuxièmement, plus important, de divertir les chats tout en les détournant de vos propres meubles.

De nombreux architectes et architectes d'intérieur surfent sur cette nouvelle vague qui consiste à bâtir un royaume animal sur de luxueux articles pour le monde des humains, comme des cocons de couchage et des sculptures murales. Le design et le style de ces arbres, de ces maisons de bois et de ces structures unique ressemblent à ceux des meubles de qualité, mais avec des caractéristiques spécifiques pour votre ami félin.

Nous nous intéressons ici au consommateur esthète qui préfère investir dans des meubles haute-couture et voit le chat comme un bel objet déco. Cet amateur de luxe et de chats veut trouver des moyens d'intégrer l'animal tendance à son intérieur et son décor. Des coins sommeil luxueux aux arbres spacieux à plusieurs étages, et des copropriétés pour chats aux paniers câlins vus comme de précieux sanctuaires, certains des objets et meubles suivants pourront même devenir des sujets de conversation.

Rendons-nous à l'évidence : les chats sont les plus sophistiqués et élégants des animaux domestiques. Leur affinité naturelle pour la vie raffinée étiquette les chats comme les plus grands experts du confort. Et comme le confort est l'ingrédient essentiel du luxe, on pourrait en déduire que le chat est l'amateur de luxe quintessentiel. Le chapitre suivant se concentre sur l'avenir du design pour les maîtres les plus exigeants : des objets d'art à la fois confortables et totalement luxueux.

Diseño

Hace tiempo, en las casas donde habitaban gatos había al menos un artículo verdaderamente feo y tolerado por el bien del pequeño miembro de la familia. A veces era posible meter rascadores o pequeños árboles en armarios y trasteros, lejos de la mirada crítica de los invitados. Sin embargo, estructuras más amplias como torres de madera para escalar forradas con restos de moqueta se empujaban a los rincones de la casa a la llegada de los invitados.

Conforme va envejeciendo la población y son más las personas que viven en espacios reducidos, estas estructuras interfieren con el limitado espacio vital y dominan el diseño de interiores en casas pequeñas y apartamentos, así que muchos tienen que renunciar a ellas. Sin embargo, quienes viven en las ciudades se percatan de inmediato de que un gato tiene la necesidad biológica de jugar, descansar, y clavar las uñas en algo que no sea un costoso sofá. Así nació la demanda de muebles especiales con estilo, integrables en el ambiente doméstico sin destruirlo. Así evolucionó la nueva ola de muebles y objetos de diseño para gatos.

En la actualidad, un grupo de diseñadores apasionados y amantes de los gatos ha aceptado el desafío de crear productos elegantes que cubran dos importantes necesidades: crear objetos que despierten el deseo y que se puedan exhibir con orgullo en cualquier área de la casa y, más importante aún, entretener y desviar la atención de los otros muebles.

Muchos arquitectos y diseñadores de interiores se han apuntado a esta moda, introduciendo una pizca de reino animal en artículos de lujo para humanos, como cápsulas para dormir y esculturas murales. El diseño y el estilo de estos árboles especiales, casitas de madera y estructuras únicas se parece al de los muebles de alta calidad, pero con características especiales para nuestro amigo felino.

Aquí nos concentramos en los consumidores atentos al estilo y al lujo, que prefieren invertir en artículos de alta costura y ver al gato como un precioso accesorio doméstico, buscando formas de incorporarlo en la disposición de los ambientes. Desde lujosos rincones para la siesta hasta espaciosos árboles y casas de niveles múltiples, pasando por preciosos santuarios de camas mullidas y acogedoras, algunos de los objetos y muebles que se presentan a continuación pueden convertirse perfectamente en temas de conversación.

Hay que reconocer que el gato es el animal más sofisticado y elegante entre los animales domésticos. Por su tendencia natural a la vida refinada, los gatos se consideran los máximos aficionados al confort y, siendo el confort el ingrediente clave del auténtico lujo, podríamos deducir que el gato es el entusiasta del lujo por antonomasia. El capítulo siguiente se concentra en el futuro del diseño para los gatos y los amos más exigentes: obras de arte, confortables y lujosas a la vez.

Design

Una volta, nella casa di ogni amante dei gatti c'era almeno un "pugno in un occhio", tollerato nell'interesse del piccolo membro della famiglia con il suo manto vellutato. A volte era possibile infilare i tiragraffi verticali e gli alberi più piccoli per arrampicarsi in stanzini e ripostigli lontani dalla vista di ospiti attenti. Ma le strutture più ampie, come le torri di legno compensato, foderate con avanzi di moquette, venivano spinte in un angolo della stanza all'arrivo di visitatori.

Visto che la popolazione invecchia e molti si trasferiscono in ambienti più piccoli, le grosse strutture interferivano con lo spazio vitale limitato e predominavano sul concetto di design d'interni in piccole case e appartamenti, tanto che a volte i proprietari erano costretti a rinunciare all'acquisto. Tuttavia, chi viveva in città imparò ben presto che per i loro felini esiste una necessità biologica di giocare, oziare e piantare le unghie in qualcosa di diverso dal vostro costoso divano. Nacque così la necessità di arredi esclusivamente per gatti dall'aspetto elegante, che potessero integrarsi nell'ambiente casalingo senza distruggerlo. Da questo si è sviluppata la nuova nicchia degli oggetti e articoli d'arredamento per gatti.

Oggi un gruppo di designer, appassionati amanti dei gatti, ha accettato la sfida di creare eleganti prodotti per gatti che soddisfino due bisogni importanti: uno consiste nel creare oggetti del desiderio che si possano esibire con orgoglio in ogni area della casa, e l'altro, più importante, nell'intrattenere e distogliere l'attenzione dal resto dell' arredamento della casa.

Diversi architetti e designer stanno cavalcando quest'onda nuova, inserendo un tocco di regno animale in articoli di lusso per gli umani, come bozzoli per dormire e sculture a parete. Il disegno e lo stile di questi alberi speciali, casette di legno e sculture uniche hanno l'aspetto e trasmettono la sensazione di un arredamento d'alta qualità, ma con caratteristiche speciali per i vostri amici felini.

Qui ci concentriamo sui consumatori consapevoli dello stile, che preferiscono investire in arredi d'alta moda e vedere il gatto come un bell'accessorio per la casa. Questo amante dei gatti orientato al lusso desidera trovare il modo di incorporare il gatto alla moda negli interni e nella struttura della casa. Da lussuosi angoli per il pisolino a spaziosi alberi a più livelli e condomini per gattini, fino a preziosi santuari in forma di soffici letti in cui cullarsi, alcuni degli arredi e degli oggetti che seguono possono essere persino descritti come oggetti sui quali si può discutere.

Guardiamo in faccia la realtà: il gatto è il più sofisticato ed elegante degli animali domestici. Grazie alla loro affinità naturale con il vivere raffinato, i gatti sono stati etichettati come i massimi conoscitori e amanti del comfort. Poiché il comfort è l'ingrediente chiave del lusso perfetto, si potrebbe dedurre che il gatto è la quintessenza dell'entusiasta del lusso. Questo capitolo che segue si concentra sul futuro del design per i gatti e i proprietari più esigenti: oggetti d'arte che sono confortevoli e assolutamente lussuosi al tempo stesso.

Not only do these chic cat products—such as the scratch lounger by Elizabeth Paige Smith—stop your feline from tearing up your furniture, but helps them sharpen their claws in style.

Diese schicken Objekte für Katzen – wie der Kratzbaum zum Relaxen von Elizabeth Paige Smith – halten Ihre Katze nicht nur davon ab, Ihre Möbel zu bearbeiten, sondern unterstützen diese auch dabei, ihre Krallen stilvoll in Form zu schärfen.

Non seulement ces produits chics pour chats – comme cette chaise longue griffoir d'Elizabeth Paige Smith – empêchent votre félin d'abîmer vos meubles, mais ils les aident aussi à faire leurs griffes avec style.

Estos productos elegantes para gatos, como el "rincón del rascado" de Elizabeth Paige Smith, impiden al felino destrozar nuestros muebles, ayudándolo a afilar sus uñas con mucha clase.

Questi prodotti chic per gatti, come il tiragraffi versione relax di Elizabeth Paige Smith, non solo distraggono i vostri felini dal distruggervi l'arredamento, ma li aiutano con stile ad affilarsi gli artigli.

The ingenious transformation of simple corrugated cardboard as a scratching post sculpture comes in the form of colorful building blocks from designer Susan Kralovec, or Warren Lieu's unique cat cocoon.

Die von Susan Kralovec stammende geniale Transformation eines simplen Wellkartons in eine Kratzskulptur zeigt sich in Form farbenprächtiger Bausteine. Alternativ dazu: Warren Lieus einzigartiger Katzenkokon aus Wellpappe.

Du simple carton ondulé se transforme ingénieusement en une sculpture griffoir qui prend la forme de blocs de construction colorés chez la designer Susan Kralovec, ou d'un exceptionnel cocon pour chat chez Warren Lieu.

La ingeniosa transformación de simple cartón ondulado en una escultura-palo para rascar se presenta en forma de bloques coloridos por la diseñadora Susan Kralovec, o de concha única, por Warren Lieu.

L'ingegnosa trasformazione di semplice cartone ondulato in una scultura-tiragraffi prende la forma di blocchi colorati grazie alla designer Susan Kralovec, o del bozzolo unico di Warren Lieu.

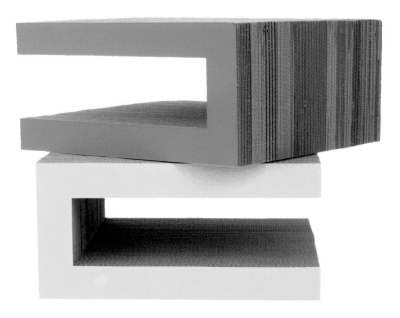

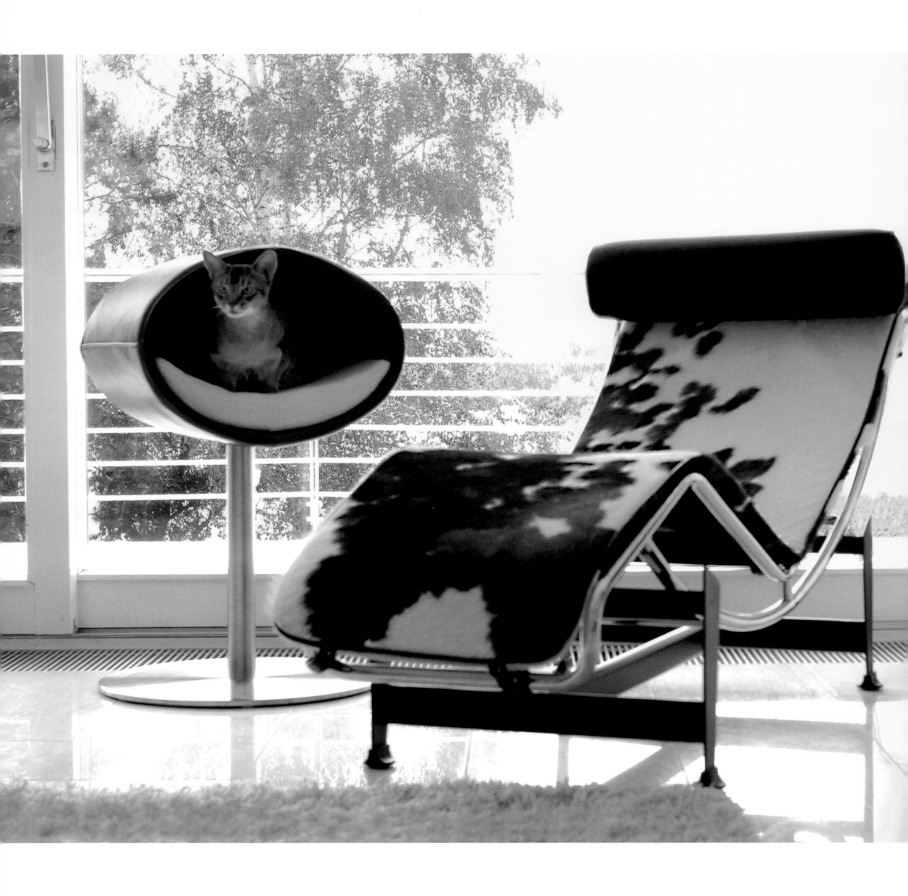

Even if you don't own cats, these ultra-fashionable furnishings from Cat Interiors could be used as stylish home accent pieces to fit any modern home. These unique pods either stand alone on metal poles or are attached to walls for cat climbing enjoyment, and are made from cool materials such as various colors of leather, embroidered felt, and natural wicker.

Selbst wenn Sie keine Katzen besitzen, können Sie mit diesen ultramodernen, zu jedem modernen Interieur passenden Möbeln von Cat Interiors stylische Akzente setzen. Diese einzigartigen Objekte befinden sich entweder freistehend auf Metallfüßen oder werden für die kletterbegeisterte Katze an der Wand befestigt. Coole Materialien stehen zur Auswahl. Es werden zum Beispiel verschiedene Lederfarbtöne, bestickter Filz oder Naturweide angeboten.

Même si vous n'avez pas de chat, ces meubles très tendance de chez Cat Interiors peuvent être utilisés comme de belles pièces pour la déco de toutes les maisons modernes. Ces pods uniques sont accrochés à des poteaux métalliques ou aux murs pour le plaisir de grimper des chats, et sont fabriqués en matériaux à la mode : cuirs de différents coloris, feutre brodé et osier naturel.

Aunque no tengamos gatos, estos muebles ultra modernos de Cat Interiors pueden servir como piezas para dar un toque de estilo a cualquier casa moderna. Estas cestas únicas se apoyan independientemente sobre palos metálicos o bien se adhieren a las paredes, para el gusto de las escaladas felinas, y están hechas en materiales modernos como cuero en varios colores, fieltro bordado y mimbre natural.

Anche se non possedete gatti, gli arredamenti di tendenza di Cat Interiors sono adatti a essere impiegati come oggetti di stile in ogni casa moderna. Queste particolarissime capsule si appoggiano su sostegni di metallo o si fissano alle pareti, per supplire al bisogno tutto felino dell'arrampicata. Sono costruiti in materiali di tendenza come cuoio in vari colori, feltro ricamato e vimini naturali.

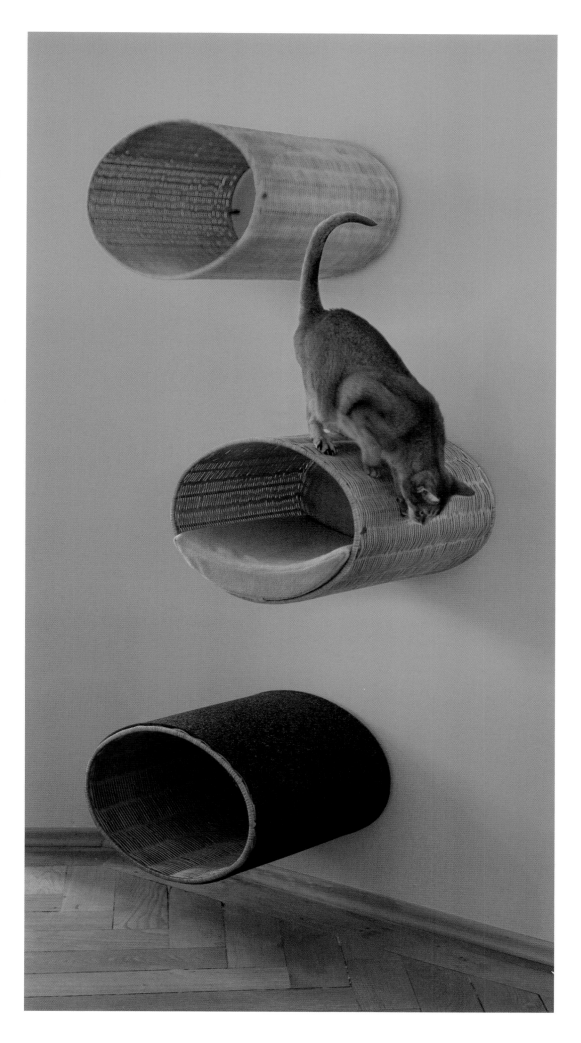

These favorite napping spots for cats are also notable design objects, such as this hand-blown glass kitty pod with a sheepskin lining that Kattbank sells for $2,400, or this sleek plywood bed by Vûrv Design that looks stylish enough for any modern space.

Diese beliebten Schlummerplätze für Katzen sind auch bemerkenswerte Design-objekte, wie dieses von Kattbank zu 2.400 Dollar angebotene mundgeblasene, mit Schaffell ausgekleidete Glasobjekt für die Katze, oder dieses Bett aus glattem Schicht-holz von Vûrv Design, das so stylisch ist, dass es in jeden modernen Raum passt.

Ces coins à sieste très appréciés sont aussi de remarquables objets de design, comme ce pod pour chat en verre soufflé à la main avec revêtement intérieur en peau de mouton vendu 2400 de dolars chez Kattbank, ou cet élégant panier en contreplaqué de Vûrv Design, assez chic pour s'accorder à tout espace moderne.

Estas áreas favoritas de siesta para gatos también son notables objetos de diseño, como esta cáscara soplada artesanalmente y forrada con piel de oveja, presentada por Kattbank por 2.400 dólares, o la lustrosa camita en madera laminada de Vûrv Design, con su estilo apto para cualquier espacio moderno.

Questi "punti preferenziali" per il pisolino costituiscono anche notevoli oggetti di design, come il guscio per gatti soffiato artigianalmente e foderato in vello di pecora, in vendita da Kattbank per 2.400 dollari, o il lucente lettino in compensato di Vûrv Design, elegante per qualsiasi spazio moderno.

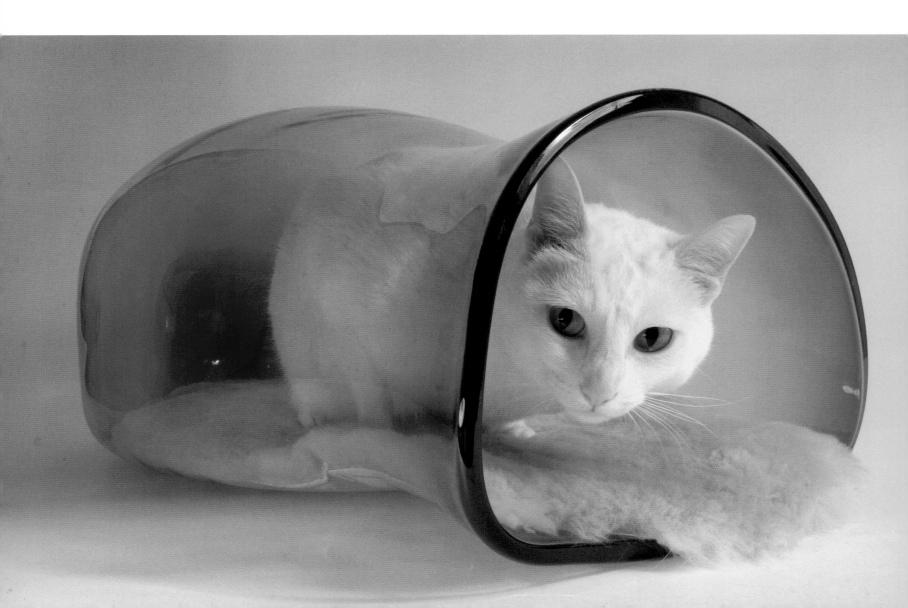

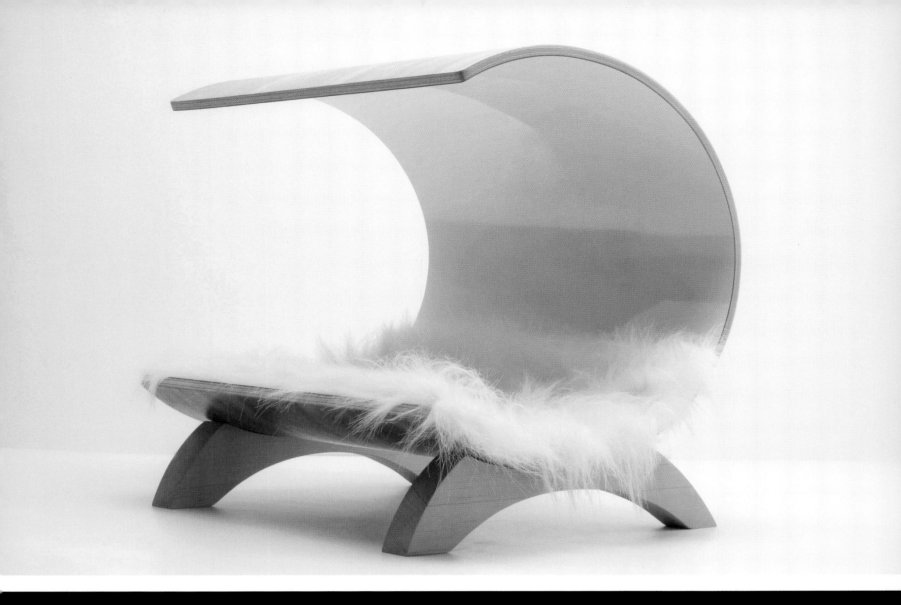

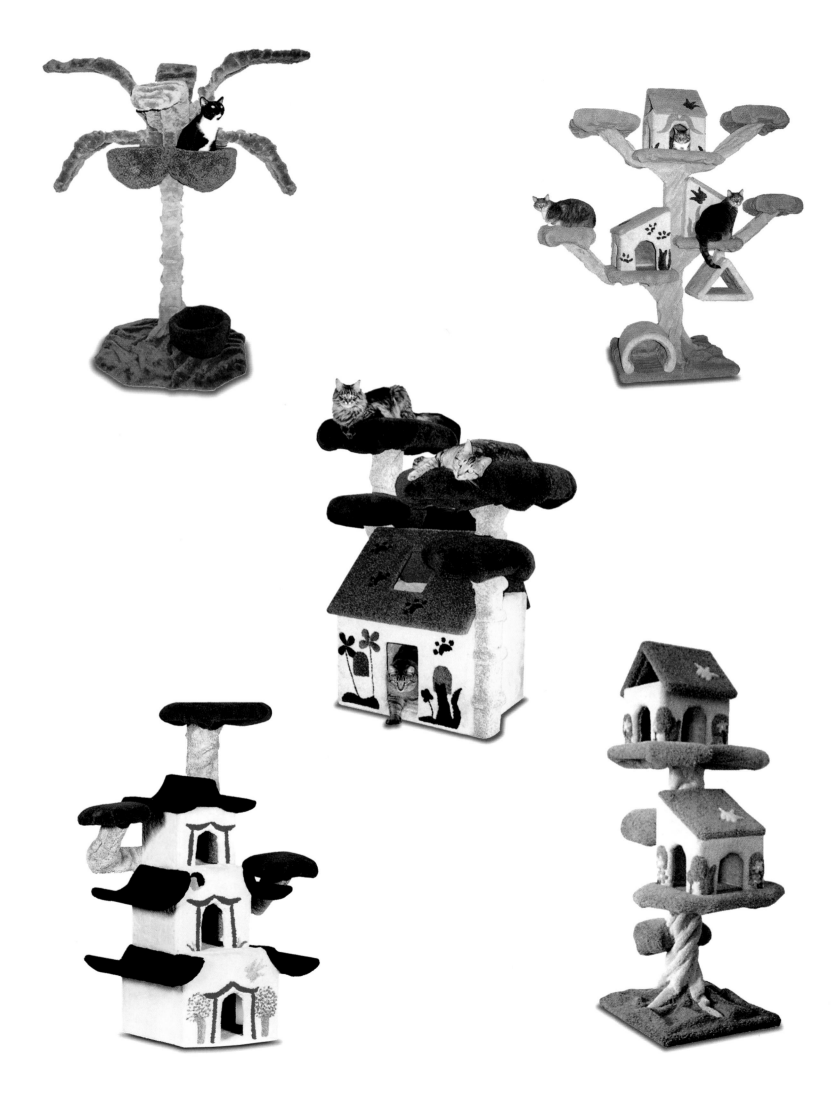

There's nothing to hide when it comes to these out-right amusing sculptured cat trees with unique decorative motifs from Angelical Cat Company that is custom built for any special request.

Diese maßgefertigten witzigen Kratzbäume mit den einzigartigen dekorativen Motiven von Angelical Cat Company müssen nicht länger versteckt werden. Jeder Sonderwunsch wird berücksichtigt.

On ne cachera pas dans un endroit discret ces arbres à chat sculptés très amusants avec leurs motifs décoratifs étonnants, de chez Angelical Cat Company, construits sur mesure pour toute demande spécifique.

Sin nada que ocultar, estos árboles de la Angelical Cat Company están esculpidos de forma claramente divertida con motivos de decoración únicos, y personalizados para cualquier exigencia especial.

Non c'è nulla da nascondere quando si tratta di questi alberi tiragraffi dalle forme divertenti, con decorazioni esclusive di Angelical Cat Company, costruiti su misura per ogni richiesta speciale.

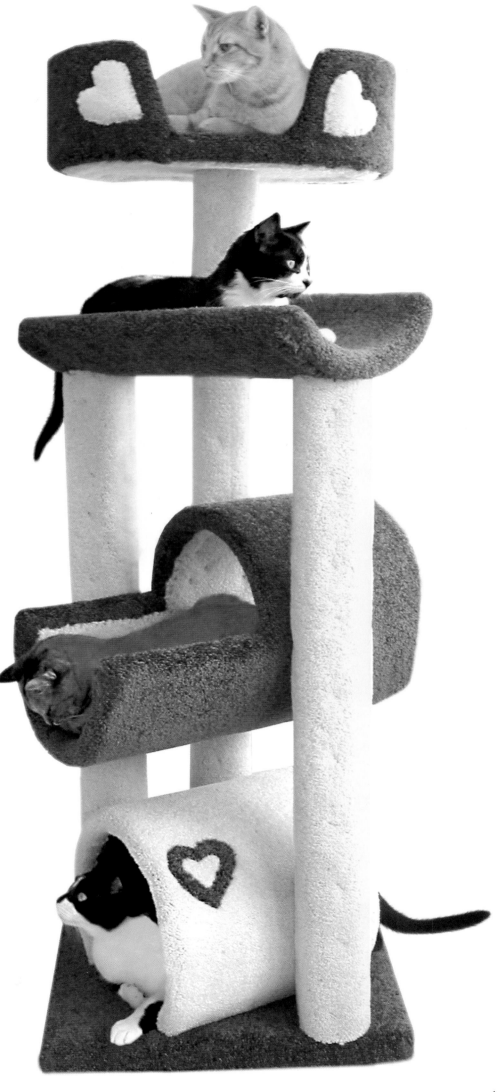

With more people working from home and living away from their families, cats are playing a bigger role in helping soothe the isolation of the modern life and becoming more like children. New cat furnishings resemble children's playgrounds, such as these extravagant structures from the German company InTIERiors.

Da immer mehr Menschen zu Hause arbeiten und dabei zugleich von ihren Familien entfernt leben, spielen Katzen eine zunehmend größere Rolle, wenn es darum geht, die Isolation des modernen Lebens abzuschwächen. Deshalb avancieren Katzen immer mehr zum Kindersatz. Neue Katzenmöbel erinnern an Kinderspielplätze, wie zum Beispiel diese extravaganten Konstruktionen der deutschen Firma InTIERiors.

Avec le nombre accru de personnes travaillant à domicile ou vivant loin de leur famille, les chats jouent un rôle important pour rompre l'isolation de la vie moderne, et sont même parfois presque considérés comme des enfants. De nouveaux meubles pour chats ressemblent à des aires de jeu pour enfants, comme ces structures extravagantes de la compagnie allemande InTIERiors.

En esta época en la que muchos trabajan desde casa y viven lejos de sus familias, los gatos juegan un papel más importante en aminorar el aislamiento de la vida moderna, convirtiéndose casi en niños. Las nuevas decoraciones para gatos recuerdan parques de juego infantiles, como estas extravagantes estructuras de la casa alemana InTIERiors.

Con sempre più persone che lavorano a casa e vivono lontano dalle loro famiglie, i gatti giocano un ruolo maggiore nell'aiutare ad alleviare l'isolamento della vita moderna e svolgere quasi il ruolo di bambini. I nuovi arredamenti per gatti ricordano i parchi giochi per bambini, come queste stravaganti strutture della casa tedesca InTIERiors.

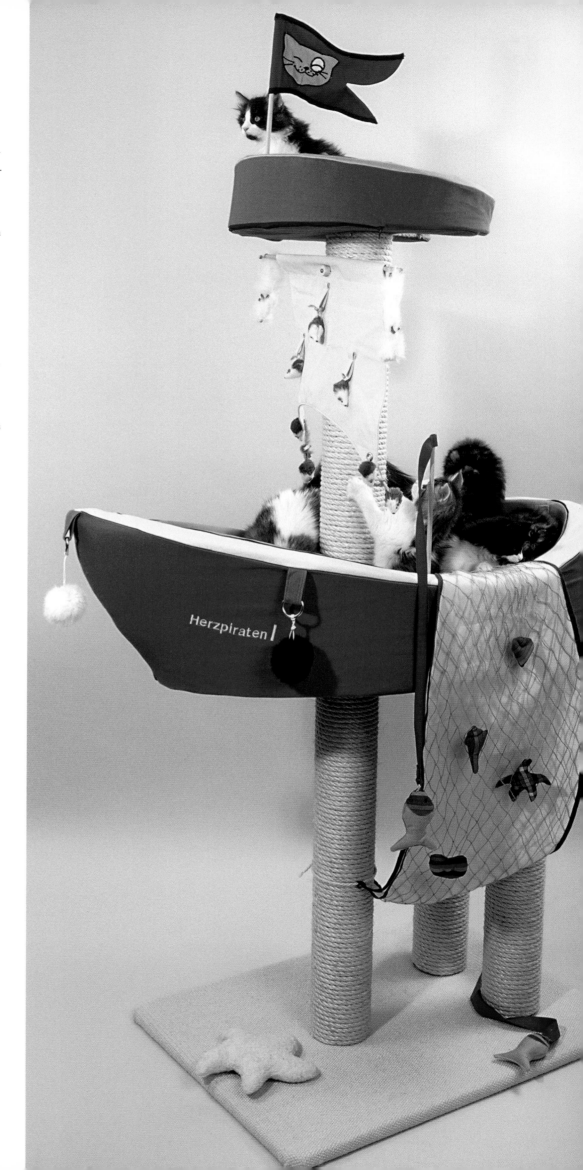

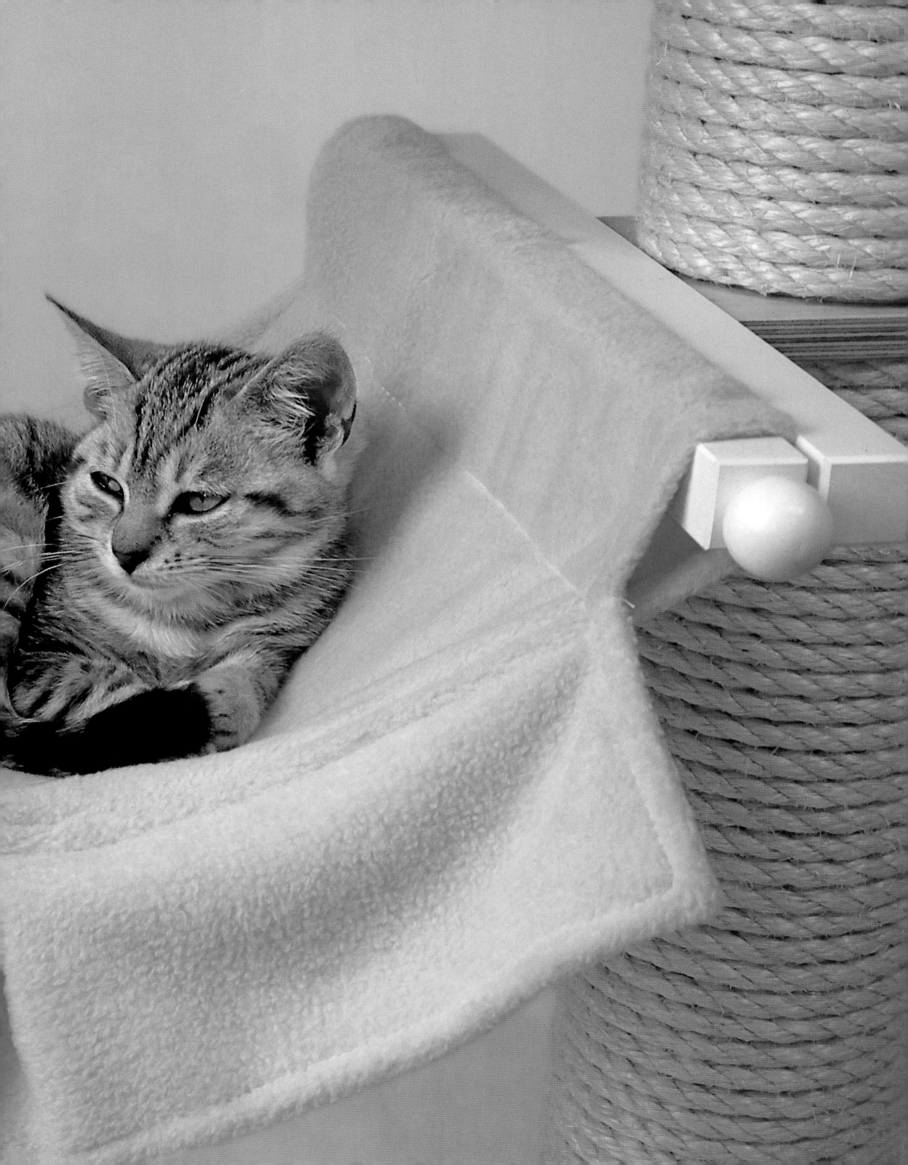

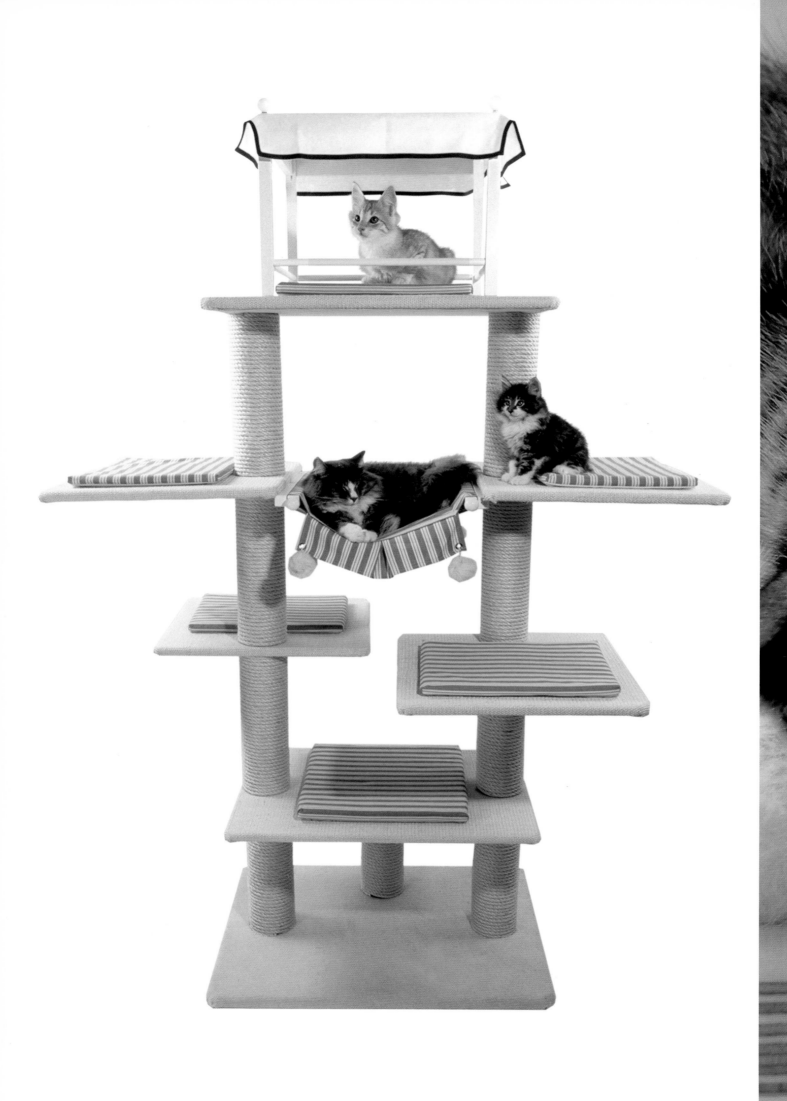

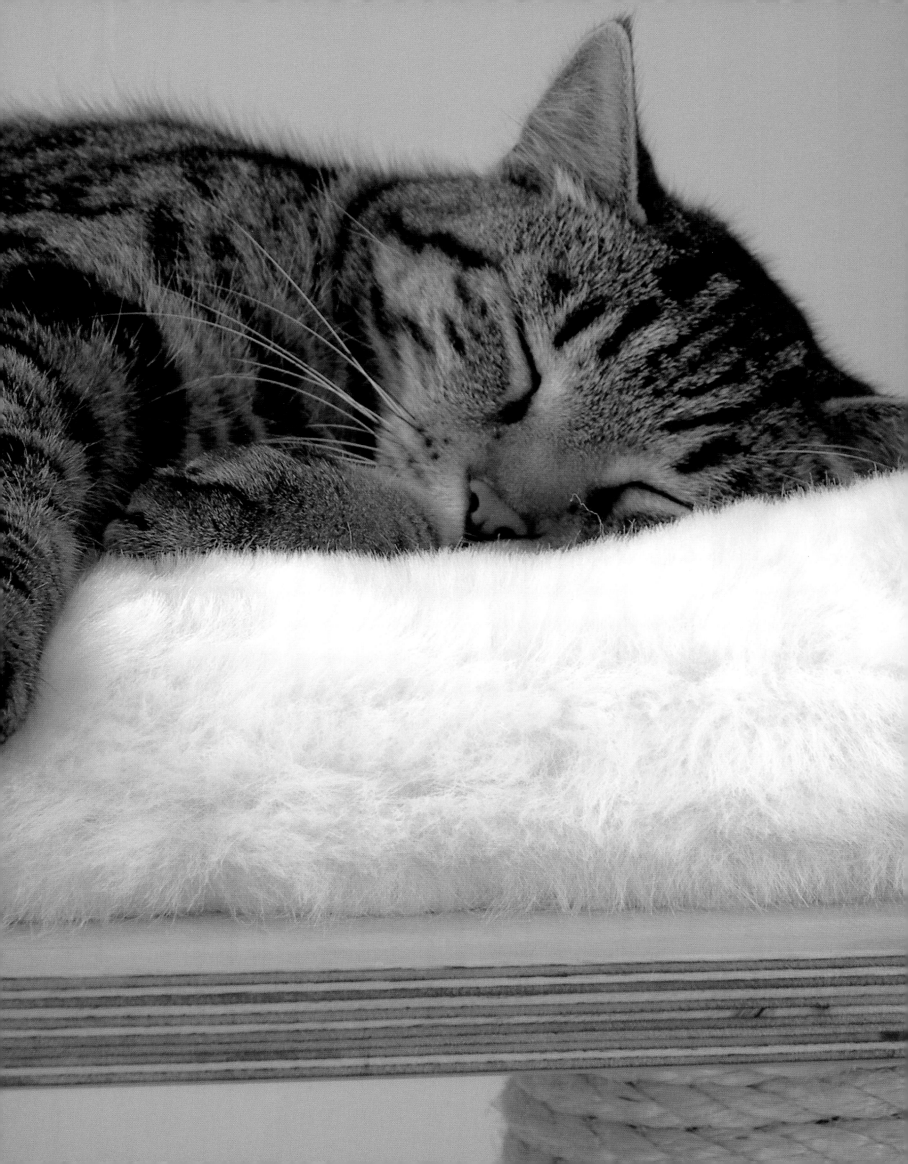

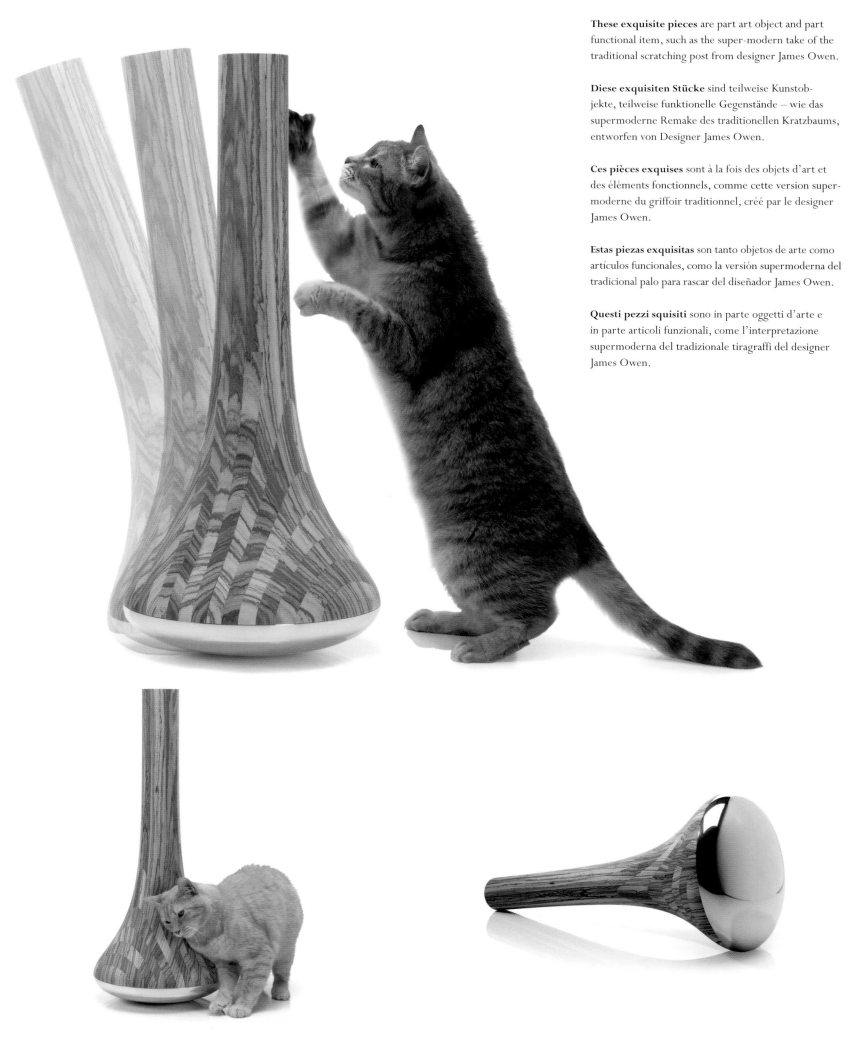

These exquisite pieces are part art object and part functional item, such as the super-modern take of the traditional scratching post from designer James Owen.

Diese exquisiten Stücke sind teilweise Kunstobjekte, teilweise funktionelle Gegenstände – wie das supermoderne Remake des traditionellen Kratzbaums, entworfen von Designer James Owen.

Ces pièces exquises sont à la fois des objets d'art et des éléments fonctionnels, comme cette version super-moderne du griffoir traditionnel, créé par le designer James Owen.

Estas piezas exquisitas son tanto objetos de arte como artículos funcionales, como la versión supermoderna del tradicional palo para rascar del diseñador James Owen.

Questi pezzi squisiti sono in parte oggetti d'arte e in parte articoli funzionali, come l'interpretazione supermoderna del tradizionale tiragraffi del designer James Owen.

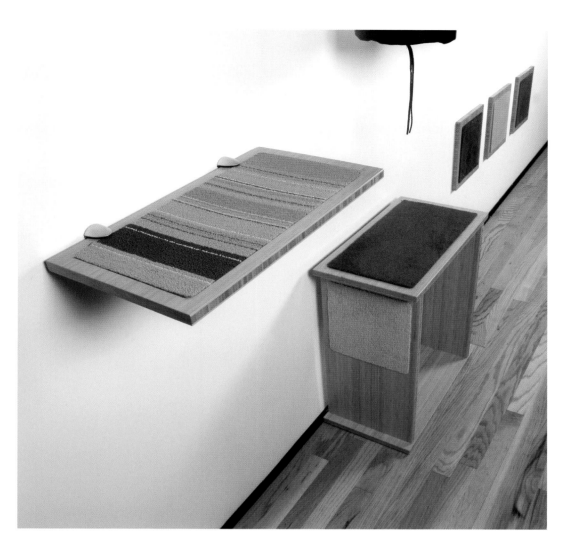

Square Cat Habitat has updated the scratching post with a modern, sustainable alternative that provides a useful place to scratch and lounge around.

Square Cat Habitat hat den Kratzbaum durch eine moderne, umweltfreundliche Alternative neu erfunden, welche sinnvollen Platz zum Kratzen und Relaxen bietet.

Square Cat Habitat a remis le griffoir au goût du jour avec une alternative moderne, durable, qui offre des espaces pour faire ses griffes et se délasser.

Square Cat Habitat ha puesto al día el palo para rascar con una alternativa moderna y sostenible, que facilita un espacio útil para rascar y holgazanear.

Square Cat Habitat ha aggiornato il tiragraffi con un'alternativa moderna e sostenibile che fornisce uno spazio utile per affilarsi le unghie e oziare.

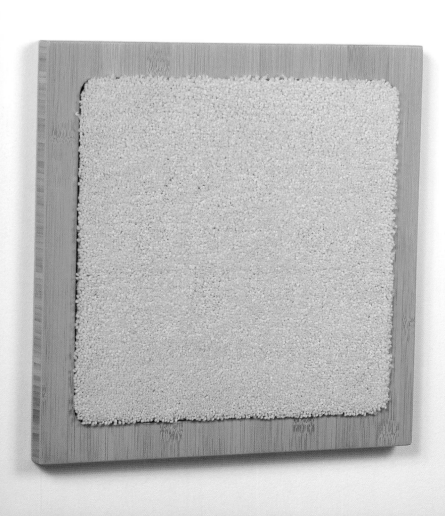

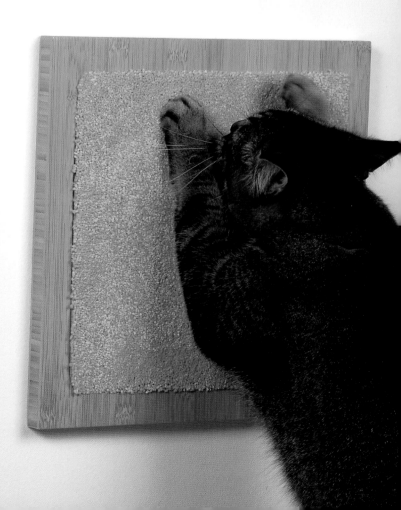

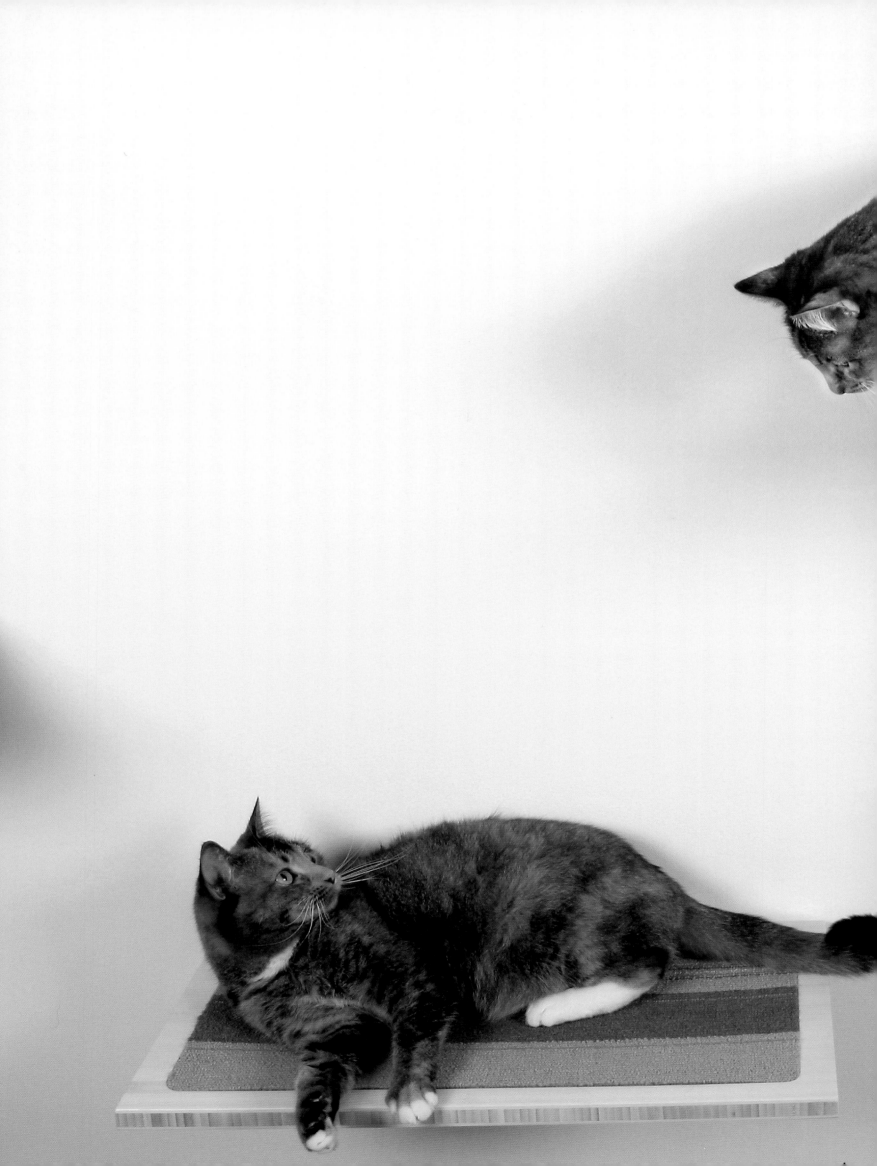

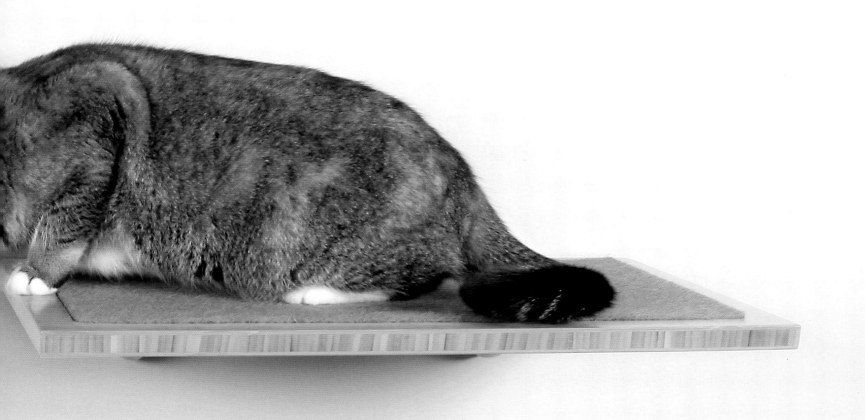

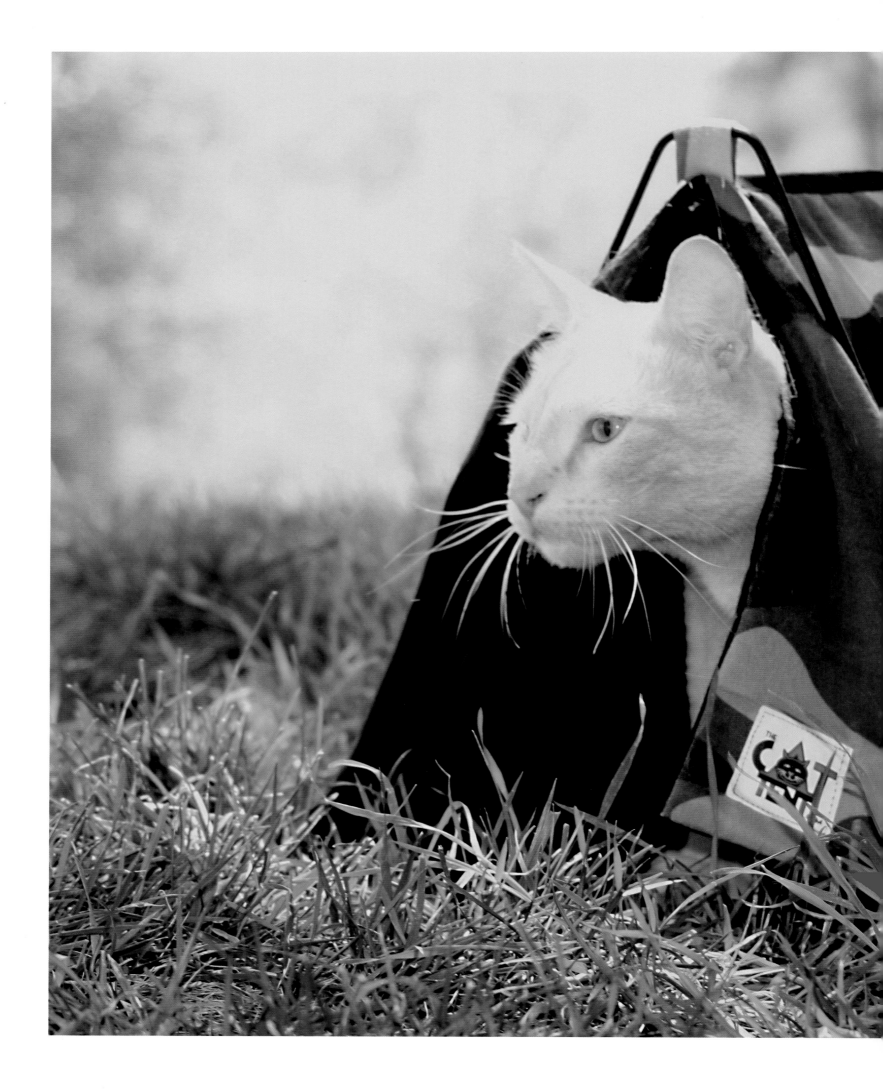

These cat tents are the perfect hiding place for the adventurous outdoor cat who wants a cozy sleeping place in a stylish setting.

Diese Katzenzelte sind das perfekte Versteck für die abenteuerlustige Outdoor-Katze, die sich eine gemütliche Schlafstelle in einer stylischen Umgebung wünscht.

Ces tentes sont la parfaite cachette pour le chat d'extérieur téméraire qui veut dormir dans un refuge coquet et confortable.

Estas tiendas para gatos representan el escondrijo perfecto para el gato aventurero que desee un lugar acogedor para dormir en una elegante instalación.

Queste tende per gatti rappresentano il rifugio perfetto per l'avventuroso micio abituato a vivere all'aperto che desidera un posticino confortevole ma elegante per i suoi sonnellini.

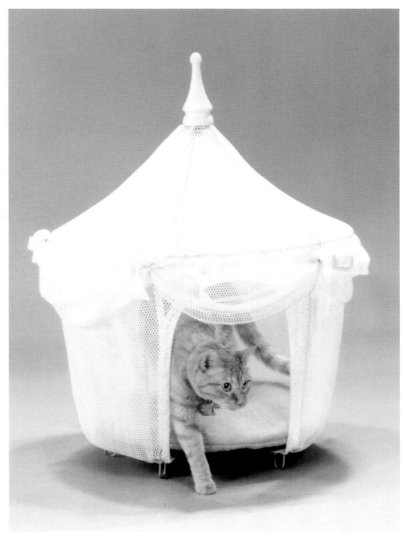

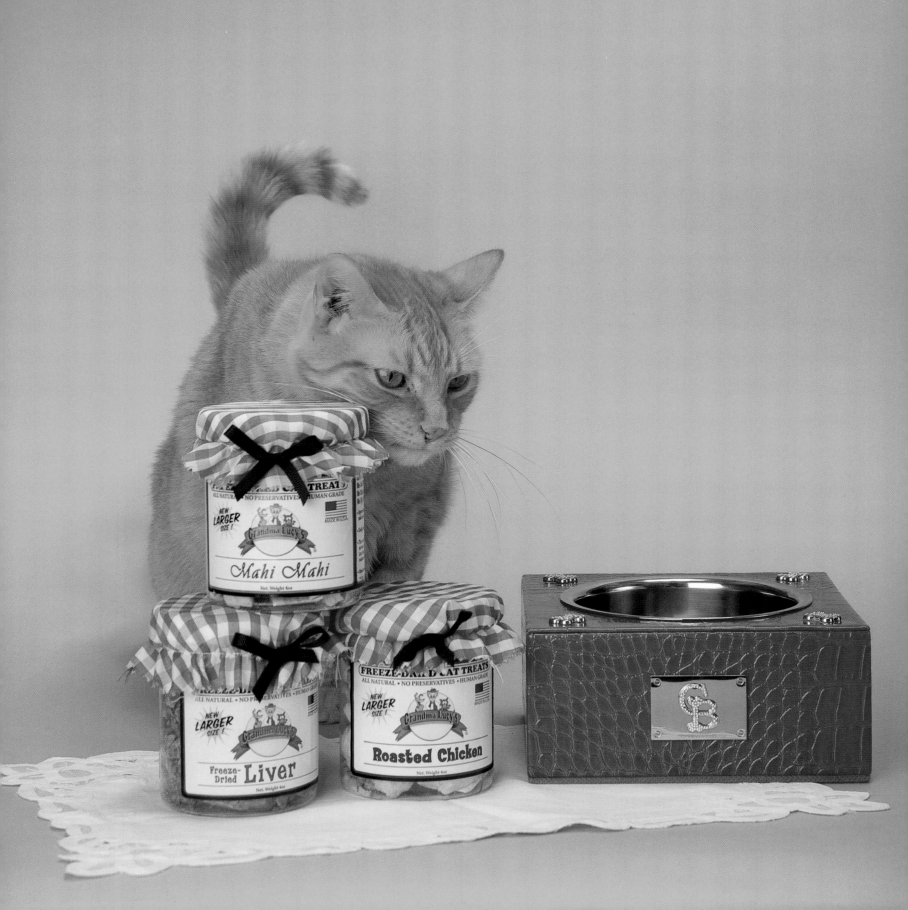

Dining

"You own a dog, but you feed a cat."

Jenny de Vries

New options for healthier pet foods and luxurious dining accessories are not just a passing trend, but a lifestyle movement that reflects the human need for a more positive approach for better health and good style.

Neue Optionen für gesündere Tiernahrung und luxuriöse Speiseaccessoires sind nicht nur ein vorübergehender Trend, sondern eine Lifestylebewegung, die menschlichen Bedürfnissen gerecht wird, wenn es um Gesundheit und guten Stil geht.

Les nouvelles offres d'alimentation plus saine et de vaisselle luxueuse pour animaux ne sont pas qu'une tendance éphémère, mais s'inscrivent dans un nouveau mode de vie qui reflète les besoins des humains : une approche plus positive pour une meilleure santé et davantage de style.

Las nuevas opciones en comidas sanas y lujosos accesorios para animales ya no son modas pasajeras, sino un movimiento en el estilo de vida que refleja la necesidad humana de un enfoque más positivo hacia la vida saludable y el buen estilo.

L'ampia scelta di cibi per gatti più sani e di lussuosi accessori da tavola non riflette solo una moda passeggera, ma il movimento contemporaneo alla ricerca di un modus vivendi più positivo all'insegna della salute e dello stile.

Dining

The sophisticated cat does not like to accept the status differentiation with humans. If you have ever owned one of these complicated cats, there are many instances when they turn their head away when you present them with some dry nibbles, or look at you with distaste when you serve them their rations on an ugly plastic dish placed on a piece of newspaper. The cat wants the same quality food as its owner, served on pretty ceramic bowls etched with its glorious name, held on an elegant stand that is placed on a bamboo mat that has a hint of lemongrass aroma. It is agreed by all cat lovers worldwide: dogs eat, but cats like to dine.

As more people battle weight and health problems, obsess over outer appearances, and dwell on enlightening their inner spiritual being, they also tend to project these same concerns on to their cats as well. We all know that cats are notorious for being particularly fussy and difficult in terms of its appetite and taste. But as health benefits, flavor, and nutritional value of pet food becomes an important issue for people, cat owners have been more finicky about what goes into their cat's body than even the cat itself. This all results with a thriving cat food industry that promises to freshen its breath, make their coats softer and silkier, and assure their longevity.

The major shift in the way pets are treated like a family member has played a significant role in the tendency to humanize our cats. Consumers today are willing to trade up on pet food that looks, feels, and smells like the finest human cuisine, with visible vegetables and savory flavors. Some companies even offer wheat- and gluten-free products for those sensitive felines, or low-fat options for those cats who packed on a few pounds.

The quality has improved so much that one marketing strategy is to provide pet food with meats that can also be consumed by humans. This extends to the 'kitty treat' market as well; natural tidbits such as dried salmon, vegan snacks, and handmade baked goods are filling the shelves of even most grocery stores.

The pet industry is also trying to mirror the preferences of the cat owner. Whether it be vegetarian, kosher, organic, or even locally grown foods, the options for feeding your feline friend is seeing so much more diversification and expansion than ever before.

Speisen

Die anspruchsvolle Katze möchte nicht anders behandelt werden als der Mensch. Wenn Sie jemals eine dieser komplizierten Katzen besessen haben, dann kennen Sie sicherlich die vielen Momente, in denen die Katze den Kopf wegdreht, wenn Sie ihr Trockenfutter anbieten, oder Sie angewidert anschaut, wenn Sie ihr ihre Rationen in hässlichen Plastiknäpfen servieren, die auf einem Stück Zeitungspapier stehen. Die Katze wünscht dieselbe Speisenqualität wie ihr Besitzer, serviert in hübschen Keramikschälchen, verziert mit ihrem wohlklingenden Namen und gehalten von einem eleganten Ständer, platziert auf einer dezent nach Zitronengras duftenden Bambusmatte. Alle Katzenliebhaber dieser Welt sind sich einig: Hunde fressen, Katzen wünschen zu dinieren.

Da immer mehr Leute von Gewichts- und Gesundheitsproblemen geplagt werden, nur auf Äußerlichkeiten achten und peinlich darauf bedacht sind, ihren inneren Seelenfrieden zu finden, neigen sie dazu, diese Sorgen auch auf ihre Katzen zu projizieren. Wir alle wissen, dass Katzen berüchtigt dafür sind, in Bezug auf ihren Appetit und Geschmack besonders wählerisch und schwierig zu sein. Aber da gesundheitliche Vorteile, Geschmack und Nährwert des Tierfutters wichtige Punkte für die Menschen sind, verhalten sich Katzenbesitzer penibler als die Katze selbst, wenn es darum geht, was in den Magen ihrer Samtpfote gelangt. All dieses hat eine expandierende Katzenfutterindustrie zur Folge, die verspricht, für frischeren Atem der Katze zu sorgen, das Fell weicher und seidiger zu machen und ein langes Leben zu garantieren.

Die Tendenz zu einer Vermenschlichung der Katze durch ihren Besitzer basiert im Wesentlichen auf der veränderten Stellung der Katze, die inzwischen der eines Familienmitgliedes gleicht. Die heutigen Konsumenten sind verrückt nach Tierfutter, das wie Haute Cuisine für den menschlichen Gaumen anmutet, dieselbe Konsistenz hat und auch so schmeckt; mit erkennbarem Gemüse und in appetitlichen Geschmacksrichtungen. Einige Firmen bieten gluten- und weizenfreie Produkte für empfindliche Katzen an oder fettreduzierte Alternativen für Tiere, die einige Pfunde zugelegt haben.

Die Qualität wurde derart verbessert, dass eine Marketingstrategie sich zum Ziel gesetzt hat, Tierfutter aus Fleisch herzustellen, das auch von Menschen konsumiert werden kann – ein neuer Boom auf dem „kulinarischen Markt für Stubentiger". Natürliche Leckerbissen aus getrocknetem Lachs, vegane Snacks und von Hand gebackene Köstlichkeiten füllen die Regale der meisten Lebensmittelgeschäfte.

Die Tierindustrie versucht, auch die Vorlieben des Katzenbesitzers zu reflektieren. Ob vegetarische Kost, koschere Kost, biologische Kost oder sogar lokal angebaute beziehungsweise erzeugte Lebensmittel – die Futterauswahl für Ihren pelzigen Freund ist vielfältiger denn je, und der Expansion sind keine Grenzen gesetzt.

Gourmet

Le chat sophistiqué n'accepte pas la différence de statut avec les humains. Si vous avez déjà possédé un de ces chats compliqués, il y a forcément eu des occasions où il a détourné la tête quand vous lui avez présenté quelques croquettes sèches, ou vous a regardé avec dégoût quand vous lui avez apporté sa ration dans une affreuse gamelle en plastique sur un papier journal. Le chat veut la même qualité de nourriture que son maître, servie dans de jolis bols en céramique gravés à son glorieux nom, sur un piédestal élégant placé sur un tapis de bambou au léger parfum de citronnelle. Tous les amoureux des chats s'accordent sur ce point : les chiens mangent, mais les chats dînent.

De plus en plus de gens luttent contre des problèmes de poids et de santé, sont obsédés par les apparences, rabâchent qu'ils veulent éclairer leur vie intérieure, ils projettent aussi ces questions sur leurs chats. Les chats sont notoirement difficiles en termes d'appétit et de goût. Mais comme les bénéfices santé, le goût et la valeur nutritionnelle de la nourriture pour animaux deviennent un sujet important pour les gens, les maîtres de chats sont encore plus pointilleux en ce qui concerne ce qui entre dans le corps de leur chats que le chat lui-même. Tout cela mène à une industrie des aliments pour chats prospère, qui promet de rafraîchir son haleine, de rendre sa fourrure plus douce et plus soyeuse, et assurer sa longévité.

Le changement majeur consistant à traiter les animaux comme un membre de sa famille a joué un rôle significatif dans la tendance à humaniser les chats. Les consommateurs d'aujourd'hui veulent acheter de la nourriture pour chats qui ait l'aspect, la texture et l'odeur de la meilleure cuisine humaine, avec des légumes visibles et un goût savoureux. Certaines entreprises proposent même des produits sans blé – ni gluten – pour les félins sensibles, ou des produits allégés en graisse pour ceux qui ont quelques kilos en trop.

La qualité a tellement augmenté qu'une des stratégies de marketing est de proposer de la nourriture animale faite avec des viandes qui peuvent aussi être consommées par les humains. Cela s'étend aussi au marché des « friandises pour minous » : des bouchées naturelles comme du saumon séché, des snacks végétaliens, et des produits faits main emplissent les rayons de la plupart des épiceries.

Le secteur animalier essaie également de refléter les préférences des maîtres des chats. Que ce vous préfériez les aliments végétariens, casher, bio ou les produits locaux, les options pour nourrir votre ami félin sont plus diverses et variées que jamais.

Cenar

Al sofisticado gato no le gusta aceptar las discriminaciones de estatus con los humanos. Quien haya poseído uno de estos complicados animales sabe que en muchos casos giran la cabeza al otro lado al presentarles unos pedazos secos de comida, o miran disgustados al servirles sus raciones en algún horroroso cuenco de plástico sobre una hoja de periódico. El gato quiere comida de la misma calidad que la de su amo, servida en cuencos de cerámica grabados con su glorioso nombre, en elegantes mesitas dispuestas sobre esterillas de bambú con aroma de limón. Los amantes del los gatos en el mundo entero están de acuerdo: los perros se nutren, a los gatos les gusta comer.

Las mismas personas que luchan contra los problemas de peso y salud, obsesionadas por su apariencia exterior, que trabajan para iluminar su ser espiritual interior, tienden a proyectar las mismas preocupaciones en sus gatos. Todos sabemos que los gatos son conocidos por ser exigentes y difíciles en cuestiones de apetito y gusto. Mientras que los beneficios para la salud, el sabor y el valor nutricional de la comida se convierten en cuestiones importantes para las personas, quienes posean un gato son aún más meticulosos con lo que entra en el cuerpo del gato que el gato mismo. Todo esto desemboca en una próspera industria que promete refrescar el aliento, volver el pelo más suave y liso y asegurar la longevidad de los gatos.

El gran cambio en el tratamiento de los animales como miembros de la familia ha jugado un papel significativo en la tendencia a humanizar a nuestros gatos. Hoy en día, los consumidores están dispuestos a gastarse el dinero en comidas para mascotas que tengan la misma apariencia, textura y olor que la más alta cocina para humanos, con sabores y aromas vegetales reconocibles. Algunas casas ofrecen incluso productos sin trigo y sin gluten a los felinos sensibles y opciones con bajo porcentaje de grasa para los gatos un poco sobrados de peso.

Ahora la calidad es tan alta que una estrategia de marketing consiste en ofrecer comida para animales hecha con carnes igualmente aptas para el consumo humano. Así se extiende también el mercado de los 'mimos' para los gatos: manjares naturales como salmón desecado, meriendas "vegan" y productos cocidos en hornos artesanales llenan las estanterías hasta en muchas tiendas de comestibles.

La industria de los artículos para animales intenta asimismo reflejar las preferencias de los amos. Con comidas vegetarianas, *kasher*, orgánicas y productos locales, las opciones para nutrir a nuestro felino experimentan una diversificación y una expansión nunca vistas.

Desinare

Il gatto sofisticato non accetta di buon grado di essere trattato differentemente dagli umani. Se avete mai posseduto uno di questi complicati gatti, vi sarà capitato diverse volte di vederli girare la testa dall'altra parte di fronte a pezzettini secchi di cibo, o di guardarvi con disgusto quando gli servite le razioni su uno sgradevole piatto di plastica posato su un foglio di giornale. Il gatto desidera cibo della stessa qualità del padrone, servito in una bella ciotola di ceramica su cui è inciso il suo nome glorioso, sorretta da un elegante supporto posto su un tappetino di bambù con un lieve aroma di citronella. Gli amanti di gatti di tutto il mondo concordano: i cani mangiano, ma ai gatti piace desinare.

Parecchie persone lottano contro problemi di peso e di salute, ossessionate con il loro aspetto esteriore, e si preoccupano di illuminare il loro essere interiore, tendendo poi a proiettare le stesse problematiche sui loro gatti. Tutti sappiamo che i gatti sono famosi per il loro essere particolarmente difficili ed esigenti in termini di appetito e gusto. E mentre i benefici per la salute, il sapore e il valore nutritivo del cibo per animali diventano questioni importanti per molte persone, i proprietari di gatti sono diventati ancora più pignoli degli animali stessi per quanto concerne il cibo per nutrirli. La conseguenza è una fiorente industria di cibo per gatti, che promette di rinfrescar loro l'alito, rendere il manto più soffice e vellutato, e assicurar loro una maggiore longevità.

Il grosso cambiamento nel modo di trattare gli animali domestici come membri della famiglia, ha giocato un ruolo significativo nella tendenza a umanizzare i nostri gatti. Oggi i consumatori sono disposti a spendere in cibo per animali con l'aspetto, la consistenza e il profumo della più alta cucina per umani, con aromi e sapori vegetali riconoscibili. Alcune marche offrono persino prodotti senza grano e senza glutine per quei felini sensibili, oppure versioni a basso contenuto di grassi per i gatti con qualche chiletto di troppo.

La qualità è talmente migliorata che una delle strategie di marketing consiste nel proporre cibo per animali con carni che possono essere consumate anche da umani. Così il mercato si estende anche ai "trattamenti speciali per gattini"; leccornie naturali come salmone secco, spuntini vegetariani integrali e cibi fatti a mano e cotti al forno occupano ormai gli scaffali di molte drogherie.

L'industria del cibo per animali punta anche a rispecchiare le preferenze del padrone del gatto. Che si tratti di cibi vegetariani, kosher, organici, o anche coltivati localmente, le possibilità per nutrire il vostro amico felino stanno sperimentando una diversificazione e un'espansione senza precedenti.

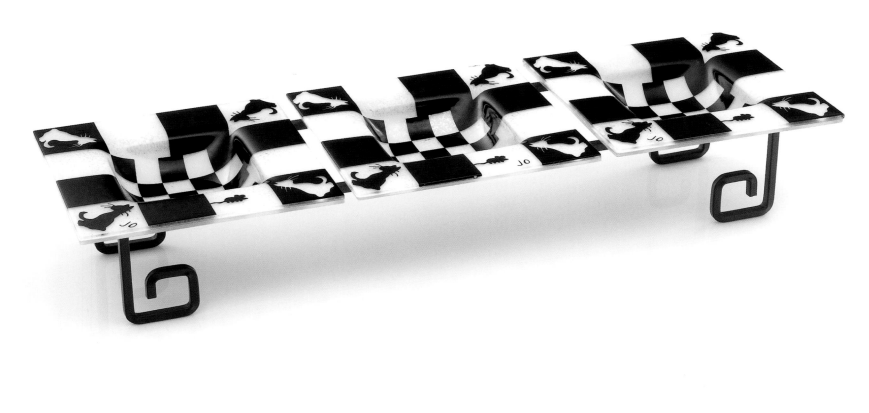

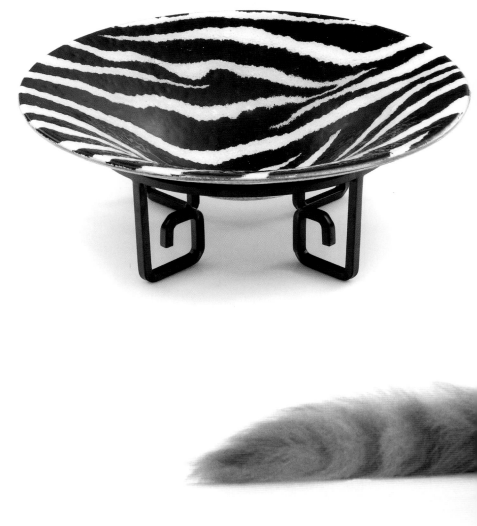

Luxury dining products are being introduced in the pet market each year, such as these elegant glass dining bowls by Sherwood Designs, or the modern stainless steel products from Wetnoz.

Luxuriöse Speiseaccessoires werden jedes Jahr auf dem Tierproduktmarkt lanciert; zum Beispiel diese eleganten Glasschüsseln von Sherwood Designs oder das moderne Produkt aus Edelstahl von Wetnoz.

De nouveaux articles de vaisselle luxueux arrivent chaque année sur le marché animalier, comme ces élégants bols en verre de chez Sherwood Designs, ou les produits modernes en inox de Wetnoz.

Cada año se introducen en el mercado de las mascotas nuevos artículos de lujo para comer, como estos elegantes cuencos de Sherwood Designs o los productos de acero inoxidable de Wetnoz.

Ogni anno il mercato degli animali domestici si arricchisce di articoli di lusso per il pranzo, come queste eleganti scodelle di Sherwood Designs o i moderni prodotti in acciaio inossidabile di Wetnoz.

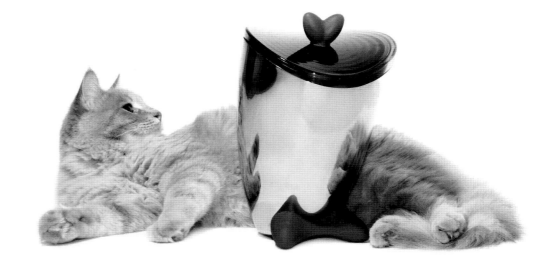

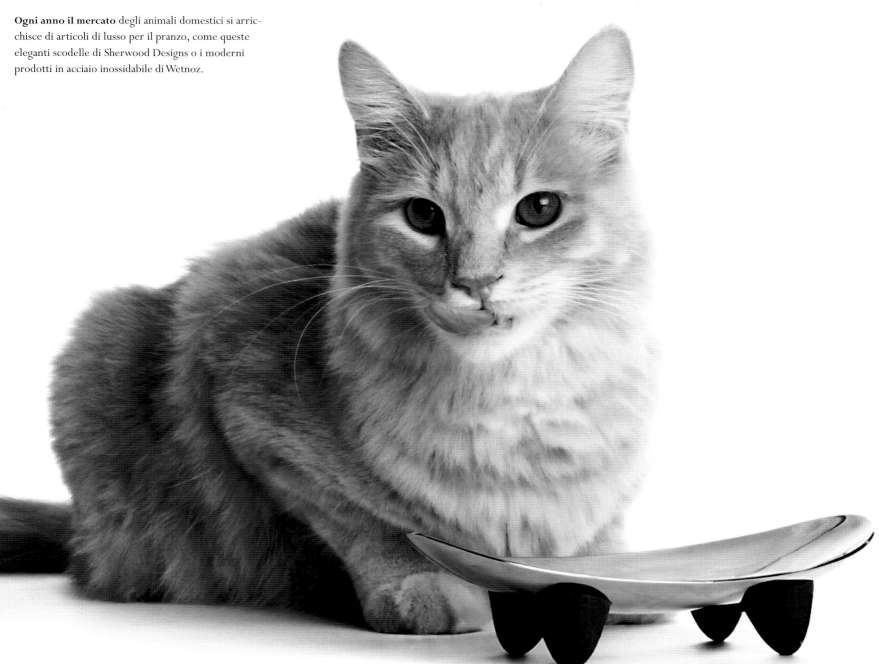

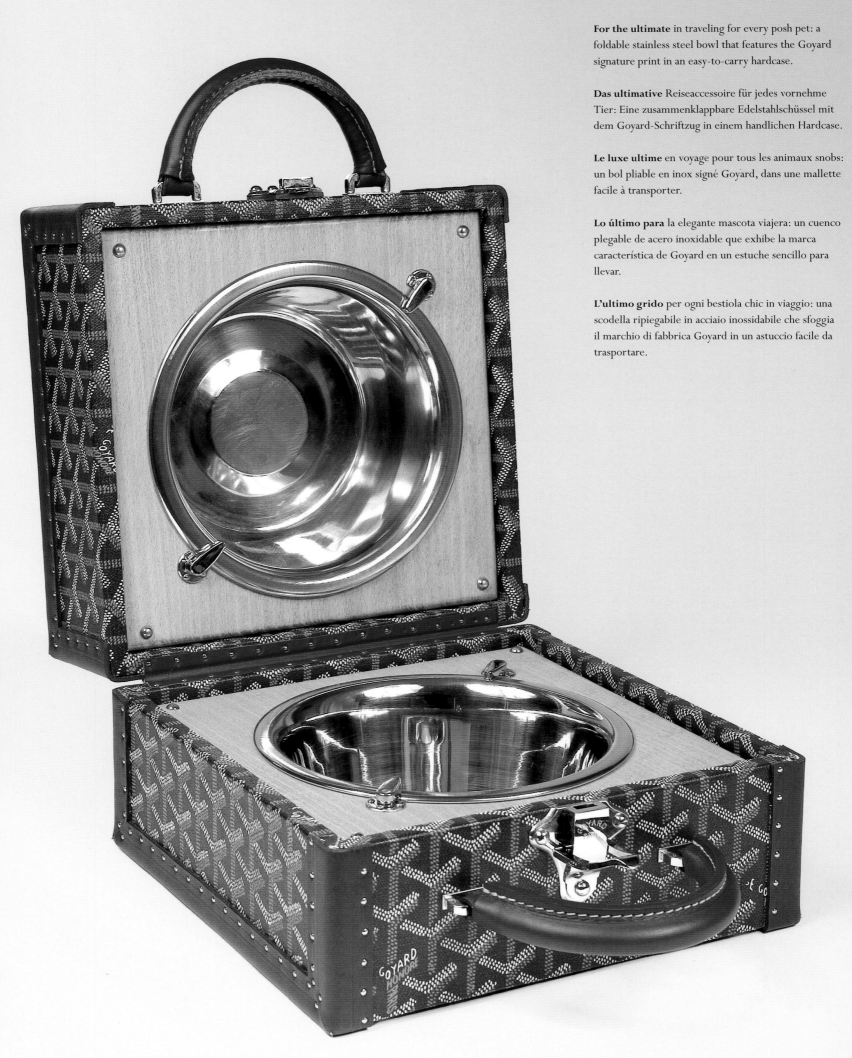

For the ultimate in traveling for every posh pet: a foldable stainless steel bowl that features the Goyard signature print in an easy-to-carry hardcase.

Das ultimative Reiseaccessoire für jedes vornehme Tier: Eine zusammenklappbare Edelstahlschüssel mit dem Goyard-Schriftzug in einem handlichen Hardcase.

Le luxe ultime en voyage pour tous les animaux snobs: un bol pliable en inox signé Goyard, dans une mallette facile à transporter.

Lo último para la elegante mascota viajera: un cuenco plegable de acero inoxidable que exhibe la marca característica de Goyard en un estuche sencillo para llevar.

L'ultimo grido per ogni bestiola chic in viaggio: una scodella ripiegabile in acciaio inossidabile che sfoggia il marchio di fabbrica Goyard in un astuccio facile da trasportare.

Today many pet boutiques such as Chrome Bones sell ultra-luxurious pet products, such as these feeding bowls with leather fringes, exotic skins, and rhinestones.

Heutzutage verkaufen viele Tierboutiquen wie Chrome Bones ultraluxuriöse Tierprodukte, wie diese Futternäpfe, versehen mit Lederfransen, exotischen Häuten und Strasssteinchen.

De nos jours, de nombreuses boutiques pour animaux comme Chrome Bones vendent des produits ultra-luxueux comme ces écuelles avec franges en cuir, peaux exotiques et faux diamants.

Hoy muchas tiendas para animales, como Chrome Bones, venden productos de super lujo, como estas escudillas para comer con franjas de cuero, pieles exóticas y diamantes de imitación.

Oggi molte boutique per animali come Chrome Bones propongono prodotti di superlusso, come queste scodelle per mangiare con frange in cuoio, pelli esotiche e strass.

These **dishes raise** the dining experience to new heights, such as the wall-mounted bowls by Everyday Studio, or the porcelain bowls on bamboo stands from RedEnvelope.

Dieses Geschirr bietet den Tieren eine ganz neue, unschätzbare Erfahrung des Speisens, wie zum Beispiel die wandmontierten Schüsseln von Everyday Studio oder die Porzellanschälchen auf Bambushaltern von RedEnvelope.

Les repas prennent une autre dimension avec des plats tels que les bols muraux d'Everyday Studio, ou les bols en porcelaine sur support bambou de chez RedEnvelope.

Estos platos elevan la experiencia de alimentar, como los cuencos montados en las paredes de Everyday Studio o las escudillas de porcelana con mesitas de bambú de RedEnvelope.

Vi sono piatti che elevano nel vero senso della parola l'esperienza del pasto, come le scodelle fissate sulla parete di Everyday Studio, o le scodelle di porcellana su supporti in bambù di RedEnvelope.

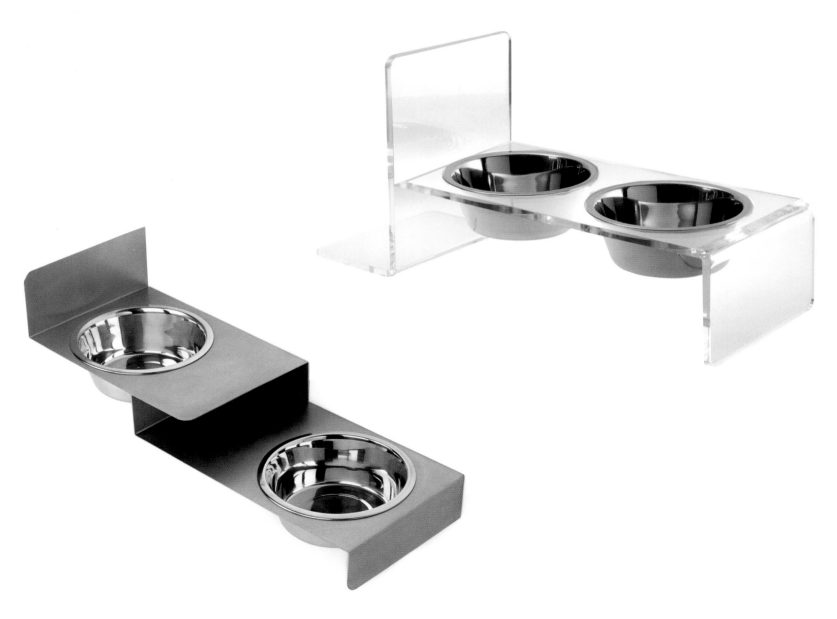

Alessi brings a fun style to your family cat with this whimsical cat bowl, or with an amusing traveling dish made from cardboard that you assemble yourself.

Alessi setzt mit diesem skurrilen Katzennapf lustige Stilakzente für Ihre Familienkatze. Als Alternative steht eine außergewöhnliche Faltschachtel für die Reise zur Verfügung, die Sie selbst zusammenbauen können.

Alessi apporte un style ludique dans la vie de votre chat grâce à cette écuelle originale ou au plat de voyage en carton à assembler vous-même.

Alessi trae un estilo divertido a nuestro gato de familia con sus caprichosas escudillas, o con un divertido plato de viaje hecho en cartón, ensamblado por uno mismo.

Alessi offre divertimento e stile al vostro gatto di famiglia con questa eccentrica scodella, o con un simpatico piatto da viaggio in cartone da assemblare.

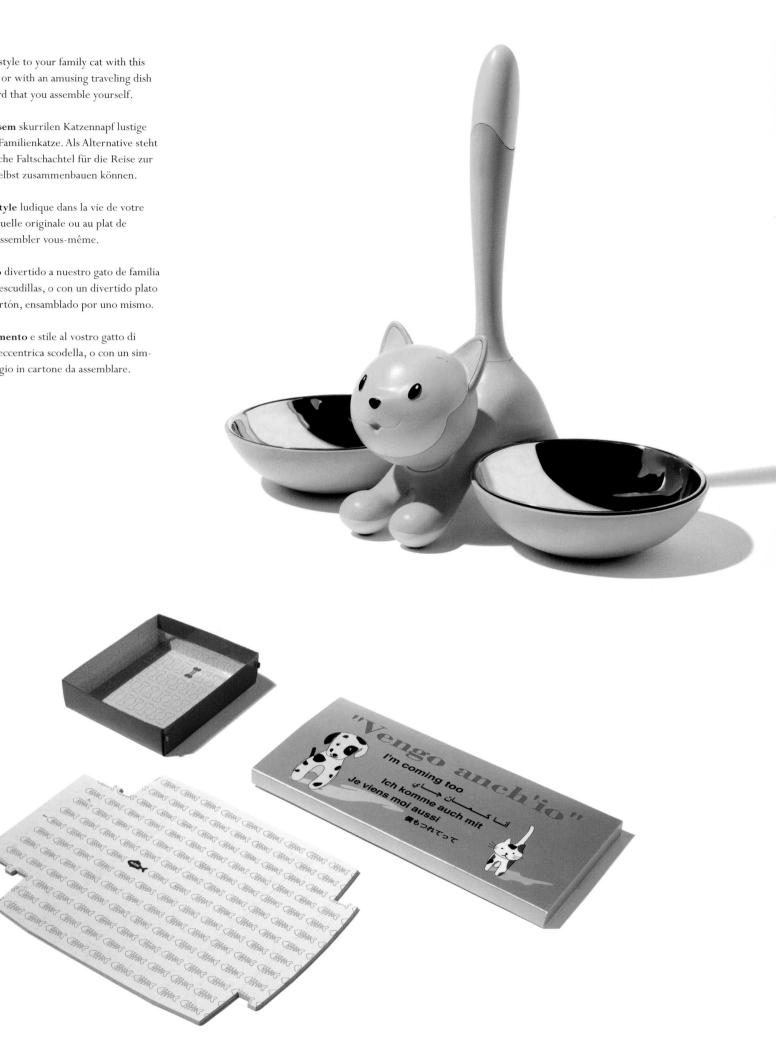

FLEA BAG

FUZZ BUTT

PSYCHO KITTY

PRINCESS

ROYAL HIGHNESS

KILLER

ATTACK CAT

THE BOSS

THE *@#! CAT

SUSHI BREATH

FAT CAT

MR. ATTITUDE

At creative "barkery" boutiques (such as the Three Dog Bakery in Los Angeles), the focus is on the finest freshly baked foods for your furry feline companion. This gourmet bakery also offers a wide variety of cat treats from savory biscuits to scrumptious cat cookies and kitty candies.

Kreative Geschäfte (wie die Three Dog Bakery in Los Angeles) fokussieren köstliche, frisch gebackene Delikatessen für Ihre Katze. Diese Gourmetbäckerei verkauft auch eine große Vielfalt an Leckerlis für Katzen; von schmackhaften Keksen bis hin zu köstlichen Cookies und Süßigkeiten.

Pour les « miaoulangeries » créatives (comme la Three Dog Bakery à Los Angeles), l'accent est mis sur les aliments les plus fins, fraîchement cuits pour votre compagnon à fourrure. Cette boulangerie gastronomique propose aussi une large variété de friandises pour chats, allant des biscuits salés aux succulents cookies pour chats et bonbons pour chatons.

En las creativas panaderías-boutiques, como la Three Dog Bakery en Los Ángeles, el enfoque está en la comida recién horneada para nuestro compañero de cuatro patas. Esta panadería de gourmet también ofrece una amplia variedad de delicias para nuestros gatitos, desde sabrosas galletas hasta riquísimos pasteles.

Nelle creative boutique-panificio (come la Three Dog Bakery di Los Angeles) si punta sui migliori cibi freschi di forno per il vostro compagno a quattro zampe. Questa panetteria per gourmet offre inoltre un'ampia varietà di piaceri per il micio, da saporiti biscotti a deliziosi dolci e canditi a misura di gatto.

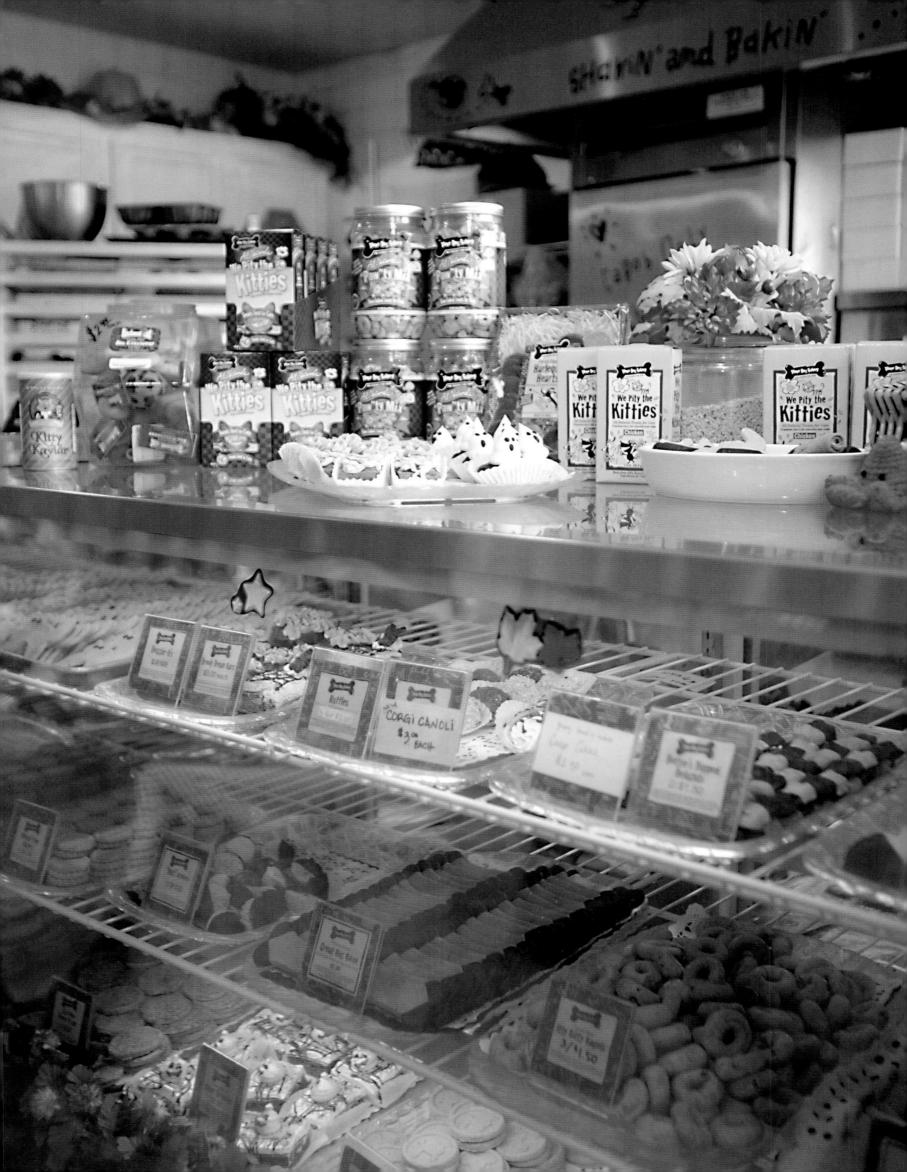

Fish Delights

TASTY TUNA BALLS

3 baby carrots (cooked until soft); 16 oz canned tuna in oil; 2 oz cooked skinless herring; 2 tbl oatmeal; 2–3 tbl grated cheese; 2 tsp brewer's yeast; catnip, chopped; 1 egg, beaten; 2 tbl tomato paste (not ketchup)

SCRUMPTIOUS SARDINES

7 oz mashed sardines; 2 oz dry non-fat milk; 4 oz wheat germ

. .

Mix ingredients into an even paste. Roll into balls. Bake at 350°F until brown. Cool thoroughly. Garnish with catnip. Decorate with cooked shelled shrimp if your cat has been unusually loving.

LECKERE THUNFISCHBÄLLCHEN

3 Babykarotten (weich gekocht); 450 g Dosenthunfisch in Öl; 60 g gekochter Hering ohne Haut; 2 EL Haferflocken; 2–3 EL geriebener Käse; 2 TL Bierhefe; Katzenminze, gehackt; 1 Ei, geschlagen; 2 EL Tomatenmark (kein Ketchup)

KÖSTLICHE SARDINEN

200 g zerdrückte Sardinen; 60 g Magermilchpulver; 20 g Weizenkeime

. .

Die Zutaten zu einer gleichmäßigen Paste vermischen. Zu Bällchen formen. Bei 180°C so lange backen, bis sie braun sind. Gut abkühlen lassen. Mit Katzenminze garnieren. Wenn Ihre Katze besonders lieb war, dekorieren Sie das Gericht mit ge-kochten, geschälten Shrimps.

BOULETTES SAVOUREUSES AU THON

3 carottes nouvelles (cuites et moelleuses); une boîte de 450 g de thon à l'huile; 60 g de hareng cuit sans peau; 2 c à s de flocons d'avoine; 2–3 c à s de fromage râpé; 2 c à c de levure de bière; herbe à chat hachée; 1 œuf battu; 2 c à s de coulis de tomates (pas de ketchup)

SUCCULENTES SARDINES

200 g de sardines écrasées; 60 g de lait écrémé en poudre; 120 g de germes de blé

. .

Mixer les ingrédients jusqu'à obtention d'une pâte homogène. Former des boulettes. Faire cuire au four à 180 °C jusqu'à ce qu'elles soient dorées. Laisser refroidir. Garnir d'herbe à chat. Décorer avec des crevettes cuites décortiquées si votre chat a été exceptionnellement adorable.

ALBÓNDIGAS DE ATÚN

3 zanahorias bebés (cocinadas tiernas); 450 g de atún de lata en aceite; 60 g de arenque cocinado sin piel; 2 cucharadas de harina de avena; 2–3 cucharadas de queso rallado; 2 cucharaditas de levadura de cerveza; hierba de gato troceada; 1 huevo batido; 2 cu-charadas de pulpa de tomate (no ketchup)

SARDINAS DE RECHUPETE

200 g de sardinas machacadas; 60 g de leche en polvo sin grasa; 120 g de germen de trigo

. .

Amasar los ingredientes en una mezcla homogénea. Formar bolitas. Hornear a 180 °C hasta que se dore. Dejar enfriar. Adornan con hierba de gato. Decorar con camarones cocidos y descascarados si su gato ha sido extraordinariamente cariñoso.

GUSTOSE POLPETTE DI TONNO

3 carote piccole (ammorbidite in cottura); 450 g di tonno in scatola sott'olio; 60 g di aringhe cotte senza pelle; 2 cucchiai di farina d'avena; 2–3 cucchiai di for-maggio grattugiato; 2 cucchiaini di lievito di birra; erba gatta tritata; 1 uovo sbattuto; 2 cucchiai di concentrato di pomodoro (non ketchup)

SARDINE SUCCULENTE

200 g di sardine schiacciate; 60 g di latte scremato in polvere; 120 g di germi di grano

. .

Amalgamare gli ingredienti fino a ottenere una pasta omogenea. Arrotolare forman-do delle polpette. Cuocere a 180 °C finché non siano dorati. Lasciare raffreddare completamente. Guarnire con erba gatta. Decorare con gamberetti cotti sgusciati se il vostro gatto si è comportato particolarmente bene.

Salmon Mousse Mouse

SALMON MOUSSE MOUSE

4 oz cooked skinless, boneless salmon; ½ cup skim milk; 1 tbsp margarine; 1 drop red food coloring; ½ cup prepared gelatin

Mash the cooked salmon and add milk slowly. Blend until creamy. Stir in margarine and food coloring. Beat rapidly until stiff. Pour in a mold only three quarters full. Chill in refrigerator (20 min.). Pour enough heated gelatin to fill the mold. Chill for one hour and remove from mold. Garnish with Bonito Flakes.

SOURIS EN MOUSSE DE SAUMON

125 g de saumon cuit, sans peau ni arête; 120 ml de lait écrémé; 1 c à s de margarine; 1 goutte de colorant alimentaire rouge; 120 ml de gélatine déjà préparée

Écraser le saumon cuit et ajouter lentement le lait. Mélanger jusqu'à obtention d'une consistance crémeuse. Ajouter la margarine et le colorant alimentaire. Battre rapidement jusqu'à ce que le tout durcisse. Remplir un moule aux trois-quarts. Faire refroidir au réfrigérateur (20 min.). Verser assez de gélatine chauffée pour remplir complètement le moule. Laisser refroidir pendant une heure et démouler. Garnir de flocons de bonite.

TOPOLINO DI MOUSSE AL SALMONE

125 g di salmone cotto, senza pelle e senza spine; 120 ml di latte scremato; 1 cucchiaio di margarina; 1 goccia di colorante alimentare rosso; 120 ml di gelatina

Pestare il salmone cotto e aggiungere il latte poco alla volta. Mescolare finché diventa cremoso. Aggiungere la margarina e il colorante. Sbattere rapidamente fino a ottenere un composto solido. Versare in uno stampo pieno per tre quarti. Raffreddare in frigorifero (20 min.). Aggiungere la gelatina sciolta fino a riempire lo stampo. Lasciare riposare per un'ora e rimuovere lo stampo. Guarnire con fiocchi di bonito.

AUS LACHSMOUSSE GEFORMTE MAUS

125 g gekochter, gehäuteter, grätenfreier Lachs; 120 ml Magermilch; 1 EL Margarine; 1 Tropfen rote Lebensmittelfarbe; 120 ml aufgelöste Gelatine

Den gekochten Lachs zerdrücken und langsam Milch einrühren. So lange vermengen, bis eine cremige Masse entsteht. Margarine und Lebensmittelfarbe hinzufügen. Schnell schlagen, bis die Masse steif ist. In eine Form gießen, die nur dreiviertel gefüllt sein darf. Im Kühlschrank kaltstellen (20 Min.). Die Form bis zum Rand mit erhitzter Gelatine füllen. Eine Stunde abkühlen lassen, dann aus der Form nehmen. Mit Bonito-Flocken garnieren.

RATÓN EN CREMA DE SALMÓN

125 g de salmón cocido sin espinas;120 ml de leche desnatada; 1 cucharada de margarina; 1 gota de colorante rojo para alimentos; 120 ml de gelatina preparada

Machacar el salmón cocido y añadir la leche poco a poco.Mezclar hasta que esté cremoso. Añadir la margarina y el colorante y remover. Batir rápidamente hasta que la mezcla quede compacta. Llenar con la mezcla tres cuartas partes del molde. Dejar enfriar en la nevera (20 min.).Verter gelatina caliente hasta llenar el molde. Dejar reposar durante una hora y desmoldar. Decorar con copos de bonito.

Fish Pate

FISH PATE

1 can tuna in olive oil; 4 oz boiled rice; 2 oz pureed liver; 2–3 sprigs parsley chopped

Mix ingredients. Roll into balls. Pat into patties. Store in refrigerator. Garnish with Bonito Flakes.

PÂTÉ DE POISSON

1 boîte de thon à l'huile d'olive; 120 g de riz cuit; 60 g de foie écrasé; 2–3 brins de persil écrasé

Mixer les ingrédients. Former des boulettes. Les aplatir légèrement. Laisser refroidir au réfrigérateur. Garnir de flocons de bonite.

PATÉ DI PESCE

1 scatola di tonno in olio d'oliva; 120 g di riso bollito; 60 g di purè di fegato; 2–3 rametti di prezzemolo tritato

Mescolare gli ingredienti. Formare palline con il composto. Battere leggermente fino a ottenere polpettine schiacciate. Riporre in frigorifero. Guarnire con fiocchi di bonito.

FISCHPLATTE

1 Dose Thunfisch in Olivenöl; 120 g gekochter Reis; 60 g pürierte Leber; 2–3 Stängel gehackte Petersilie

Zutaten miteinander vermischen. Zu Bällchen formen. Fest zu Pastetchen klopfen. Im Kühlschrank aufbewahren. Mit Bonito-Flocken garnieren.

PATÉ DE PESCADO

1 lata de atún en aceite de oliva; 120 g de arroz hervido; 60 g de puré de hígado; 2–3 ramilletes de perejil troceado

Mezclar los ingredientes. Formar pelotitas. Hacer pequeñas porciones. Guardar en la nevera. Decorar con copos de bonito.

Grandma's Kitty Treats

GRANDMA'S KITTY TREATS

8 oz whole wheat flour; 2 tbsp wheat germ; 2 oz soy flour; ½ tsp bone meal;
1 tsp crushed dried catnip leaves; ⅓ cup confectioners' milk; 1 tbsp kelp;
1 tbsp (unsulfured) molasses; 1 egg; 2 tbsp olive oil; ⅓ cup milk

Mix the dry ingredients together. Add the molasses, egg, oil, milk.
Make into small balls. Bake at 350°F (20 min.) until brown. Cool thoroughly.
Serve only if your cat has been a very good kitty.

LES FRIANDISES POUR CHATONS DE MAMIE

250 g de farine de blé complète; 2 c à s de germes de blé; 60 g de farine de soja;
½ c à c de farine d'os; 1 c à c d'herbe à chat séchée et écrasée; 90 ml de lait condensé
sucré; 1 c à s de laminaire (algue); 1 c à s de mélasse (sans soufre); 1 œuf; 2 c à s
d'huile d'olive; 90 ml de lait

Mélanger ensemble les ingrédients secs. Ajouter la mélasse, l'œuf, l'huile, le lait.
Former de petites boulettes. Faire cuire au four à 180 °C jusqu'à ce qu'elles soient
dorées. Laisser refroidir totalement.
Servir uniquement si votre chat a été un très gentil minou.

DELIZIE FELINE DELLA NONNA

250 g di farina di frumento integrale; 2 cucchiai di germi di grano; 60 g di farina di
soia; ½ cucchiaino di farina di ossa; 1 cucchiaino di foglie di erba gatta secca sminuz-
zata; 90 ml di latte concentrato; 1 cucchiaio di alghe; 1 cucchiaio di melassa senza
zolfo; 1 uovo; 2 cucchiai di olio d'oliva; 90 ml di latte

Mescolare gli ingredienti asciutti. Aggiungere la melassa, l'uovo, l'olio e il latte.
Impastare e formare palline. Cuocere in forno a 180 °C (20 min.) finché non siano
dorate. Lasciare raffreddare completamente.
Servire solo se il vostro gatto è stato davvero un bravo micio.

OMAS KÄTZCHENLECKERLIS

250 g Weizenvollkornmehl; 2 EL Weizenkeime; 60 g Sojamehl; ½ TL Knochenmehl;
1 TL zerdrückte, getrocknete Katzenminzeblättchen; 90 ml Kondensmilch;
1 EL Kelp; 1 EL Melasse (ungeschwefelt); 1 Ei; 2 EL Olivenöl; 90 ml Milch

Die Trockenzutaten miteinander vermischen. Melasse, Ei, Öl und Milch hinzufügen.
Kleine Bällchen formen. Bei 180 °C ca. 20 Min. backen, bis sie braun sind. Gut
abkühlen lassen.
Gönnen Sie Ihrem Kätzchen diese Delikatesse nur, wenn es ganz lieb war.

DELICIAS FELINAS DE LA ABUELA

250 g de harina de trigo entera; 2 cucharadas de germen de trigo; 60 g de harina
de soya; ½ cucharadita de harina de hueso; 1 cucharadita de hojas de hierba de gato
triturada; 90 ml de leche para dulces; 1 cucharada de algas; 1 cucharada de melaza sin
azufre; 1 huevo; 2 cucharadas de aceite de oliva; 90 ml de leche

Mezclar los ingredientes sólidos. Añadir la melaza, el huevo, el aceite y la leche.
Formar pequeñas bolitas. Hornear a 180 °C (20 min.) hasta dorar. Dejar enfriar por
completo.
Servir solamente si su gato se ha portado realmente bien.

Boulder Cat Food Company is committed to the health and well-being of all animal companions by creating only the best gourmet pet foods made from 100 percent meat.

Boulder Cat Food Company hat sich die Gesundheit und das Wohlbefinden sämtlicher tierischer Lebensgefährten auf ihre Fahnen geschrieben, indem nur das beste Gourmetfutter kreiert wird, das zu 100 Prozent aus Fleisch besteht.

Boulder Cat Food Company se dévoue à la santé et au bien-être de tous nos compagnons à quatre pattes en créant uniquement des aliments gourmets 100 pour cent viande pour animaux.

Boulder Cat Food Company se compromete con la salud y el bienestar de todos los compañeros animales, creando únicamente las mejores comidas de gourmet, hechas al 100 por ciento de carne.

Boulder Cat Food Company si impegna per la salute e il benessere di tutti i compagni animali creando solo i migliori cibi da gourmet, costituiti per il 100 percento da carne.

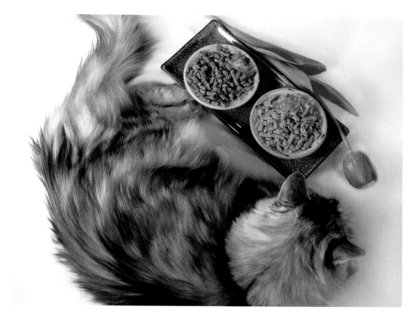

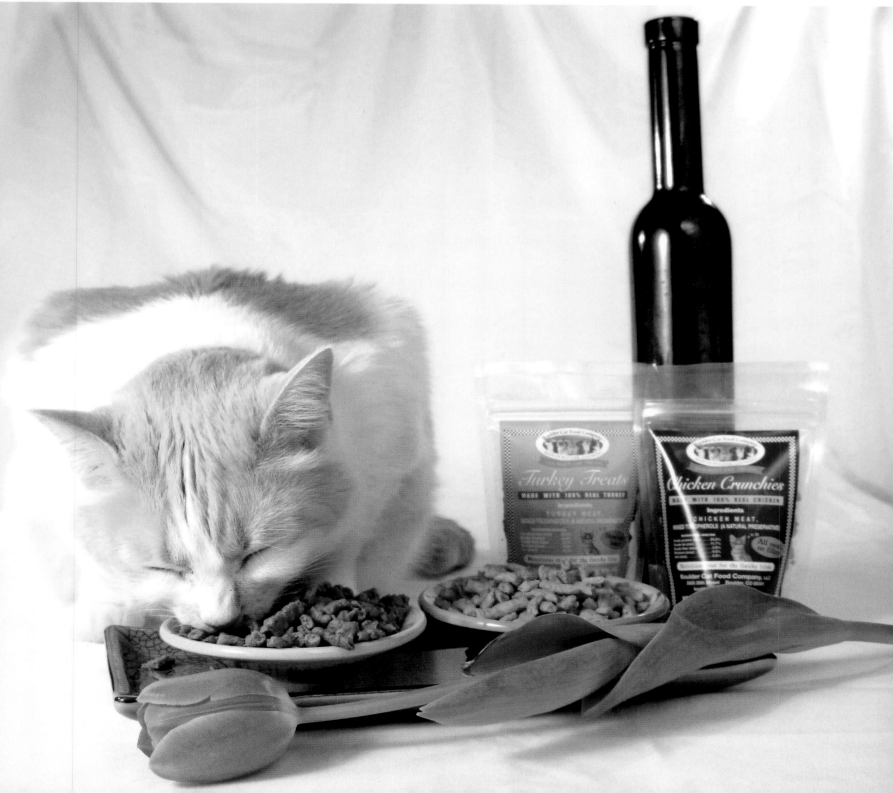

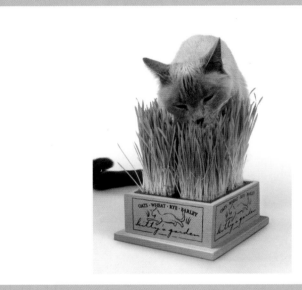

A substantial part of the $53 billion global marketplace spent on pets each year is targeting the rising number of health-conscious consumers who are willing to pay the premium for pet foods with superior nutrition of naturally-occurring vitamins, minerals and enzymes with human-quality ingredients.

Jedes Jahr werden weltweit 53 Milliarden Dollar in Tiernahrung umgesetzt. Ein bemerkenswerter Anteil davon zielt auf die steigende Zahl gesundheitsbewusster Verbraucher ab, welche bereit sind, einen Aufpreis für Futter zu zahlen, das mit natürlichen Vitaminen, Mineralien und Enzymen angereichert wird. Die Zutaten sind tatsächlich vergleichbar mit der Qualität der Nahrungsmittel für Menschen.

Une part substantielle du marché mondial de 53 milliards de dollars consacrés chaque année aux animaux est dépensée par le nombre croissant d'acheteurs soucieux de la santé de leurs compagnons, et prêts à mettre le prix pour des aliments aux qualités nutritives supérieures avec des vitamines, minéraux et enzymes naturels, équivalents aux produits destinés aux hommes.

Una parte sustancial de los 53 billones de dólares que se gastan cada año en el mercado global de las mascotas apunta a la creciente cantidad de consumidores atentos a la salud, dispuestos a pagar una suma adicional por una comida para animales con un valor nutritivo superior en vitaminas, minerales y enzimas naturales, con ingredientes de la calidad de los alimentos para humanos.

Una parte sostanziale dei 53 miliardi di dollari spesi ogni anno sul mercato degli animali domestici punta sul numero crescente di consumatori attenti alla salute, disposti a pagare il giusto prezzo per cibi per animali con supplemento di vitamine, minerali ed enzimi presenti in natura e con ingredienti di qualità tale da renderli adatti anche per i loro padroni.

Katie's Farm makes the best certified organic treats and is the only operation to grow its own high quality ingredients from their own garden; they slow oven bake their unique treats with recipes that have been carefully researched for the highest nutritional value.

Katie's Farm fertigt die besten Bioleckerlis und ist der einzige Betrieb, der seine eigenen Zutaten von höchster Qualität in seinem eigenen Garten anbaut. Die unvergleichlichen Leckerlis werden bei niedriger Hitze nach Rezepten gebacken, die sorgfältig unter Berücksichtigung des höchsten Nährwertes ausgewählt werden.

Katie's Farm fabrique les meilleures friandises certifiées bio ; elle est la seule entreprise à cultiver ses propres ingrédients de qualité dans son propre jardin. Les friandises sont cuites lentement au four, avec des recettes spécialement élaborées pour leur qualité nutritionnelle.

Katie's Farm produce las mejores delicias orgánicas certificadas y es el único establecimiento que cultiva sus propios ingredientes de calidad; cocinan lentamente sus exquisiteces únicas con recetas cuidadosamente seleccionadas de altos valores nutritivos.

Katie's Farm produce le migliori delizie biologiche certificate, ed è l'unica azienda che coltiva in proprio gli ingredienti di alta qualità nel proprio orto; prepara in forno a lenta cottura le sue delizie uniche, con ricette accuratamente ricercate per fornire un altissimo valore nutritivo.

Tiki's cat food formulas are made from the highest quality, human grade, whole seafood ingredients with the same aroma and appearance of canned food for humans.

Tiki's Katzenfutter ist von höchster Qualität und wird aus hochwertigsten, reinen Meeresfrüchten zubereitet. Das Futter entspricht dem Standard der Nahrungsmittel für Menschen und hat ein ähnliches Aroma und Aussehen wie die für den menschlichen Verzehr bestimmte Dosenkost.

Les formules alimentaires pour chats de Tiki sont fabriquées à base d'ingrédients à la qualité équivalente aux meilleurs produits pour la consommation humaine, avec des fruits de mer entiers, et le même arôme, la même apparence que les plats en conserve pour humains.

Las fórmulas de comidas para gatos de Tiki incluyen ingredientes y mariscos de la mejor calidad, a nivel humano, con el mismo aroma y el mismo aspecto de la comida en latas para los seres humanos.

Le formule del cibo per gatti di Tiki comprendono solo i migliori frutti di mare della più alta qualità, con lo stesso aroma e aspetto del cibo in scatola per consumatori umani.

Beauty &
Wellness

"Cats are rather delicate creatures and they are subject to a many ailments, but I never heard of one who suffered from insomnia."
Joseph Wood Krutch

There are countless new ways to pamper your beloved kitty, from a beautifying session at an exclusive cat spa to acupuncture from a homeopathic vet.

Es gibt zahlreiche neue Möglichkeiten, Ihr geliebtes Kätzchen zu verwöhnen; von einer Schönheitsbehandlung in einem exklusiven Spa für Katzen bis hin zur Akupunktur, ausgeführt von einem homöopathischen Tierarzt.

Il y a d'innombrables nouvelles manières de chouchouter votre chat adoré, de la séance de soins de beauté dans un spa exclusif à l'acupuncture chez un vétérinaire homéopathe.

Existen infinitas maneras para mimar a nuestro gatito adorado, desde una sesión de belleza en una spa exclusiva para gatos, hasta acupuntura por un veterinario homeopático.

Esistono infiniti modi per viziare il vostro adorato micio, da una sessione di bellezza di un centro benessere esclusivo per gatti all'agopuntura praticata da un veterinario omeopatico.

Beauty & Wellness

The classy cat knows how to take good care of itself; it thrives on plenty of sleep and is very picky when it comes to its eating and beauty regimen. Nevertheless, the pet industry now offers a multitude of services for continuing good health and appearance. The pet beauty industry aims to make cat owners feel as if they are giving extra tender loving care to their special furry friends with bath products made from organic and botanical ingredients found in the finest human shampoos and conditioners. A considerable number of cat owners today don't mind shelling out luxury prices for salon-quality pet products, such as lavender-infused aromatherapy soaps, hypoallergic shampoos, and cat wipes with aloe. And if luxury home spa products are not enough to indulge your kitty, pet spas today will send out a car service and pick up your feline and indulge them with a wide range of unique services such as pedicures for tired paws, cream conditioning massage treatments, and oatmeal baths for problem skin.

Cat owners also want the same first class health care for their pets that they want for their own family members. As Chinese acupuncture and various chiropractic techniques are becoming more accepted by humans, and cat owners are taking those healing practices to their furry friends. It's not uncommon for Dr. Fong, for instance, a certified acupuncturist through the International Veterinary Acupuncture Society, to do several such sessions a day on our four-legged felines.

The elaborate services now being offered to ensure their cat's quality of life not only means holistic and herbal remedies, but also includes psychotherapy and dental practices usually performed on human patients, such as braces to fix crooked teeth, root canals, and crowns for chipped teeth. For some pet lovers, no medical procedure is too extreme; there is a broad spectrum of treatments available for cancer and illnesses that require high-tech surgeries and state-of-the-art technology such as magnetic resonance imaging.

One might think the pampering of pets is getting out of hand when you look at the following new trend in kitty care: plastic surgeons are performing cat rhinoplasty, eye lifts, and other cosmetic procedures to help correct certain unwanted features. But the final question is settled by Neuticles, a patented testicular implant company that allows your cat to retain their natural look after being neutered. At about $1,000 a pair, many might think that no one would go this far to restore the masculine self-esteem and outer appearance of their cat, but tell that the quarter of million people who ordered this strange service for their neutered pets.

Schönheit & Wohlbefinden

Beauté & Bien-être

Die klassische Katze weiß, was das Beste für ihr Wohlbefinden ist; sie ist darauf bedacht, ausreichend Schlaf zu bekommen und sehr penibel, wenn es um Fressen und Schönheit geht. Nichtsdestotrotz bietet nun auch die Tierproduktindustrie zahlreiche Angebote zur Erhaltung der Gesundheit und des Erscheinungsbildes. Auf dem Beautyproduktesektor suggeriert die Tierindustrie den Katzenbesitzern, ihren pelzigen Freunden eine extra Portion Liebe geben zu können, indem sie die Tiere mit Badeprodukten aus pflanzlichen Inhaltsstoffen (aus kontrolliert biologischem Anbau!) verwöhnen, die auch in den edelsten Shampoos und Conditionern für Menschen zu finden sind. Eine beachtliche Anzahl von Katzenbesitzern hat heutzutage nichts dagegen, wahrlich luxuriöse Preise für Tierprodukte in Salonqualität zu zahlen, wie zum Beispiel mit Lavendel getränkte Aromatherapie-Seifen, hyperallergene Shampoos und Katzentücher mit Aloe Vera. Und falls luxuriöse Wellnessprodukte für zu Hause nicht ausreichen, um ihr Kätzchen zu verwöhnen, schicken Ihnen Tierwellnesscenter sogar einen Wagen, um Ihre Katze abzuholen und sie mit einer breiten Palette einzigartiger Serviceleistungen zu verwöhnen, wie beispielsweise Pediküre für müde Pfoten, Behandlungen mit einer Crememassage und Haferkleiebäder für die Problemhaut.

Katzenbesitzer wünschen für die Gesunderhaltung ihrer Katze dieselbe First-Class-Versorgung, die sie auch für ihre eigenen Familienmitglieder haben möchten. Da chinesische Akupunktur und diverse chiropraktische Techniken immer beliebter bei den Menschen werden, befürworten Katzenbesitzer diese Heilmaßnahmen auch für ihre pelzigen Freunde. Es ist zum Beispiel nichts Außergewöhnliches für Dr. Fong, ein durch die International Veterinary Acupuncture Society zertifizierter Akupunkteur, pro Tag mehrere solcher Sitzungen mit unseren Vierbeinern durchzuführen.

Die bis ins kleinste Detail durchdachten Dienstleistungen, die mittlerweile zur Erhaltung der Lebensqualität der Katze angeboten werden, beschränken sich nicht nur auf ganzheitliche Medizin und Kräuterheilmittel, sondern beinhalten auch Psychotherapie und zahntechnische Praktiken, die gewöhnlich bei menschlichen Patienten angewendet werden, wie beispielsweise Zahnspangen, um schiefe Zähne zu richten, Wurzelbehandlungen und Kronen für abgebrochene Zähne. Einige Tierliebhaber schrecken vor keiner noch so extremen medizinischen Prozedur zurück; es gibt ein breites Spektrum an Behandlungen für Krebs und Krankheiten, die nur in Hightech-Praxen durchgeführt werden können sowie innovative Technologien wie die bildgebende Kernspindtomographie.

Man könnte meinen, die Verhätschelung von Tieren gerät außer Kontrolle, wenn man den neuen Schönheitstrend für Katzen betrachtet: Schönheitschirurgen nehmen plastische Nasenoperationen an Katzen vor, Augen werden geliftet, und andere kosmetische Anwendungen unterstützen die Korrektur unerwünschter optischer Eigenschaften. Aber den Vogel schießt die Firma Neuticles ab, ein Unternehmen, das sich auf patentierte Implantate spezialisiert hat, die es ermöglichen, dass Ihr Kater sein natürliches männliches Aussehen behält, nachdem er kastriert wurde. Viele mögen annehmen, der Preis von ungefähr 1.000 Dollar pro Paar würde die Leute abschrecken, das männliche Selbstwertgefühl und Erscheinungsbild ihres Katers wiederherzustellen ... Aber sagen Sie das mal den Viertelmillionen Menschen, die diesen befremdlichen Service bereits für ihre kastrierten Tiere in Anspruch genommen haben.

Le chat élégant sait comment prendre soin de lui-même : il a besoin de beaucoup de sommeil et il devient très difficile quand il s'agit de sa nourriture et de sa beauté. Néanmoins, le secteur animalier propose maintenant une multitude de services pour une bonne santé et une belle apparence. Le secteur de la beauté animalière tend à faire penser aux maîtres de chat qu'ils montrent encore plus d'affection à leur ami à fourrure en lui offrant des produits de bain faits d'ingrédients biologiques et végétaux utilisés dans les shampooing et après-shampooings pour humains. Un nombre considérable de maîtres de chats n'hésite pas à dépenser des sommes faramineuses pour des produits pour animaux de qualité équivalente à celle des salons, comme des savons d'aromathérapie parfumés à la lavande, des shampooings hypoallergéniques, et des serviettes à l'aloe vera. Et si les produits de spa luxueux à domicile ne suffisent pas à contenter votre chat, les spas pour animaux enverront un véhicule chercher votre félin pour lui offrir une large gamme de services uniques comme la pédicure pour les pattes fatiguées, des massages avec crème et des bains de flocons d'avoine pour les peaux à problèmes.

Les propriétaires de chats veulent aussi pour leurs animaux les mêmes soins de première classe que pour les membres de leur propre famille. Alors que l'acupuncture chinoise et les diverses techniques de chiropractie sont de plus en plus acceptées par les humains, les maîtres de chats appliquent ces techniques de soin à leurs amis à fourrure. Il n'est pas inhabituel pour le Dr. Fong, par exemple, un acupuncteur certifié par l'International Veterinary Acupuncture Society, de pratiquer plusieurs sessions par jours sur des félins.

Les services élaborés offerts pour assurer la qualité de vie des chats ne se limitent plus aux soins holistiques et phytothérapiques, mais s'étendent aussi à la psychothérapie et aux pratiques dentaires habituellement réservées aux humains, comme les appareils dentaires pour réparer les dents tordues, les traitements des racines, et les couronnes pour dents abîmées. Pour certains amoureux des animaux, aucune procédure médicale n'est trop extrême : il y a un large spectre de traitements disponibles pour le cancer et les maladies qui demandent des opérations high-tech et des technologies de pointe comme l'IRM.

On pourrait penser que les efforts pour dorloter les animaux sont devenus incontrôlables quand on voit les nouvelles tendances des soins pour chats : des chirurgiens esthétiques pratiquent des rhinoplasties félines, des liftings des paupières, et autres procédures plastiques pour corriger certains traits indésirables. Mais la question finale est réglée par Neuticles, une société qui a breveté un implant testiculaire permettant à votre chat de garder son aspect naturel après castration. A environ 1000 $ la paire, beaucoup pourraient penser que personne n'irait aussi loin pour restaurer la confiance virile et l'apparence extérieure de leur matou, mais allez dire cela aux 250 000 personnes qui ont commandé cet étrange service pour leur chat castré.

Belleza & Bienestar

Con su clase, el gato sabe cómo cuidar de sí mismo: le encanta dormir mucho y es muy exigente a la hora de comer y ocuparse de su belleza. Afortunadamente, la industria de artículos para animales ofrece hoy multitud de servicios para mantener la salud y el buen aspecto. La industria para animales domésticos intenta hacer que los amos se sientan como si les estuvieran regalando un cuidado y una ternura extra, con productos de baño hechos con los mismos ingredientes orgánicos y biológicos que se encuentran en champúes y acondicionadores para las personas. Hoy en día, a muchos propietarios de gatos no les importa afrontar precios de lujo en productos de calidad profesional como jabones de aromaterapia con olor a lavanda, champúes hipoalergénicos y toallitas humedecidas con aloe. Y si los productos para uso doméstico no son suficientes para gratificar a nuestro gato, hoy los spas ofrecen un servicio de recogida en coche para conceder a nuestro felino una amplia variedad de servicios únicos como pedicura para zarpas cansadas, tratamientos de masaje con cremas acondicionadoras y baños de avena para los problemas de piel.

Los propietarios quieren para sus gatos las mismas curas reservadas a los miembros de la familia. Conforme se aceptan la acupuntura china y varias terapias quiroprácticas, los mismos métodos curativos se extienden a nuestros amigos de cuatro patas. No es raro para el Dr. Fong, por ejemplo, acupuntor certificado por la Sociedad Internacional de Acupuntura Veterinaria, efectuar varias sesiones cada día sobre pacientes felinos.

Los elaborados servicios ofrecidos hoy en día para asegurar la calidad de vida de los gatos comprenden no solo remedios holísticos y de herbolario, sino también las mismas psicoterapias y prácticas dentales de los humanos, como ortodoncias, empastes y coronas para dientes careados. Para algunos amantes de los animales, no hay procedimientos médicos demasiado extremos; existe una amplia gama de tratamientos contra el cáncer y enfermedades que requieren cirugía avanzada y moderna tecnología, como la resonancia magnética.

Podríamos pensar que nos estamos excediendo mimando a los animales si nos fijamos en las últimas tendencias: cirujanos plásticos que realizan rinoplastias para gatos, estiramientos de la piel que rodea los ojos y otros procedimientos cosméticos para corregir rasgos no deseados. La cuestión se decide definitivamente con Neuticles, una compañía de implantes testiculares patentados que permite a nuestro gato mantener su aspecto natural después de la castración. A unos 1.000 dólares la pareja, muchos pensarán que nadie llegaría a tanto para restablecer la autoestima masculina y el aspecto exterior de un gato, pero las 250.000 personas que pidieron este insólito servicio son de otra opinión.

Bellezza & Wellness

Il gatto di classe sa come prendersi cura di sé; si concede sonno in abbondanza e diventa molto esigente quando si tratta di mangiare e di trattamenti di bellezza. Nonostante ciò, l'industria degli animali domestici offre ora una moltitudine di servizi per la cura della salute e dell'aspetto fisico. L'industria della bellezza per animali domestici mira a far sentire ai proprietari di gatti come se stessero dando un extra di cure amorose ai loro speciali amici dal manto vellutato, con prodotti per il bagno composti da ingredienti organici e botanici che si trovano nei migliori shampoo e balsami per gli umani. Una quantità considerevole di proprietari di gatti non esita a sborsare delle somme ingenti per prodotti da salone di bellezza, come saponi per l'aromaterapia agli infusi di lavanda, shampoo ipoallergenico e salviette per gatti all'aloe. E se i lussuosi prodotti per le cure di bellezza casalinghe non bastassero a viziare il vostro gattino, oggi i centri benessere manderanno una vettura con autista a prendere il vostro felino e viziarlo con un'ampia gamma di servizi specializzati come la pedicure per zampe affaticate, i trattamenti di massaggio con creme tonificanti e i bagni d'avena per problemi cutanei.

I proprietari di gatti cercano per i loro amati cuccioli gli stessi trattamenti di prima classe riservati ai membri della loro stessa famiglia. Mentre l'agopuntura cinese e le diverse terapie chiropratiche vengono sempre più accettate dagli umani, i proprietari di gatti estendono le stesse pratiche guaritrici ai loro piccoli amici dal manto vellutato. Non è inusuale che il Dr. Fong, ad esempio, un agopuntore certificato dalla International Veterinary Acupuncture Society (Società Internazionale per l'Agopuntura Veterinaria), esegua diverse sedute al giorno sui nostri amici a quattro zampe.

Gli elaborati servizi offerti al giorno d'oggi per assicurare la qualità di vita dei gatti non significano solo rimedi olistici e a base di erbe, ma includono anche la psicoterapia e le cure dentali riservate normalmente a pazienti umani, come apparecchi per raddrizzare denti irregolari, otturazioni per le radici e capsule per denti scheggiati. Per alcuni amanti dei gatti, nessuna procedura medica è troppo esagerata; esiste un'ampia gamma di trattamenti disponibili per il cancro e altre malattie, che richiedono delle operazioni di chirurgia high-tech e tecnologie in piena regola, come la risonanza magnetica.

Viene da pensare che si stia esagerando con la cura degli animali domestici se si guarda a tutte le nuove tendenze nel campo delle cure per gattini: chirurghi plastici che eseguono procedure di rinoplastica e lifting oculare e altre operazioni cosmetiche mirate a correggere caratteristiche indesiderate. Ma il culmine si raggiunge con Neuticles, una società di impianti testicolari brevettati che permette al vostro gatto di mantenere il suo look naturale dopo la castrazione. Al prezzo di circa 1.000 dollari al paio, molti potrebbero credere che nessuno arriverebbe a tanto pur di ripristinare l'autostima maschile e l'aspetto esteriore del proprio gatto, ma ditelo alle 250.000 persone che hanno ordinato questo strano servizio per i loro gatti castrati.

These pet beauty products were all created with the health of your cat and the environment in mind. Products from companies such as earthbath, Happytails, and Cat Faeries represent a high quality line of all-natural pet care that offer solutions for the unique needs of your cat. All of these products offer elements reserved for the most exclusive spa treatments for humans, such as coat conditioning with natural ingredients or exclusive aromatherapy essences with natural oils.

Diese Beautyprodukte für Katzen werden unter Berücksichtigung der Gesunderhaltung Ihrer Katze sowie der Umweltverträglichkeit auf sorgfältige Weise erzeugt. Produkte der Firmen earthbath, Happytails und Cat Faeries stehen für eine hochwertige Serie natürlicher Tierpflegeprodukte, welche Lösungen für die einzigartigen Bedürfnisse Ihrer Katze bieten. All diese Produkte beinhalten Dinge, die sonst nur den exklusivsten Behandlungen in den Wellness-Centern für Menschen vorbehalten sind; zum Beispiel Fellpflege mit natürlichen Inhaltsstoffen oder exklusive Aromatherapieessenzen mit natürlichen ätherischen Ölen.

Ces produits de beauté pour animaux ont tous été créés avec le bien-être de votre chat et l'environnement à l'esprit. Des compagnies telles qu'earthbath, Happytails et Cat Faeries proposent une gamme de produits de soins de qualité entièrement naturels qui résolvent les problèmes spécifiques de votre chat. Tous ces produits contiennent des éléments utilisés dans les traitements de spa pour humains les plus exclusifs, comme le démêlant pour pelage aux ingrédients naturels ou les essences d'aromathérapie à base d'huiles naturelles.

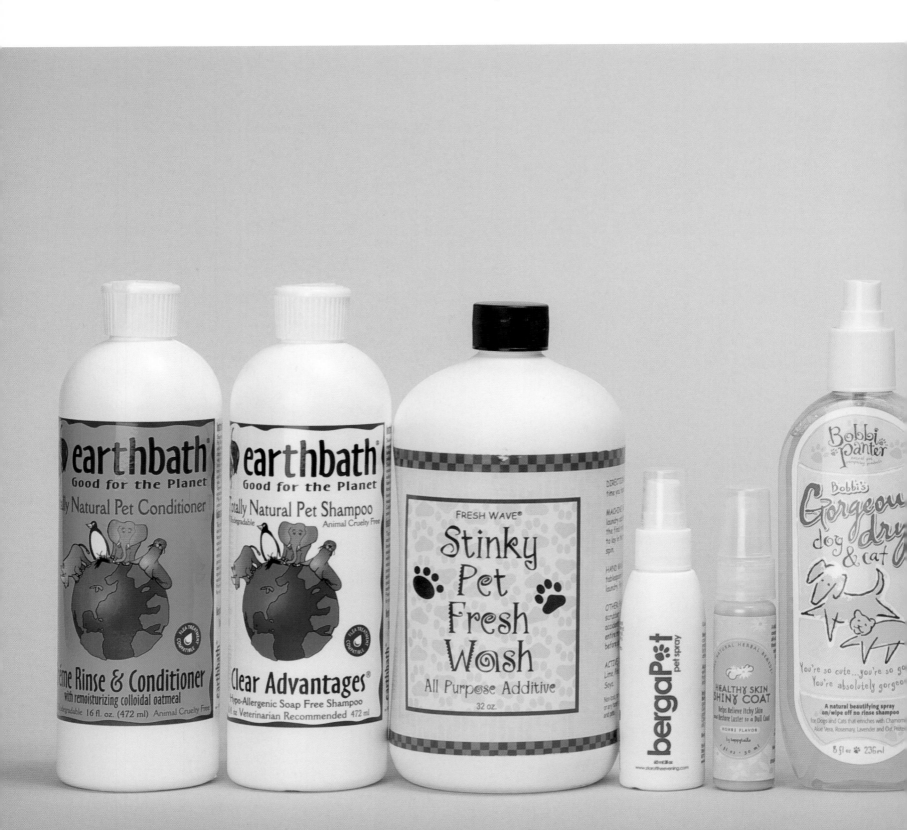

Todos estos productos de belleza para mascotas fueron creados pensando en la salud de nuestro gato y en el medio ambiente. Productos de casas como earthbath, Happytails, y Cat Faeries representan una línea de alta calidad para el cuidado natural de los animales, que ofrece soluciones para las exigencias únicas de nuestro gato. Todos estos productos ofrecen elementos reservados para los tratamientos spa más exclusivos para humanos, como acondicionamiento del pelo con ingredientes naturales, o bien esencias exclusivas para la aromaterapia con aceites naturales.

Questi prodotti per animali domestici sono stati creati tenendo presente la salute del vostro gatto ma anche dell'ambiente. Prodotti di aziende come earthbath, Happytails, and Cat Faeries presentano linee di alta qualità per la cura naturale al 100 percento, offrendo soluzioni per le esigenze esclusive del vostro gatto. Tutti i prodotti contengono elementi che sono riservati ai più esclusivi centri benessere per umani, come il trattamento della pelliccia con ingredienti naturali o delicate essenze per l'aromaterapia con oli naturali.

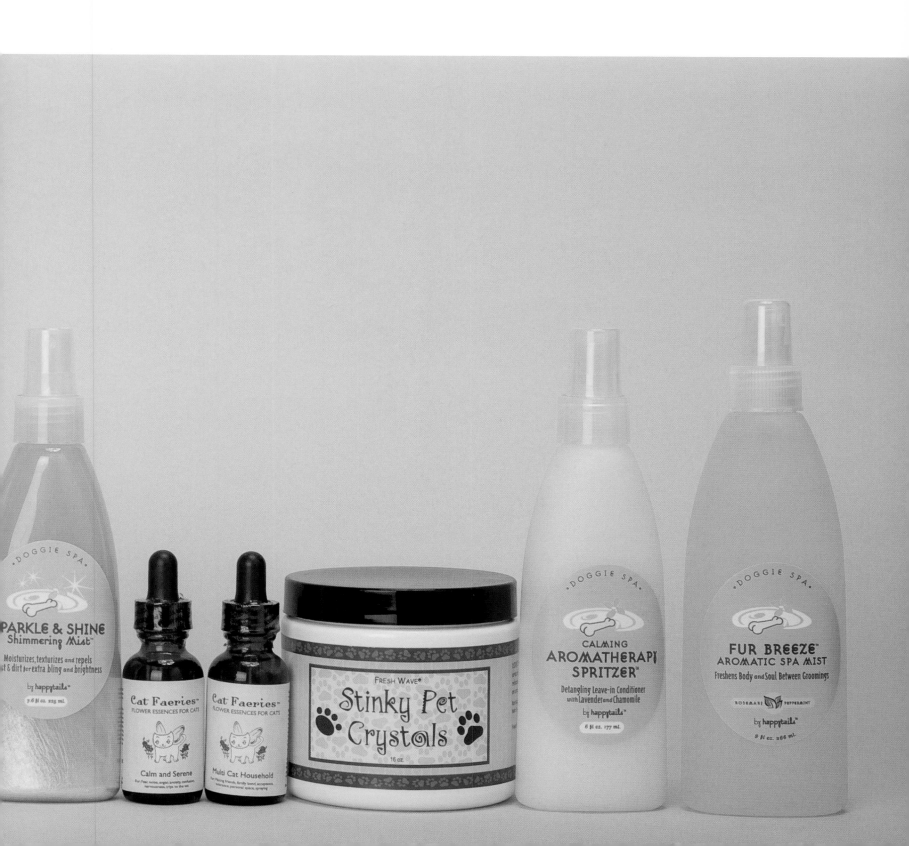

Many boutiques such as kit'n k'poodle offer not only personalized skilled grooming services with holistic shampoos and the most innovative techniques for all breeds, but extras such as an aromatic herbal rinse, cream conditioning, and professional styling with power drying.

Viele Geschäfte wie kit'n k'poodle bieten nicht nur persönliche Pflegeleistungen mit Shampoos, die dem holistischen Konzept entsprechen, und innovativste Technik für alle Rassen an, sondern auch Extras wie aromatische Kräuterspülungen, Cremepflege und professionelles Styling mit anschließendem Powerföhnen.

De nombreuses boutiques comme kit'n k'poodle proposent non seulement des services de toilettage personnalisés avec des shampooings traitants et les techniques les plus innovantes pour toutes les races, mais aussi des petits plus comme le rinçage aromatique aux herbes, l'après-shampooing et le coiffage professionnel au sèche-cheveux.

Muchas boutiques, como kit'n k'poodle, no sólo brindan servicios de cuidado personalizados y calificados con champús holísticos y las técnicas más innovadoras para todas las razas, sino también extras como el aclarado con hierbas aromáticas, cremas acondicionadoras y peinado profesional con secado.

Molte boutique, come kit'n k'poodle, offrono non solo servizi di cura personalizzati e qualificati con detergenti olistici e le tecniche più innovative per tutte le razze, ma anche servizi extra come il risciacquo con erbe aromatiche, il trattamento con creme e la pettinatura professionale con turboasciugatura.

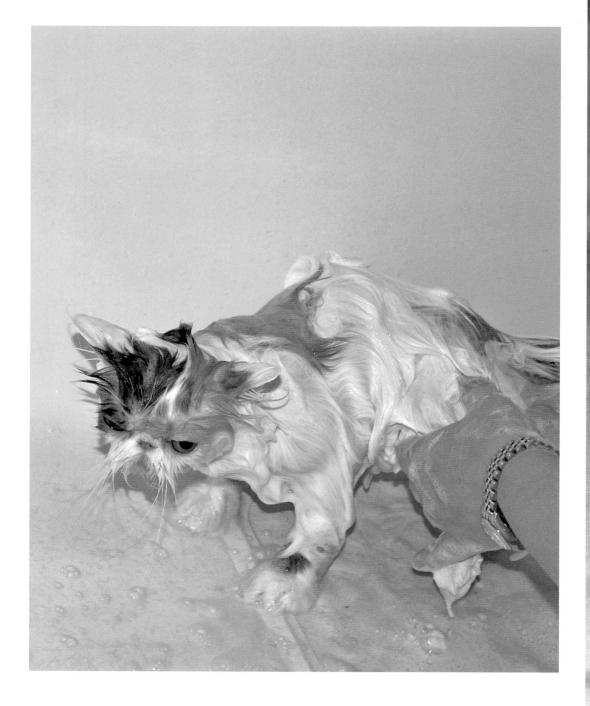

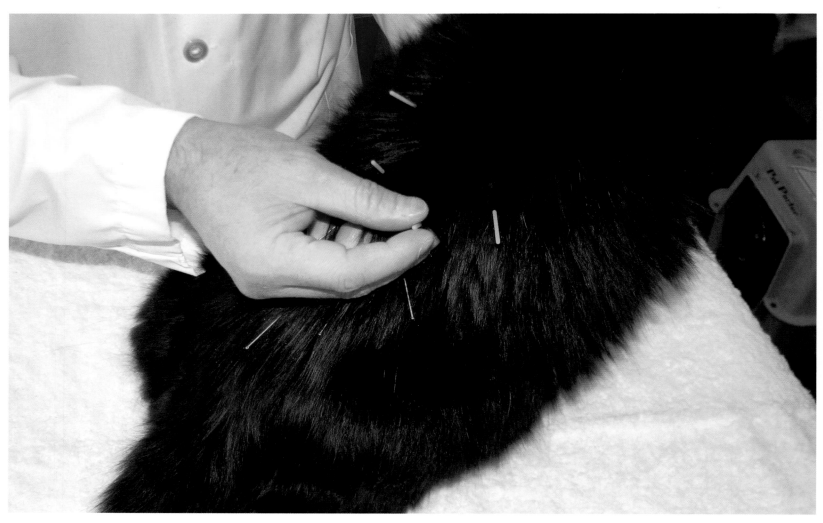

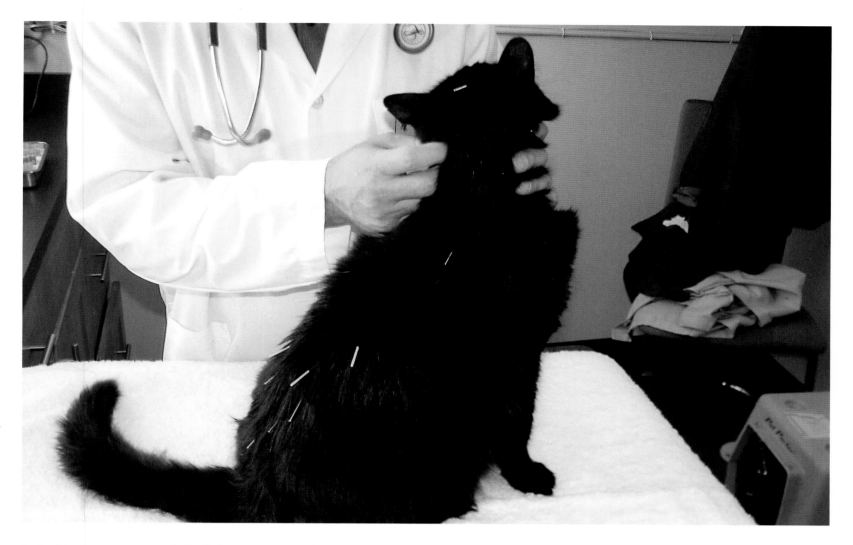

Dr. David Fong is part of a new field of holistic veterinarians who are dedicated to exploring new and different modalities to help heal ailments, including acupuncture, Chinese Herbal Medicine, chiropractic, nutritional guidance, and Contact Reflex Analysis.

Dr. David Fong gehört zur neuen Generation ganzheitlich orientierter Tierärzte, die sich neue Möglichkeiten zur Heilung unterschiedlichster Gebrechen zum Ziel gesetzt haben. Dazu gehören Akupunktur, traditionelle Chinesische Medizin, Chiropraktik, Ernährungsberatung und Reflexzonenanalyse.

Le Dr. David Fong fait partie d'un nouveau groupe de vétérinaires polyvalents qui se dévouent à la recherche de nouvelles méthodes de soigner les maladies : acupuncture, phytothérapie chinoise, chiropraxie, conseils nutritionnels et réflexothérapie.

El Dr. David Fong pertenece al nuevo campo de los veterinarios holísticos, dedicados a explorar nuevas y diferentes modalidades para ayudar a curar las enfermedades, utilizando entre otras técnicas, acupuntura, medicina herbal china, quiropráctica, orientación nutricional y análisis de los reflejos de contacto.

Il Dott. David Fong fa parte del nuovo settore dei veterinari olistici, dediti a esplorare nuove e diverse modalità terapeutiche, compresa l'agopuntura, la medicina erboristica cinese, la chiropratica, la consulenza nutrizionale e l'analisi riflessologica a contatto.

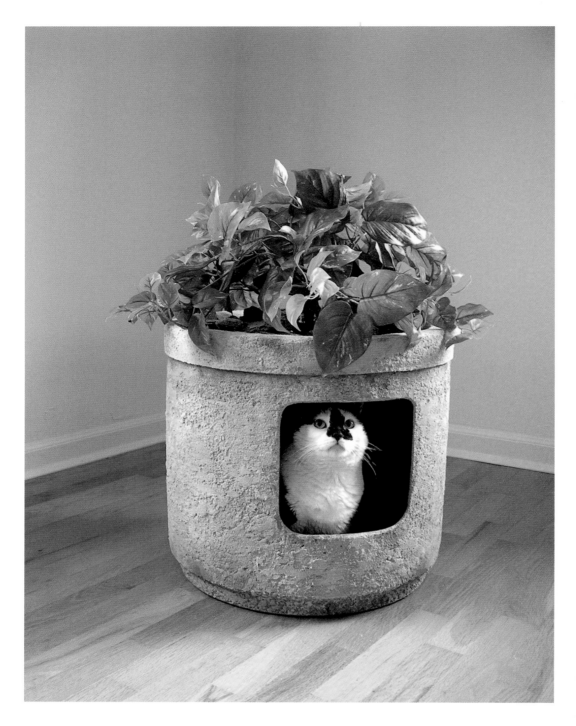

There are many creative ways to hide the unsightly litter box, such as this large litter 'pot' that holds plants, or these fun covered easy-to-clean trays from Kitty a GoGo.

Il existe de nombreuses manières créatives de cacher un bac à litière inesthétique, comme ce grand pot qui contient des plantes, ou ces casiers amusants faciles à nettoyer de Kitty a GoGo.

Es gibt viele kreative Möglichkeiten, die hässliche Katzentoilette zu verstecken. Eine ist dieser große Pflanzentopf, eine andere sind die lustig beschichteten und leicht zu reinigenden Wannen von Kitty a GoGo.

Existen varias maneras creativas para ocultar la antiestética cajita de las necesidades, como esta voluminosa "maceta", con plantas y todo, o las divertidas bandejas, sencillas para limpiar, de Kitty a GoGo.

Esistono diversi modi creativi per nascondere l'inestetica cassetta per i bisogni, come questo "pentolone" che occulta la cassetta tra le piante, o le cassette dai simpatici rivestimenti e facili da pulire di Kitty a GoGo.

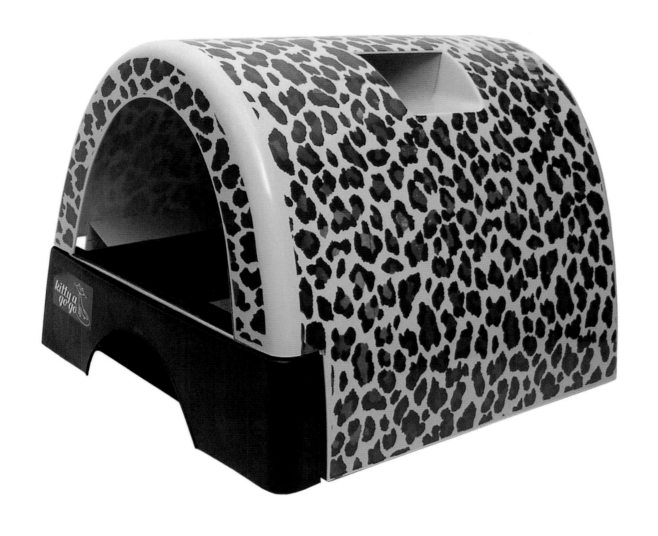

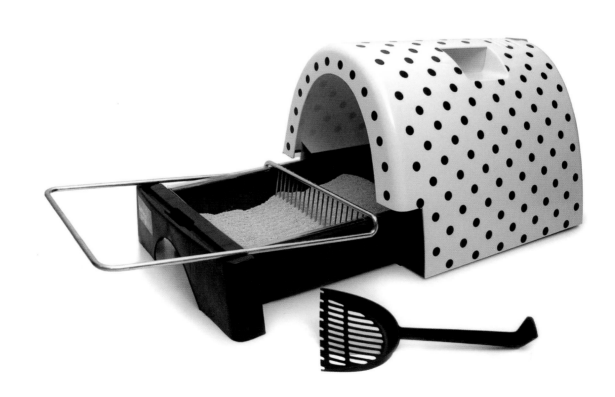

Existing products such as litter scoopers and trays are being revamped and retooled to attract the attention of cat owners who prefer high style over function.

Für Katzenbesitzer, welche Styling über Funktionalität stellen, wurden bestehende Produkte wie Katzentoiletten und -wannen aufgepeppt und umfunktioniert, um sie attraktiver zu gestalten.

Des produits classiques tels que pelles et bacs à litières sont retravaillés et relookés pour attirer les propriétaires de chats qui font passer le style avant la fonctionnalité.

Los productos existentes, como paletitas y bandejas para las necesidades se renuevan y se reequipan para llamar la atención de los amos de gatos que prefieren el estilo antes que la funcionalidad.

I prodotti esistenti come palette e vassoi per le cassette sono stati rinnovati e riattrezzati per piacere a quei proprietari di gatti per cui uno stile impeccabile viene prima della funzionalità.

A current survey estimated that more than 97 percent of all pet owners admitted to having offered a gift to their furry feline on special occasions before. New exclusive lines of unique beauty products targeted to cats, such as *Sexy Beast* designed by Karim Rashid or the *Oh My Cat* perfume, are profiting from this explosion in the pet gift market.

Eine aktuelle Erhebung ergab, dass mehr als 97 Prozent aller Tierhalter zugeben, ihrer Katze bereits ein Geschenk zu besonderen Anlässen gemacht zu haben. Neue exklusive Beautyproduktserien, speziell für Katzen, wie *Sexy Beast*, entwickelt von Karim Rashid, oder das *Oh-My-Cat*-Parfum, profitieren von diesem Boom auf dem Tiergeschenkmarkt.

Selon une étude récente, plus de 97 pour cent des propriétaires d'animaux admettent avoir déjà offert un cadeau à leur félin pour des occasions particulières. De nouvelles gammes de produits de beauté réservés aux chats, comme le *Sexy Beast* de Karim Rashid ou le parfum *Oh My Cat* profitent de ce boom du marché des cadeaux pour animaux.

Una reciente encuesta determina que más del 97 por ciento de los propietarios de mascotas ha admitido haber hecho algún regalo a su compañero felino en ocasiones especiales en el pasado. Nuevas líneas exclusivas de productos de belleza únicas destinadas a los gatos, como *Sexy Beast*, diseñado por Karim Rashid, o el perfume *Oh My Cat*, aprovechan de la explosión en el mercado de regalos para mascotas.

Un recente sondaggio ha stimato che oltre il 97 percento di tutti i proprietari di animali domestici ammette di aver offerto un regalo al loro amico felino in occasioni speciali. Nuove linee esclusive di prodotti di bellezza unici che puntano ai gatti, come *Sexy Beast*, disegnata da Karim Rashid, o il profumo *Oh My Cat* approfittano di questo boom nel mercato dei regali per animali.

Revolutionary new pet products now aim to help cat owners help make their little ones look their very best, such as this professional grooming tool from FURminator that reduces shedding up to 90 percent.

Revolutionäre neue Tierprodukte zielen mittlerweile darauf ab, die Katzenbesitzer dabei zu unterstützen, dass ihre süßen Kleinen perfekt aussehen. Eine große Hilfe bei der Fellpflege ist dieses professionelle Utensil von FURminator. Das Haaren Ihrer Katze wird bis zu 90 Prozent reduziert.

Grâce à de nouveaux produits révolutionnaires, les maîtres attentionnés peuvent désormais aider leurs petits compagnons à paraître au mieux de leur forme, notamment avec cet instrument de toilettage professionnel de chez FURminator qui réduit la desquamation jusqu'à 90 pour cent.

Los nuevos revolucionarios productos para animales domésticos se proponen ayudar a los propietarios para que sus pequeños amigos tengan un aspecto inmejorable, como este instrumento de cuidado profesional de FURminator, que reduce las pérdidas de pelo hasta el 90 por ciento.

Los nuevos revolucionarios productos para animales domésticos se proponen ayudar a los propietarios para que sus pequeños amigos tengan un aspecto inmejorable, como este instrumento de cuidado profesional de FURminator, que reduce las pérdidas de pelo hasta el 90 percento.

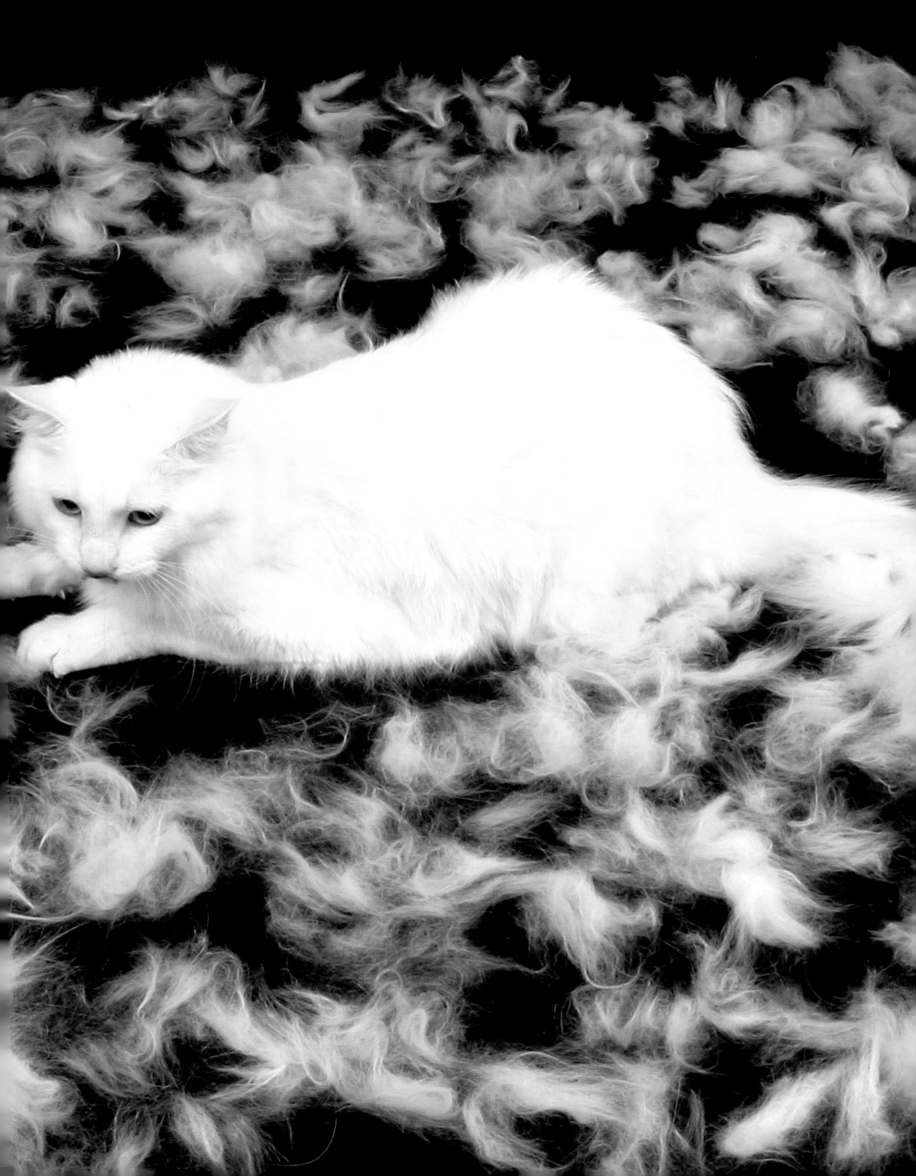

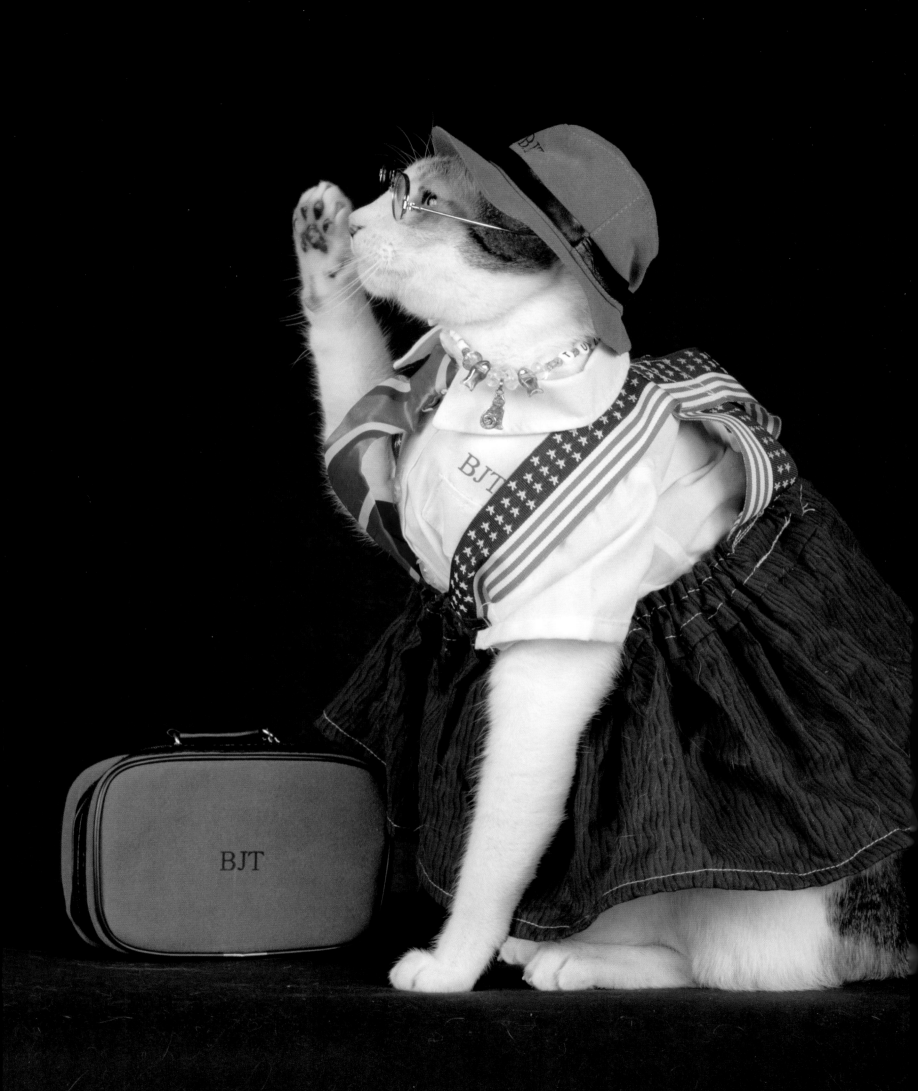

Travel

"Dogs have owners, cats have staff."

Unknown

Most people love to travel with their best friend, even if that best friend has four legs.

Die meisten Menschen lieben es, mit ihrem besten Freund zu verreisen, selbst wenn der beste Freund vier Beine hat.

La plupart des gens aiment voyager avec leur meilleur ami, aussi quand leur meilleur ami a quatre pattes.

Muchos prefieren viajar con su mejor amigo, aunque este mejor amigo ande en cuatro patas.

Molti amano viaggiare con il loro migliore amico, anche se il migliore amico ha quattro zampe.

Travel

The long-awaited summer finally arrives and I want to pack up my bags and head out for my yearly vacation. But then the inevitable happens. My cat Sushi freaks out when she sees my suitcase, knowing she will soon be left behind to be cared for by my reluctant friend. But today that anxiety is finally put to rest. There are more than enough suitable places that accommodate a furry feline, and not just your run of the mill cattery. All traveling cat owners can revel in another new revolution in the pet industry: cat boarding 'homes' and pet hotels with plush private suites that offer personal pet-sitting and spa services. There are even services that place your feline with host families, or home-based programs for overnight boarding for those cats that suffer from separation anxiety or stress-induced disorders.

Thanks to some very creative kitty hoteliers, staying at the local cattery is no longer a forced prison sentence for the beloved cat. New pet hotels provide games for daily exercise, grooming, camps and 'pet parties' for socializing, and even an on-site vet to deal with medical conditions and watch pets with special needs. These establishments consider the emotional well-being, health, and happiness of each pet with personalized service and care.

We live in an age where jet-setters and global nomads with disposable income have the possibility to be indulgent toward their feisty felines. Today even major luxury hotel chains are starting to feed that growing trend; resorts offer pet taxi services to grooming appointments, hotel room numbers with their names are imprinted on gold-plated tags, and kitty cuisine is served on hand-painted ceramic plates. Some hotels boast an assortment of toys and plenty of delicious snacks—even delicacies such as caviar—all designed to please the discriminating tastes of the sophisticated cat and its luxury-minded owner.

The boarding services and pet hotel accommodations are so appealing to my cat that nowadays she sincerely looks forward to checking into her exclusive kitty condo to chill with her jet-set posse. Her leisurely days at the pet hotel are spent lounging around in a heated lambskin bed as she awaits her next playtime appointment, nibbling on salmon treats as she watches the Animal Planet on her own personal TV. Now when she sees me pull out my suitcase from the closet, she frantically races toward her carrier and jumps happily into her travel bag. Let's hope the condition doesn't become so lavish at these pet hotels that I have to deal with an unhappy cat returning back home.

Reise

Endlich ist der lang ersehnte Sommer da. Jetzt möchte ich meine Koffer packen und meinen Jahresurlaub antreten. Aber dann passiert das Unvermeidliche. Meine Katze Sushi flippt völlig aus, wenn sie meinen Koffer sieht, weil sie weiß, dass sie bald zurückgelassen wird, um von meiner widerwilligen Freundin versorgt zu werden. Nun hat diese Angst ein Ende. Es gibt mehr als genug geeignete Plätze, die einen Stubentiger beherbergen können, als ausschließlich Ihre mittelmäßige, normale Katzenpension. Alle reisenden Katzenbesitzer können die neue Revolution der Tierindustrie feiern: Katzenpensionen und Tierhotels mit vornehmen Privatsuiten, die persönliches Petsitting und Wellness anbieten. Es gibt sogar die Möglichkeit, ihre Katze in einer Gastfamilie unterzubringen oder Angebote für Zuhause mit Übernachtungsservice für Katzen, die unter Trennungsängsten leiden beziehungsweise unter stressbedingten Verhaltensstörungen.

Dank einiger sehr kreativer Hoteliers, die sich auf das Wohl unserer Stubentiger spezialisiert haben, gleicht der Aufenthalt in der ortsansässigen Katzenpension nicht mehr länger dem gezwungenermaßen erteilten Urteil zu einer Gefängnisstrafe für Ihre geliebte Katze. Neue Tierhotels haben Spiele in ihrem Angebot für die tägliche Fitness, Fellpflege, Camps und „Tierparties" zum Knüpfen von Kontakten mit anderen Tieren und sogar eine medizinische Betreuung vor Ort inklusive der Überwachung von Tieren mit besonderen Bedürfnissen. Diese Einrichtungen berücksichtigen das emotionale Wohlbefinden, die Gesundheit und die Zufriedenheit eines jeden Tieres durch eine persönliche Betreuung und Pflege.

Wir leben in einem Zeitalter, wo Jetsetter und Weltenbummler mit einem frei verfügbaren Einkommen die Möglichkeit haben, zügellos die Bedürfnisse ihrer launischen Samtpfötchen zu befriedigen. Es gibt heute sogar einschlägige Luxushotelketten, die beginnen, sich auf diesen steigenden Trend einzustellen; Resorts bieten einen Tiertaxiservice zu Fellpflegeterminen an, Hotelzimmernummern mit ihren Namen werden in vergoldete Schilder gestanzt und Haute Cuisine für den verwöhnten Katzengaumen wird auf handbemalten Keramiktellern serviert. Einige Hotels rühmen sich mit einer Auswahl an Spielsachen und köstlichen Snacks in Hülle und Fülle — sogar Delikatessen wie Kaviar — alles darauf abgestimmt, die kritischen Geschmäcker der anspruchsvollen Katze und ihres luxusorientierten Besitzers zu befriedigen.

Die Unterbringung und Leistungen im Tierhotel gefallen meiner Katze so gut, dass sie sich aufrichtig auf das Einchecken in ihrem exklusiven Katzenstudio freut, um mit ihrer Jetset-Truppe mal wieder so richtig zu chillen. Ihre gemächlichen Tage im Tierhotel verbringt sie mit Herumlungern auf einem beheizten Lammfellbett, während sie auf ihren nächsten Spieltermin wartet. Währenddessen knabbert sie Lachsleckereien und guckt „Animal Planet" auf ihrem eigenen TV-Gerät. Wenn sie jetzt sieht, dass ich meinen Koffer aus dem Schrank hole, rast sie wie wahnsinnig zu ihrem Rollwagen und springt überglücklich in ihre Reisetasche. Hoffen wir mal, dass die Bedingungen in diesen Tierhotels nicht so ansprechend werden, dass ich mich eines Tages mit einer unglücklichen Katze herumplagen muss, wenn ich sie wieder zurück nach Hause bringe.

Voyage

L'été longtemps attendu arrive enfin et je veux faire mes bagages et partir pour mes congés annuels. Mais l'inévitable arrive. Ma chatte Sushi devient folle quand elle voit ma valise, sachant qu'elle sera bientôt laissée de côté, et gardée par un ami réticent. Mais aujourd'hui enfin l'anxiété n'est plus de mise. Il existe quantité de lieux convenables pour accueillir un félin à fourrure, et qui ne se limitent pas aux pensions ordinaires. Tous les maîtres de chats qui voyagent peuvent révéler une autre révolution du secteur animalier : les pensions et hôtels avec suites privées pour chats qui proposent du cat-sitting personnalisé et des services de spa. Il existe même des services qui placent votre félin en famille d'accueil, ou des programmes à domicile pour garder toute la nuit ces félins qui souffrent d'anxiété due à la séparation ou de troubles du comportement liés au stress.

Grâce à certains hôteliers pour chats très créatifs, le séjour dans une pension locale n'est plus une sentence de prison pour notre animal bien-aimé. Les nouveaux hôtels pour chats proposent des jeux pour l'exercice quotidien, des services de toilettage, des activités camping et des « fêtes d'animaux » pour qu'ils se socialisent, et disposent même d'un vétérinaire sur place pour s'occuper des problèmes de santé et surveiller les animaux ayant des besoins particuliers. Ces établissements prennent en compte le bien-être émotionnel, la santé et le bonheur de chaque animal avec des services et soins spécialisés.

Nous vivons à une époque où les jet-setters et les nomades mondiaux aux revenus confortables ont la possibilité de satisfaire les caprices de leurs félins. De nos jours, même les plus grandes chaînes hôtelières de luxe commencent à suivre cette tendance : les centres proposent des services de taxi pour des rendez-vous chez le toiletteur, des numéros de chambres d'hôtels avec leurs noms imprimés sur des étiquettes en plaqué or, et la cuisine pour chat est servie sur des assiettes en céramique peintes à la main. Certains hôtels proposent un assortiment de jouets et toutes sortes de délicieuses bouchées — avec parfois même du caviar — tous conçus pour satisfaire le palais délicat du chat sophistiqué et de son maître amateur de luxe.

Les services de pension et les hôtels pour animaux attirent tellement ma chatte qu'aujourd'hui elle attend vraiment avec impatience sa réservation dans sa copropriété réservée aux chats pour traîner avec ses potes de la jet-set. Son séjour à l'hôtel se passe étendue dans un lit chauffé en peau d'agneau en attendant son prochain rendez-vous de jeu, et à grignoter des friandises au saumon en regardant Animal Planet sur sa propre télé. Maintenant quand elle me voit sortir ma valise du placard, elle court comme une folle jusqu'à sa poussette et saute joyeusement dans son sac de voyage. Espérons que les conditions d'accueil à l'hôtel ne deviennent pas si raffinées que j'aie à m'occuper d'un chat malheureux de son retour.

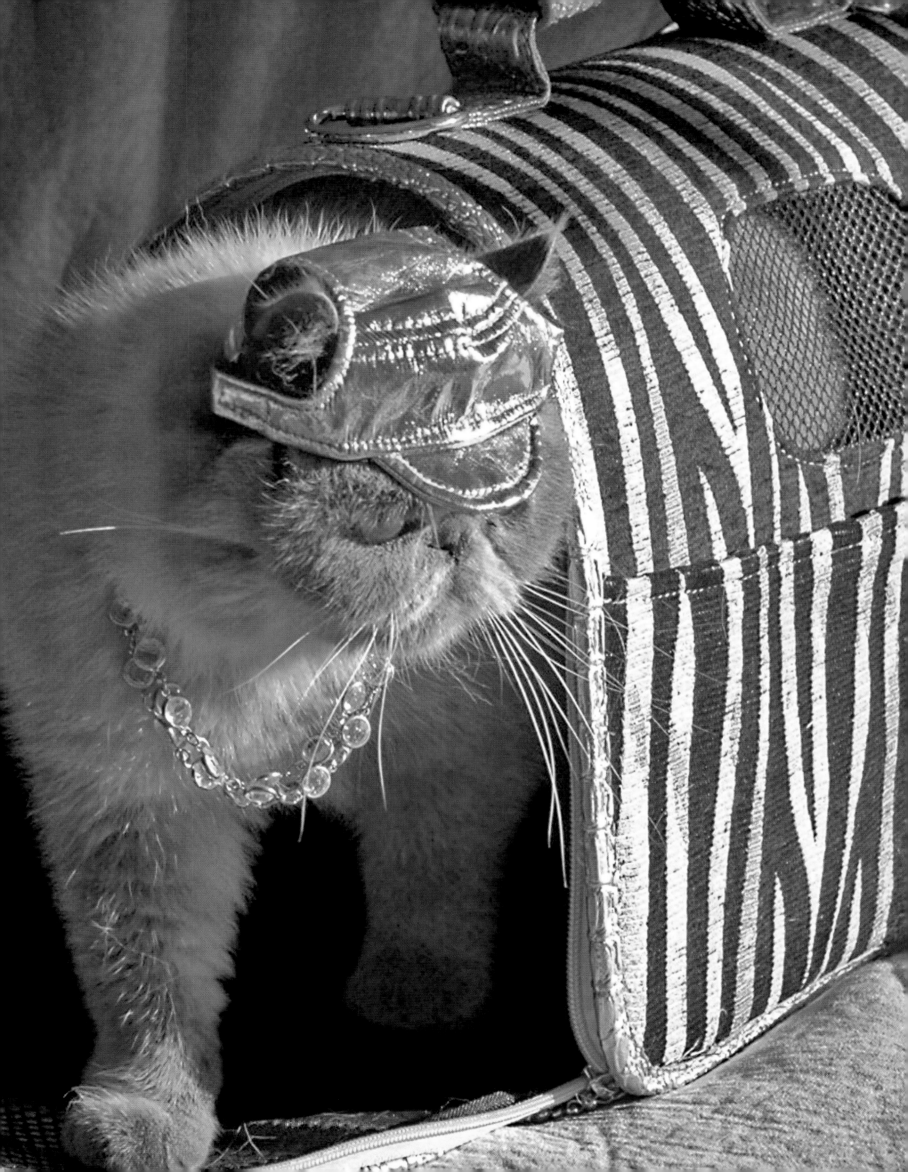

Viaje

Al fin llega el deseado verano, y quiero hacer las maletas e irme de vacaciones. Pero ocurre lo inevitable. Mi gata Sushi enloquece al verme la maleta, sabiendo que pronto la voy a dejar y que se va a hacer cargo de ella una amiga que no está muy por la labor.

Hoy ya no hay razón para tanta ansiedad. Existen sitios adecuados en abundancia donde alojar a un felino, y mucho mejores que una simple gatería. Todos los propietarios de gatos que salgan de viaje pueden disfrutar de otra revolución en la industria: 'casas' y hoteles para gatos, con exuberantes suites y servicio de atención personal y de spa. Existen también sitios para dejar a nuestro felino en familias de acogida, o programas domésticos para alojamiento nocturno de esos gatos que sufren de ansiedad por la separación o de estrés.

Gracias a unos hosteleros muy creativos, la estancia en la gatería local ya no es una sentencia de encarcelamiento para el adorado gato. Los nuevos hoteles para animales proporcionan juegos para el ejercicio diario, aseo, campamentos y fiestas para socializarse, hasta un veterinario residente para todas las urgencias médicas y las necesidades especiales de los animalitos. Estos establecimientos consideran el bienestar emocional, la salud y la felicidad de cada gato con servicio y cuidado personalizado.

Vivimos en una época en la que los miembros de la alta sociedad y los nómadas globales con buenos ingresos tienen posibilidades para ser indulgentes con sus enérgicos felinos. Hasta las grandes cadenas de hoteles de lujo empiezan a interesarse por las últimas tendencias, ofreciendo servicios de taxi para citas de aseo, números de habitaciones con nombres impresos en placas chapadas en oro y alta cocina servida en platos de cerámica pintados a mano. Algunos hoteles ostentan surtidos de juguetes y abundancia de deliciosos piscolabis –hasta exquisiteces como caviar– todo concebido para acomodarse a las exigencias del gato sofisticado y de su amo aficionado al lujo.

Los servicios de pensión y los alojamientos en hoteles de gatos resultan tan atractivos para mi gata que cuenta los minutos para personarse (mejor dicho, "gatearse") en su pensión exclusiva y relajarse en compañía de su pandilla de la alta sociedad gatuna. Sus días de descanso en el hotel transcurren entre la ociosidad en camas de piel de cordero con calefacción, esperando la próxima cita para jugar, mordisqueando bocadillos de salmón y mirando el Animal Planet en su televisor privado. Ahora, cuando me ve sacar mi maleta del trastero, se introduce a todo correr en su bolsa de viaje. Esperemos que las condiciones en estos hoteles no se vuelvan tan suntuosas que me toque enfrentarme a una gata sin ganas de volver a casa.

Viaggio

L'estate lungamente attesa finalmente arriva, e mi accingo a fare i bagagli e partire per le vacanze. Ma poi accade l'inevitabile. La mia gatta Sushi impazzisce alla vista della mia valigia, sapendo che presto verrà lasciata a casa, assistita da una riluttante amica.

Ma ora quell'ansia è finalmente un ricordo del passato. Esistono posti in abbondanza per alloggiare un felino dal manto vellutato, che non sia solo una banale pensione. Tutti i proprietari di gatti che si mettono in viaggio possono contare su una nuova rivoluzione nell'industria degli animali domestici: "case" alberghi e hotel per gatti con sfarzose suite private che offrono servizi personalizzati di assistenza e cure di bellezza. Esistono anche servizi che sistemano il vostro felino presso famiglie, o programmi domestici per il ricovero notturno dei gatti che soffrono di ansia da separazione o disturbi da stress.

Grazie ad alcuni albergatori di gatti molto creativi, la permanenza presso una pensione non è più una sentenza di prigione forzata per l'adorato gatto. I nuovi hotel forniscono giochi per l'esercizio quotidiano, servizi di toilette, campeggi e "party per animali domestici" durante i quali socializzare, ed anche un veterinario in loco che si occupa delle condizioni mediche e assiste i mici nelle loro speciali esigenze. Queste strutture si interessano del benessere emotivo, della salute e della felicità di ogni gatto con servizi e cure personalizzate.

Viviamo in un'epoca un cui i membri dell'alta società e i viaggiatori globali con consistenti redditi a disposizione possono permettersi di concedere molto ai loro incontentabili felini. Adesso addirittura le grosse catene di alberghi di lusso iniziano ad interessarsi di questa tendenza emergente; gli alberghi resort offrono servizi di taxi per appuntamenti di toilette per animali, cartellini placcati in oro con incisi il numero della camera e il nome del gatto, e la cucina per gatti viene servita in piatti di ceramica dipinti a mano. Alcuni alberghi vantano un assortimento di giocattoli e un'abbondanza di deliziosi spuntini – comprese delicatezze come il caviale – tutto progettato per accontentare i gusti discriminanti del sofisticato gatto e del suo proprietario, amante del lusso.

I servizi di pensione e gli alloggi negli alberghi sono così piacevoli per la mia gatta che ormai non vede sinceramente l'ora di presentarsi al suo condominio per gatti esclusivo per rilassarsi in compagnia del suo gruppetto dell'alta società. Le sue giornate di piacere all'albergo trascorrono tra l'ozio su un lettino riscaldato, in pelle d'agnello, nell'attesa del prossimo appuntamento giocoso, gustando dei bocconcini di salmone osservando Animal Planet nella sua TV personale. Oramai, quando mi vede tirare fuori la valigia dal ripostiglio, corre freneticamente verso il suo cestino da trasporto e salta felicemente sulla sua cesta da viaggio. Speriamo che le condizioni al suo albergo non diventino così sontuose da costringermi ad affrontare una gatta infelice una volta tornata a casa.

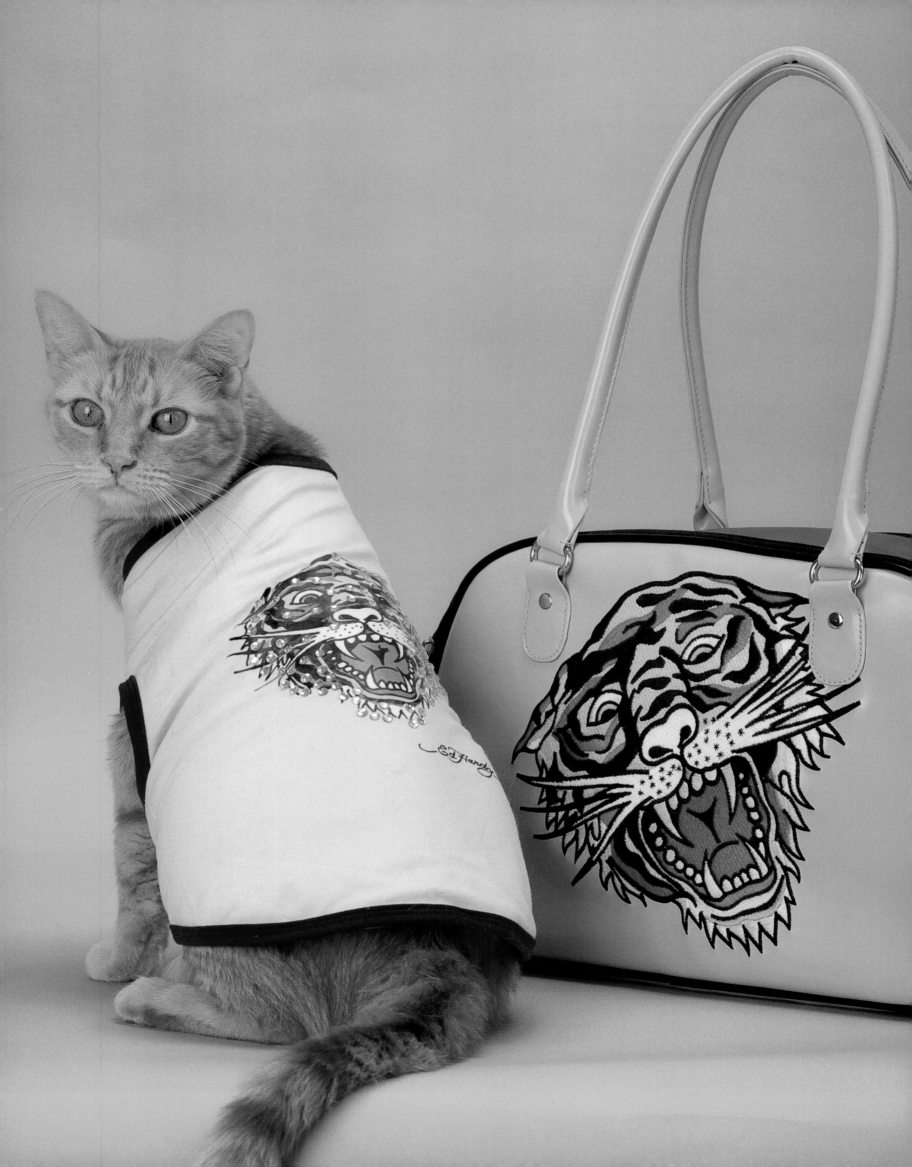

Today a plethora of boarding facilities and hotels are going that extra mile to accommodate and actively court our furry friends with a long list of pampering services.

Heute gibt es unzählige Unterbringungsmöglichkeiten und Hotels, die keinen Aufwand scheuen, um unsere pelzigen Freunde zu beherbergen und mit zahlreichen Leistungen zu umsorgen, bei denen der Verwöhnfaktor ganz groß geschrieben wird.

De nos jours, une pléthore de pensions et d'hôtels font tout pour recevoir et séduire nos amis à fourrure, et proposent une longue liste de services et de soins.

Hoy en día, multitud de pensiones y hoteles se esfuerzan para acomodar y mimar a nuestros amigos peludos con una larga lista de servicios.

Oggi una grande quantità di pensioni e hotel sono disposti a fare di tutto per alloggiare i nostri amici in pelliccia corteggiandoli con un lungo elenco di servizi mirati a viziarli e coccolarli.

Well-groomed pets of luxury-minded owners are treated like kings at such posh pet resorts that offer nearly every amenity a guest would demand from a leading top human hotel, such as limo pickup, custom cuisines, and pampering spa treatments.

Gut gepflegte Tiere luxusorientierter Besitzer werden in solchen Nobelresorts für Tiere wie kleine Könige behandelt. Die Resorts bieten nahezu jede Annehmlichkeit, die ein Gast von einem führenden Tophotel für Menschen erwartet, wie Abholung mit der Limousine, eine auf die jeweiligen Bedürfnisse abgestimmte Cuisine und Wellnessbehandlungen zum Verwöhnen.

Les animaux choyés par des maîtres amateurs de luxe sont traités comme des rois dans de tels centres chics pour animaux qui proposent presque tous les services qu'un client humain pourrait exiger d'un grand hôtel, tels transport en limousine, plats personnalisés et soins de spa pour se chouchouter.

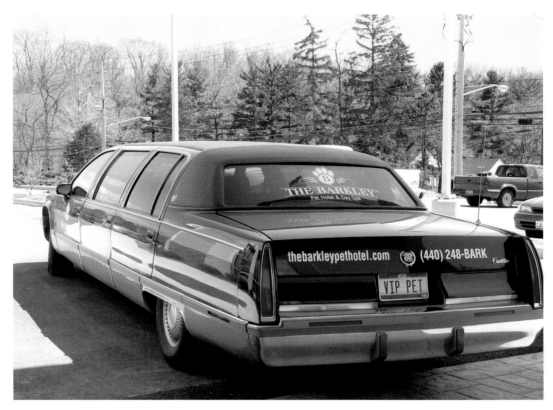

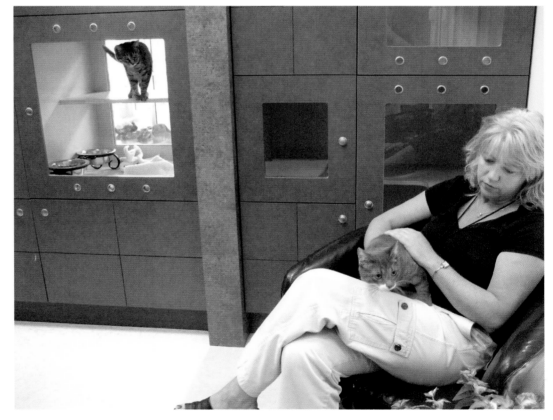

Los animalitos bien cuidados por propietarios orienta-
dos hacia el lujo son tratados como reyes en opulentas
instalaciones que ofrecen casi cualquier amenidad que
un huésped pediría en un hotel humano de primera,
como servicio de recogida en limusina, cocina perso-
nal, y tratamientos spa consentidores.

Bestiole ben tenute da proprietari orientati al lusso
ricevono un trattamento da re in alberghi esclusivi che
offrono quasi qualsiasi amenità che un ospite possa
chiedere a un hotel per ospiti umani, come il trasporto
in limousine, la cucina personalizzata e trattamenti
benessere di ogni tipo.

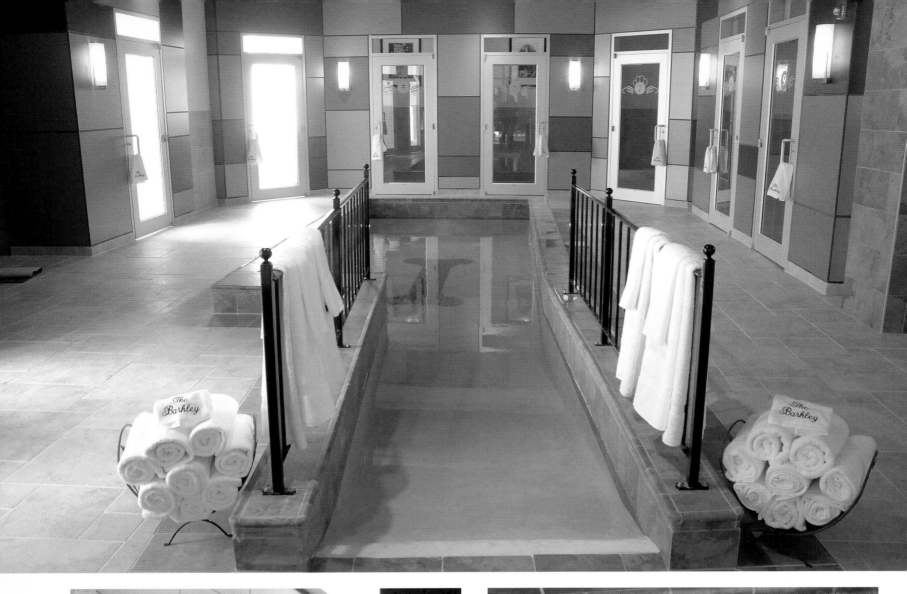

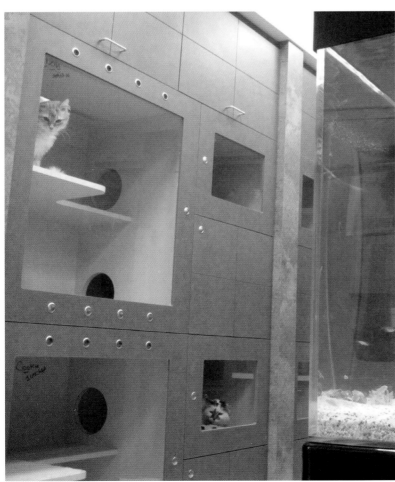

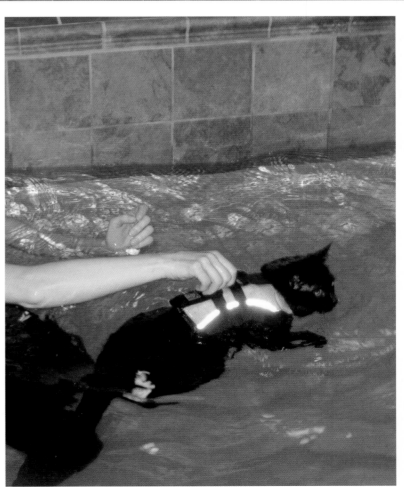

It may be difficult to get your furry friend to come back home after a short stay at one of these special catteries that strive to impress even the most finicky cat.

Es kann durchaus schwierig sein, Ihren Stubentiger nach einem Kurzaufenthalt in einer dieser speziellen Katzenpensionen wieder nach Hause zu bewegen, denn sie haben sich zum Ziel gesetzt, selbst die wählerischste Katze zu beeindrucken.

Votre compagnon félin pourrait ne plus vouloir rentrer à la maison après un séjour dans une des ces chatteries spéciales qui font tout pour contenter même le chat le plus difficile.

Puede resultar complicado convencer a nuestro amiguito para volver a casa tras una breve estancia en una de estas "gaterías" especiales, que se afanan por impresionar hasta al gato más caprichoso.

Può essere difficile convincere il vostro amico a quattro zampe a tornare a casa dopo una breve permanenza in una di queste pensioni speciali per gatti, che non risparmiano alcuno sforzo per conquistare anche il gatto più capriccioso.

Images: Amber Ley Cattery in Great Britain

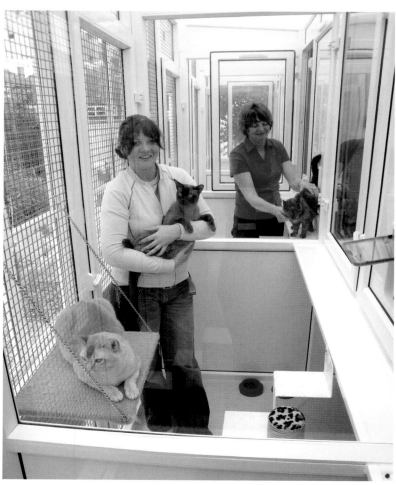

Most luxury catteries today offer separate "suites" for felines with comfy beds, private bathrooms, personal televisions showing 'video catnip', and views of an aquarium or bird-filled garden.

Heute bieten die luxuriösesten Katzenpensionen separate „Suiten" für Katzen an. Zur Verfügung stehen komfortable Betten, private Bäder und eigene TV-Geräte, auf denen „Katzenminzevideos" bewundert werden können. Außerdem können sich die Stubentiger am Anblick eines Aquariums ergötzen oder die Aussicht auf einen von Vögeln wimmelnden Garten genießen.

La plupart des chatteries de luxe offrent aujourd'hui des « suites » séparées pour félins avec panier confortable, salle de bains privée, télévision personnelle avec « vidéo herbe à chat » et vues sur un aquarium ou un jardin plein d'oiseaux.

Hoy en día muchas "gaterías" de lujo ofrecen "suites" separadas para felinos con cómodas camitas, cuartos de baño privados, televisores personales con "hierba de gato en vídeo" y vistas sobre acuarios o jardines repletos de pájaros.

Molte pensioni di lusso per gatti oggi offrono "suite" separate per felini con soffici letti, bagni privati, TV personali con erba gatta in video e viste su un acquario o su un giardino pieno di uccelli.

Left: Amber Ley Cattery
Right: Moss Side Cottage Cattery

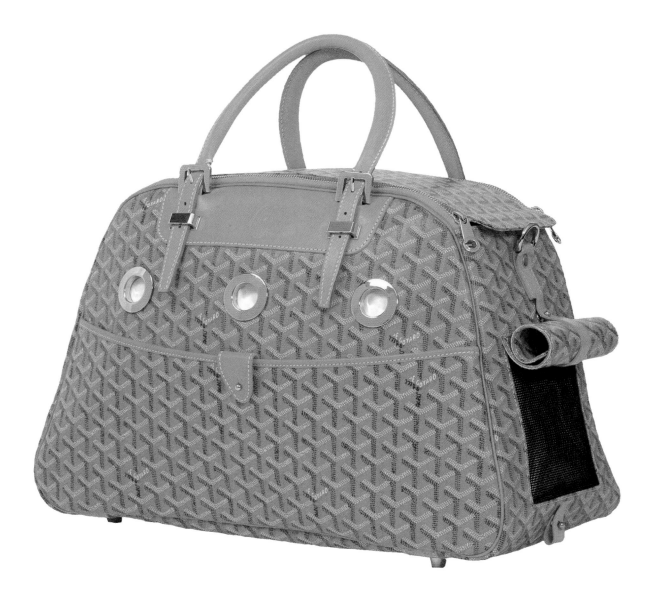

Travelers with pets are such a huge market today that global companies such as Goyard and IKEA are offering gorgeous accessories for the jet-setting pet and its style-conscious owner.

Reisende mit Tieren sind heutzutage Gegenstand eines gigantischen Marktes. Deshalb bieten global operierende Firmen wie Goyard und IKEA fantastische Accessoires für das Jetset-Tier und seinen stilbewussten Besitzer an.

Les voyageurs avec animaux représentent désormais un marché si énorme que des entreprises internationales comme Goyard et IKEA proposent aujourd'hui de fabuleux accessoires pour le chat jet-set et son propriétaire tendance.

Los viajeros con animales representan hoy un mercado enorme, hasta el punto de que empresas internacionales como Goyard e IKEA ofrecen maravillosos accesorios para el animal del jet-set y su amo atento al estilo.

I viaggiatori con animali rappresentano ormai un mercato così ampio che anche multinazionali come Goyard e IKEA offrono meravigliosi accessori per la bestiola del jet-set e il suo proprietario attento allo stile.

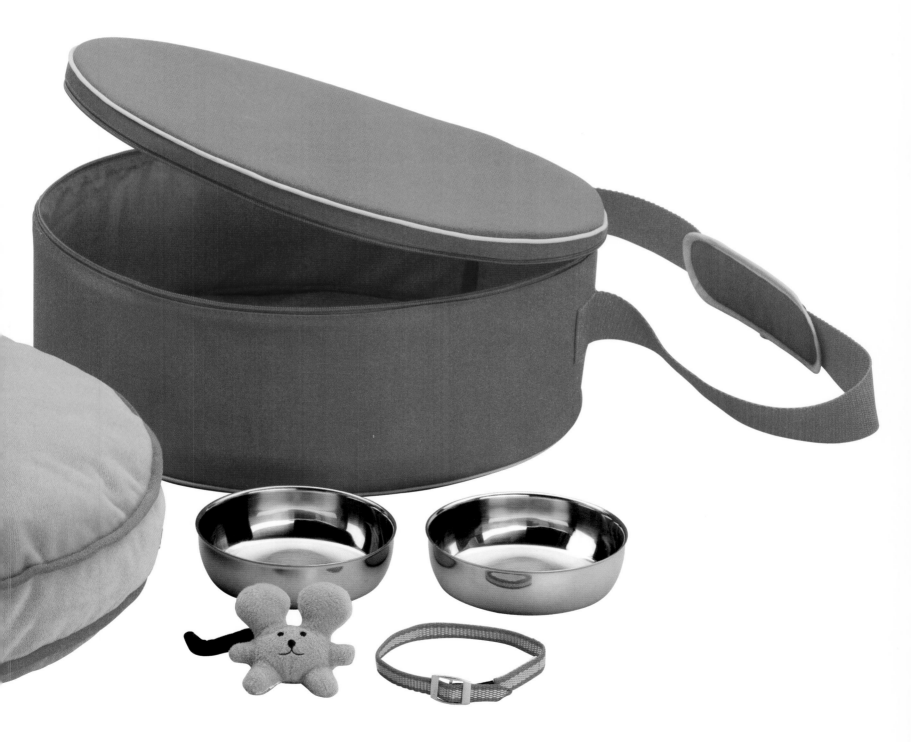

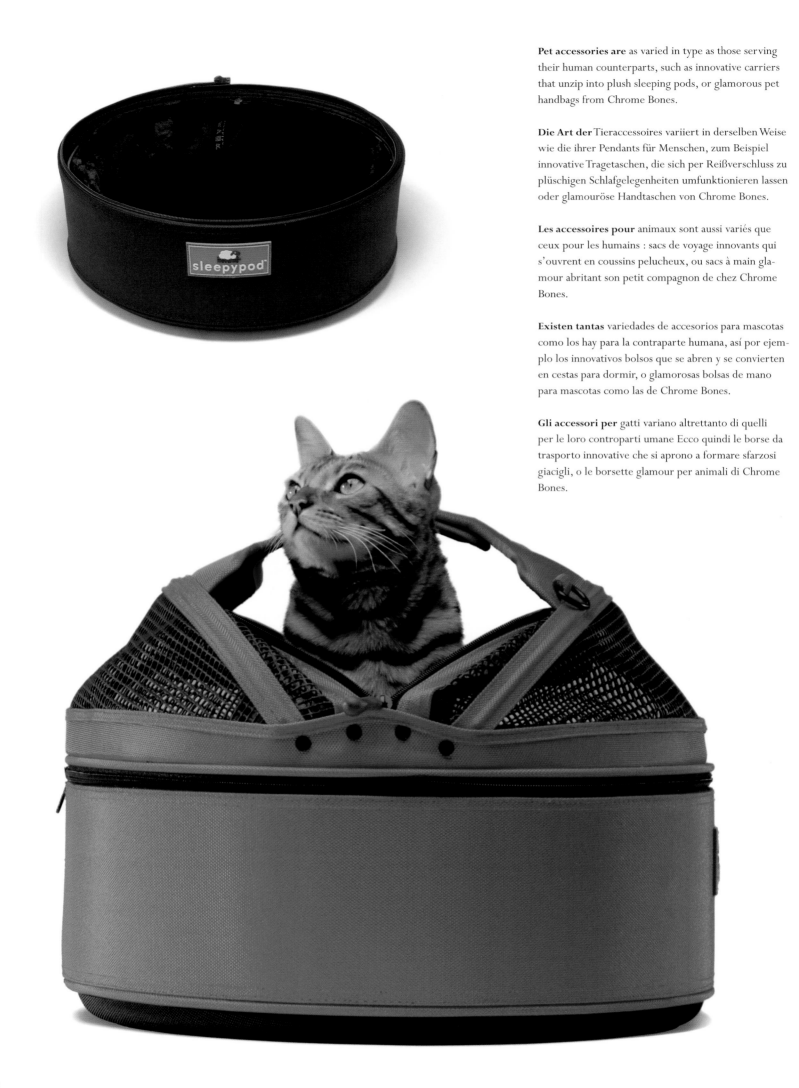

Pet accessories are as varied in type as those serving their human counterparts, such as innovative carriers that unzip into plush sleeping pods, or glamorous pet handbags from Chrome Bones.

Die Art der Tieraccessoires variiert in derselben Weise wie die ihrer Pendants für Menschen, zum Beispiel innovative Tragetaschen, die sich per Reißverschluss zu plüschigen Schlafgelegenheiten umfunktionieren lassen oder glamouröse Handtaschen von Chrome Bones.

Les accessoires pour animaux sont aussi variés que ceux pour les humains : sacs de voyage innovants qui s'ouvrent en coussins pelucheux, ou sacs à main glamour abritant son petit compagnon de chez Chrome Bones.

Existen tantas variedades de accesorios para mascotas como los hay para la contraparte humana, así por ejemplo los innovativos bolsos que se abren y se convierten en cestas para dormir, o glamorosas bolsas de mano para mascotas como las de Chrome Bones.

Gli accessori per gatti variano altrettanto di quelli per le loro controparti umane Ecco quindi le borse da trasporto innovative che si aprono a formare sfarzosi giacigli, o le borsette glamour per animali di Chrome Bones.

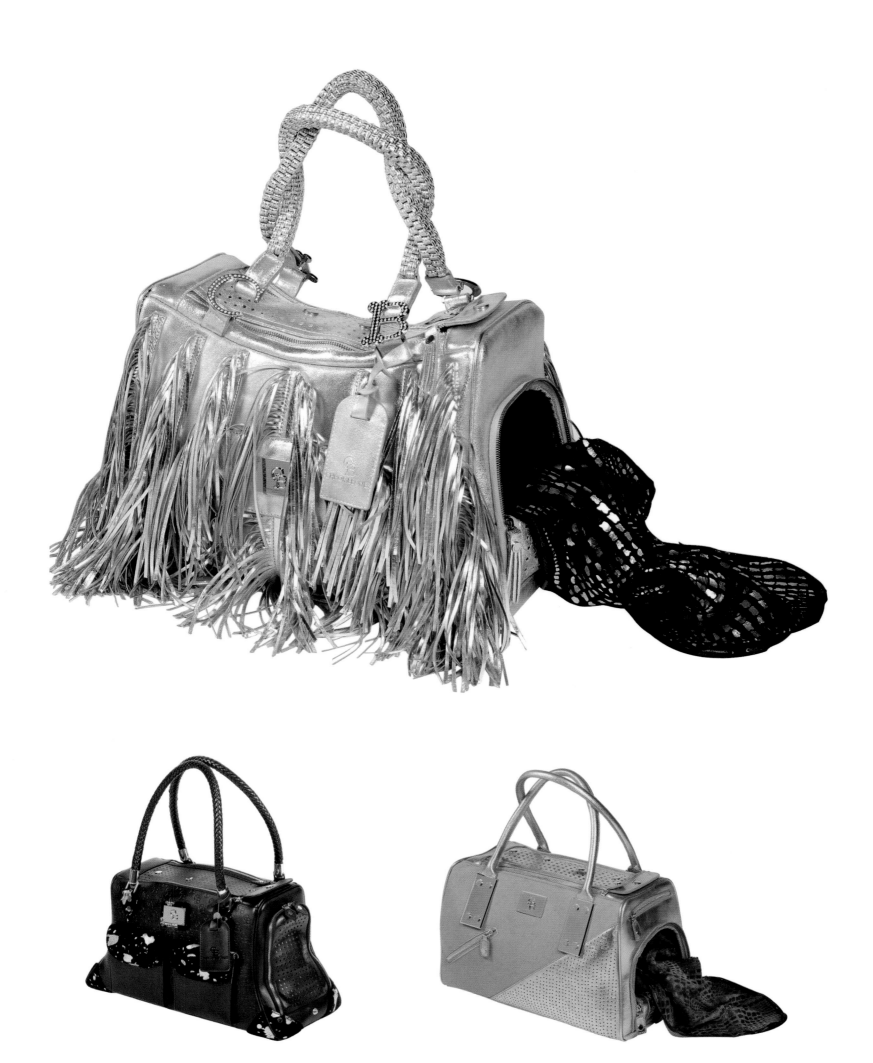

The logo-obsessed pet lover can make their best friend into their best-accessorized friend with leashes and carriers from global luxury brands such as Louis Vuitton.

Der Logofetischist unter den Tierliebhabern kann seinen besten Freund mit Accessoires wie Leinen und Tragetaschen globaler Luxusmarken optisch aufwerten wie hier von Louis Vuitton.

L'amateur de griffes renommées peut transformer son meilleur ami en son ami le plus accessoirisé avec des laisses et sacs de grandes marques de luxe telles que Louis Vuitton.

El amante de los animales obsesionado por las marcas, puede convertir a su amigo en el mejor ornamentado con correas y bolsas de viaje de marcas de lujo internacional como Louis Vuitton.

L'amante degli animali ossessionato dalle griffe può valorizzare il proprio migliore amico grazie ad accessori come guinzagli e borse da trasporto di marche di lusso internazionali come Louis Vuitton.

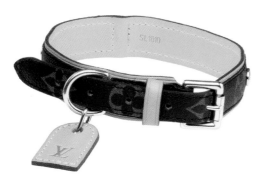

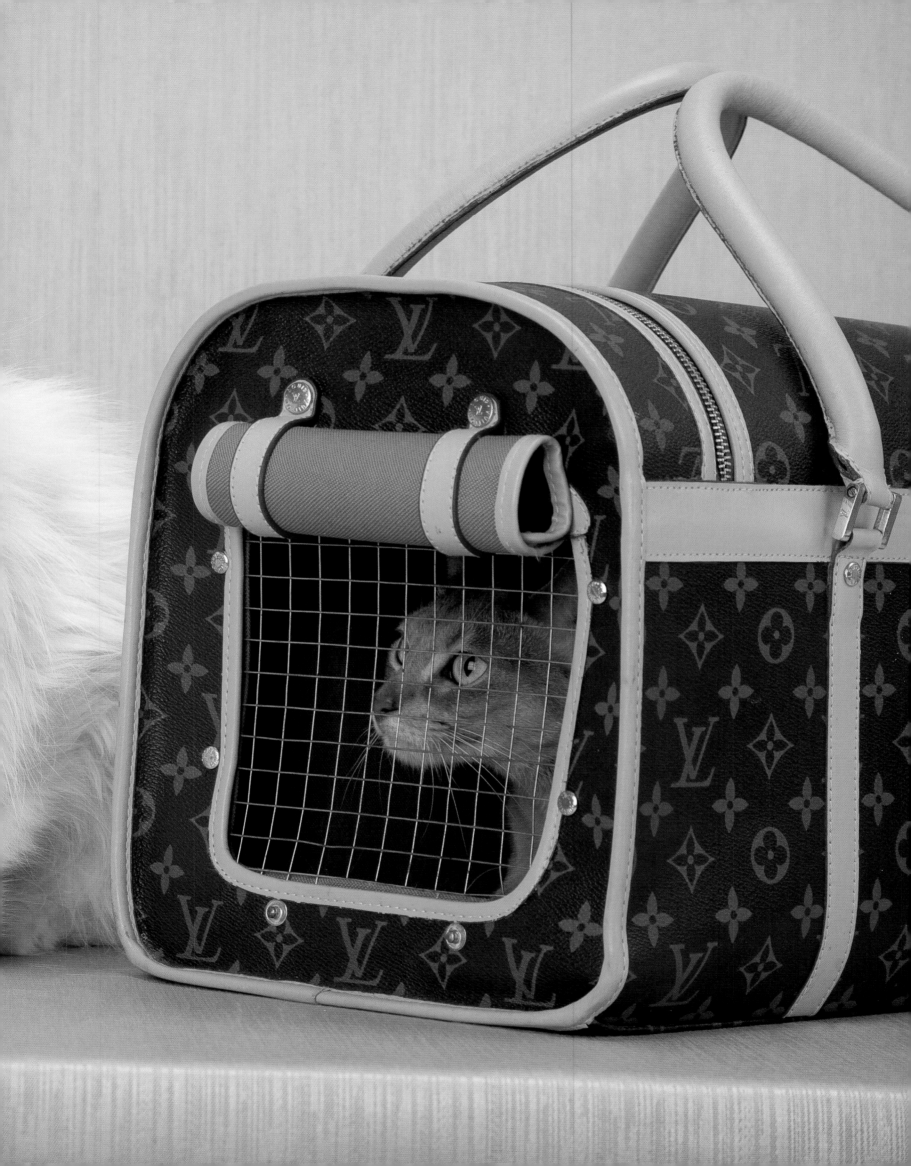

If you decide to take your cat for a walk, then it would be suggested you make the best of the stylish products out there, such as this cute stroller that can be folded into a car carrier.

Sie wollen Ihre Katze ausführen? Wie wäre es mit diesem Vorschlag: Bringen Sie ein stylisches Produkt zur Geltung, zum Beispiel diesen süßen Katzenbuggy, der zusammengefaltet in eine Autotragetasche passt.

Si vous décidez d'emmener votre chat en promenade, choisissez de le faire avec un maximum d'élégance, par exemple avec cette jolie poussette qui peut être pliée pour devenir un panier à voiture.

Si decidimos llevar a nuestro gato de paseo, es recomendable sacar el máximo provecho de los elegantes productos disponibles, como este lindo carrito plegable para el transporte en el coche.

Se decidete di portare il vostro gatto a fare una passeggiata, è consigliabile approfittare degli eleganti prodotti disponibili sul mercato, come questo grazioso passeggino, ripiegabile per il trasporto in automobile.

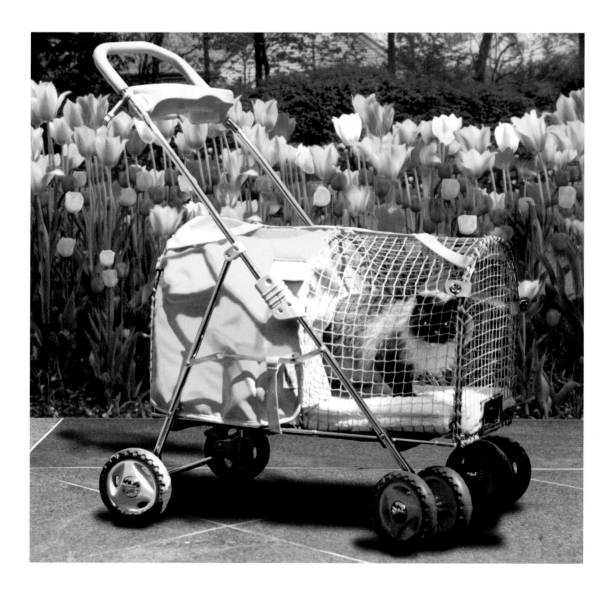

More companies provide animals with products closely modeled after the ones sold to humans, such as these travel duffle bags from Argo.

Immer mehr Firmen bieten Produkte für Tiere an, welche denen für Menschen stark nachempfunden sind – wie diese Duffle-Reisetaschen von Argo.

Un nombre accru de compagnies propose aux animaux des produits sur le modèle de ceux vendus aux humains, comme ces sacs de voyage molletonnés de chez Argo.

Cada vez más empresas proporcionan a los animales productos basados estrictamente al estilo de los que se venden a los humanos, como estas bolsas de viaje de Argo.

Altre aziende forniscono agli animali prodotti modellati su quelli per viaggiatori umani, come queste sacche da viaggio di Argo.

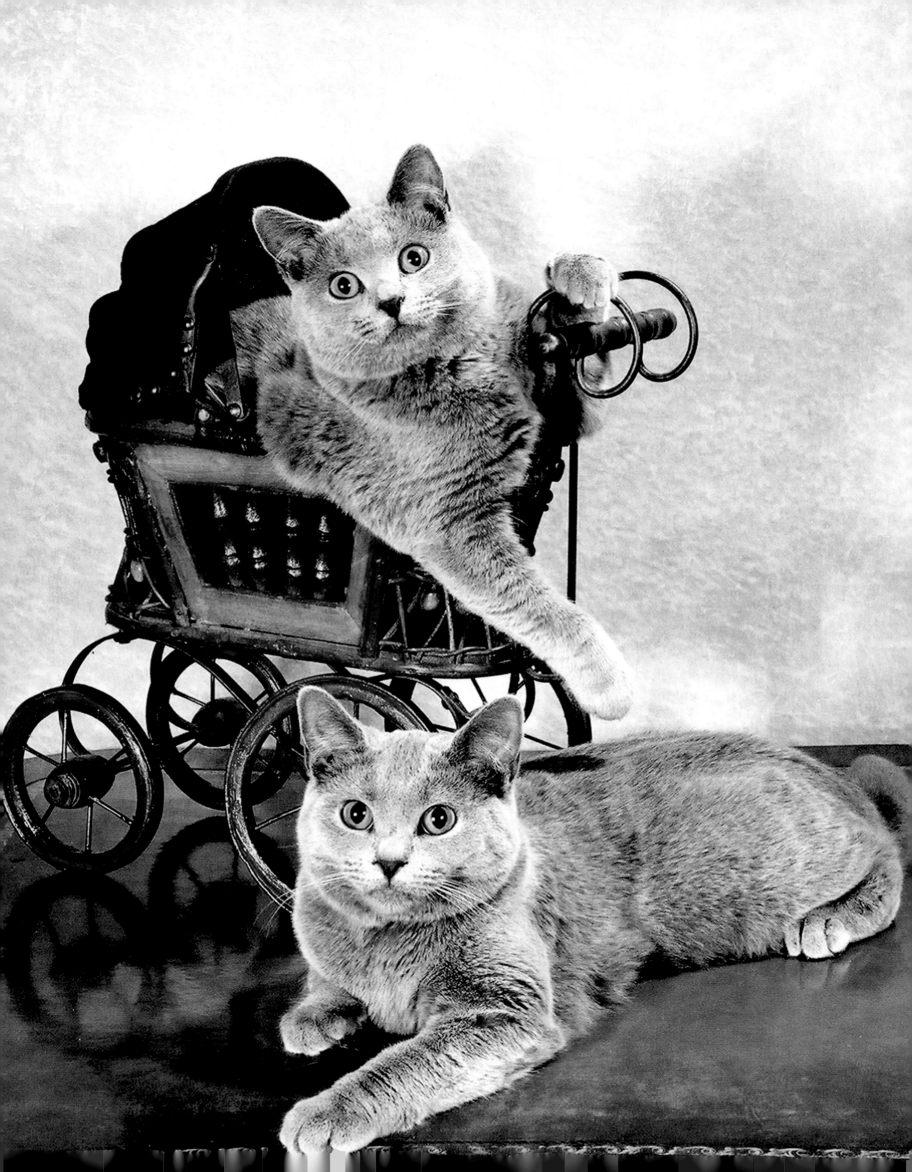

Lifestyle

"Of all God's creatures, there is only one that cannot be made slave of the leash. That one is the cat. If man could be crossed with the cat it would improve the man, but it would deteriorate the cat."

Mark Twain

Sixty percent of households that own cats today do not have children at home, so that many of these empty nesters go to extremes when it comes to honoring their furry felines.

In 60 Prozent der Haushalte, die heutzutage Katzen besitzen, leben keine Kinder, sodass viele dieser Paare bis ins Extreme gehen, wenn es gilt, den Bedürfnissen ihrer geliebten Kätzchen gerecht zu werden.

De nos jours, 60 pour cent des foyers possédant un chat n'ont pas d'enfant ; c'est pourquoi dans un grand nombre de ces « nids vides », on n'hésite pas à aller à l'extrême quand il s'agit de gâter son compagnon à quatre pattes.

En el 60 por ciento de los hogares donde hay un gato, no hay niños, y por lo tanto muchas de estas familias llegan a extremos a la hora de consentir a sus felinos.

Oggi nel 60 percento delle case in cui risiedono gatti non sono presenti bambini, per cui molte coppie arrivano a livelli estremi quando si tratta di onorare i loro felini impellicciati.

Lifestyle

Long gone is the simple cat from past generations who roamed freely and fearless in nature, whose only duty was to catch mice and birds. The sophisticated cat confined indoors—an idle creature with selfish intentions—has no ambition than to peacefully spend its life in a world of comfort and luxury, and wear its fur better than its neighbor. Unlike the dog, the cat refuses to be owned, but will happily make a partnership. A cat lover knows that their furry feline will never come running when it hears its name, but will happily take the message and get back to you at its own discretion. It is not a superficial species that extends their love as easily as the overly-excited canine. Cats are fickle and cunning, but only because it has an innately cautious and audacious spirit. The sophisticated cat will never demean itself to make any public display of obedience or affection, since the utterly independent cat will express itself on its own kitty terms, and most likely without anyone else present. But even with the controlled and debonair attitude characteristic of some aristocratic snob—in complete contrast to the neediness of the slobbering, slavish dogs—the cat still contributes an abundance of amusement and warmth to millions of pet owners.

Cats enthusiasts today can choose from a range of lifestyle services and offerings that celebrate the independent and courageous spirit of the feline species. True cat lovers are bent on catering to their pet's every whim, to the point of lavishing pricey gifts on their feline friends. There are professional photographers who specialize in staged portraits of your furry companion, or professional artists that will create a lavish oil painting of your little four-legged family member. There are also many other services that used to cater to humans that now include your little kitty, such as event management companies that will include your cat in your wedding ceremony, or summer camps that entertain your cat, and even day care that trains your feisty feline into well-behaved sophisticated pets.

The ultimate luxury in life is where one gets all of the necessities in life, with all the time in the world to lie around without a single stress in the world, and an enormous amount of affection without doing anything to earn it. We could all take lessons from our furry friend who, as W. L. George once perfectly described, is the one animal in the world that is able to "obtain food without labor, shelter without confinement, and love without penalties".

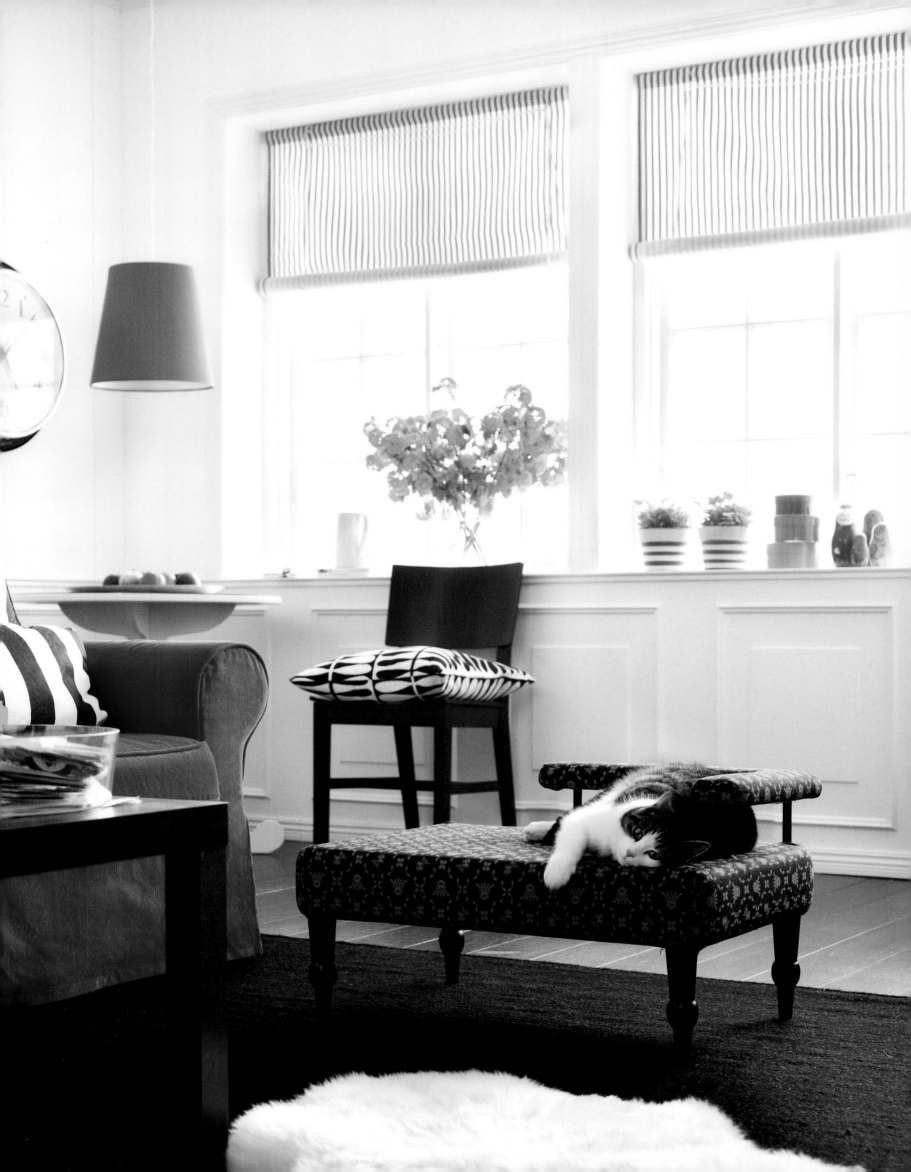

Lebensart

Es ist lange her, dass die „einfache" Katze der früheren Generationen frei und furchtlos in der freien Natur umherstreifte und ihre einzige Aufgabe darin bestand, Mäuse und Vögel zu fangen. Die anspruchsvolle, ans Haus gebundene Katze – eine faule Kreatur mit selbstsüchtigen Intentionen – hat keinerlei andere Ambitionen, als ihr Leben friedlich in einer von Luxus und Komfort geprägten Welt zu verbringen und ihren Pelz mit mehr Eleganz zu tragen als die Nachbarin. Anders als der Hund mag es die Katze nicht, wenn man von ihr Besitz ergreift, sie geht jedoch gerne eine Partnerschaft ein. Der Katzenliebhaber weiß, dass seine Katze nie angelaufen kommt, wenn sie ihren Namen hört, die Nachricht jedoch glücklich zur Kenntnis nimmt und diskret darauf zurückkommen wird, wenn es ihr genehm ist. Es handelt sich nicht um eine oberflächliche Spezies, die ihre Zuneigung und Liebe so großzügig verteilt wie der extrem lebhafte Hund. Katzen sind wechselhaft und listig, aber nur weil sie von Haus aus ein umsichtiges und kühnes Wesen haben. Die anspruchsvolle Katze würde sich nie selbst erniedrigen, um öffentlich Gehorsam oder Zuneigung zu bekunden, da das völlig unabhängige Tier sich selbst nur zu ihren eigenen katzenspezifischen Bedingungen ausdrückt und das höchstwahrscheinlich nur, wenn niemand anderes präsent ist. Aber selbst mit der kontrollierten und lässig-eleganten Eigenschaft eines aristokratischen Snobs – im absoluten Gegensatz zu der Bedürftigkeit des geifernden, sklavischen Hundes – erfreut die Katze immer noch Millionen Tierbesitzer mit einem Überfluss an Amüsement und Wärme.

Katzenfanatiker können heute aus einer Palette von Lifestyleservicen und Angeboten auswählen, die den unabhängigen und couragierten Geist dieser Spezies würdigen. Wahre Katzenliebhaber sind versessen darauf, sich auf jede Marotte ihres Tieres einzulassen. Sie gehen sogar so weit, ihre Katzen mit kostspieligen Geschenken zu überhäufen. Es gibt professionelle Fotografen, die sich auf perfekt inszenierte Portraits ihrer pelzigen Lebensgefährten spezialisiert haben oder professionelle Künstler, die ein aufwändiges Ölgemälde Ihres kleinen vierbeinigen Familienmitgliedes anfertigen. Es gibt auch viele andere Angebote, die früher ausschließlich auf menschliche Bedürfnisse zugeschnitten waren, jetzt aber auch Ihr kleines Kätzchen einbeziehen, wie zum Beispiel Eventunternehmen, die Ihre Katze in eine Hochzeitszeremonie einbinden oder Sommercamps, die zur Unterhaltung Ihrer Katze dienen. Es gibt sogar eine Tagesbetreuung, die Ihre kratzbürstige Katze zu einem wohlgesitteten mondänen Tier ausbildet.

Ultimativer Luxus im Leben heißt alle notwendigen Dinge im Leben zu bekommen, alle Zeit der Welt zu haben, um faul herumzuliegen, absolut stressfrei zu sein und eine immense Menge an Zuneigung zu genießen, ohne etwas dafür tun zu müssen. Wir alle könnten viel von unserer geliebten flauschigen Katze lernen, die, wie W. L. George sie einst perfekt beschrieb, das einzige Tier der Welt ist, das in der Lage ist „ [to] obtain food without labor, shelter without confinement, and love without penalties" (Futter zu bekommen, ohne etwas dafür tun zu müssen, Schutz zu genießen, ohne eingesperrt zu sein und Liebe zu empfangen, ohne eine Gegenleistung zu erbringen).

Art de vivre

Il a depuis longtemps disparu, le « simple » chat des générations passées, qui vagabondait librement et sans peur dans la nature, et dont le seul devoir était d'attraper les souris et les oiseaux. Le chat sophistiqué confiné à l'intérieur – une créature oisive aux intentions égoïstes – n'a d'autre ambition que de passer sa vie paisiblement dans un monde de confort et de luxe, et de porter sa fourrure mieux que son voisin. Contrairement au chien, le chat refuse d'avoir un maître, mais il acceptera volontiers un partenaire. L'amoureux des chats sait que son félin n'arrive jamais en courant lorsqu'il entend son nom, mais enregistre joyeusement le message et vient quand il le souhaite. Ce n'est pas une espèce superficielle qui prodigue son amour aussi facilement que le chien, toujours trop enthousiaste. Les chats sont inconstants et roublards, mais seulement parce qu'ils ont de naissance un esprit à la fois prudent et audacieux. Le chat ne s'abaissera jamais à manifester publiquement son obéissance ou son affection, car il est extrêmement indépendant et s'exprime dans ses propres termes de matou, et le plus souvent quand personne d'autre n'est présent. Mais même avec l'attitude contrôlée et nonchalante caractéristique de certains aristocrates – en contraste total avec l'obséquiosité du chien bavant – le chat offre toujours beaucoup d'amusement et de chaleur à des millions de maîtres d'animaux.

Les amateurs de chats peuvent aujourd'hui choisir une gamme de services et d'offres qui célèbrent l'esprit indépendant et courageux de l'espèce féline. Les vrais amoureux des chats sont prêts à céder à toutes les lubies de leur animal, au point de lui offrir des cadeaux de prix. Il existe des photographes professionnels spécialisés dans les portraits mettant en scène votre compagnon à fourrure, ou des artistes professionnels qui créeront un splendide tableau à l'huile de ce membre spécial de votre famille. De nombreux autres services qui s'adressaient uniquement aux humains concernent maintenant aussi votre petit minou, par exemple des sociétés d'organisation d'événements qui incluent votre chat dans votre cérémonie de mariage, des colonies de vacances pour amuser votre chat, et même des centres de soins de jour qui entraînent votre félin revêche pour en faire un animal de compagnie sage et sophistiqué.

Le luxe ultime dans la vie, c'est d'avoir toutes les nécessités de la vie, avec tout le temps du monde pour se reposer sans le moindre stress au monde, et une énorme quantité d'affection sans avoir rien à faire pour le mériter. Nous pourrions tous prendre des leçons de notre ami à fourrure qui, comme W. L. George l'a un jour parfaitement décrit, est le seul animal au monde qui soit capable « [to] obtain food without labor, shelter without confinement, and love without penalties » (d'obtenir de la nourriture sans travail, un abri sans être enfermé, et de l'amour sans punition).

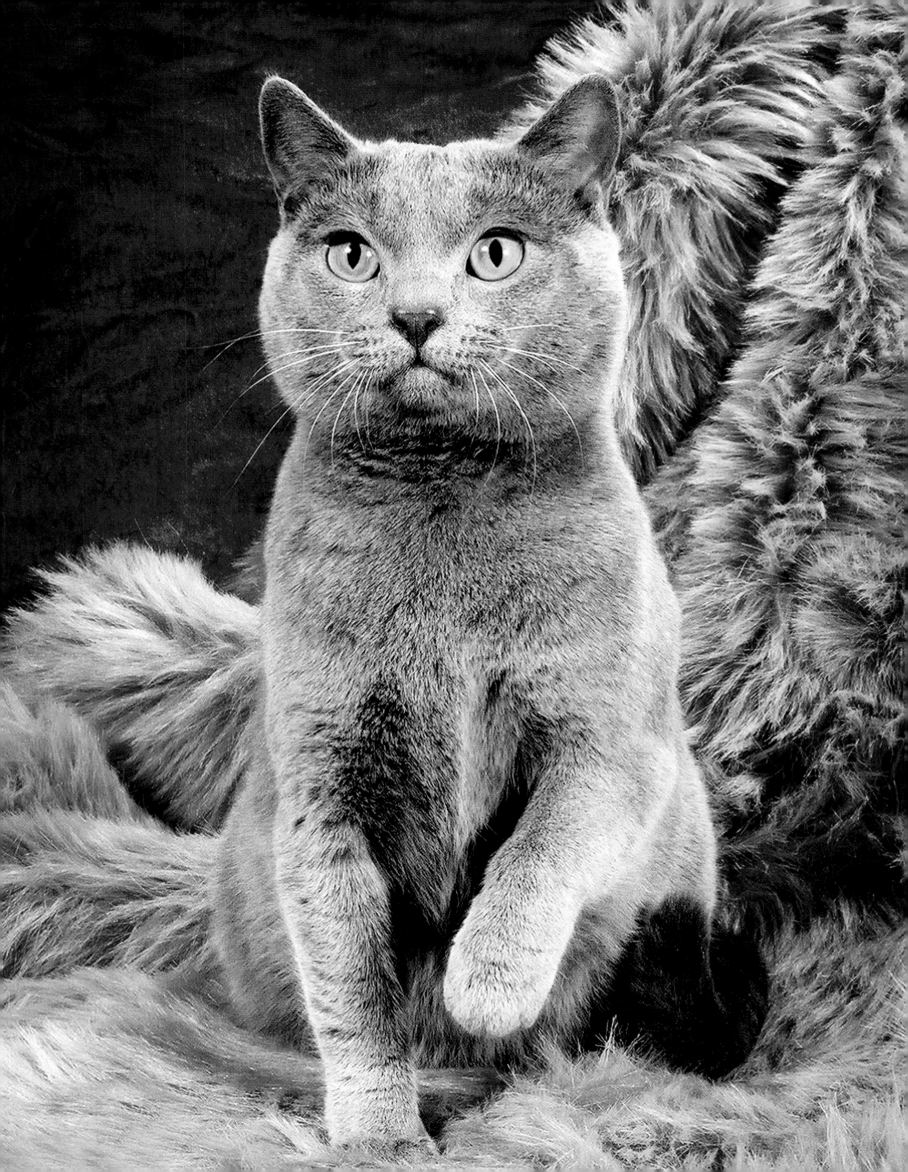

Estilo de vida

Lifestyle

Ya desapareció el "simple" gato de las generaciones pasadas, vagando de forma libre y osada por la naturaleza, cuyo único deber era el de atrapar ratones y pájaros. El gato sofisticado de ahora vive encerrado; criatura perezosa con inclinaciones ególatras, no tiene otra ambición que la de que su vida transcurra pacíficamente en un mundo de confort y lujo, y de lucir un pelo más bonito que el de su vecino. A diferencia del perro, el gato no acepta ser poseído, pero sí apreciará una asociación. Todo amante de los gatos sabe que su felino nunca vendrá corriendo al oír su nombre, sino que recibirá de buena gana el mensaje, presentándose a su antojo. No pertenece a esas especies superficiales que van esparciendo con facilidad su amor, como la canina, que fácilmente se excita. Los gatos son volubles y astutos, pero solo por su espíritu congénitamente cauto y audaz. El gato sofisticado nunca se postra hasta hacer públicas muestras de obediencia o afecto, sino que se expresa en sus propios términos, y probablemente cuando no haya nadie alrededor. Sin embargo, aún con la actitud comedida y afable, característica de la aristocracia esnob —en completo contraste con la dependencia del perro, babeante y servil— el gato contribuye con creces a la diversión y al calor de millones de amos.

Hoy, los entusiastas de los gatos pueden elegir entre una variedad de servicios y ofertas dedicadas al estilo de vida, que hacen honor al espíritu independiente y valiente de la especie felina. Lo auténticos amantes de los gatos se prodigan para asistir a sus animales en cada capricho, hasta el punto de ofrecerles costosos regalos. Existen fotógrafos especializados en retratos con toda su preparación y artistas profesionales que crean espléndidas pinturas al óleo del miembro cuadrúpedo de la familia. Hay igualmente muchos otros servicios, tradicionalmente dedicados a los humanos y ahora también a los gatos, como empresas de gestión de eventos que incluyen a nuestro amigo en una ceremonia nupcial o campamentos de verano para entretener a nuestro gato, y hasta centros de cuidado diario para adiestrar a nuestro enérgico felino, convirtiéndolo en un animalito formal y sofisticado.

El máximo lujo en la vida es conseguir cubrir todas las necesidades, teniendo todo el tiempo para descansar sin ninguna preocupación y una enorme cantidad de afecto, sin hacer nada para ganárselo. Podríamos todos tomar ejemplo de nuestro tupido amigo que, como una vez describió perfectamente W. L. George, es el único animal del mundo que sabe "obtain food without labor, shelter without confinement, and love without panelties" (conseguir comida sin trabajo, amparo sin reclusión y amor sin penas).

Sono lontani i tempi in cui il "semplice" gatto delle generazioni passate vagabondava liberamente e senza timori attraverso la natura, il cui unico dovere consisteva nel catturare topi ed uccelli. Il sofisticato gatto, confinato tra quattro mura — una creatura pigra con intenzioni egoiste — non ha altre ambizioni se non quella di trascorrere pacificamente la propria vita in un mondo di comfort e lusso, e sfoggiare il suo pelo migliore di quello del suo vicino. A differenza del cane, il gatto rifiuta di essere posseduto, ma sarà ben disposto verso una collaborazione. Un amante dei gatti sa che il suo felino dal manto vellutato non accorrerà mai quando sentirà chiamare il suo nome, ma sarà felice di prendere nota del messaggio e si farà vedere secondo la sua discrezione. Non è una specie superficiale, che estende facilmente il proprio amore come fanno i cani, estremamente eccitati. I gatti sono volubili e astuti, ma solo perché possiedono una cautela innata e uno spirito audace. Il gatto sofisticato non si abbasserà mai a mostrare in pubblico dell'obbedienza o segni d'affetto, in quanto il gatto sommamente indipendente si esprimerà nei propri termini di gatto, e molto probabilmente quando non è presente nessun altro. Eppure, anche con l'atteggiamento controllato e bonario caratteristico di certa aristocrazia snob — in completo contrasto con la necessità del cane sbavante e servile — il gatto ancora contribuisce in abbondanza al divertimento e al calore di milioni di padroni di animali.

Oggi gli entusiasti dei gatti possono scegliere tra una vasta gamma di servizi e offerte sullo stile di vita, che celebrano lo spirito indipendente e coraggioso della specie felina. I veri amanti dei gatti si piegano a soddisfare ogni capriccio dei loro animali, al punto di offrire ai loro amici felini regali sontuosi. Esistono fotografi professionali specializzati in ritratti di scena dei vostri compagni dal manto vellutato, o artisti professionisti che sapranno creare superbi dipinti ad olio dei membri a quattro zampe della vostra famiglia. Ci sono anche molti altri servizi, tradizionalmente riservati agli umani, che ora includono anche il vostro piccolo gattino, tra cui imprese organizzatrici di eventi che includeranno il vostro gatto nella vostra cerimonia di nozze, o campeggi estivi che intrattengono il vostro gatto, e persino scuole giornaliere per l'addestramento del vostro agitato felino, che lo trasformeranno in una creatura sofisticata di buone maniere.

Il nonplusultra del lusso nella vita consiste nel soddisfare tutte le necessità della vita, con tutto il tempo del mondo per rilassarsi senza nessuna preoccupazione al mondo, e una quantità enorme di affetto senza dover fare niente per meritarselo. Potremmo tutti prendere esempio dal nostro amico a quattro zampe che, come una volta descrisse perfettamente W. L. George, è l'unico animale al mondo in grado di ottenere "del cibo senza lavorare, un riparo senza essere rinchiuso e amore senza penalizzazioni".

Cats are very peculiar about how they travel. Special facilities, such as Pet Camp in San Francisco, California, have created unique environments that cater to feline sensitivities, such as these private Safari Gardens that let cats experience a taste of the exotic.

Katzen sind sehr eigen in Bezug auf die Art und Weise, wie sie reisen. Deshalb gibt es nun spezielle Einrichtungen wie das Pet Camp im kalifornischen San Francisco, welches eine Verwöhnatmosphäre für pelzige Begleiter bietet.

Les chats sont très difficiles quant à leurs conditions de voyage, des installations spécifiques comme le Pet Camp à San Francisco ont donc été créées pour offrir un environnement câlin à vos amis félins.

Los gatos son muy especiales a la hora de viajar. Esto cambia en establecimientos especiales, como Pet Camp en San Francisco, que crean un ambiente especial para los compañeros de cuatro patas.

I gatti hanno un modo molto particolare di viaggiare. Di qui l'esigenza di strutture speciali come Pet Camp a San Francisco, che creano un'atmosfera ideale per soddisfare ogni esigenza dei compagni a quattro zampe.

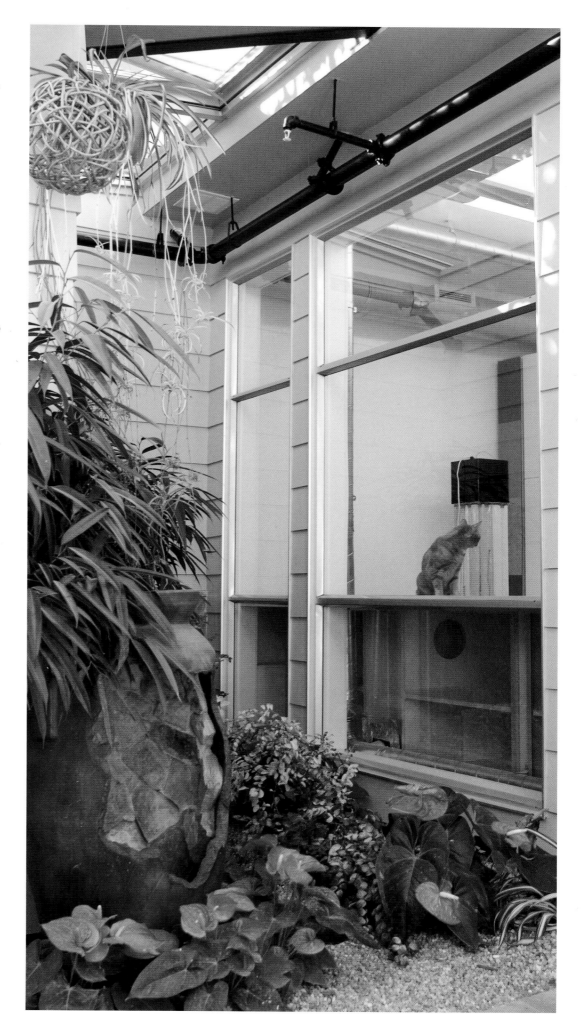

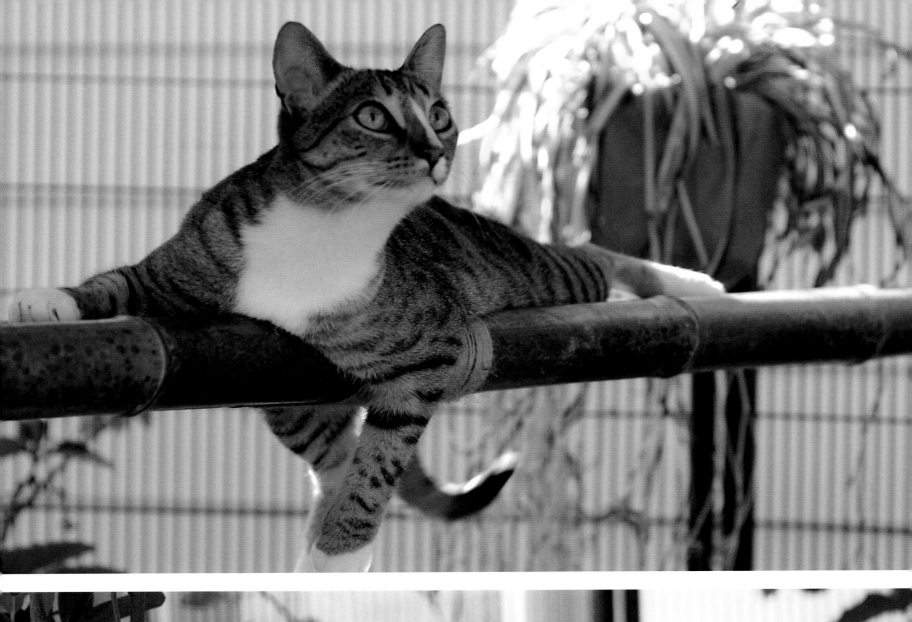
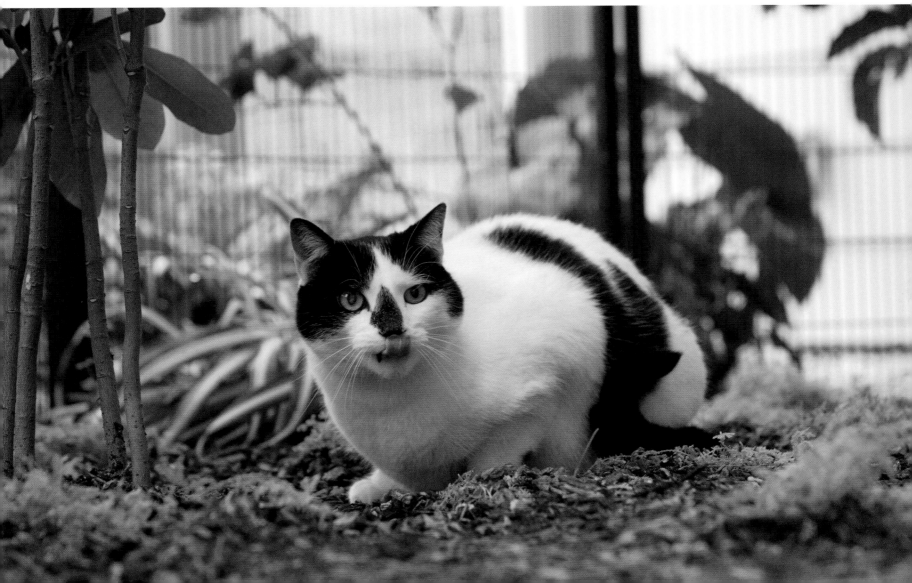

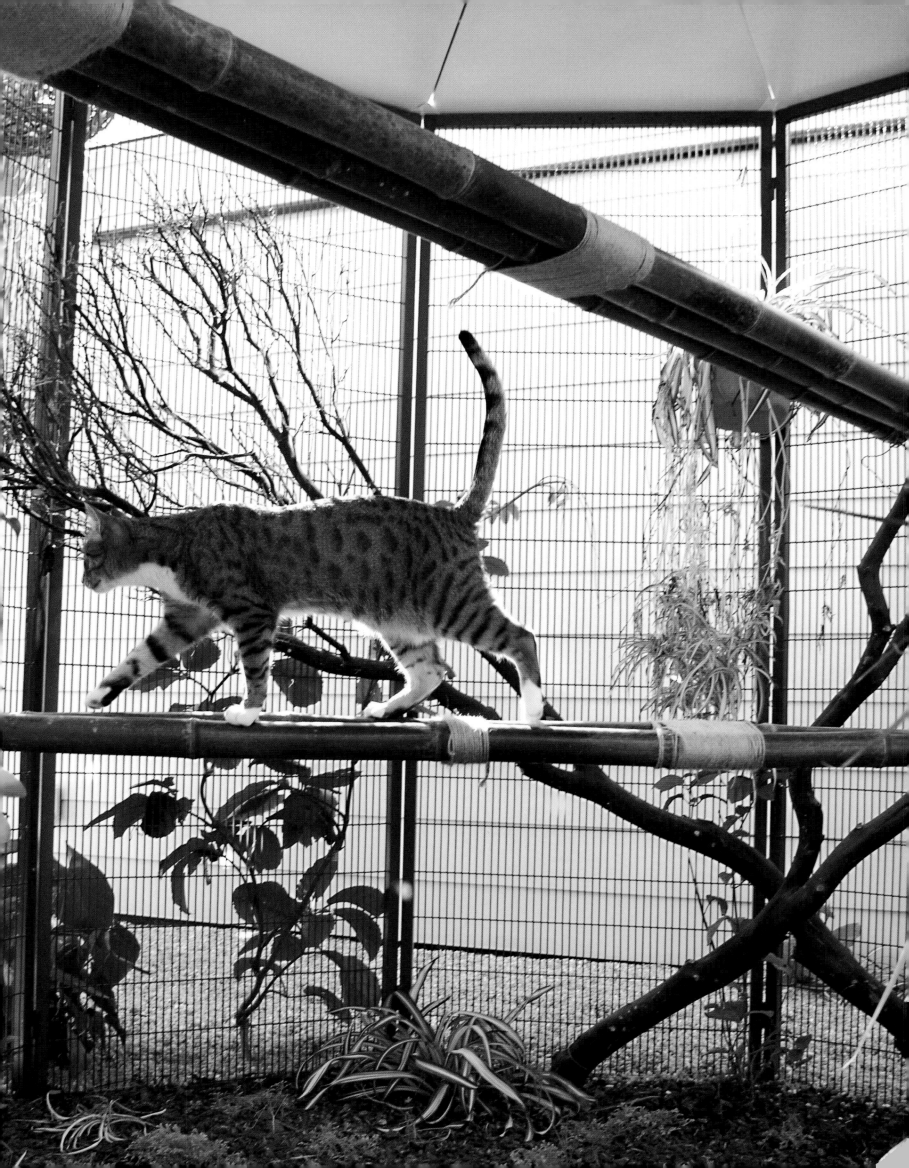

These special cat breeds, such as the Savannah or Bengal, carry a hefty price tag in the tens of thousands of dollars, and even comes with a nine to twelve month waiting period before you get your hands on one.

Spezielle Katzenrassen, wie beispielsweise die Savannah oder Bengal, kosten saftige Zehntausende und es gibt eine Wartezeit von neun bis zwölf Monaten, bis Sie endlich Ihr lang ersehntes Kätzchen in den Händen halten dürfen.

Le prix de ces chats de races rares, comme le Savannah ou le Bengal, peut atteindre des sommes astronomiques, et il n'est pas rare de devoir attendre de neuf à dix mois avant d'en obtenir un.

Estas razas de gato especiales, como la Savannah o la Bengala, conllevan un esfuerzo económico considerable que llega a las decenas de miles de dolares e incluso requieren un período de espera entre nueve y doce meses antes de tener un ejemplar entre las manos.

Queste razze speciali di gatti, come la Savannah o la Bengalese, comportano un notevole impegno economico, nell'ordine delle decine di migliaia, imponendo addirittura liste di attesa tra e i nove e dodici mesi a chi vuol mettere le mani su un esemplare.

Renee Grant will capture your cat's unique personality and exact likeness in an oil painting set in its favorite background, making your pet portrait even more personal.

Renee Grant hält die einzigartige Persönlichkeit Ihrer Katze naturgetreu in einem Ölgemälde fest, inszeniert vor deren Lieblingshintergrund, sodass Ihr Tierportrait noch persönlicher wird.

Renee Grant saisit la personnalité unique et l'apparence exacte de votre chat dans une peinture à l'huile où il figure dans son décor préféré, pour un portrait encore plus personnel.

Renee Grant captura la personalidad única y el aspecto exacto de su gato, en una pintura al óleo preparada en su entorno favorito, dando un toque aún más personal al retrato de su animalito.

Renee Grant saprà rendere il carattere del vostro gatto e il suo aspetto in un dipinto a olio sul suo sfondo preferito, dando così un tocco personale al ritratto del vostro animale da compagnia.

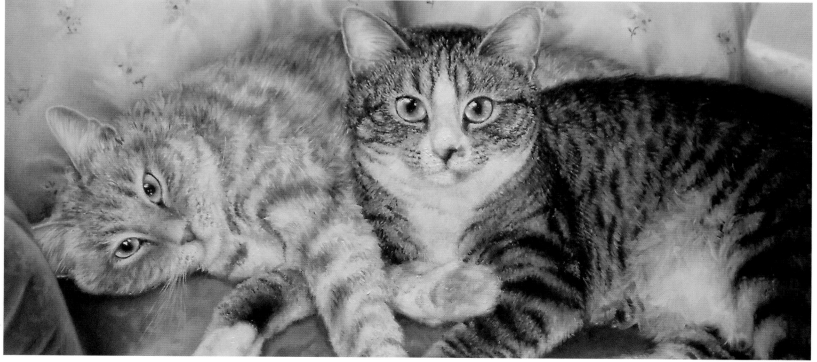

Portrait artist Todd Belcher specializes in custom pet portraits that he paints by hand from multiple photographs, utilizing his exceptional artistic gift to convey the unique spirit and likeness of his subjects.

Der Portraitkünstler Todd Belcher hat sich auf individuelle Auftragsbilder von Tieren spezialisiert, die er von zahlreichen Fotografien abmalt. Hierbei nutzt er seine außergewöhnliche künstlerische Begabung, um den unverwechselbaren Charakter und das Konterfei seiner Modelle auszudrücken.

Le portraitiste Todd Belcher se spécialise dans les portraits d'animaux personnalisés qu'il peint en se basant sur de nombreuses photographies, utilisant son don artistique exceptionnel pour traduire l'esprit et l'apparence uniques de ses modèles.

El retratista Todd Belcher se ha especializado en retratos personalizados de animales, pintados a partir de múltiples fotografías, comunicando el espíritu y el aspecto único de sus modelos.

Il ritrattista Todd Belcher è specializzato in ritratti personalizzati di animali, che dipinge a mano a partire da diverse fotografie, sfruttando il suo eccezionale dono artistico per trasmettere lo spirito e l'aspetto peculiari del soggetto.

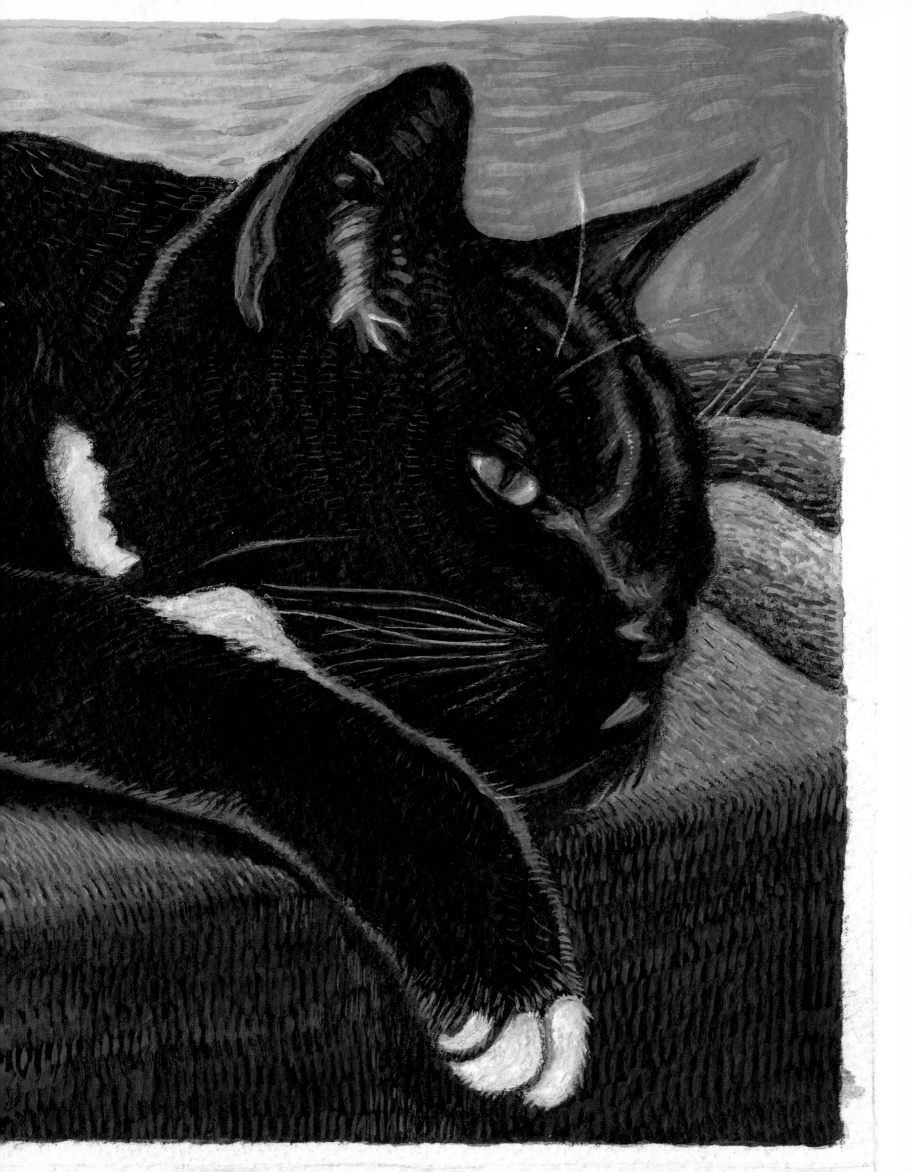

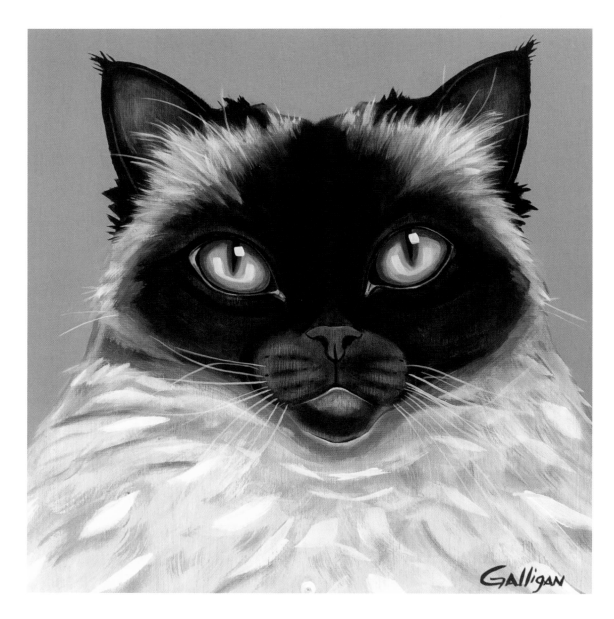

A pet portrait by Christopher Galligan is no ordinary portrait. Infused with sensitivity and insight into a pet's unique personality, he blends his own style of whimsical realism into every portrait, resulting in a breathtaking, emotional portrait that reveals the very soul of your pet.

Ein Tierportrait von Christopher Galligan ist kein gewöhnliches Portrait. Mit Sensibilität und Gespür für den Charakter eines jeden Tieres schafft er Portraits in seinem extravaganten Stil des Realismus. So schafft er atemberaubende, hoch emotionale Portraits, welche die Seele Ihres Tieres offenbaren.

Un portrait animalier de Christopher Galligan n'est pas un portrait ordinaire. Sa sensibilité et sa perspicacité lui permettent de connaître la personnalité unique de l'animal, à laquelle il mêle son propre style réaliste fantasque dans ses portraits époustouflants, qui révèlent l'âme de votre chat.

Un retrato de su mascota hecho por Christopher Galligan no es un retrato cualquiera. Transmite con sensibilidad e intuición la personalidad única del animal, contribuyendo con su propio estilo de realismo caprichoso en cada retrato, engendrando imágenes emocionantes que revelan la verdadera esencia de nuestro compañero.

I ritratti di animali firmati Christopher Galligan non sono ritratti qualsiasi. Con sensibilità e perspicacia nei confronti della personalità unica di ciascun animale, egli infonde il proprio stile stravagante e realista in ogni ritratto, creando opere mozzafiato e profondamente emotive che rivelano la vera anima del vostro compagno.

This robotic furry version of the beloved cat is so lifelike, that even its response and movements mimic the real thing; it will purr, turn his head, move his ears and blink his eyes, sit, stretch, cuddle, and sleep in response to its feelings and exchanges with people. The only major difference with a real cat is that it will never go looking for a litter box.

Diese mechanische Version der geliebten Katze ist dermaßen lebensgetreu nachgebildet, dass sogar ihre Erwiderungen und Bewegungen eine echte Katze nachahmen; sie schnurrt, dreht ihren Kopf, bewegt ihre Ohren und blinzelt. Sie sitzt, streckt sich, rollt sich zusammen und schläft entsprechend ihren Gefühlen und dem Austausch mit den Menschen. Der einzige wirkliche Hauptunterschied zu einer echten Katze ist: Sie wird nie nach einer Katzentoilette suchen.

Cette version robotisée du chat bien-aimé a des réactions et des mouvements qui imitent si bien le vrai qu'il paraît vivant : il ronronne, tourne la tête, bouge ses oreilles et cligne des yeux selon ses sentiments et ses échanges avec les gens. La seule différence majeure avec un vrai chat : il n'a pas besoin de litière.

La versión robotizada y peluda del adorado gato es tan fiel a la realidad que hasta sus respuestas y movimientos imitan a los gatos verdaderos; ronronea, gira la cabeza, mueve las orejas y parpadea, se sienta, se estira, se acurruca y duerme en relación a sus emociones y a los intercambios con la personas. La única diferencia notable con un gato auténtico es que nunca buscará una cajita para hacer sus necesidades.

La versione robotica e pelosa dell'adorato gatto è così verosimile che anche le reazioni e i movimenti imitano la realtà; fa le fusa, gira la testa, muove le orecchie e ammicca, si siede, si stiracchia, fa le coccole e dorme in risposta ai propri sentimenti e alle interazioni con le persone. L'unica grande differenza con un gatto vero è che non cercherà mai una cassetta per i bisogni.

the cat owner's maintenance log
Dr. David Brunner and Sam Stall

Track all the functions of your feline model!

Each page of *The Baby Owner's Maintenance Log* provides plenty of space for tracking one week of your model's first year. Note the first time the vocal capabilities function, the first night you activate sleep mode effectively, and the time of the baby's first step. Complete regular maintenance checklists to prepare for visits to the baby's service provider, and use the helpful charts to track waste functions and sleep functions.

Useful schematic diagrams accompany tips and advice from the best-selling *The Baby Owner's Manual* on everything from swaddling the baby to bathing to dealing with tantrums. Don't miss a single moment!

[auditory sensor (left)] [auditory sensor (right)]

[waste ejection port]

[propulsion apparatus]

ISBN 1-931686-25-4 $12.95 US
90000
QUIRK
BOOKS
www.quirkbooks.com

the **cat**
owner's maintenance log
by Dr. David Brunner and Sam Stall

[optical sensors]

[self-cleaning apparatus]

[balancing aid]

[motion sensors]

[tracking device]

[retractable grips]

RECORDING AND EVALUATING YOUR FELINE'S PERFORMANCE

MODEL NAME BREED

QUIRK

the **cat**
owner's manual

MODEL *Feline*

OPERATING INSTRUCTIONS, TROUBLESHOOTING TIPS, AND ADVICE ON LIFETIME MAINTENANCE

by Dr. David Brunner and Sam Stall

[optical sensors]

[self-cleaning apparatus]

[balancing aid]

[motion sensors]

[tracking device]

[retractable grips]

TYPE | *Domesticated*

If you want to become more deeply involved in a pet's life, heart and soul, you might consider reading one of the thousands of manuals on the topic of cat care.

Wenn Sie am Leben eines Tieres stärker Anteil nehmen bzw. sich in sein Herz und seine Seele hineinversetzen möchten, sollten Sie erwägen, einen der Tausenden von Ratgebern zum Thema Katzenpflege zu lesen.

Si vous voulez comprendre davantage la vie, le cœur et l'âme d'un animal, vous devriez songer à lire un des milliers de manuels consacrés aux soins des chats

Si quieren implicarse aún más en la vida, en el corazón y en el alma de un animal, podría ser oportuno leer uno de los tantos manuales sobre el tema de cuidado de animales.

Se desiderate farvi coinvolgere fino in fondo nella vita, nel cuore e nell'anima di un animale, datevi alla lettura di uno degli infiniti manuali sull'argomento della cura dei gatti.

This specialized kit guarantees that with proper training techniques your furry feline family member can use the toilet just like any other person in your home.

Dank dieses speziellen Bausatzes wird sichergestellt, dass Ihr pelziges Familienmitglied nach entsprechend guter Einweisung die Toilette wie jede andere Person in Ihrem Haushalt benutzen kann.

Ce kit spécialisé garantit qu'avec un entraînement approprié, votre petit félin pourra utiliser les toilettes tout comme n'importe lequel des autres membres de votre famille.

Este kit especializado garantiza que con su adecuado adiestramiento el lanudo miembro felino de nuestra familia utilizará el excusado exactamente al igual que cualquier otra persona en casa.

Questo kit specializzato garantisce che, con le opportune tecniche di addestramento, il membro felino della vostra famiglia apprenda a servirsi della toilette come ogni altra persona in casa.

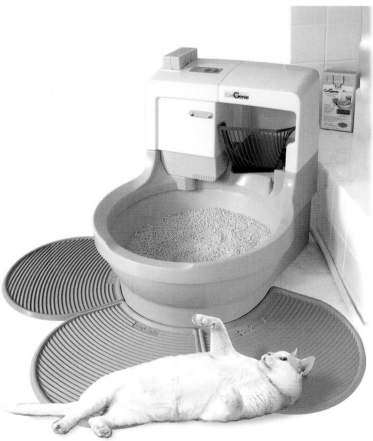

The high-tech CatGenie is a self-flushing and self-washing litter box that grants the cat lover's wish to never scoop or smell litter again with permanent washable granules that never needs changing.

Das Hightech CatGenie, eine selbstspülende und selbstreinigende Katzentoilette, sorgt dafür, dass dank des permanent waschbaren Granulats der Katzenliebhaber nie mehr in seinem Leben Katzenstreu entfernen oder riechen will. Dieses Granulat muss niemals ausgetauscht werden.

Le CatGenie est un bac à litière autonettoyant high-tech qui exauce le souhait de tout amateur de chat : ne plus jamais vider ou sentir la litière, grâce à des granulés lavables permanents qui n'ont jamais besoin d'être changés.

La supertecnológica CatGenie es una cajita para necesidades auto-lavadora y auto-limpiadora, que satisface el deseo del amante de los gatos que no quiera recoger ni oler nunca más los restos, con gránulos permanentes y lavables que nunca necesitan sustitución.

La supertecnologica CatGenie è un cassetta auto-sciacquante ed auto-pulente, che realizza il desiderio dell'amante dei gatti di non dovere più raccogliere o annusare i bisogni, con granuli lavabili permanenti che non necessitano di sostituzione.

Cats symbolize a security blanket that gives comfort and love in today's fast-paced world. From personalized coasters, picture frames, quilts to pillows, the cat frenzy can be seen everywhere.

Katzen symbolisieren eine „Kuscheldecke", die Trost und Liebe in der hektischen Welt von heute bietet. Von personalisierten Untersetzern und Bilderrahmen über Tagesdecken bis hin zu Kissen: Der „Katzenhype" ist überall gegenwärtig.

Le chat est comme un doudou qui donne confort et amour dans le monde stressant d'aujourd'hui. Des dessous de verre aux cadres photos, en passant par les duvets et les oreillers, la « chat-mania » est visible partout.

Los gatos simbolizan una manta de seguridad, que proporciona confort y amor en el frenético mundo moderno. Desde posavasos personalizados, a marcos para cuadros, hasta colchas y almohadas, "la gato manía" es visible por doquier.

I gatti simboleggiano una "coperta di Linus" che fornisce conforto e amore nel frenetico mondo moderno. Dai sottobicchieri personalizzati alle cornici, dalle trapunte ai cuscini, la gattomania è visibile ovunque.

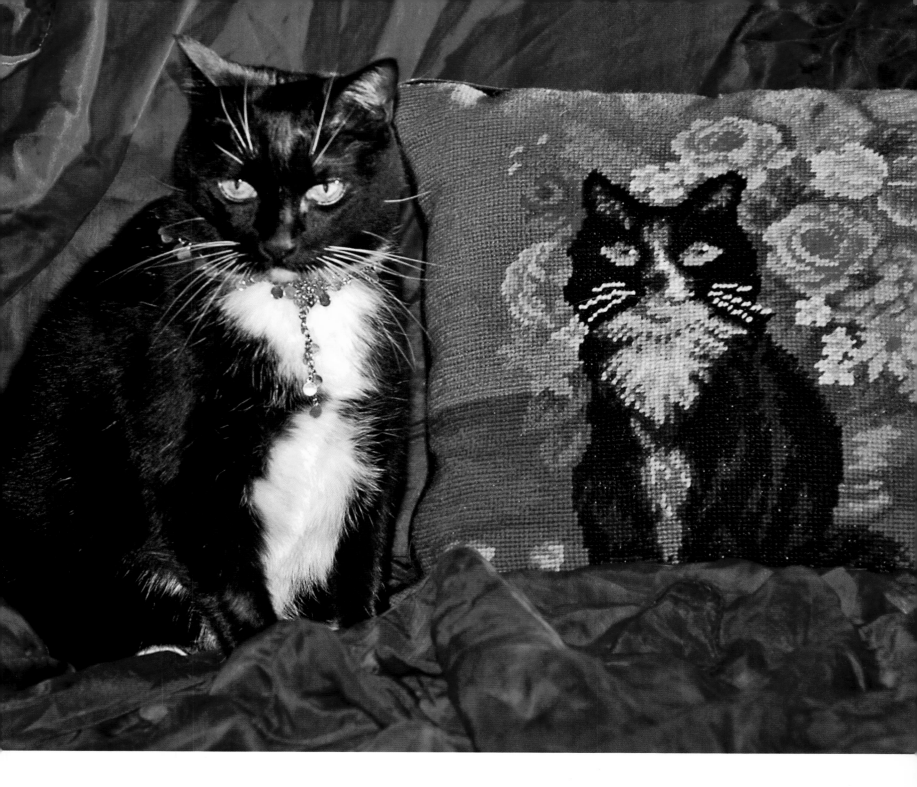

Display your cherished feline in a charming way by having them woven into a decorative pillow or one-of-a-kind heirloom keepsake.

Verewigen Sie Ihre geschätzte Katze auf charmante Weise, indem Sie ihr Konterfei in ein dekoratives Kissen einweben lassen. So haben Sie ein immerwährendes Andenken an Ihren Liebling.

Affichez votre félin chéri de manière charmante en faisant tisser son portrait comme coussin décoratif ou autre souvenir unique.

Exhiba a su adorado felino de forma encantadora, plasmando su imagen sobre una almohada decorativa o en una joya de familia única en su género.

Immortalate il vostro adorato felino facendolo ricamare su un cuscino o riproducendolo in un oggetto da lasciare alle generazioni future.

Cats are little angels with invisible wings

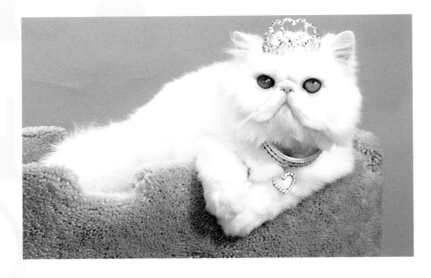

Accessories | Necessities

Automatic self-cleaning litter box by CatGenie
www.catgenie.com

Glamorous carriers, beds, and bowls by
Chrome Bones
www.chrome-bones.com

Toilet training kit by CitiKitty
www.citikitty.com

De-shedding razor by FURminator
www.furminator.com

Scratch sculpture designed by James Owen
www.jamesowendesign.com

Elegant dining bowls by Jo Sherwood
www.josherwooddesign.com

Colorful stylish litter box by Kitty a GoGo
www.kittyagogo.com

Sleepypod carrier
www.meowme.com

Cat Robot by Omron Company
www.necoro.com

Hidden litter box by Pet's Best Products
www.petsbestproducts.com

Pet accessories by RedEnvelope
www.redenvelope.com

Pet designs by Rocco & Jezebel
www.roccoandjezebel.com

Argo carriers by Teafco
www.teafco.com

Cat tents
www.thecattent.com

Fun dining bowls and signs
by Tumble Weed Pottery
www.tumbleweedpottery.com

Drinking water fountain by Veterinary Ventures
www.vetventures.com

Dining bowls and canister by Wetnoz
www.wetnoz.com

Fashion

Personalized rhinestone collars
from 26 Bars and A Band
www.26BarsAndABand.com

Unique collars from Animal Stars
www.AnimalStars.com

Costumes by Catron Fashions
www.catronfashion.com

Fashionable products from Dogs Department
www.dogsdepartment.com

Pet Jewelry handcrafted by Dorothy Bauer
www.dorothybauerdesigns.com

Unique collars by Holly & Lil Studio
www.hollyandlil.co.uk

Decadent Dining

A web-only pet supply retailer with a special
'Cat Department' that carries over 2,150 cat
and kitten products and accessories, with latest
information on health and wellness provided
by veterinarians through www.ThePetCenter.
com, the leading Internet Animal Hospital.
www.petfooddirect.com

These cat food recipes have been scientifically
researched and tested to produce the most
wholesome products for your feline compan-
ions using the highest quality natural ingredi-
ents that are fit for human consumption, and
some are even certified organic.

www.bouldercatfoodcompany.com
www.sojos.com (by Sojourner Farms)
www.katiesfarm.ca
www.catniptoys.com
www.pcs-pantry.com
www.pupcatbakery.com
www.heidisbakery.com
www.threedog.com

Tiki Cat by Petropics
www.petropics.com

Stylish Cat Furnishings

These companies offer a gorgeous collection of contemporary cat furnishings for the design-oriented home and style-conscious cat owner.

b.pet design for animals
www.bpet.it

Luxury furniture by Bulldog Bed & Company
www.bulldogbedandcompany.com

Cat Interiors
www.cat-interiors.de
www.pet-interiors.de

Catnap
www.catnap-global.com

CIZL
www.cizl.com

Danish Design by Susanne Mortensen
www.danishdesign.co.uk

Everyday Studio by Susan Kralovec
www.everydaystudio.com

IKEA Pet Collection
www.ikea.com

Entire line of unique cat playhomes by InTIERior
www.intierior.de

Kattbank litter bench and catpod
www.kattbank.com

Cat Cocoon designed by Warren Lieu
www.one-form.net

Lord Lou
www.lordlou.com

Ultra-stylish cat houses designed by Marco Morosini
www.marcomorosini.com

Cat tents by The Persnickety Pet
www.pettents.com

Modern cat homes by Pre Fab Pets
www.pre-fab-pets.com

The Refined Feline
www.therefinedfeline.com

The Royal Dog and Cat
www.the-royal-dog-and-cat.de

Elizabeth Paige Smith
www.kittypod.com

Luxurious beds by Robbie Quinton
www.sosadie.com

Square Cat Habitat
www.squarecathabitat.com

Vûrv Design
www.vurv.ca

WowBow
www.wowbow.co.uk

Traditional Furnishings

Adorable hand-crafted wooden cat houses by Robert Stabob come in a variety of styles and colors, even with modular tri-level condos and heated outdoor homes.
www.stabobspethouses.net

Angelical Cat offers the world's largest selection of cat furniture, perches, and kitty condos with over 140 models to choose from.
www.angelicalcat.com

House of Cat designers create any cat structure to any customer specification.
www.houseofcatsintl.com

Unique Luxury Pet Boutiques

Cat Faeries | Gail Colombo
www.catfaeries.com

George
www.georgesf.com

kit'n k'poodle | Karen Wood
www.kitnkpoodle.com

Muttropolis
www.muttropolis.com

Pawsitively Posh | Joyce Reavey
www.pawsitivelyposh.com

Trixie + Peanut
www.trixieandpeanut.com

Wagging Tail | Jean McCoy
www.wagwagwag.com

Kitty Care | Lodging

There are many catteries worldwide who offer unique boarding environments for your cat. It is impossible here to list the literally hundreds of luxury catteries, hotels, and cat spas worldwide who will treat your kitty like VIP, but here are just a few notables:

Amber Ley Cattery
www.amberleycattery.co.uk

Barkington Inn and Pet Resorts
www.barkington.com

The Barkley
www.thebarkleypethotel.com

The Cat Connection
www.thecatconnection.com

Cat Safari and Pet Camp
www.petcamp.com

The Furry Best Pet Resort & Spa
http://thefurrybestpetresortands.liveonatt.com

Holiday Barn Pet Resorts
www.holidaybarn.com

Moss Side Cottage Cattery
www.mosssidecattery.com

Mountaineer Pet Care Center
www.mountaineerpetcare.com

PETsMART's Pets Hotel
www.petshotel.petsmart.com

Ritzy Canine Carriage House
www.ritzycanine.com

Other Helpful Websites:
www.catchannel.com
www.petsit.com
www.petsitters.org

Pet-Friendly Luxury Hotels and Resorts

There are thousands of hotels and resorts that welcome pets. The following list contains some of the most recognizable luxury hotel chains that welcome your furry feline friends in many of their properties. Please inquire with reservations before you take your kitty with you.

Conrad Hotels
www.conradhotels.com

Crowne Plaza Hotels and Resorts
www.crowneplaza.com

Four Seasons Hotels and Resorts
www.fourseasons.com

Hilton Hotels
www.hilton.com

Intercontinental Hotels and Resorts
www.InterContinental.com

Kimpton Hotels
www.kimptongroup.com

Las Ventanas, Los Cabos, Mexico
www.lasventanas.com

Le Meridien Hotels
www.lemeridien-hotels.com

Loews Hotels
www.loewshotels.com

Marriott Hotels
www.marriott.com

The Peninsula Hotel in Beverly Hills, California
www.beverlyhills.peninsula.com

Ritz-Carlton Hotels
www.ritzcarlton.com

Sheraton Hotels
www.sheraton.com

Hotel Sofitel
www.sofitel.com

St. Regis Hotels
www.stregishotels.com

Westin Hotels & Resorts
www.westin.com

Wyndham Peaks Resort & Golden Door Spa
www.wyndham.com

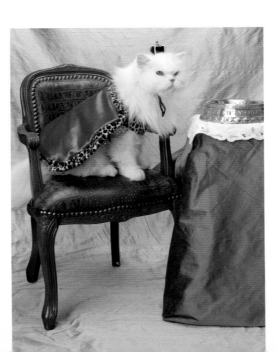

W Hotels
www.whotels.com

For more information:
http://en.escapio.com/pet-friendly-hotels-
pet-friendly-accommodation
www.petsonthego.com
www.roadandtravel.com

Wellness

Find holistic veterinarians—like Dr. David
Fong at San Francisco Veterinary Specialists
(*www.sfvs.net*)—that will administer acupunc-
ture, homeopathic and herbal medicine, chi-
ropractic, nutritional counseling, and contact
reflex analysis to care for your cat.
www.holisticvetlist.com

Drs. Foster and Smith includes a great selec-
tion of quality cat furnishings, toys, accessories,
treats and catnip products, grooming supplies,
supplements, and medications, as well as free
expert veterinary animal health care informa-
tion to keep your cat healthy with their award
winning website www.PetEducation.com with
thousands of articles on pet care.
www.drsfostersmith.com

Beauty Products

First aid spray by BergaVet
www.staroftheevening.com

Natural pampering line of shampoos and
conditioners by Bobbi Panter
www.bobbipanter.com

All-natural, bio-degradable
pet care products by earthbath
www.earthbath.com

Fresh Wave odor neutralizers for Stinky Pets
www.stinky-pet.com

Feline spa line and grooming products by
Happytails
www.happytailsspa.com

"Oh My Cat!" perfume
www.chicpaws.com

Premium skin and coat care products with
herbal treatments by SheaPet
www.sheapet.com

"Sexy Beast" product line by Karim Rashid
www.karimrashid.com

Exotic Cat Breeders

Serrano Bengals and Savannahs | Linda Bosnich
www.serranobengals.com

Animal Photographer | Cat Whisperer
Marion Vollborn
www.ragdoll-siona.de

Savannah Cats
Monika Binder | Editor "Katzen Extra"
www.savannah-cat.de

Birman Cats | Ice Fire Cats
Kerstin Hasse-Schieder
www.icefirecats.de

Pet Photography

Larry Johnson
www.JohnsonAnimalPhoto.com
+1 225 291 7733

Chanan Photography
by Richard and Nancy Katris
www.chanan1.com
+1 951 685 2739

Charlotte Marres
www.charlottemarres.nl
+31 6 41861213

Pet'ographique Boutique and Pet Photo Studio
www.petographique.com
+1 702 568 0500

Pet Portraits

Chris Galligan | +1 310 430 9790
www.galligangallery.com

Renee Grant | +1 718 464 0683
www.ergstudios.com

Todd Belcher | +1 336 201 7475
www.jimmydog.com

Linda Nelson | +1 949 300 2224
www.lindanelsonart.com

Tips

This web site is set up for cat lovers and anything
to do with owning and caring for one.
www.catarticles.com

This website is a companion shopping and
information site for *I Love Cats*, a bi-monthly
general interest magazine. The web store is the
perfect place to find a gift for the cat lover, or
to get practical information about wellness and
cat maintenance.
www.iluvcats.com

This website is an easily navigated, all-inclusive
resource for the above-average cat owner with
hundreds of categories and thousands of inform-
ative listings.
www.meowhoo.com

This informative website provides information
about cat health, diet, behavior, mind and spirit
for readers that are passionate about cats, and
crave information on how to improve their
daily lives.
www.thedailycat.com

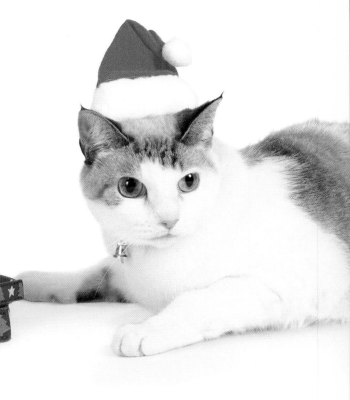

Online Stores

You'll find wonderfully unique cat toys and accessories for your cats as well as extensive information on cat products. You can shop by type and brand, as well as unique search options by breed or cat personality, while looking for that perfect product for your cat.

www.catfaeries.com
www.catsplay.com
www.cattoys.com
www.esmartcat.com
www.idogbeds.com
www.kitnkpoodle.com
www.luxuryforcats.com
www.lilapaws.co.uk
www.midnightpass.com
www.moderntails.com
www.omegapaw.com
www.pawprintzpetboutique.com
www.petquarter.com
www.quintessentialpet.com
www.spoiledrottenkitties.com
www.tailsbythelake.com
www.thegildedpaw.com
www.woofnwhiskers.co.uk

Organizations and Shows

American Boarding Kennel Association has become the recognized leader in the pet services industry representing the busiest and most professional boarding and daycare facilities, grooming shops and support businesses worldwide.
www.abka.com

Fédération Internationale Féline
www.fifeshowagenda.org
www.fifeweb.org

Cat Fanciers' Association
www.cfa.org

The International Cat Association
www.tica.org
www.ticamembers.org (Show Calendar)

Governing Council of the Cat Fancy
www.gccfcats.org

American Cat Fanciers' Association
www.acfacats.com

Magazines

American Magazines

Cat Fancy
Cats USA
Kittens USA
www.bowtieinc.com

Cat Fanciers' Almanac
+1 908 528 9797

Cat Rags
www.catrags.com

Cat World International
+1 602 995 1822

Pet Owner's WORLD
http://www.petsit.com/content49.html

German Cat Magazines

Geliebte Katze
die edelkatze
Our Cats
Katzen Extra

Worldwide

Atout Chat
+33 22 83 97 94 (FR)

CATS
Fax +44 161 236 5534 (GB)

Chats Canada Cats
+1 905 459 1481 (CA)

Cat World
+44 1403 711511 (GB)

National Cat Magazine
Fax +61 2 9674 2004 (AU)

Books

These books are highly recommended for anyone who is owned by a cat or aspires to be. Each manual has reliable information on topics from preventative healthcare and common health ailments to solving behavior problems.

The Cat Lover's Survival Guide
by Karen Commings
Specific advice covers managing the litter box, dealing with hair balls, finding a lost cat, furniture alternatives to dissuade clawing, gardening with a cat in the yard, dealing with a cat's disabilities as it ages, and much more.

The Cat Owner's Manual and Maintenance Log
by David Brunner
This is a great beginner's guide to feline technology through step-by-step instructions, helpful schematic diagrams, and plenty of useful advice for both new and experienced cat owners.

Cats for Dummies
by Gina Spadafori, Paul D. Pion, Dr. Paul D. Pion, Lilian Jackson Braun
This educational, comprehensive, and entertaining book explores hundreds of frequently asked questions and presents useful strategies from protecting feline friends from daily hazards to humane ways to correct undesirable habits.

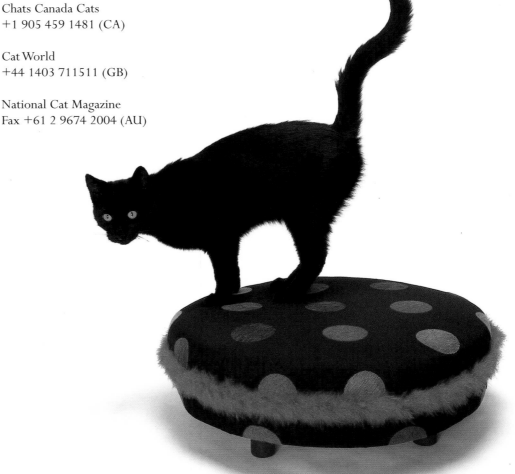

Products | Services

We wish to thank the following manufacturers, designers, artists, hotels, shops, and other cat enthusiasts who helped make this book possible:

26 Bars and A Band (p 26 top; 220)

Acupuncture at Barkley Hotel (p 147)
Alessi S.p.a., Crusinallo, Italy (p 127)
Amber Ley Cattery, Great Britain (p 173; 174)
Angelical Cats (p 100/101; back cover top left)
Animal Stars (p 32/33; back cover top right)
Argo by Teafco (p 183)
Arica Dorff (p 4/5; 6/7; 12/13; 14; 24; 27; 84)
av Ljusdal Norwegian Forest Cat Breeder
 www.ljusdal.de (p 102/103; 106)

b.pet (p 60; 68/69)
Barkley Pet Hotel, United States (p 170/171; 172)
BergaPet Spray (p 148)
Bobbi Panter Gorgeous Dry Spray (p 148)
Boulder Cat Food Company | Charles Withers (p 135)

Cat Faeries (p 30 carrot catnip)
Cat Faeries Natural Healing Flower Essence (p 149)
Cat Interiors (p 10/11; 44 toys top; 58/59; 61; 96; 97)
Cat Owner's Manual and Maintenance Log (p 207)
Cat Safari (p 163; 191; 192/193; 194/195; 196/197)
CatGenie (p 209)
Catnap (p 17; 21; 53; 62/63; 35 bed; 215;218; cover)
Catron Fashions | Mary Catron (p 21; 30; 50; 216; 219)
Catsplay (p 25; 31)
Chanan Photography (p 8/9; 160; 145)
Chris Galligan (p 204/205)
Chrome Bones (p 2 bed; 28/29; 30 dining; 114 dining; 125; 179)
Citikitty Toilet Training Kit (p 208)

Deb Clifford (Art Direction)
 Style Communications (p 163; 191; 192/193; 194/195; 196/197)
Dick Mueller (p 113)
Dogs Department (p 19 collar)
Dorothy Bauer (tiara: p 35; 220; black crown: 216)
Dr. David Fong, Holistic Veterinarian
 San Francisco Veterinary Specialists (p 152/153)

earthbath natural products (p 148)
Ed Hardy | Courtesy of Chrome Bones Boutique (p 166)
Elizabeth Paige Smith (p 74/75; 92; 92/93; 94)
ERG Studios (p 200/201)
Everyday Studio (p 95 bottom; 126 center, bottom)

Farameh Kitty Recipes (p 132/133; 134)
Finamedia Anselm Fina (p 61)
Fotostudio Beate Wendler (p 10/11; 58/59; 96)
Foxy Hound Grooming Salon (p 140; 143; 150/151)
FURminator (p 158/159)

Gail Colombo | Cat Faeries (p 30; 149; 152/153)
George Boutique (p 44 snake/mouse toys, center, 214 bottom)
Goyard (p 124; 176 top)
Grandma Lucy's Treats
 Courtesy of Wagging Tail Boutique (p 114)

Happytails Products: Sparkle & Shine,
 Aromatherapy Spritzer, Fur Breeze (p 148/149)
Heads & Tails Sardine Cat Treats
 Courtesy of George Boutique (p 136 left bottom)
Helena Pechacek
 Bulldog Bed and Company (p 217 center right)
Holly & Lil Studio (p 38/39)
House of Cats (p 78/79)

Ice Fire Cats | Kerstin Hasse-Schieder
 www.icefirecats.de (p 48/49; 57; 106)

IKEA (p 80/81; 117; 119; 187; 176/177 bottom)
InTIERiors (p 42/43; 44 fruit toys, center;
 46/47; 48/49; 57; 91; 102/103; 104/105; 106/107; 212/213)

James Owen Designs (p 108)
Jean McCoy
 Wagging Tail Boutique (p 114; 121; 148/149; 216 dining bowl)
Jimmy Dog Designs (p 202/203)
Jo Sherwood Designs (p 122)

Karen Wood | kit'n k'poodle boutique
 (p 37; 140; 143; 150/151; 165; 211;214 top)
Katie's Farm Organic Pet Bakery (p 138)
Kattbank (p 82/83; 98)
Kelly Calderón (p 135)
Kerstin Hasse-Schieder | inTIERior.de (p 42/43; 44; 46/47;
 48/49; 57; 91; 102/103; 104/105; 106/107; 212/213)
Kim Bull | Designer WowBow (p 55; 87)
Kit'n K'poodle Boutique
 (p 37; 140; 143; 150/151; 165; 211;214 top)
Kitty a GoGo (p 155)
Kitty Kaviar Treats | Courtesy of Wagging Tails Boutique (p 121)

Larry Johnson (p 34; 36; 168; 184; 189)
Lila Paws (p 77)
Linda A Bosnich
 Serrano Bengals and Savannahs (p 198; 199 bottom)
Lord Lou (p 64/65; back cover bottom right)
Louis Vuitton (p 180/181; back cover bottom left)
Luc Ekstein (p 2; 17; 21; 22/23; 28/29; 30; 35; 50; 53; 62/63;
 114; 121; 148/149; 156; 166; 181; 215; 216; 218; cover)

Marco Morosini (p 70)
Marion Vollborn | www.ragdoll-siona.de (p 42/43; 46/47; 213)
Mark Rogers Photography (p 163; 191; 192/193; 194/195; 196/197)
Marya Hart (p 37; 140; 143; 150/151; 165; 211; 214 top)
Michael Dar (p 220)
Midnight Pass (p 182)
Monika Binder | Editor "Katzen Extra"
 www.savannah-cat.de (p 102/103; 106)
Moss Side Cottage Cattery (p 175)
Muttropolis (p 40/41; 136 right bottom)
Necoro Robot by Omron (p 206)

Oh My Cat! perfume by Chic Paws (p 157 top)
One Form Design (p 95 top)

Patricia Soskel (p 100/101; back cover top left)
Pawsitively Posh (p 66)
Persnickety Pet (p 113 bottom)
Pet Camp (p 163; 191; 192/193; 194/195; 196/197)
Pet'ographique
 (p 4/5; 6/7; 12/13; 14; 24; 27; 84)
PetsBestProducts.com | Ronald Evans (p 154)
PetsHotel by PetSmart (p 169)
Pre Fab Pets (p 71; 76)
Princess Cook | House of Cats International (p 78/79)

Quirk Books (p 207)

Ragdoll Siona Breeder Marion Vollborn
 www.ragdoll-siona.de (p 46/47)
RedEnvelope (p 126 top)
Robbie Quinton (p 22/23)
Robert Schott (p 50)
Rocco and Jezebel (p 156)
Royal Cat and Dog Company (p 26 center; 67)

Sexy Beast by Karim Rashid (p 157 bottom)
Simin Bakian (p 216 miniature chair)
Sleepypod (p 178)
Smart Cat (p 72/73)
Smart Cat Catnip Grass (p 136 left center)
Sojos (p 136 right, top and bottom)
SoSadie (p 22/23)
Square Cat Habitat (p 89; 109; 110/111)

Stabobs Pet Houses (p 50)
Stephanie and Todd Belcher (p 202/203)
Stinky Pet Fresh Wash and Crystals (p 148)

Tails by the Lake (p 210)
The Cat Tent (p 112)
Three Dog Bakery (p 130/131; 137)
Tiki Cat Food by Petropics (p 139)
Trixie + Peanut (p 26 bottom; 45; 136 left top; 217)
Tumble Weed Pottery (p 128/129; 212)

Vûrv Design (p 99)

Wagging Tail Boutique
 (sweaters: p 2; 22/23; 28/29; toys:17; dining bowls: 30; 114; 121; 216)
Warren Lieu (p 95)
Wetnoz (p 123)
Wow Bow (p 55; 87)

Yeowww! 100% Organic Catnip Cigar
 Courtesy of Muttropolis (p 136 right bottom)

Photographers

Beate Wendler (p 10/11; 58/59; 96)
Bill Niemeyer (p 152/153)
Charlotte Marres (p 19; 64/65; Back cover bottom right)
Chris Galligan (p 204/205)
David Robinson (p 55; 87)
Dick Mueller (p 113 bottom)
Eric Walsh (p 138 bottom)
Finamedia Anselm Fina (p 61)
Helena Pechacek (p 217 center right)
Janielle Stringer (p 112)
Jeffery C. Smith (p 32/33; Back cover top right)
Jens Kilian (p 130/131; 132/133; 134; 137)
Jim Brown (p 198; 199 bottom)
Kelly Calderón (p 135)
Kerstin Hasse-Schieder
 inTIERior.de (p 42/43; 44; 48/49; 57; 91; 104/105; 107)
L. Irizarry (p 26 bottom; 45; 136 left top; 217)
Larry Johnson Photography (p 34; 36; 168; 184; 189)
Luc Ekstein (p 2; 17; 21; 22/23; 28/29; 30; 35; 50; 53; 62/63;
 114; 121; 148/149; 156; 166; 181; 215; 216; 218; Cover;
 Back cover bottom left)
Lucy McMurray (p 138 top)
Marion Vollborn (p 42/43; 46/47; 212/213)
Mark Rogers Photography
 (p 163; 191; 192/193; 194/195; 196/197)
Marya Hart
 (p 37; 140; 143; 150/151; 165; 211;214 top)
Michael Dar (p 220)
Monika Binder | Editor "Katzen Extra"
 www.savannah-cat.de (p 102/103; 106)
Patricia Soskel (p 100/101; Back cover top left)
Pet'ographique (p 4/5; 6/7; 12/13; 14; 24; 27; 84)
Princess Cook (p 78/79)
Renee Grant (p 200/201)
Richard Katris | Chanan Photography (p 8/9; 145; 160)
Robert Hackett (p 139)
Ronald Evans (p 154)
Rowland Roques-O'Neil (p 38/39)
Saam Gabbay (p 74/75; 92/93; 94)
Straub Collaborative (p 108)
Timothy Gunther (p 82/83; 98)
Todd Belcher (p 202/203)
Warren Lieu (p 95)

Produced by fusion publishing gmbh, stuttgart . los angeles

Editorial team:

Patrice Farameh (Editor & Author)

Jens Kilian (Layout)

Alphagriese Fachübersetzungen, Düsseldorf (Translations)

www.fusion-publishing.com

Special Thanks

This book would have never been possible without some very supportive people who were as passionate about this project as I was; my sincere thanks to photographer Luc Ekstein for capturing many of the gorgeous images for this book, even my most wildest style ideas; my heartfelt gratitude to a group of dedicated cat lovers who were crucial to the editorial process–Kirsten Schneider-Buckner and Birgitt Steinberg from Catnap, Karen Wood from kit'n k'poodle, and Gail Colombo from Cat Faeries; a special thanks to Jean McCoy from Wagging Tail boutique and Adrian Beyaz from Chrome Bones who supplied us with so many luxurious products for the photo shootings; a heartfelt appreciation for the photographers Richard Katris from Chanan Photography, Arica Dorff from Pet'ographique, Marya Hart, Jens Kilian, Mark Rogers, Kelly Calderón, and Larry Johnson for supplying us with so many of the exquisite feline images; perfection could have not have been attained without the expert editorial eyes of Nina Tebartz at teNeues Publishing, as well as the the detailed image quality control from „Matze" Herterich and the production coordination support from Hanna Martin at Fusion Publishing.

No felines were harmed during making of this book. A big round of 'paws' goes to our beautiful kitty supermodels who became our patient muses so that we could create the perfect picture: Boya, Oliver, Simba, Pustefix, Raleigh, Mel, Lucy, Bubba, Prince, Ruddy, Moon, Fawkes, Whiskers, Kismet, Nepal, Winter, Peter, Mikesch, Samira, Aaron, Ragdoll Siona cats, Ice Fire cats, and so many others.

Published by teNeues Publishing Group

teNeues Verlag
Am Selder 37, 47906 Kempen, Germany
Tel.: 0049-(0)2152-916-0, Fax: 0049-(0)2152-916-111
Email: books@teneues.de
Press department: arehn@teneues.de
Tel.: 0049-(0)2152-916-202

teNeues Publishing Company
16 West 22nd Street, New York, NY 10010, USA
Tel.: 001-212-627-9090, Fax: 001-212-627-9511

teNeues Publishing UK Ltd.
P.O. Box 402, West Byfleet, KT14 7ZF, Great Britain
Tel.: 0044-1932-403509, Fax: 0044-1932-403514

teNeues France S.A.R.L.
93, rue Bannier, 45000 Orléans, France
Tel.: 0033-2-38541071, Fax: 0033-2-38625340

www.teneues.com

© 2008 teNeues Verlag GmbH + Co. KG, Kempen

ISBN: 978-3-8327-9224-4

Printed in Italy

Bibliographic information published by Die Deutsche Bibliothek. Die Deutsche Bibliothek lists this publication in the Deutsche Nationalbibliografie; detailed bibliographic data is available in the Internet at http://dnb.ddb.de.

The beloved 'Sushi' and her loyal servant Patrice Farameh

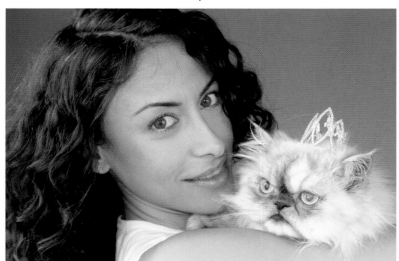

Photo: Michael Dar
Tiara: Dorothy Bauer Designs